LONDON

THE CLASSIC GUIDE

ARTHUR MEE

AMBERLEY

Tribute

This book owes a great debt to the faithful research and skilful cooperation of Conway Walker, Hugo Nelson Tyerman and Sydney Warner, and for the pictures to Sidney Tranter, Art Editor and the following photographers: Bedford Lemere, W. Bennington, W. S. Campbell, A. Cooper and Sons, J. Dixon-Scott, Herbert Felton, His Majesty's Stationery Office, Humphrey Joel, A. F. Kersting, Liberty's, Donald McLeish, W. H. Newbery, Royal Commission on Historical Monuments, W. F. Taylor, Valentine and Sons, W. Whiffin, York and Sons, and others

First published 1937

This edition first published 2014

Amberley Publishing
The Hill, Stroud
Gloucestershire, GL5 4EP

www.amberley-books.com

Copyright © Arthur Mee 1937, 2014

The right of Arthur Mee to be identified as the Author
of this work has been asserted in accordance with the
Copyrights, Designs and Patents Act 1988.

British Library Cataloguing in Publication Data.
A catalogue record for this book is available from the British Library.

ISBN 978 1 4456 4217 8 (print)
ISBN 978-1-4456-4239-0 (ebook)

Typeset in 9.5pt on 12pt Minion.
Typesetting and Origination by Amberley Publishing.
Printed in the UK.

Contents

The Magnet of the World

We have only to open our eyes and on every hand is a touch of something that stirs the sense of wonder within us. The Roman bastion in the City, the parchment given to London by the Conqueror and the white house Gundulf built for him, the noble monuments of medieval days, the glory of the Tudors, the stately dignity of Inigo Jones and Christopher Wren – all these are in our streets; and in our halls and palaces is the glowing beauty of the centuries. There is no other city with treasure such as ours. It is stirring to remember that for so long London has been the citadel of freedom, holding the fort of Liberty and keeping watch that it should not perish from the earth; but it is something also to realise that London as she stands is the noblest visible monument existing to the spirit of mankind.

It has drawn one-quarter of the people of England within its focus, for Greater London, with all the neighbouring parts which share its life and work and interests, now numbers about ten million people. In some way or other all these are part of it, drawn into it or affected by it. If they do not come into the County of London with which this book deals, they come into Police London, Postal London, Telephone London, Water London, Electricity London, Transport London. If they do not live in the County Council's 117 square miles they live in the 700 square miles of these Londons that throw out their ever-spreading tentacles round a quarter of the English people.

The government of this vast metropolis is in the hands of about 2,000 councillors and aldermen sitting on thirty public bodies: twenty-seven boroughs, two cities, and the County Council over all – yet not quite over all, for the City of London is entrenched in its own Square Mile with a form of government by which it has been ruled for centuries. It may be said, indeed, that the government of London shows something of the flexibility of the British Constitution, for the City is a kingdom to itself in which the Lord Mayor rules, where even the King does not enter without permission, and within the City lies the Temple, a little world of its own where the Lord Mayor has no power.

But this is the exception, a curiosity of one square mile; for the rest the County Council rules from County Hall, with the many detail matters in the hands of twenty-eight smaller councils, covering the City of Westminster, the royal borough of Kensington, and twenty-six towns not frequently visited

by the traveller yet all with an interest of their own and many of them crammed with history. It is with the London of these twenty-nine cities and towns that this book deals, with all these places and the hundred areas within them that have become familiar to us with such names as Dulwich, Highgate, Streatham, Peckham, Brixton, Norwood, Tooting, St John's Wood, and Camden Town. It is not possible in such a comprehensive book to deal with Greater London and bring in such attractive places as Richmond Park and Kew, with the famous gardens visited by a million people every year. There is no sight more wonderful in Greater London's 700 square miles when the gardens are in their spring or summer glory, but they lie outside London and belong to Surrey in our survey of the King's England.

It is still for what is old in London that the traveller comes to it, yet it is the everlasting fascination of the world's great city that it knows no age. It belongs to all time. It agrees with the poet who prayed Let me grow lovely, growing old, and to the Londoner who has known the city all his life there is something almost for tears in the new beauty that comes to it with change. The little Dutch Garden by the Round Pond is like a dream of colour. The Battersea Power Station is one of the sights of the world at night. The Embankment floodlit is an impressive scene, with the great white tower of Shell-Mex growing whiter as we drive away and the vast mass growing darker. The spectacle from Lambeth Bridge is a glimpse at last of what the riverside will be in twenty years or fifty. The transformation has begun. The South Bank is changing its dress. The Duchy of Cornwall has pulled down its mean estates. We are on the way to the day when the Thames will run through the heart of the town and no more, divide it into Rich and Poor, Dignity and Infamy.

If the Romans walled the City round, if the Conqueror dominated it with his marvellous tower, if the Tudors made it the wondrous spectacle we love to think of, if Christopher Wren and Inigo Jones clothed it with a gracious dignity, if the nineteenth century filled it with great houses and stately palaces, the twentieth century is not unworthy of it all. We have only to walk about the City, in and out of its maze of streets, to see the vast temples of commerce rising like mountains fashioned by the hand of man. We have only to walk along Millbank to see what can happen when a slum comes down. We need only walk through Regent Street and up Oxford Street, down Portland Place and through the streets of Marylebone, to see that there is rising a new London fit to be neighbour of the old.

Our first ancestors built their homes on piles and often our architects must follow their example to get a firm foothold in London, but nothing has held back our miraculous engineers, and the story of the twentieth

century London and the building of it is sometimes more romantic than a novel. Some of it comes into this book. Perhaps we should remember that our ancestors had their troubles too in laying their foundations. In exploring London we have seen the foundations of the Confessor's Chapel, and touched the bases of the Norman columns under the marvellous mosaic floor on which our kings are crowned. These foundations are so strong that when they laid Robert Browning in his grave the Confessor's concrete could be pierced only inch by inch, men standing by sharpening tools, and Browning sleeps (as Tennyson does) in the impregnable security of these massive Saxon walls.

The new Bank, with Mr Wheeler's Ariel poised above it like a Young Lady of Threadneedle Street, and with the lovely corner like a Roman temple through which we may walk, is an admirable example of the tribute Commerce pays to Art in modern London. There are hundreds of beautiful sculptures on the massive offices that go up everywhere in these days. It is worth while to go to the City to see the marvellous frieze of the Chartered Accountants, one of the best contributions of our time to London's outdoor gallery of art. It is one of the delights of the new London that it is not afraid of being new and being beautiful. Mr Selfridge, transformer of Oxford Street, has no need to put his name on his shop, with its stately front, its wonderful doorway, and its delightful roof. Liberty's tell us with both their fronts, and with the frieze so happily broken by the figures on its skyline, that Beauty is their stock-in-trade. It is true that London is growing more beautiful and mote impressive every day. If we could count them we should find that there are thousands of beautiful things looking down on our streets; we know thousands of cherubs and cupids and dolphins and camels and saints, even on our lamp-posts.

It is the thought of a lamp-post that brings us to Trafalgar Square, with Nelson so high on his column, and below him at each corner of this famous place a lamp that flickered on the deck as he walked about it on the night before Trafalgar, and on the evening after, when every heart was breaking with sorrow because Nelson was dead. These four octagonal lamps were there.

Go where you will, it is the same in London; we are walking through history. If we take a walk down Fleet Street to Dr Johnson's garret we have within almost a stone's throw on one side or the other buildings by Christopher Wren, the graves of crusaders and of Oliver Goldsmith, and the Conqueror's original Domesday Book; and at one end of this street between the Crown of St Dunstan's and the Cross of St Paul's lies Wynkyn de Worde who carried on Caxton's printing, while at the other end Queen

Elizabeth keeps watch where William Tyndale began his work of fixing the language Fleet Street speaks. This statue of Queen Elizabeth looked down on Elizabeth as she rode to St Paul's.

Much London has lost, but much remains. It is incredible to look at a picture of St Giles's Church in Cripplegate within the memory of a living man and to see it in a country lane. So it must have been when they brought here the blind old man in grey, his friendly neighbours looking on in sympathy but little dreaming that this blind man who had found his paradise at last was immortal next to Shakespeare. We have lost the quiet ways and the leisured haunts of peace, but we have in the midst of the seething tide of London's life parks, with lakes and bridges and lovely gardens. Ten thousand vehicles pass our busiest corner in an hour, but we can miss them all by stepping off the pavement into the spacious glory of Hyde Park or into the rural walk down Constitution Hill, to see the wild duck on the pond and to look from the little bridge on London's finest view by day or night. The streets are impassable with their thousands of cars and myriads of people, but there is always a quiet place where we may stand and see life rushing by, or sit and imagine ourselves far from the madding crowd. A village street in Somerset or a narrow lane in Devon is not more restful than a winding path in St James's Park.

And, if we would seek our peace indoors, the wonder and the beauty of the world is ours. We may spend an hour with Gainsborough or Constable or Sir Joshua Reynolds in Trafalgar Square, or in the charming rooms of the Portrait Gallery round the corner. We may walk along Millbank to the Tate Gallery or across Oxford Street to the matchless gems of the Wallace Collection. We may look in at a church in Piccadilly to find ourselves spellbound by the work of Grinling Gibbons, or call at the Royal College of Surgeons and ask to see the masterpiece of Alfred Gilbert, in which the figures seem to live, though they hold in their hands a casket with their ashes.

We may visit seven cathedral churches. Paddington's Greek Cathedral may be locked, and the Catholic Apostolic Cathedral in Gordon Square may not be open, but Southwark has two and Westminster has two, and St Paul's is aglow with colour as this generation has never seen it before. Here at last meet Nelson and Wellington who never met in life. Here lies Lord Leighton on his lovely tomb. Here in white marble is Lord Kitchener. Somewhere under this vast dome is the dust of Philip Sidney and Van Dyck, and in the crypt, the most famous underground gallery in England, sleeps Christopher Wren.

Of the incomparable beauty of the Abbey all the world knows. It has the highest nave in England, the most wonderful roof, and some of the loveliest

tombs in the world. With seventy royal graves about them sleep Elizabeth and Mary Queen of Scots, between them lies the founder of our Tudor dynasty, and at the gate of this wondrous chapel sleeps Henry the Fifth with his Kate beside him at last, after lying in an open coffin for people to see, so that Pepys stooped down and kissed her when she had been dead 200 years. In the nave lies the Unknown Warrior, between the grave of Livingstone and the monument of Pitt, and off the cloisters is one of the most illustrious secular buildings on the earth, the Chapter House in which representative government was born.

The Crystal Palace is no more, but the South Kensington that grew out of it is one of the glories of the world. Its museums are packed with millions of beautiful and remarkable things. The Geological Museum, new in time for the World Economic Conference which perished so pitiably in the home of the fossils, is the finest museum of its kind in Europe, magnificently housed. In the Victoria and Albert we can walk for miles among treasures of almost unimaginable beauty. The captivating Science Museum beats the kinema for interest and is visited by more than a million people every year. It is the epitome of our wonderful century, dazzling with colour and alive with movement, with James Watt's Garret in which the Age of Power was born, and with all the wonders that have come in its train. In the British Museum at Bloomsbury, now with the great University rising up beside it, we walk through space and down the corridors of time, for its treasure is gathered from the ends of the earth and from the ruins of the ancient empires. Here we look on a man in his grave as they huddled him up in it perhaps ten thousand years ago. Here are mummies in their painted coffins. Here is most of the beauty that is left of the Seven Wonders of the World. Here are the sculptures of the Parthenon, the Rosetta Stone that unlocked the mysteries of Egypt's hieroglyphics, a gallery of portraits painted in Pompeii, the bulls that guarded the palace gates of the King of Assyria, and the triumphal scenes that lined his corridor, so that we may walk along it as he did and look upon this witness of his mighty deeds.

But London, old or new, is like the widow's cruse, mysterious and inexhaustible. It is older than freedom, but it is ever renewing its youth. When half the world would speak to the other half it speaks through Faraday Building. When the troubled world seeks rest it comes to London. The nations go mad, but London keeps its head. The wonder of cities and the centre of the Empire, it stands in cloudy days like an island of calm weather. The storms may beat about it and the winds may blow, but it remains the magnet of the world.

Westminster

Round Parliament Square

May we not say of Westminster that somehow it is like the British Constitution, always the same yet ever changing? The heart of it stands from generation to generation. Parliament, the Abbey, the parks, Charing Cross, and Hyde Park Corner – they are always with us, but the twentieth century comes on apace, and Regent Street, and Piccadilly Circus, and Buckingham Palace, and even the winding Strand, are not the same. It is incredible how much has changed in our own time beyond remembrance, and yet it is Westminster, with Parliament and the Abbey, and Nelson on his Column, and the little bridge across the lake, that remains; the pictures do not fade away. Everybody

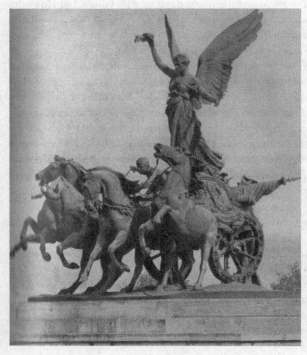

The Quadriga
at Hyde Park

knows them – the incomparable view of Parliament from the river, the white towers of Christopher Wren seen from St James's Park, the view from the suspension bridge by day or night, the trees and towers from Waterloo Place, the sweep of the Thames along the Embankment, the cavalcade surging past Trafalgar Square, Whitehall on Armistice Day with a hundred thousand people gathered by the Cenotaph, the walk from Millbank with the great window of Westminster Hall and the eastern windows of the Abbey in front of us, the surprising little streets round the Abbey, Queen Anne's Gate, the squares once so rich and now so poor, the Quadriga on Constitution Hill and the great colonnade it looks down on, the glorious facade of the Law Courts, and the lovely peep of St Mary-le-Strand, looking like a green lady when the leaves are out: all this is the Westminster the Londoner takes away with him when he goes far from home.

We will walk about it, seeing it indoors and out-of-doors, seeing much of the beauty we have missed so long and perhaps something unbeautiful we would gladly miss. We could wish that Clifton Suspension Bridge ran across the Thames again at Charing Cross, as once it did. We could wish that all the poor stuff were pulled down in some of our great places. We could wish that this famous city had a famous City Hall, the loveliest in the world. We could wish the stations were better, and the theatres – that they could house themselves as superbly as the shops. But if some things disappoint us, much remains. This city with boundaries so surprising, with its population halved while its rateable value doubles, with its acres reaching from the eastern side of Chancery Lane till they swallow up most of Kensington Gardens, has in its keeping the most solemn traditions and the most majestic possessions of the English-speaking race, and the change that is overtaking the world is making Westminster not less but more worthy of the glory that is hers.

We will begin our journey in the very heart of it, in that place which is old and new, the seat of Parliament, the shrine of faith, and the highway of a ceaseless tide of life, Parliament Square.

Parliament Square

There is no square in England that means so much to us as Parliament Square. It is not yet entirely worthy of its fame, but time is bringing down the things that have no business there, and its great architectural group is unequalled in London. Above it all rise the towers of Parliament, with the western towers and all the turrets of the Abbey looking up to them. On the Whitehall side is the stately block of the Ministry of Health; in the shadow of the Abbey is little St Margaret's, and across the road is the medieval-looking building which the twentieth century has added to this scene, Middlesex Guildhall,

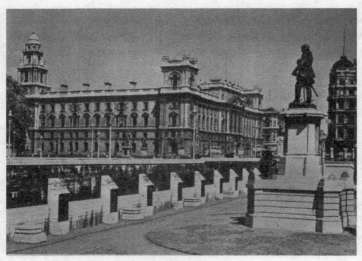

Cromwell and the Government Buildings

Amid all this that is so stately stands a group of famous men, magnificent in bronze: Abraham Lincoln looking out on this great scene, Oliver Cromwell guarding Parliament, Sir Robert Peel standing bareheaded as if addressing the House, Disraeli in his peer's robes with the Collar of the Garter, Palmerston carrying his mantle, Canning with a scroll, and the fourteenth Earl of Derby holding a dispatch.

On Sir Robert Peel's statue we may see in bronze the interior of the House of Commons, crowded. Lincoln's statue, showing him standing in front of his chair, is a copy of the statue by Augustus St Gaudens. Lord Derby's statue is by Matthew Noble; one of the panels shows him speaking and the other at his inauguration as Chancellor of Oxford University. Cromwell is one of the greatest statues in London, and shows the Protector uniformed and bareheaded, his right hand on a sword, the Bible in his left, and in front of him the British lion

Round about the square are three monuments that do not properly belong to it. One is the red granite column 60 feet high to Westminster old boys who fell in the Crimea; it is not beautiful, but has figures of the Confessor, Henry the Third, Elizabeth, and Queen Victoria, and is crowned with St George and the dragon. The other is the ornate fountain to the men who freed the slaves; it is a monument gone astray in spite of good intentions, and should be removed. The third monument of this group is in Old Palace Yard, near

the scene of the execution of Sir Walter Raleigh, the great bronze of Richard Lionheart on his prancing horse, holding his sword high.

Middlesex Guildhall

We will begin our visits in Parliament Square with Middlesex Guildhall, the twentieth century building like a piece of medieval England. There has been no more successful building set up in London in our time than this lovely little Guildhall in the shadow of Westminster Abbey. Here was built soon after the Norman Conquest the Westminster City of Refuge, a remarkable fortress with walls 25 feet thick which had rights of sanctuary till the Reformation.

The building holds itself together in a square compact mass which is given a feeling of lightness by the upward throw of the tower. Its ornament is balanced and restrained; its windows are well grouped. The architecture and sculpture of the doorway strike a sudden and powerful note.

The great doorway rising to the roof has a long frieze of sculpture running right and left and over the threshold, crowned at the roof level with a row of figures standing guard above the upper arch. The sculpture immediately over the doorway tells the story of Henry the Third granting a charter to Westminster Abbey. There are ten finely carved figures in the scene, and set under beautiful canopies on each side are figures of Prudence and Justice. The line of the frieze is broken in the middle, and just above the keystone of the arch is set a small finely sculptured panel of the Great Hall at Hampton Court, with a tiny figure of Law on each side.

The sculptures on the frieze to the right and left of the doorway represent two historic scenes – Lady Jane Grey accepting the crown, and the sealing of Magna Carta. High up at the roof level the great doorway ends in a sculptured gable of fine symbolical figures with Britannia in the centre, and above them all a solitary St George. The figures stand for Wisdom, Architecture, Literature, Government, Sculpture, Music, Truth, Law, Shipping, and Education. Behind them rises the noble tower, relieved with dignified ornament, shaped into great arches, and crowned with a parapet and a charming turret. It has four gargoyles peeping out.

The interior of the Guildhall is in perfect keeping. A broad winding staircase rises from the ball, with a bust of Edward the Seventh bidding us welcome. The two courts are on the ground floor and the great Council Chamber above. The oak panelled walls and carved seats are beautiful, their long plain lines suddenly bursting into a knot of foliage. The ceilings are magnificent, the first court having a fan-vaulted roof. There are screens worked in oak with a delicacy as fine as wrought iron.

The Middlesex Guildhall has in its possession a very precious document, the warrant by which Ben Jonson was arrested after his fatal duel, and under which he was ordered to be branded on the thumb with the letter T, showing that he had escaped Tyburn.

Behind the Guildhall lies the GHQ of Methodism, the Central Hall, which rose on the site of the old Aquarium. It was built from a fund of a million guineas raised at the beginning of the century, but remained unfinished, a blot on this proud scene for nearly a generation, owing to a dispute about light.

Crossing from the Guildhall to the Parliament House, we have before us an hour or two of childlike wonder as we walk about inside and out of the Palace of Westminster.

The Houses of Parliament

We should approach it, if we can, by London's oldest highway, the river; it is a memorable experience to come slowly up stream and watch the river front of our Parliament House changing with its lights and shadows. If we cannot go by boat we can all cross Westminster Bridge and walk along the delightful, almost-forgotten, stretch of Embankment leading to Lambeth Bridge. There we see the immense front of the Palace of Westminster as it stretches for 940 feet. We see the level mass rising from the strong unbroken line of the river wall, the light catching hundreds of pinnacles and little gilded vanes between three great towers.

These towers that dominate the skyline are more than stones and mortar: they are the sentinels of the nation, symbols of government; they tell us by day and by night that Parliament is at work. The huge Victoria Tower, the noblest tower in England and the highest in the world rising straight from a street, flies the Union Jack from its mast by day when Parliament is sitting. The tower at the other end, the noblest clock tower in the world, has a light above Big Ben which shines like the lamp of a lighthouse as long as Parliament is sitting. The flag by day and the lamp by night are the signal to London that Parliament goes on.

Between these two is the central tower, an elegant octagon which acts as a foil to the sturdy squareness of the other two. It rises above the Central Hall, and at its summit a hundred yards above the street is an open lantern surrounded by rich ornament.

Looking across the river at the long facade we see at either end two wing towers which are part of this great front and make a noble business of turning the walls round the corner. We see how the architect, in designing the palace, urged it upward by every conceivable means, particularly by the

six-sided buttresses which divide the facade into thirty-five bays, in which the windows are set.

Richly carved and panelled, these buttresses run the length of the building, rising above the parapet and ending in pinnacles crowned with gilded vanes. Upon this scheme of buttressed bays, with variation in the shape of buttress and window, the main fronts of the palace are planned. Crossing the upright lines of the buttresses on the river front are rich deep horizontal bands of ornament. At a distance they have the effect of stone embroidery, the chief band running between the first and second floor windows; but if we stand on the terrace we see that this band is a series of carved panels, each containing two figures supporting an armorial shield with a crown on the top. It is a great gallery of the Kings and Queens of England from the Norman Conquest to Victoria, a lovely stone pageant carrying the story of the Crown down the centuries, bearing the stamp of their personal history in dress and other details. William Rufus, for example, carries a small model of his Westminster Hall. Toward the north end of the facade kings and queens give place to heraldic beasts bearing the shield and the crown; we see the lion and the unicorn again and again, and boars, stags, and gazelles. Between the sculptured panels are smaller decorative reliefs in which we find the rose, the thistle, and the shamrock, and below the first floor windows runs an endless ribbon in stone, in and out of the niches of the buttresses, carved with the names and dates of kings. High above, on the parapet between the buttresses, is the most charming fantasy of all, a little figure of a queen set in a niche with a pinnacle over her head.

The lines of ornament follow the wing towers round and continue on the other fronts. In each face of the wing towers angels bear the shield and crown, with a buttress running up the centre between them, and set in the buttress, as if it were a Jacob's ladder, are six kings in niches rising one above the other, leaving the angels far below to guard the crown.

When we have crossed the bridge and passed through Victoria Gardens we have a splendid view of the great south front, and the majesty of Victoria Tower grows upon us. We see the tower better from Old Palace Yard, where it enshrines the royal entrance to the House of Lords, and is richly decorated with figures and heraldic sculpture and bands of Tudor roses. Colossal lions, sitting on pedestals and holding banners, guard the great archway, which is 50 feet high, and in the spandrels are angels supporting shields. Five richly carved niches contain statues of patron saints of the three kingdoms, with an angel on either hand, and all over the tower we may count twenty-two kings and queens, and twelve lions and unicorns.

We have now before us the long line of the House of Lords, the loveliest front of all, an enrichment of the scheme of the others. Three-storeyed oriel windows rise alternately between the square buttresses, crossed by bands of heraldic carving, and the parapet along this irregular front has a charm peculiar to itself. The long front is broken on the ground floor by the arched gateway for the peers, and at the eaves, above the gateway, by a lovely little tower with carved pinnacles at the corner. We should walk slowly from Millbank approaching this fine spectacle, which is completed by the great window end of Westminster Hall, beyond the bronze of

Richard Coeur de Lion sitting on his horse. It is one of the best sights that London has.

Guarding the entrance to Parliament for all of us is a huge crowned lion and a cheerful unicorn, and in the spandrels over the entrance are three tiny angels and a stag. The entrance seems curiously quiet, because in the arcading there are twenty-six canopied niches and above them four more, all, like Keats's village in the Ode on a Grecian Urn, emptied of their folk.

The Clock Tower, its walls delicately panelled and divided into three storeys, rises like a solemn shaft with a gilded and gorgeous head above the light and fanciful facade of the Palace. An open balustrade runs along the base of the clock stage, which is surrounded by fine stone ornament embodying the rose, thistle, and shamrock.

Big Ben's Tower rises 316 feet above high-water mark to the top of the spire. The light that burns in the lantern is 250 feet up and throws its beam many miles. Big Ben (named after Sir Benjamin Hall, Chief Commissioner of Works when the bell was hung) hangs from a massive iron girder and has round him four smaller bells for the quarters. His chimes are set to the tune of

So hour by hour, be Thou my Guide,
That by Thy power, no step may slide.

The hammer strikes the bell at the completion of each hour; the new hour begins when the chimes end.

The Central Tower, through which the ventilation system works, houses the great Central Hall which has the biggest octagonal Gothic roof in London (or perhaps in England) without a central pillar, 60 feet across. The top stone of this tower has lately been replaced and the old one is now on a Kent hilltop, higher than it stood when here; it has on it the words, scratched by a workman when the tower was built, 'Bud of central spire.'

The Victoria Tower is 75 feet square and 327 feet high to the top of the pinnacles, 400 feet to the top of the flag staff, so that the flag flies higher

than the Cross on St Paul's Dome. It is used for storing precious documents, and to it are brought the voting papers after every General Election, to be kept as long as needed.

The royal staircase in the Victoria Tower leads to a porch paved with Devonshire and Irish marble tiles, and we come up through the King's Robing Room, 54 feet long with six stained windows. At one end is the Chair of State under an oak canopy carved with shamrock, rose, and thistle, and the walls are panelled and painted. The upper compartments are filled with carvings of twenty-one scenes from the life of King Arthur, from the scene of his being delivered to Merlin at his birth to the bearing of Sir Galahad's soul to heaven. There is a marble fireplace with metal figures of St George fighting and conquering, and the frescoes on the walls are also of King Arthur's Round Table. They express the five ideas of Hospitality, Mercy, Religion, Generosity, and Courtesy, the pictures being: The admission of St Tristram to the Round Table Sir Gawaine swearing never to be against ladies The Vision of Galahad Arthur spared by an adversary Sir Tristram playing a harp to a lady

We now arrive in the Royal Gallery, 110 feet long, an impressive apartment of great grandeur, with stained glass windows and gilded statues of eight monarchs: Alfred and the Conqueror, Henry the Fifth and Queen Elizabeth, Richard the First and Edward the Third, William the Third and Anne. There is a great fresco on each wall and the arms of kings run below the windows. Both frescoes are by Daniel Maclise, one showing the death of Nelson at Trafalgar, the other the meeting of Wellington and Blücher at Waterloo. In the Prince's Chamber, a smaller room on the way to the House of Lords, Queen Victoria sits enthroned holding a sceptre and a laurel crown. The back of her throne is crowned with lions and there are sea horses at the foot. On the right of the throne is Justice and on the left Mercy, with a small image of Truth worn round the queen's neck; on the pedestal are reliefs of Commerce, Science, Art, and Invention. The windows have stained glass and the walls have bronze reliefs by William Theed with full portraits of monarchs above the bronzes. There are twenty-eight painted portraits, including all the wives of Henry the Eighth and Mary with Philip, and the twelve scenes in bronze show these events: The Field of the Cloth of Gold, Henry the Eighth receiving Charles the Fifth, the escape of Mary Queen of Scots, the murder of Rizzio, Mary looking back on France, Elizabeth knighting Drake, Raleigh laying his cloak for her, Philip Sidney's death, Jane Grey reading, Catharine of Aragon pleading, Henry receiving Cabot, and Edward the Fourth granting a charter.

The House of Lords

We pass into the House of Lords, magnificent with its canopied throne, its gorgeous panelling, its painted roof, its brilliant windows, its sculptured ornament, and its gilded pendants. At each end of the Chamber are three great arches with panels in them, the three over the throne showing the Black Prince receiving the Garter, Prince Henry before the judge, and the baptism of Ethelbert; and the three opposite being Justice, Charity, and Religion. Between the windows are stone figures of the eighteen barons who wrested Magna Carta from King John. The roof is flat in 1eighteen small compartments, each compartment divided into four and carved with devices and symbols all in gold. The walls below the windows are panelled and every other panel has a beautifully carved pillar with a bust of a king. The gallery front is panelled with heraldry. The great canopied throne raised on three steps has space for two state chairs under the central canopy, and is exquisitely carved, the back being rich with painted heraldry. In the front of the main canopy the splendour of the screen is enriched with five statues, the centre one being St George slaying the dragon.

The House of Commons

Beyond the corridor is the Commons Lobby, leading into the House itself. Compared with the richness of the Lords the Commons is plain, but indeed it is a rich and splendid chamber, with tiers of seats rising on one side of the Speaker's chair, galleries all round, and (high up at the back) the seats from which ladies are allowed to peep.

So far the tour of the Houses of Parliament has been the tour we make on a visiting day; it is interesting to call on a member and see the House in working order, when we enter by the doorway of St Stephen's Hall.

Until 1547 the Commons met in the Chapter House; from 1547 to 1834 they met in St Stephen's Chapel, founded by Edward the First and finished with great magnificence by his two succeeding namesakes.

St Stephen's Hall

St Stephen's Hall was rebuilt to occupy the same lines as St Stephen's Chapel. Its windows are filled with stained glass, there are stone seats along the walls, and twelve statues line the hall in white marble. They are John Hampden and Lord Falkland; Sir Robert Walpole, our first Prime Minister; Lord Mansfield, the great judge; the two William Pitts; Edmund Burke and Charles James Fox; Lord Clarendon and Sir John Selden, Lord Chancellor Somers, and the Irish leader Henry Grattan. There are also twenty-four statues of kings and queens in the niches round the doorways of the hall, six on each side. Inside the hall are two fine mosaics over the doorways by Professor Anning Bell, showing

the founding of the earliest chapel by King Stephen and its rebuilding by Edward the Third. But what has given St Stephen's Hall a new magnificence in our own time is the fine series of paintings in the panels left empty by the architect.

On the walls of the staircase by which the Members of the Commons descend to the Terrace is a ten-feet-wide painting of the Coronation of Edward the Confessor, and in frames at the foot of this staircase are paintings of Virtues and the Nativity. These are Professor Tristram's reconstructions from copies made by Stothard and others of some thirteenth and fourteenth century wall paintings in the Painted Chamber and St Stephen's Chapel of the old palace, which was destroyed by fire in 1834.

We pass from St Stephen's Hall up the steps into the Central Hall, its roof inlaid with Venetian glass, mosaic panels over its four doorways, and twenty-four statues of kings and queens in niches on the walls. The panels over the doorways have in them mosaic portraits of two of our four patron saints by Sir Edward Poynter (George and David) and two by Anning Bell (Andrew and Patrick). On the floor of the hall are four statues, of Lord John Russell, Lord Granville, Lord Iddesleigh, and Mr Gladstone. There are four archways out of the Central Hall, two to the Lords and Commons, the one by which we come, and the one in front of us, which leads to waiting halls and committee rooms. Passing to these through the corridor in front of us we have on each side three magnificent frescoes painted by artists of our own time, much reproduced and therefore familiar.

The corridor brings us into the lower waiting hall, which has a statue of John Bright by Bruce Joy, and the famous bust of Cromwell supposed to be by Bernini, who knew him; and on the staircase to the upper waiting hall is a statue of Sir Charles Barry, the standard yard and the pound weight let into the wall, and the picture of Queen Elizabeth Wedding the Realm.

Westminster Hall

If the Palace of Westminster is the greatest building in London it has in it the most wonderful hall in the world, the Hall of William Rufus with the roof of Richard the Second, 240 feet long, 68 wide, and 92 feet to the height of its roof. On the floor stand six kings: William Rufus, John, the first two Henrys, Richard the First, and Stephen; and in recesses of the wall are three statues of the thirteenth century.

The Great Hall has been saved for us in our time, like the rest of the Palace of Westminster, by the genius of our architects, in this case by Sir Frank Baines, for so long in charge of our national buildings and our Office of Works, and builder of the immense new Thames House on Millbank.

It has been said by an expert that as a structural achievement the roof of Westminster Hall is something to be compared with the building of the Forth Bridge, and it has been no less of an achievement to save it. At the corner of this famous hall, near the steps, is the entrance to one of the loveliest sacred places in England, St. Stephen's crypt. It is fourteenth century and is remarkably like the beautiful Chapel of Sainte Chapelle in Paris.

St Margaret's

From Parliament House we cross the way to Parliament's Church. As we come up to the abbey doorway we pass on our left a church with a dainty little porch looking like a small companion (as indeed it is) of our national fane. It is St Margaret's, the church of the House of Commons, the church of the Dominions, the parish church of the people as opposed to the conception of the Abbey as a monastic church. It has all these distinctions, and it has the distinction also of being charming in itself, with Norman stones in its foundations and with the nave and aisles of the sixteenth century, and the chancel as Abbot Islip devised it. Two stones have been found in the walls with his curious rebus of an eye and a man cutting a slip off the branch of a tree. The church has plain clerestory windows, eight bays, and no screen. There are angels at the top of the columns and the walls are crowded with memorials. The front pew has always been set apart for the Speaker.

The church has great associations. There is a brass tablet which announces that the body of Sir Walter Raleigh lies here, and it may be true, although it is uncertain.

The most precious possession of St Margaret's is its old east window, which is interesting for its own sake and has had a strange career. It was ordered to be made by Ferdinand and Isabella of Spain, the Isabella who sold her jewels to find money for Columbus and gave her daughter Catharine of Aragon to be an English queen. The great west window facing it is America's tribute to Sir Walter Raleigh as the coloniser of Virginia.

Both aisles have many Tudor monuments. In the south aisle, over the east doorway, kneel Thomas Seymour and his wife under an arch, and, going west, the notable monuments are Lady Dudley, a painted figure lying on her tomb, sister of Lord Howard of Effingham; a tablet to Sir Henry Layard; a medallion of a faithful servant Jane Rogers; a portrait in white marble of Mr Arnold-Forster; a medallion of Alfred Lyttelton with figures of Faith, Generosity, Fortitude, and Justice; a group of Hugh Houghton with his small and neat wife and two children in Tudor dress; Mary Brocas, a big bust with hood and bow as in the seventeenth century; and an ornamental brass of Lord Eversley, eighteen years Speaker.

The west wall has a Tudor lady on each side of the door; Blanche Parrye kneeling at a desk in a recess, and Dorothy Stafford with three sons facing three daughters, a neat little row on scarlet cushions. Also on this wall is a medallion, held by a heroic figure, of Sir Peter Parker; he was a young captain of twenty-eight, and the relief shows a battle scene at sea in the Napoleon days. The north aisle going east has a bust of Canon Conway, a tablet of Wenceslaus Hollar, the famous engraver who (we read) was 'a Bohemian gentleman famous in the Arts who left many works to eternise his memory.' Thomas Arnwaye kneels with his wife, both very neat in their Tudor dress, with this delightful ending to the epitaph: Of such men as this Arnwaye was God make the number large.

There is a bust of James Palmer, a seventeenth century parson; and a painted bust of Cornelius Van Dun, a friend who joined with Palmer in founding Westminster Almshouses; a bust with a painted beard in a round recess with the inscription worn away; and the stout figure in armour of Francis Egioke, kneeling on gold tasselled cushions under a canopy rather like a theatre box.

The altar plate of St Margaret's includes an eighteenth century loving cup engraved with the figure of St Margaret, and four alms-dishes with religious

St Margaret's

scenes. A great Prayer Book bound in scarlet and gold, which was in use before Waterloo but has long been away from the church, has lately come home again; it is a beautiful volume.

Out of St Margaret's by the charming west porch, we have before us the great doorway by which we enter our national shrine, the North Transept entrance to Westminster Abbey.

Westminster Abbey

It is our chief historic place. We come to it in our times of triumph and in our hours of grief. Here we crown our kings and lay our famous men. It stands amid London's streaming roar, yet here, a few feet from the penny bus that passes by all day, lies Queen Elizabeth in perfect quiet, and Henry of Agincourt, and David Livingstone. Nowhere else lie so many generations of our mighty dead.

The stones of the Confessor's church are down in the ground, but the walls we see have been raised anew on the old foundations. They are the work of 600 years of building and many generations of kings: Henry the Third in the thirteenth century, Henry the Seventh in the sixteenth, and the inspiration of Christopher Wren in another 200 years. A little Norman can be found by those who look for it, but the Abbey as we see it is the work of our Early English builders; it is one of its glories that it is so English. It was Henry the Third who pulled down the Confessor's chapel and built a greater one, Henry the Fifth whose chantry gave it a new splendour, and Henry the Seventh who crowned it with a wonder that holds us spellbound. Today it runs like a street of immortality for 500 feet from the west door, past the Unknown Warrior's grave, past Livingstone's and Newton's, up the steps of the Sanctuary, through the fifteenth century doorway to the Confessor's tomb, past the grave of Shakespeare's patriot king, and into the wonder of wonders, the chapel of the Knights where lies the founder of our Tudor dynasty with seventy royalties about him, under a great stone roof hanging in space like lace.

At this entrance, which most of us use, is a great arch with a tympanum of Christ in Majesty and six orders of moulding and carving. There are two rows of figures round the arches, one row with people set in circles and one with a kind of procession; altogether there are about 150 figures and grotesques about the northern doorway, more than twenty on the buttresses. They represent saints and kings and the heavenly choir. The central dividing pillar of the doorway is richly decorated.

We must climb up to the roof of the abbey and walk about it indoors and out to realise how wonderful it is. There is splendid carving that no

one sees, and particularly impressive are the flying buttresses of Henry the Seventh's Chapel, with evil spirits running down them as if fleeing in terror from the sacred place. The great splendour of the pinnacles of this chapel, with their dome-like caps 73 feet above us, is little realised from below. The buttresses of this chapel are octagonal, and elaborately adorned with panelling in which we see the portcullis, the double rose, and other Tudor decoration. The architectural device which makes this chapel possible, with its wonderful roof weighing many tons yet seeming to hang like lace, is a masterpiece of invention and enables the broad clerestory windows to fill the chapel with light.

The nave of the abbey is the loftiest in England. No other building in this country has a complete group of chapels surrounding an apse. In the foundations is the concrete laid by Saxon masons, and in the roof must be over a mile of medieval timbers. But it is indoors that we must come to find the matchless interest of this place, our sacred temple and our house of history.

North Transept of the Abbey

The chief monument in the North Transept is on our right as we enter, John Bacon's Chatham, 33 feet high. He is speaking, and below him sits Britannia with Earth and Sea. At his feet are Prudence and Fortitude, and the epitaph says that under him Britain reached a height of prosperity and glory unknown to any former age. With him lies his son, William Pitt, and not far off is Charles James Fox.

Forward along the aisle stands the full figure of Palmerston, clasping his hands, and then comes a group of three naval captains killed under Sir George Rodney in 1782. Turning into the west aisle of the North Transept, we enter at Matthew Noble's bust of a Prime Minister, Lord Aberdeen.

In the centre of this aisle stands the most dignified monument in the whole of the North Transept, Flaxman's figure of Lord Mansfield, who lived through most of the eighteenth century and was famous for half of it. The monument has an architectural curiosity, for behind the pedestal crouches a condemned criminal.

Poets Corner

We pass between the Sanctuary and the Choir into the most popular, if not by any means the most beautiful, part of the abbey, Poets Corner. It is not worthy of English Poetry or English Art as it presents itself to the eye, but if we remember what these walls enclose there is no place in London more moving, for here is the dust of a host of poets from Chaucer to our time, and the monuments of some who are greater than all.

There have been found in our time (revealed in 1936) two thirteenth century paintings on the south wall of Poets Corner, by the door that leads us to the chapel of St Faith. Both are over nine feet high and the colours are rich and luminous after nearly seven centuries.

It is one of the romantic facts of the abbey that the foundations of the Confessor's Church were laid in concrete. The concrete is below the floor of Poets Corner, and Tennyson and Browning sleep encased in it.

We will take Poets Corner wall by wall, beginning with the north wall which backs on to the Sanctuary and has against it two huge monuments looking on to the poets. They are those of Robert South, a prebendary of the abbey, and of the famous Westminster schoolmaster Richard Busby, in the school cap he refused to remove in the presence of Charles the Second. Walking into the Corner, we begin on the left with three busts, a big one of Dryden smiling between smaller ones of an Archbishop of Canterbury (Campbell Tait) and Longfellow, a tribute to American poetry in our sacred aisle. The monument to Abraham Cowley was set up in the bad old days when one monument in the abbey was broken to make room for another; it is a tall pedestal with an urn and foliage set in a broken fragment of an arch, and it breaks into Chaucer's tomb. On the other side of Chaucer is a medallion of the poet John Philips, and over Chaucer is a neat portrait of John Roberts, faithful secretary to one of George the Second's ministers.

Set among the monuments of these smaller folk is the superbly simple tomb of the Father of English Poetry, a dignified canopied sarcophagus with Tennyson and Browning on the floor in front of it. Next to Chaucer comes a medallion of Barton Booth, the actor, with one cherub crowning him with a wreath, another bringing a scroll of his virtues, and by the doorway is Michael Drayton in a little turned-down collar. Turning the corner at the door are three men in a row on the south wall: Ben Jonson, Samuel Butler, and John Milton. Below them is Edmund Spenser, and under Milton is the monument of poet Gray, with a woman holding a medallion and pointing as if to Milton above. One of the most precious spots of the abbey is by this south wall. Through the open door we see the Chapter House, the cradle of Parliament; on one side of us lies Chaucer, and at our feet lies Edmund Spenser in one of the most memorable graves in the world, for in it Shakespeare's pen may have crumbled into dust, or may still be there. Many less interesting graves in the Abbey have been opened, but never this.

Here in Poets Corner Jonson's bust has three masks with queer expressions, and engraved below is the inscription copied from the ancient stone over his grave in the nave, 'O rare Ben Jonson.'

A projecting wall divides Poets Corner into two, beginning by Milton's bust, and each side of the wall is lined with monuments. At this point comes the Chapel of St Faith, supposed to have been built for the use of the monks while Henry the Third's new abbey was rising. We come into it by a thirteenth century door and the chapel is much as it has been since the door was made. A painting of St Faith is fading on the east wall, there are a few thirteenth century tiles with lions, knights, and eagles on them, and eleven fine stone corbels have queer medieval faces.

The Abbey Sanctuary

We come now to the Sanctuary, full of loveliness. It has mosaic paving brought from Rome by Abbot de Ware in 1268; the abbot lies beneath it with his friend Walter de Wenlock and two other abbots, one of them a witness of Magna Carta at Runnymede. The mosaic pavement under which they lie is one of the wonders of the Abbey, and has perhaps fifty thousand small pieces of marble in it, arranged in circles and all sorts of shapes, and with colour still bright after six centuries. Under this floor are the oldest known stones in Westminster, the remains of two Saxon columns of the Confessor's church. One can be seen through a small trapdoor.

The seats for the priests are the oldest woodcarving in the abbey, lovely sedilia with four bays carved in oak, with glass and plaster work on the canopies, and crowned or mitred heads hanging from the canopies. At the back of the seats are paintings of King Sebert and Edward the First, and on the other side (looking down into the Ambulatory) is a painting of the Confessor and fragments of paintings of Gabriel and the Madonna.

Near the sedilia lies Henry the Eighth's unwanted wife Anne of Cleves, with an unfinished monument in front of which hangs a sixteenth century Brussels tapestry. By the tapestry hangs the best portrait of its age existing anywhere, and the oldest known painting of an English king, throned and crowned and holding the orb and sceptre. He is Richard the Second, who lies a few feet away from where his portrait hangs, and he is wearing a robe of red and ermine with a short cape, a rich collar, and a robe of blue decorated with flowers and crowns.

In front of the high altar stands the processional cross given by Mr Wanamaker of New York; it is rich beyond expectation, for its top is solid gold, strengthened by ivory and with 175 sapphires let into it among the small figures of Our Lord and Apostles. On the altar itself are two candlesticks which were paid for out of the savings of the cook at Westminster School, who in 1694 bequeathed all she had for this purpose. When Lord Rosebery's daughter Peggy Primrose was married in the Abbey Lord Rosebery gave

the cross in memory of the wedding, and it was shaped to match the cook's candlesticks.

The frieze above the altar was made last century to match the medieval stone frieze on the other side; it is the work of Sir Gilbert Scott, who refashioned the Sanctuary. Over the altar is a glass mosaic of the Last Supper, the work of a Venice craftsman. The screen is pierced for doorways on each side of the altar, and at each doorway (opening into the Confessor's Chapel) are two stone figures in niches. They are Paul and Peter, Moses and David.

On the left of the Sanctuary are three of the finest tombs in the abbey; they are thirteenth and fourteenth century, and in them lie the Earl and Countess of Lancaster and the Earl of Pembroke. The Earl of Pembroke lies in the middle tomb of this splendid trinity, a crusader with his sword ready, his hands clasped on his breast, his feet on a lion, and in the trefoil at the head of his gabled canopy a figure in armour on a galloping horse. On the other side of the gable is a horseman riding with his hands clasped in prayer. The tomb is a magnificent spectacle after 600 years and has weeping men and women in sixteen niches, though all but one have lost their heads.

The Earl of Lancaster (Edmund Crouchback) lies nearest to the altar, where he was laid in 1296. His tomb is the richest of the group, with gold as bright as in the fourteenth century, with three elaborately pinnacled canopies, horse riders in the trefoils of the gable on both sides, and about 150 small painted coats-of-arms representing most of the noble houses of the time. There are twenty weepers in beautiful niches. His countess, who died twenty-three years before him, lies in the lovely little tomb at the west end of the group, with six weepers, two angels supporting her head and two dogs at her feet.

The choir runs down into the nave between the narrow aisles of monuments, and is fitted with fifty-two handsome gilded stalls of the nineteenth century by Sir Gilbert Scott. The canopies are richly carved. It is an impression of richness and gold that we receive as we look into it.

Round the Sanctuary

Round the sacred heart of the abbey, the Sanctuary, and the Confessor's Chapel, runs the Ambulatory, and all about it are famous chapels in which lie nobles, priests, and kings. We will walk round the Ambulatory itself before seeing the chapels; the way is through the eighteenth century gates by the south transept, under the bridge of Henry the Fifth's Chantry and past the steps to Henry the Seventh's Chapel, to the gates by the north transept.

Entering at the south gate (by Poets Corner) we come to an altar tomb in a wall recess which has been here since 1270. It is worth examining closely,

for its top stone is inlaid with mosaic and patterned with curious circles; the arch over it is a century later than the tomb. Now comes next on the wall a bust of Richard Tufton. It is one of two seventeenth century black and white memorials that balance each other here, the other being to Sir Robert Aiton, who wrote the first version of Auld Lang Syne. Both are in oval recesses, and one bust is between standing figures of Apollo and Athena, while the other is flanked by reclining figures apparently of Mars and Mercury.

On our left is King Sebert's tomb, the oldest grave in the abbey, though the plain altar tomb we see was set up in 1308. It is in a recess at the back of the Sanctuary under the sedilia, and has traces of painting, a crowned head, a Catherine wheel, and vines in its decorations. Above it are painted panels on the back of the Sanctuary seats, showing a pilgrim and the Madonna.

On the wall by the steps which lead to the Confessor s Chape is one of the most remarkable paintings in England, an altarpiece called the Retable. It comes from about 1380, and is a senes of wooden panels about eleven feet long. Battered by ill-usage (it was long used as a piece of board for protecting the wax effigies close by) it has lost its grandeur, but it is easy to see how noble it has been.

Looking down into the Ambulatory is the beautiful tomb of Edward the Third which we come upon in the Confessor s Chapel, on this side are lovely bronze figures of six of his children, a captivating company. High above us is the sculptured bridge formed by the chantry of Henry the Fifth, under which we pass to the north arm of the Ambulatory. Immediately under the bridge on the other side is the famous iron grille by Thomas of Leighton Buzzar , protecting the tomb of Queen Eleanor; it is a wonderful piece of work, with little animals and roses in great numbers. Beyond it are the backs of the other tombs lining the Confessor's Chapel, and beyond these are the backs of the Sanctuary tombs.

This side of the tomb of Henry the Third is magnificent with its decoration of mosaic circles and the twisted shafts at the corners. Two men on horseback look down into the Ambulatory from the back of the tombs in the Sanctuary, one on the tomb of the Earl of Pembroke who lies by the high altar, and the other on the tomb of the Earl of Lancaster, who lies with him. One of these horsemen is perhaps unique in sculpture, for he sits on his horse with his hands folded in prayer. The riders are in the trefoils of the magnificent arches, a gorgeous array of pinnacles. In the front of these three tombs, nearest the altar, is the Earl of Lancaster, and in the third his countess; between them lies the Earl of Pembroke. As seen from the Ambulatory six weepers look from one tomb, eight from another, and ten from another; it is the richest line of sculpture in this famous aisle of history. On the wall below these tombs is

what is left of some of the oldest frescoes in the abbey, with ten figures of crusading knights holding banners.

Facing her lord's tomb is the tiny chapel built by the Countess of Pembroke, now known as the Chapel of Our Lady of the Pew. It has a charming doorway with two fourteenth century heads beside it and a fragment of rich fifteenth century work above it. By the door is a relief of Jane Crewe of 1639; she lies dying with her family weeping. Hereabouts is a big stone monument of the Earl of Bath (1764) with a medallion and weepers; the huge monument of General Wolfe; and another big monument of Earl Ligonier, a Huguenot refugee who joined Marlborough's army, with a medallion and a figure of Britannia; Admiral Charles Holmes standing at his gun dressed like a Roman, in the fashion of the eighteenth century; and a fifteenth century brass portrait of Sir John Harpeden and Abbot Etaney.

We have now completed our walk round the Ambulatory and return to the south gate to look through its chapels one by one.

The Chapels Round the Sanctuary

We begin with the chapel of St Benedict, reached from the transept, behind the bust of Dryden. In the middle of the floor is the tomb of a charming couple lying in white marble; they are the Earl of Middlesex and his wife,

The Sanctuary of the Abbey

probably chiselled by Nicholas Stone; both wear their coronets, both have ruffs, and both are holding their rich robes. They are very beautiful. By the iron rails lies Cardinal Langham, Archbishop of Canterbury, on a beautiful panelled tomb; he is at prayer in his robe and mitre and with his crozier. There are two dogs at his head and two at his feet with bells' on their collars.

Against the east wall of the chapel is the monument of the Countess of Hertford, a very important-looking lady in bounteous robes, fur-lined cloak, and French cap; her tomb has six columns, five obelisks, two pavilions, and two arches. Kneeling under an arch in the wall is a Dean of the Abbey in the last years of Elizabeth, Gabriel Goodman; he kneels at prayer in his skull-cap and robes. Near him is a wall memorial of three cherubs and an urn to Dean Sprat of 1683, and there is a big brass of Dean Bill in the doctor's robes he wore when Elizabeth came to the throne.

Through the iron gates we reach the Chapel of St Nicholas, passing into it through a fifteenth century stone screen in which the door has been hanging on its hinges all the time. It is a fascinating place, packed with fame and glory.

The wife of Protector Somerset wears a lovely red cloak, a French cap, a ruff, and a coronet, her head on two embroidered cushions and her feet on a castle. Another castle crowns the tomb, which has eight marble columns, four obelisks, two birds on crowns, and five lions. On another tomb of the seventeenth century the curtains are thrown back to reveal the figures of Elizabeth Fane and her husband, both lifelike figures with their eyes open, kneeling at their tomb with cherubs and angels about.

The Marchioness of Winchester, who died just before the Armada, has lost the hands she was clasping, but is still a rich figure in a fur-lined cloak, French cap, and coronet. In front of her tomb kneel two children looking at each other, and near them is a tiny tomb with a small child lying on it, 18 inches long.

In the middle of the chapel is the handsome and imposing tomb of Sir George Villiers and his wife by Nicholas Stone, a beautiful pair in white marble richly apparelled with lions at their feet. Against the wall behind her is the entrance to the vault of the proud Percys, where lies an eighteenth century Duchess of Northumberland. A little relief scene shows her giving charity, and we read that she was an ornament of the courts, an honour to her country, a patron of the great, and a protector of the poor. By the screen lies the Duchess of York of 1431 in a cloak and widow's hood, and there is an attractive little black pyramid for the baby son of Nicholas Bagenall, who died in 1687.

The finest tomb in the chapel is that on which Elizabeth's greatest statesman kneels 24 feet above us. Strange it is to see Lord Burghley kneeling so modestly, almost lost in the splendour of this tomb, for he was the founder

of the house of Cecil, and for forty years he ruled England with Queen Elizabeth. He is not here, but on the tomb, below its pinnacles and pavilions, lies Lady Burghley in a long cloak, a French cap, and a ruff, and slightly raised above her is her daughter Lady Oxford, with a unicorn at her feet. With them kneel one son and three daughters, the daughters making a fascinating group with their neat headdresses, the son (Sir Robert Cecil) kneeling at the end of the tomb between two columns with a stiff ruff and a short cloak.

We come now to the Chapel of St Edmund with an almost unrivalled collection of tombs in so small a space, and Bulwer Lytton sleeping here without a monument. By the fifteenth century screen (with eight bays and sixty-four arches) is one of the rarest figures in the abbey, the superb oak effigy on a plain oak tomb of William de Valence. He is magnificent today, but in 1296 he must have been a dazzling sight, for he was covered with bands of copper and the beautiful Limoges enamel. He is in full mail with a short coat to the knee and a rich and lovely blue and gold sword belt, and there is a decorated band on his forehead. His head is on a lovely cushion and his feet on a lion, and he carries a fine shield. He had thirty weepers, now all lost, but the tiny shields round the tomb are still rich and bright. There are only a hundred ancient oak figures in all our English churches, and this is among the very best of them.

Guarding the doorway with William de Valence lies John of Eltham, son of Edward the Second; he has a lovely tomb and his figure, the oldest alabaster figure in the abbey, is 600 years old as this is written, in 1937. It is magnificently apparelled, with angels supporting his head, his legs crossed, and a lion at his feet. He has a lovely shield with the arms of England and France, and his armour is greatly enriched.

Near John of Eltham stands a miniature tomb which must have been a gem in its best days. It stands upright panelled in two tiers, reminding us of Innocents Corner not far away. On it lie a brother and a sister, the boy with a hip belt and his cloak thrown back, the girl with a lovely short coat; they have been here 600 years and are the children of Edward the Third.

A perfect gem of sculpture is the Duchess of Suffolk lying in her coronet with an ermine mantle, her head on a fine embroidered cushion and her hands clasped. Fler dress is rich beyond description and her cloak is engraved with about a hundred tiny ornaments.

The eighth Earl of Shrewsbury lies here under a great arch with shields all round and fifty-six panels in the canopy. He lies on a higher level than his wife, both elaborately dressed, he in armour and cloak, she with a hood, a great ruff, and a coronet. Under an arch at the side is a little figure of their

daughter kneeling on a cushion between two pillars, stiff but charming.

Proud Sir Richard Pecksail kneels on a monument with six compartments, himself in one great arch, two wives in smaller arches, and four daughters below, looking as if they had all been born on the same day and made in the same mould. They are Tudor.

A lonely figure Sir Bernard Brocas looks in the great space of his arch; he was an official at the Court of Richard the Second, and is in armour with his head on a helmet and his feet on a lion. Francis Holies was carved by Nicholas Stone sitting like an armoured Roman, a very fine figure in alabaster. The Lord John Russell who died just before the Armada came is a fine figure lying with his head on his hands, a small son tucked away at his feet, his heraldic boastings supported by bedeswomen. Elizabeth Russell, dying just before Queen Elizabeth, sits on a chair in a corner, the first statue in the Abbey not lying down, and she has her head on her hand and is pointing to a skull beneath her foot. The story is that she died from a prick of a needle caused when sewing on a Sunday.

On the top of two later tombs in this chapel are brass portraits of the Duchess of Gloucester of 1399 and Archbishop Waldeby of 1397. They are about ten feet long, an extraordinary size for brasses.

Passing under the bridge we come to the north side of the Ambulatory, and on our right are the Chapels of St Paul and St John, the tiny Chapel of Our Lady of the Pew, and the lovely stone screen behind which lies the Chapel of Abbot Islip.

St Paul's Chapel

The door into the Chapel of St Paul is 500 years old. In the middle of the floor is a beautiful railed tomb on which lies Sir Gyles Daubeney, Lieutenant of Calais, with his wife. Above the arch rises a massed structure with two vivid figures standing by a pavilion, two obelisks, and (on the top) much heraldry with scales, an hourglass, and a skull. Under the window next to them lies the First Gentleman of Charles Stuart's Bedchamber; he is Sir James Fullerton, and slightly below him lies his wife. The tomb is black and white and the figures are fine, he with cherubs at his head, she in a widow's veil.

In the next bay lies Queen Elizabeth's Lord Chancellor Sir Thomas Bromley, on a richly carved tomb in a rich gown with eight children in front, and in the spandrels of the arch figures of Fame and Immortality.

Here in all her glory lies Philip Sidney's aunt, alone with an extraordinary porcupine at her feet on a stupendous monument. Next to her is one of Cromwell's chancellors, Lord Cottington, a black and white figure lying strangely, on a rush mattress, with a lace collar and long rows of buttons.

In a tomb by the doorway, forming part of the remarkable stone screen of the chapel, lies Lord Bourchier, King's standard-bearer at Agincourt. The black sarcophagus of Sir Henry Belasyse, a general under William the Third, rests on two helmets, and dominating the chapel is a monument with no tomb, one of the five Chantrey statues of James Watt.

The Colossus of the Abbey

Next to St Paul's is the Chapel of St John reached through the doorway of Our Lady of the Pew. In the middle is a big tomb with the white figures of the Earl of Exeter and his wife, of Stuart days. He wears a mantle of the Garter and she a cloak, and there is space on the tomb for a second wife, who did not come.

The chapel has no monumental distinction, unless it is for size. Perhaps Lord Hunsdon's tomb is the colossus of the Abbey. It stands 36 feet high, but with no figures of Lord Hunsdon or his wife sleep below. It stretches across the chapel, a vast structure with a black on white tomb in a great recess.

The Waxwork Show

Over Abbot Islip's chapel is one of the surprises of the abbey, the delight of children, for it is nothing else than a little waxwork show. In this small room are ten images richly clothed as in life, in scarlet and ermine, with more jewels than we can count, and all attractive lifelike figures. At the top of the steps Charles the Second faces us, looking what he was, a lace collar round his neck and feathers in his hat. Queen Elizabeth is covered with pearls, and her face was moulded from her death mask. William and Mary stand with the crown between them. Queen Anne is crowned with the orb and sceptre and much decked with jewels. The Duchess of Richmond (La Belle Stuart) is here with the parrot that lived with her for forty years, and she has a painted fan: Charles the Second braved smallpox to see her. There is also an eighteenth century Duke of Buckingham, the Duchess, and her little son. The duke has a gold cloak and white stockings, and is sleeping in his coronet; he is the only one here lying down. All these are in their contemporary clothes except Queen Elizabeth, whose costume is a century too late for her. The other two figures are the most famous of all, Chatham looking like life itself in a scarlet and ermine robe, and Nelson looking, in the words of one who knew him, 'as if he was standing there.' He is in most of his own clothes, his own linen shirt (with the right arm cut off), his own white stockings, his own coat, and a new hat from his old hat shop in St James's Street.

We have been round the chapels surrounding the Confessor's Chapel; we now come to the tomb in which he lies with kings all round him. His

impressive shrine stands in the centre of the chapel behind the Sanctuary, one end facing the old stone screen at the back of the high altar, the other facing the chantry of Henry the Fifth. Along each side are three fine tombs: on one side Edward the Third, his Queen Philippa, and Richard the Second; on the other side Edward the First, his Queen Eleanor, and Henry the Third.

The floor of the chapel is paved with ancient tiles, as is the pavement of the Sanctuary, some of which we may see near the Coronation Chair. The sword and shield are fourteenth century, the blade of the sword over five feet long, the wooden shield covered with canvas and bordered with leather.

The Coronation Chair

The chair is one of London's most thrilling possessions. In it our kings have been crowned for over 600 years.

Its appeal today is rather in its simplicity. In the box-like space below the seat of this oak chair is set a great stone, a huge boulder 26 inches long and 16 wide, nearly a foot thick, with staples and rings by which it may be lifted in and out when the chair is moved for the crowning. It is the Stone of Scone, going back farther in legend than we need follow it, for no man knows how old it is.

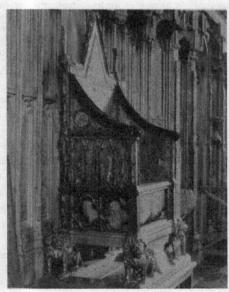

The Coronation Chair

The Tombs of the Kings

At each end of the medieval screen by which the chair stands is a doorway to
the Sanctuary, and the chair is carried through for the crowning. The screen
itself is beautifully panelled and has battered fragments of nine canopies,
with an elaborate cornice from end to end on which medieval craftsmen
have carved fourteen scenes from the life of the Confessor.

The six great tombs surrounding the Confessor's look down on to the
ambulatory below.

Henry the Fifth sleeps on a raised platform reached from the ambulatory,
and the turreted gateway of his tomb faces the Confessor's tomb. He lies
fashioned in English oak with a lovely vaulted ceiling above him in stone,
and above that a chapel which forms a bridge high over the ambulatory, its
outer walls covered with one of the most remarkable galleries of sculpture the
past has bequeathed to us. The gateway of this chantry forms the east end of
the Confessor's Chapel, and the wall behind the altar forms the entrance to
the Chapel of Henry the Seventh. The turrets and the walls are covered with
sculptures set in recesses with wonderful canopies; there are over a hundred
statues of various sizes, and though the stone work has been battered by the
hand of time it is of extraordinary beauty, and needs only restoration to make
it as wondrous a spectacle as Henry the Seventh's Chapel itself. It is the bridge
between the two most visited chapels in the abbey, so that it is remarkable for
its position as well as for its historic interest and its architectural beauty.

Everywhere the stone is carved in open tracery and is a marvellous sight,
with what seem like hundreds of little windows with delicate sculptured
fragments among them. The two turrets are built round the great pillars of
the abbey, and each turret has two storeys with great statues, capped by a
third storey with tiny figures.

The doors in the turrets are original and have been on their hinges for 500
years. The steps lead us to the chapel over the tomb, and the newel ends in
a carved capital of angels from which springs a little fan vault resting on
angels holding crowns. The front of the chapel over the gates is low, but the
back wall rises high and is covered with statues in seven canopied niches,
one empty. Between these run up tiers of tiny niches in which are apostles
and prophets. It is the middle figure that is missing from the big niches, and
across the empty space the kneeling Gabriel gazes towards the Madonna
sitting in wrapt attention, with her arms crossed. On each side of them is a
saint and a king, six big figures in all.

The north and south faces of this chapel, running over the ambulatory,
are both remarkable. The arches have spandrels filled with heraldry and
crowned angels, and the friezes above the arches are filled with crowned

leopards, antelopes, and swans. Standing on the south front is St Dorothy with a basket of flowers, and on the north is St Barbara with an open book and her hand on a spire. High above the arches run rows of great canopied figures and groups of sculpture, a wonderful spectacle, for each figure has a double canopy with crested tops of swans and antelopes. In the midst of this mass of statues are four groups of sculpture, two showing the crowning of the king and two the king on horseback; each side has a coronation and a riding scene. In the actual crowning scene (perhaps the oldest coronation scene existing), two prelates stand on each side holding the crown, with one peer on each side kneeling in his robes. In the other crowning scene the king is holding the orb and sceptre, and a bishop is steadying the crown on his head. In the two riding groups the king is shown in armour, once galloping over a stream and once over open country. Among the fifty-five figures still left in fifty-eight niches are nobles and judges in belted gowns, men with purses and books, a turbaned man with a long-forked beard, and a sitting lady pointing to a book she holds. They represent the Dignities and the Virtues, but they are more than conventional figures; they are, said one of our art experts, like natural figures, and the Madonna has the head of a frank English country girl with her hair thrown back.

The vaulting over the tomb platform is very beautiful, with chained swans and pairs of antelopes carved in its tracery. Above the open chapel is a saddle of King Henry's horse, a painted shield he bore, and one of his tilting helms, alt fixed on a bar running across.

The Glory Beyond Compare

The chapel is raised by its approaching steps to the level of the Confessor's Chapel, and three arches open on the vestibule which brings us to the famous gates. The vestibule itself is an astonishing sight, with traceried and panelled walls that would hold the traveller long if it were not for the wonder he sees beyond. The vestibule walls are richly panelled, and the ceiling, one of the dazzling sights of the abbey, has six rows of twenty-one double panels alternately red and green, 252 panels in all. Then there are twenty-one heart-shaped ovals seven times repeated, 147 in all, with blue backgrounds and carvings in the centre of roses and portcullises. The effect of this mass of delicate carving is remarkable and impressive. There are scores of lovely spandrels, over a hundred pierced bronze panels in the gates, hundreds of tiny carvings in the ovals and the cornices, and over 500 window panels on the walls.

The great gates of oak and bronze rank for wonder with the famous gates of the Baptistry in Florence, and they are believed to be the work

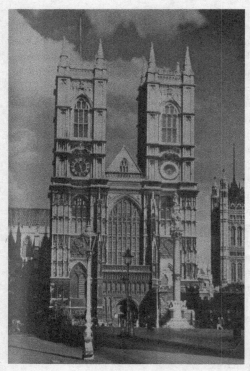

The Western Towers of
the Abbey

of Torrigiano or Thomas Ducheman. They have about 120 panels, each panel hammered out with eagles, crowns, lions, monograms, fleur-de-lys, and portcullises; there are thousands of atoms of craftsmanship in these designs. The bronze facings of the doors are fixed with ornamental studs, with bigger ones of roses and winged dragons, over a thousand in all.

North, south, east, and west, the interior is a marvel of craftsmanship; north and south with the lovely stalls rising with their wonderful canopies, east with the little chapels and the captivating windows, west with the white stone screen of sheer loveliness rising over the gates. High above the stalls a cornice of angels with crowns runs round, and above all these is a crowd of great statues, one of the most remarkable galleries of sculpture in the land.

The Stalls of the Knights

The stalls for the Knights of the Bath run along each side of the chapel nave, each stall having a tip-up seat carved in the sixteenth century with one of

the scenes beloved by the medieval craftsman. Each stall has a red and gold sword on the front and each knight has his crest at the top.

On the front of the stalls are fixed about 400 enamel plates with the heraldry of the knights. The book-boards in front of the stalls are vaulted beneath; under one we counted fifty bits of carving. The panelling of the stalls is superb, but it is the canopies that are astounding in their delicacy, their almost unbelievable fineness.

The miserere seats are the work of craftsmen of the early sixteenth century, except one carved with foliage on the south side, which is thirteenth. We find among them the familiar scenes of a mermaid with a comb and a mirror, the Judgment of Solomon, three monkeys on a cooking pot, a goose riding on a fox, a wild man with a woman and four children, a woman beating a man with her distaff, the devil playing a drum, a demon seizing a clerk with a box of money near, a chained bear playing bagpipes, a windmill with a beast on the steps, a monster attacking a dragon (with several heads broken), Samson fighting the lion, a boy on a hobby-horse, a Jester in his cap, a man riding on a barrel, and another pushing him off with his foot, and a series of scenes of David and Goliath.

Behind the stalls on each side are four bays with open arches, then a row of window tracery, then the cornice of angels holding crowns over roses and gates and fleur-de-lys. Above the angel cornice rise elegant stone pedestals richly sculptured in three stages and pierced with windows and rich friezes, and on these pedestals stand extraordinary lifesize stone statues of saints, bishops, philosophers, and kings. They stand in vaulted recesses with lovely stone canopies over them, and over all is a cresting of delicate foliage.

Above these statues (largely hidden from us by the enchanting banners hanging above the stalls) rise the great windows, and from the shafts between them spring the stone ribs of the fans of the roof. The ribs are carved and their delicate projecting cusps end in rich cones, about 250 of them. (It was one of these that fell in 1932, and led to the restoration of the chapel.)

The Gallery of a Hundred Statues

The gallery of about a hundred statues, above the banners, is an astonishing collection, all intended to represent people and subjects. They are sculpture at its best, natural living types and not archaic or conventional figures. Each one can be moved, and they were put in the crypt during the war. There is St Michael with a boy in a basket, Peter with the keys, Stephen with a handful of stones, Paul with a broken sword, St Giles with a hind leaping up, St Edmund with an arrow, St Margaret with her staff in a dragon's mouth, Christ giving blessing with

His feet on the orb, Hugh of Lincoln with a swan, St Anthony with a book and bell and a pig, St Eloy with a horseshoe, St Jerome as a cardinal with a lion at his feet, St Lawrence with the gridiron of his martyrdom, the Confessor with a sceptre and a ring, St George and his dragon, St Zita in a turban and with a rosary, St Catherine with her hand on a sword piercing the head of an emperor (who is holding a broken wheel), a figure with spectacles (rare in sculpture), and a striking group of philosophers wearing big hats.

The Wonder of the King's Tomb

In this superb place lie over seventy royalties – not only the founder king with his queen and his mother, but Queen Elizabeth and Mary Queen of Scots, Charles the Second and all his families, Queen Anne and her seventeen children (all of whom with one exception died in their cradles), James the First and Edward the Sixth, four children of Charles Stuart, ten children of James the First. The founder of the chapel sleeps between two graves of kings, James the First on the west and Edward the Sixth on the east.

The tomb of Henry the Seventh has in front of it an altar much more interesting than it appears. It was fashioned as we see it about 1870, but in it is embodied part of the ancient altar which stood here, the work of Torrigiano, destroyed in the Civil War. Fragments of it are still kept in the triforium, but fortunately part of the frieze and the pillars were found in good condition and are worked into the modern altar. Over the altar is a fifteenth century Madonna by Bartolemmeo Vivarini.

The king's tomb is enclosed within a bronze screen which in itself is one of the wonders of the abbey, the work of Thomas Ducheman. It has nine bays on each side and six at each end, with turrets at the corners. Two tiers of pierced panels run round the screen, divided by a rail and crowned by a vaulted cove supporting a cornice and a parapet. The parapet has eighty-four panels with roses and portcullises alternately. In the lower tier each panel is square-headed with two main lights and sue smaller lights – thirty bays with sixty main lights and 180 smaller ones. The heads of each pair of main lights have a dragon and a greyhound facing each other; the tracery in the heads of the smaller lights is bound with knots. The upper tier of panels has two main lights and eight smaller lights, like double windows with eight panes – that is, thirty bays with sixty main lights and 240 smaller ones. There are therefore in the whole screen 120 main lights and 420 smaller lights. The central mullions of these windows have dragons at the head. Round the base of each tier runs a line of pierced quatrefoils and fleur-de-lys; there are 600 of these piercings.

At each corner of the screen is a five-sided turret, and in the centre on all four sides is a crown, held out on an arm. There are two doorways recessed

in a small porch, and six figures are still left in the niches. They are St James with a hat and scallop shell, the Confessor in his Parliament robes, St John with a chalice, St George with the Dragon, St Bartholomew, and an unknown figure of great dignity. Within this marvellous screen rests Henry the Seventh and his queen; he asked in his will that ten thousand masses should be said for his soul, and now he dwelleth, as Francis Bacon said, more richly in his tomb than he did live in any of his palaces.

The tomb inside the screen is the work of Pietro Torrigiano. The contract for it is dated 1512 and the work occupied him for six years. The base is a white marble step with a bronze frieze of foliage and roses let into the plinth above it, and on this rests the tomb itself, with bronze turrets at the corners and rich bronze pilasters between the bays. At one end of the tomb are winged cherubs supporting the crowned shield of France and England, and at the other a dragon and a greyhound supporting a crowned rose. On each side are three bays with a gold medallion in each, set in a bronze wreath. In each wreath are two figures of saints.

At each of the four corners sits a winged cherub; all have lost the standards Torrigiano put in their hands. Two are supporting the royal arms, and the

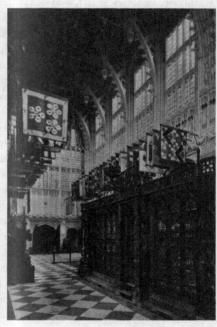

Henry VII's Chapel

other two a panel with the inscription. The king and queen lie at prayer on plain cushions and in simple dignity, Henry in a long robe wearing a flat cap and resting his feet on a lion, Elizabeth in a fur-lined robe with a lion at her feet. It is not to be doubted that Henry the Seventh and his Queen Elizabeth sleep in the rarest tomb in the loveliest setting in England.

The Seven Chapels Round Henry the Seventh

Round this famous tomb are seven chapels, two in the aisles and five in the bays of the apse. We may look first at the five chapels in the apse, two facing each other across the tomb, two in the bays nearer east, and the central eastern chapel now empty. The roofs of all the chapels are fan-vaulted and the walls have galleries of sculpture; in all respects the architecture is enriched in keeping with the main chapel and its wonderful roof. On the walls are nine consecration crosses, three on the west wall over the gates, and three on the outer walls of the north and south aisles, between the windows.

The two chapels facing across the king's tomb are the richest of the five. In one lies George Villiers, Duke of Buckingham, proudest noble of England in his day, negotiator of the marriage of Charles Stuart with Henrietta Maria, yet doomed to die by an assassin's hand. In the other lies the Duke of Richmond, Ludovick Stuart, who was entertained with splendour by Queen Elizabeth, attended James from Scotland on his accession, and died suddenly in bed at Whitehall. Both tombs are magnificent.

The tomb of George Villiers on the north side crowds the chapel with its bronze and marble splendour. It has sixteen figures and sixteen skulls on it. At each corner of the tomb is a black obelisk supported by skulls, and high up (20 feet or more) are symbolical figures with shields and cherubs. At the corners are four bronze weepers: Mars, Neptune, and two women. The duke and his duchess lie superb in gilded bronze, both arrayed in embroidered robes and handsome coronets; he is in armour enriched with anchors and monograms. Looking down on them from behind are four of their children, a lovely group in white marble, three kneeling on cushions and a little one reclining at the back with his head on his hand, his elbow on a skull.

The companion tomb of the Duke of Richmond is of equal splendour, the duke and his wife lying in bronze, he in his mantle of the Garter, she wearing her coronet, under a wonderful canopy borne on the shoulders of colossal bronze figures of Hope, Truth, Faith, and Charity. Crowning the tomb is a trumpeting angel. On the walls of the chapel are ten sculptured angels and two other figures, one a bishop holding a mitred head. In one of the two plainer chapels eastward lies Dean Stanley, and in the other another Duke of Buckingham. The dean is on the south and lies in white marble with his hand

on his breast, a simple figure as so many remember him. With him sleeps his wife, shown as Lady Bountiful in the window, and near him is the Duke of Montpensier wearing his coronet and holding a book richly bound; he has a rich gown embroidered with the lilies of his native France. In the opposite chapel the Duke of Buckingham (1743) fills the bay, reclining as a Roman with weeping figures and a Roman soldier's equipment massed about him. A winged figure of Time is bringing a medallion with four portraits, cherubs helping him to carry them.

Cromwell's Chapel

Cromwell's body was embalmed and laid in the vault below this chapel, and an effigy was made in the style of those in the room over Abbot Islip's chapel. The effigy was brought to the abbey and remained for three months on view. In every way Cromwell was brought like a king to his burial. Eighteen months afterwards Charles the Second came back, and in six months more the order was given 'that the carcases of Oliver Cromwell, Henry Ireton, John Bradshaw, and Thomas Pride, be with all expedition taken up and drove upon a hurdle to Tyburn, and there hanged up in their coffins for some time and after that buried under the gallows.' They were dug up, the brave Admiral Blake among them, and in their places were laid the various families of Charles the Second, most of them made dukes and earls.

Queen Elizabeth's Tomb

Queen Elizabeth lies in the third bay of the aisle; the fourth bay is Innocents Corner. She lies (with her sister Mary Tudor) in a black and white tomb adorned with ten marble columns with gilt capitals. Round the tomb run forty-one painted shields and on the top are heraldic beasts at the corners. The canopy is painted with gilded roses.

At the end of the aisle sleep two little brothers and two little sisters. The brothers were the sons of Edward the Fourth, the little princes suffocated in the Tower to pave the way to the bloodstained throne for their uncle Richard the Third. For 200 years their deaths were a mystery, but in 1674 their bones were found in the Tower and set in a niche in the east wall of this aisle, near the two daughters of James the First, who died within a year. Princess Mary in a rich headdress, with a lion at her feet and four cherubs round her, rests on her elbow looking at a cradle in which her small sister Sophia lies under a rich coverlet of alabaster. Looking down on all this are three stone saints and live angels with crowns, and on the back of the knight's stalls hangs a tapestry with three more saints.

Mary Queen of Scots

Crossing by the gate into the south aisle of Henry the Seventh's Chapel (the aisle of Mary Queen of Scots) we enter it by a porch with three fine medallion portraits of men of our time, three Empire men: Lord Curzon, Lord Cromer, and Lord Milner, all let into the wall in white marble. Two arches lead us into the first bay, where rests Margaret, Countess of Lennox. She lies on a rich tasselled cushion wearing a cap and coronet, a full cloak drawn about her, and under it an embroidered dress, a serious-looking figure with a magnificent alabaster lion at her feet. But the interest of the tomb is in her group of eight children, four sons and four daughters kneeling on each side, for one of them is Lord Darnley. He has lost the crown which was fixed above his head, but he is an attractive figure in a short coat of armour with a cloak thrown over it, a ruff below his curly hair. His wife and queen lies in the tomb beyond, one of the loveliest of the thousand figures sculptured in the abbey. She lies on her great tomb enclosed by railings, superbly carved in white marble with her head on two cushions and a crowned lion upright at her feet. Her canopy is raised on eight black-and-white marble columns and adorned with forty-four bosses of flowers, with angels in the spandrels, heraldic figures, and coats-of-arms. Her lovely cloak is thrown open so that we see her hands gracefully clasped across her breast and the knotted girdle with tassels to her feet.

The next bay is famous also for its beauty, for in it is the great tomb by Torrigiano on which lies the mother of the Tudor dynasty, Margaret Beaufort. She is a fine gilded bronze figure with a gilded canopy at her head and an antelope at her feet, and on each side of her is laid a bronze standard with traceried panels, the moulded bands capped with embattled cresting.

Looking down on Margaret Beaufort is a huge statue of Lady Walpole, who died in 1737 after having 'lived a private life though born to shine in public.' On the wall is a delightful bronze medallion by Torrigiano of Sir Thomas Lovell, Speaker of the House of Commons; it has been here over 400 years, a round bronze in a wooden frame richly carved with roses and foliage.

By the altar at the end of the chapel is the towering monument of Earl Gower, with his upright armoured figure and a tasteless pillar decorated with anchors, all very much out of place. Behind the altar, with no monuments, lie two kings and two queens: Charles the Second and William the Third, Mary the Second and Queen Anne (with her sixteen infants). Over the altar is a tapestry, five sculptured angels with crowns, and two niched statues, one with a sword resting on a curious medieval head, the other with a cross in a dragon's mouth. The chapel, like Queen Elizabeth's, is lit by four big windows of sixty lights.

We feel, in the solemn quietude of these eastern chapels of our national shrine, a sense of the continuity of history for many generations, and an understanding of the appeal the great monuments of the ages make to the human mind. The walls are rich with carvings, the vaulted roofs all captivate the eye, the immortal dead lie round about us; and of their monuments it is true to say, as one of our greatest experts on the abbey said, that if they were in Italy the traveller there would count them among the most wonderful things seen on the Italian tour.

The Nave of the Abbey

The great Nave has become the holy of holies to the myriads who throng the abbey from year's end to year's end, for in a grave in the middle of the floor, with William Pitt looking down and David Livingstone close by, lies the Unknown Warrior. It is perhaps the most visited spot in London.

Let us walk round the walls, beginning with the south wall and going west from the corner of the choir screen.

Here is Major Andre, who went to his death as a spy 'beloved by the army and lamented by his foes.' The sculptured relief shows a soldier with a flag of truce handing to George Washington a letter Andre wrote to him the night before his execution. Next to him is Sir Palmes Fairborne, Governor of Tangiers in 1680, wounded by a shot from the Moors, and now comes Roger Townshend, killed while he was only twenty-eight, fighting against the French in North America; two striking Red Indians are holding up the sarcophagus, and there is a relief of a battle scene on his great tomb. Here is the bust of Sidney, Earl Godolphin, in his wig, and then comes a huge monument up to the clerestory windows of two faithful friends who lost their lives in 1672, Sir Charles Harbord and Clement Cotterell. Cotterell boarded a Dutch ship and pulled down its flag, and the monument has a fleet of ships, something like Father Time vanquishing Death, and cherubs blowing trumpets. A huge monument of John Smith is crowned with gaudy figures and a medallion, and has a mourning woman sitting on the tomb with a medallion of a wigged head. Dean Wilcocks is remembered by a scroll of his virtues and a relief scene of the Abbey, showing the towers which were set up in his day.

Here comes a cloister door with eighteenth and nineteenth century busts and monuments all round it. General Wade who made the roads is remembered by an extraordinary monument of Death trying to overthrow Fame. Sir James Outram, the Bayard of India, has a small bust on a pedestal with a relief and two figures, and there are figures of Peace and Innocence by John Bacon in memory of Anne Whytell. Dr John Thomas is shown with

a little holy lamb and books, and above him is a bust of John Ireland; and balancing these across the bay is another scholar with his books (Zachariah Pearce) with the famous Dean Buckland above him. In the centre of the group is a big sculpture to Katherine Bovey with a medallion between two sitting figures. On one side of the door is the first Lord Lawrence, who raised an army of 50,000 and captured Delhi, and on the other side is Chantrey's Colonel Herries, standing with his horse.

The next bay has an extraordinary mass of sculpture spreading across the bottom of the window, a jumble of ships and figures and palm trees and anchors. On the left of it is a monument to Admiral Tyrrell, and on the right is a door with a stone above it to Dean Ryle. It was he who brought to fruition the idea of the burial of an Unknown Warrior, and his name is carved on a floorstone by the warrior's grave.

We are now near the great west door, and up above us is the old Abbot's Pew, built in the sixteenth century by Abbot Islip; it fills the bay and is reached from the deanery. Below it is a fine medallion of William Congreve with masks lying about him, and near him is a bust of John Friend, a physician.

The Warrior's Chapel

The west corner bay has been made in our time into the Warrior's Chapel, screened from the nave by handsome black-and-gold gates designed by Mr Comper, with a medallion in the centre on which is a tribute from the city of Verdun to the British Army: on it is a helmeted head which seems to say, They Shall Not Pass. Inside the chapel is a stone carved and painted with the Empire's flags, a mass of colour with an inscription telling that it is to the memory of a million men who died in every quarter of the earth and on all the seas, their graves made sure to them by their kin.

High up on a windowsill are three busts, one by Bruce Joy of Matthew Arnold, the others by Thomas Woolner of Charles Kingsley and Frederick Denison Maurice. On another windowsill is a great stone figure standing at an urn, with an epitaph he may or may not deserve, for he is James Craggs, Secretary for War, who was accused of bribery in the South Sea Bubble and died before it could be proved. He lies in the same grave as Addison.

Below this monument is a small bronze to Dame Millicent Fawcett and her blind husband. His fine face, by Alfred Gilbert, is in a small medallion, and below is a symbolical panel with two sitting figures of Brotherhood and five others standing between them representing Zeal, Justice, Fortitude, Sympathy, and Industry, the inscription saying that she was a courageous Englishwoman who won citizenship for women. The wall below these

monuments is panelled, and has a small tribute to twelve men from the abbey staff who fell in the war.

Over the great west door stands William Pitt, fashioned by Westmacott as Chancellor of the Exchequer; he is speaking, and below him is History recording his speeches and Anarchy languishing in chains. On the other side of the door is a man sitting on a sarcophagus with a cherub weeping for Sir Thomas Hardy, an eighteenth century admiral; and on the north side, facing Sir Isaac Newton, is Jeremiah Horrocks, first man to predict and see the transit of Venus; a cherub holds his portrait. Near him stands one of the noblest men of last century, Lord Shaftesbury.

Here is a magnificent tomb given to the abbey by our own century, the work of Sir William Goscombe John. It is the tomb of Lord Salisbury, head of three British Governments, and a power in parliament for nearly half a century. He lies sculptured in bronze in his Garter robes, and on each side of the tomb are fine figures famous in the story of his house. On one side are Queen Elizabeth's Cecil, Lord Burghley; the first Earl of Salisbury, builder of Hatfield House in Tudor days; and Joseph the second marquis. On the other side are the wives of these Cecils, Lady Mildred, Lady Elizabeth, and Lady Frances, the Prime Minister's mother. At each corner of the tomb are two canopied figures symbolising the virtues of the Cecils, and all about it are shields and coronets associated with the story of their 400 years.

The Salisbury tomb stands at the entrance of the north-west chapel where, in the centre of the floor, is an extraordinary monument of James Montagu, who fell on the first of June 1794 in the victory over the French fleet. Two huge lions guard his pedestal, and an angel rests above his figure as if calling him aloft. Behind him is a tomb like a House of Death, by E. H. Baily, with three lamenting figures at the door, up a few steps. There is a bust of Lord Holland at the top. Perhaps the finest sculpture here is to Sir James Mackintosh, judge, philosopher, statesman; on his bust is a stone figure of Fame recording his praises, and we are told that he sought to moderate the rigours of harsh laws and broaden the foundations of national freedom. Near him is a fragment of American history older than the United States, a huge tablet set up by Massachusetts Bay Province in 1758 in honour of Lord Howe, who was slain while marching with British troops. Two lions hold up the inscription, and there is a figure of a woman. A fine stone sculpture in deep relief is to an officer who fell at the storming of San Sebastian, Sir Richard Fletcher; on the monument stand two lovely figures, one with a sword, the other weeping with his arm round his friend.

On the walls and at the windows in this chapel are bust portraits of General Gordon by Onslow Ford, Joseph Chamberlain, Zachary Macaulay,

Lord John Russell, George Tierney, Lord Lansdowne (1863), Colonel Lake (1808), Thomas Arnold of Rugby by Alfred Gilbert, and James Rennell, a surveyor of India, the last two on the windowsill with a monument of a woman holding a medallion of Andrew Horneck, a seventeenth century theologian.

Outside this chapel, so near to his rival Pitt, stands Charles James Fox with two weeping figures; he is falling into the arms of Liberty, and one mourner is holding his hand and another his head. Next to him comes the modest remembrance of one of the most popular Prime Ministers of our own century, a bust of Sir Henry Campbell-Bannerman. In memory of General Stringer Lawrence is a relief of an Indian scene; then comes the Countess Clanricarde, resting her head on her elbow. Now follows the figure of an eighteenth century woman holding a medallion of John Woodward, and on the windowsill above is a bust of the geologist Sir Charles Lyell, who is buried here. So simple a tribute has learning, yet next to it is a colossus of monuments to two captains who fell at Brest in 1794; their portraits are on an urn held by two big figures, and their names are Harvey and Hutt. Curiously interesting is the monument next to theirs, on which Mary Beaufoy kneels, posing with one hand on her heart and the other spread out as if beckoning; one cherub is crowning her and two others look sad, but the monument is interesting for these words cut on it, This monument was made by Grinling Gibbons. Now comes the kneeling figure of Jane Stotevill in the ruff and hood of Stuart days, with fragments of sculpture on the walls behind her including the vine of Life and a grisly figure of Death. On the next windowsill is one of the ugliest monuments in the abbey, in three tiers of straight lines like a zigzag; it is by Westmacott, and is one of two murder scenes sculptured in the nave. This one shows Spencer Perceval, Prime Minister just before Waterloo, resting his head on a woman's shoulder while another woman sits at the head of the tomb on which he lies. Above is a relief of the assassination scene in the lobby of the House of Commons. Now comes an eighteenth century bust of Richard Mead, one of the first inoculators against plague, and near him the eighteenth century Admiral Baker, remembered by a marble column with queer beasts and a pompous head on it. Next to it is a medallion of Henry Priestman, who commanded a squadron for Charles the Second.

Then come plain tombs, and we are at the gates of the north aisle, ironwork from the end of the seventeenth century. Between the two aisle gates, backing on to the screen which forms the west end of the choir, are two huge Rysbrack monuments to two famous men. One is the immortal Isaac Newton, who leans an arm on four books to suggest his learning, a globe above him representing Astronomy; the other is to James Stanhope, one of

Marlborough's generals. The great Voltaire was a looker-on at Newton's funeral.

The Choir Aisles

From the great nave we pass into the two choir aisles, both crowded with monuments, one with many modern memorials. The North Choir Aisle has been called the Musicians Aisle, but we come to it for its tributes to music, science, and humanity.

Here is the bust of William Croft, who bequeathed to the Church a masterpiece of burial music, which was played at Handel's funeral here; Croft is in a big wig and there is a neat carving of an organ below him. John Blow, composer of a hundred anthems, thought to be the greatest organist in the world when he played in the abbey in the seventeenth century, lies near Purcell, who has 'gone to that blessed place where only his harmony can be exceeded.' Here is a black bust of Orlando Gibbons, organist of the abbey before him, and here is Michael Balfe, the Irish composer, conducting Italian opera in London in the early days of Queen Victoria. They are the musicians.

For Science we have five busts in a row, five rings of fame, for they are set in circles: Sir George Stokes the physicist, Lord Lister the famous benefactor of humanity, Charles Darwin and Alfred Russel Wallace, who worked out evolution unknown to each other, and John Couch Adams who discovered a world by mathematics, finding Neptune all unknown to Leverrier the Frenchman, who was finding it at the same time. Below these five is a marble bust of Sir Joseph Hooker, the famous botanist, and a bronze bust of Sir William Ramsay, the famous chemist.

For Humanity there is here the statue of Thomas Fowell Buxton, sitting as if thinking about the slaves to be set free; Wilberforce sitting at ease as he was often seen; W. E. Forster the Quaker, who carried through Parliament the bill founding popular education; and Sir Stamford Raffles, who brought Singapore under the flag and came home to found the London Zoo. His statue is by Chantrey, and shows him with his head on his hand, looking upwards.

The little aisle is crowded with miscellaneous monuments. Sir Thomas Heskett lies resting his head on his elbow, wearing an Elizabethan ruff. Dr Hugo Chamberlin is a huge sprawling figure with a book and two statues of Health and Medicine. Lord Kingsale in a big Stuart wig is resting on a sarcophagus held up by two small cherubs. Lord John Thynne lies in white marble with a stag at his feet. Sir George Staunton, an eighteenth century peacemaker in India, is talking with an Indian under a palm tree. Archbishop

Agar of Dublin (a cherub is dropping a mitre on his head) is with a group of people. Philip de Saumarez, an eighteenth century naval lieutenant, is revealed to us by a cherub holding back a curtain. George Lindsay Johnstone is mourned by a weeping woman sculptured by Flaxman, 'an affectionate sister weeping for the most affectionate of brothers,' and there are weeping figures for St Edmund Prideaux and Prebendary Sutton. Below a window on which rests two neat white tombs is a bust of Temple West, an eighteenth century sailor.

Murder in Pall Mall

The South Choir Aisle has a remarkable variety of sculpture, with some strange and curious scenes and much fine work. It has a picture of a murder in Pall Mall which would do credit to our picture papers. The victim was Thomas Thynn, a Wiltshire man barbarously slain by hired assassins as he rode through Pall Mall in 1682. We see him lying with loose drapery about him, a cherub at his feet, and on a panel is a sculptured scene of the murder. Here he is in his coach, surrounded with horsemen and assassins, one of whom has just fired his pistol through the window. It was all about a girl who comes into Evelyn's Diary, and Thynn was murdered to get him out of the way of another match. The figures are vivid and lifelike, and it is odd to think that at least three men sculptured in the abbey were hanged on the scaffold.

Over the door and under the organ is a tablet by Sir George Frampton with a small figure of Canon Barnett, whose preaching crowded a church in East London which has now been pulled down because there were no longer any Christians there to go to it; he founded Toynbee Hall. On the opposite wall is John Wesley preaching to the world which was his parish, a fine relief in marble, and near it is a bust of Isaac Watts. Andrew Bell, a prebendary remembered as an educator in India a hundred years ago, is talking to a class of boys, and Thomas Owen Tudor is a fine figure of a judge with a red cloak over his robes. There is a Flaxman bust of the famous Corsican General Paoli, 'one of the most illustrious characters of the age in which he lived.' A monument by Hubert le Sueur of Sir Thomas Richardson has a back piece with a rich recess in which is a small bronze bust, and there is a Rysbrack bust of Sir Godfrey Kneller, the only painter in the abbey. William Wragg is remembered in a sculptured relief as an American who was loyal in the Rebellion. The Duke of Marlborough's son George Churchill has a huge monument with an urn and sorrowing cherubs, and on the sill above sits a man looking down with cherubs above him; he is Martin Folkes, an eighteenth century antiquary whose collection was disposed of at an auction

lasting fifty-six days. In another window is a monument of John Methuen, an eighteenth century soldier, and his son Sir Paul; and the famous Cloudesley Shovel is reclining like a Roman under a curtained canopy, with a relief of ships below him. It is said that his poor monument is by Grinling Gibbons. The immortal Robert Clive has a fine medallion by John Tweed, and there is a rich and splendid figure of a Tudor knight on a mattress with his hands clasped; his name is William Thynne.

Here is the monument of a lady lying in Kent whose name belongs to any literary history of the seventeenth century: she is Dame Grace Gethin, who left a bundle of papers which her executors published as her own work before it was found that they were mostly copied from books. The book had a wide vogue before the truth was discovered, and though it is regarded as a great imposture it is believed that Lady Grace was perfectly innocent. Here she kneels with angels sheltering her and bringing her a crown and a laurel wreath.

There are busts of two sisters, Elizabeth and Judith Freke, on a big eighteenth century monument, a white one of Anne Wemyss of 1698, a medallion of Sir John Burland of 1776, and under a draped canopy a bust of George Stepney, a seventeenth century man in a wig.

The great space of the nave has in it many graves of those who have no monuments. In the nave and its choir aisles lie Sir Charles Barry, architect of the Houses of Parliament; Mr Bonar Law, a wartime Prime Minister; Sir Gilbert Scott, who restored the abbey choir; Robert Stephenson of the steam engine; George E. Street, architect of the Law Courts; Lord Kelvin, immortal scientist and inventor; Sir Sterndale Bennett and Sir Charles Stanford, musical composers; John Hunter the great surgeon and John Herschel the astronomer; Baroness Burdett Coutts, the richest heiress of the Victorian Era; and Dean Bradley, to whom the Abbey owes so much.

The Unknown Warrior

But in this space across which Isaac Newton looks to William Pitt, with Ben Jonson standing on his feet under its pavement, are graves more thrilling than all these, for in the middle of the floor lies David Livingstone and beyond him is the Unknown Warrior.

It is the most moving spot in the abbey for all who come. No man knows who lies in this grave; all that is known is that he is a soldier who fought in France, fell on the field, and was buried there without a name. He gave his life for his country, little dreaming that he would sleep in the most famous grave in all the world.

From Jericho to Jerusalem

By a door in the nave we may go up into Jericho Parlour and on from Jericho to Jerusalem. A small room with a fireplace, Jericho Parlour was added to the Abbot's Lodging early in the sixteenth century, and was then panelled with the linenfold still here. In its windows are seventeenth century panels of glass with roses, eagles, crowns, and Peter's keys, and there is a leather chest 300 years old. One possession the twentieth century has put into this old room, a memorial stone from the Empire Exhibition at Wembley, brought here by the suggestion of George the Fifth.

We come to the Jerusalem Chamber through a small lobby with three sixteenth century panels in a window, one having a castle with three towers on it, and we enter this famous fourteenth century room by a sixteenth century doorway. The chamber was built by Abbot Islip, and the fine roof is original, with hundreds of gold stars painted in its three bays, and painted beams resting on curved braces which spring from grotesque heads. There is an ornate overmantel of the seventeenth century, elaborately panelled in cedar supposed to have come from Lebanon. The walls are panelled, and the chamber still possesses the long table at which the Revisers of the Bible did their work. The walls are hung with tapestries.

In the north window of the Jerusalem Chamber is the oldest glass in the abbey, six panels of the thirteenth century, showing the Massacre of the Innocents, the Beheading of John the Baptist, the Stoning of Stephen, the Descent of the Holy Ghost, the Ascension, and St Nicholas drawing a ship ashore with the false pilgrim falling overboard. The panels are curiously shaped, rather like hearts, and the work is very crude, with about twenty-five figures recognisable. There is a later panel of the Resurrection. On the south wall are busts of Henry the Fourth and his famous son, and across the top is a long painting of the coronation of Queen Victoria.

In one of the window bays hangs a portrait painted on oak of Henry the Fourth, who died in this room.

Rich in so much that is famous, the Abbey is not rich in glass, though it has a little that is precious; and it is not rich in brasses, though it has a few that are interesting. There are eight brasses in the Ambulatory and its chapels, and they are from three centuries. The oldest is 1395, John of Waltham in the Confessor's Chapel in his bishop's mitre; two years later is the brass of Archbishop Waldeby in St Edmund's Chapel, and two years later still, also m St Edmund's Chapel, is Eleanor Duchess of Gloucester in her widow's veil. Both these are huge brasses on altar tombs. Three fifteenth century brasses show Sir John Harpeden in armour, Abbot Estney in his robes and mitre, and Sir Thomas Vaugkan, and two of the sixteenth century are Sir

Humphrey Stanley in armour and Dean Bill in his doctor's robes. There are one or two modern brasses in the nave, and one to a Bishop of Ohio in St Faith's Chapel.

The Cloisters

The Cloisters of the abbey are nearly 200 yards round and are divided into thirty-five bays; the oldest part is thirteenth century and the rest fifteenth. They are interesting, to those who have time to saunter in them, for such stone slabs as can be deciphered, for old benches and old doorways, and especially for relics of a game played here in Shakespeare's day, Nine Men's Morris. In the east walk lies Mrs Aphra Behn, the barber's daughter who wrote the first novel in England published by a woman and was sent by Charles the Second as a spy to Antwerp. Also in the east walk is an inscription to Edmund Godfrey, who lies in the churchyard of St Martin-in-the-Fields. All England was shaken by the mystery of his death, a tragedy arising out of the infamous crimes of Titus Oates. In the south walk is a fine processional doorway of the fourteenth century, but the best doorway (one of the finest in

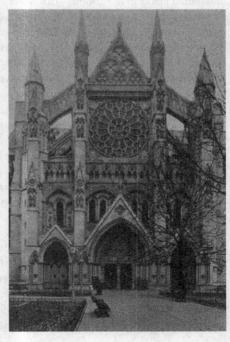

The North Door of the Abbey

the abbey precincts) is that which leads us into the vestibule of the Chapter House. Near it is the most famous epitaph in the cloisters: Jane Lister, deare child. Jane was the daughter of Dr Martin Lister, a naturalist, and physician to Queen Anne; her mother was a Yorkshire lady who lies at Clapham, where her epitaph in the church is, Hannah Lister, deare wife.

Opening off the Cloisters is one of the oldest visitable parts of the abbey, the eleventh century Chapel of the Pyx. We come into it by a door which has been swinging on its hinges for over 600 years; there are two of them, fastened with seven keys (the one we saw was about two feet long). The three locks are 600 years old, and close by on the wall are the marks of the masons who built the doorway in the thirteenth century. Also in the wall is a piscina used for washing the holy vessels when this gloomy vaulted chamber was a sacred place. In the floor is a patch of medieval tiles, probably laid down when the floor of the Chapter House was laid.

The Chapter House

The Chapter House is for our British race one of the most precious buildings in the world, and for those who love medieval art there are few more interesting places in this country. This noble hall, in which Cardinal Wolsey once held court, is the cradle of our freedom, the home of our Parliament. From March 26, 1257, when Parliament was divided into two houses, the Commons sat here until January 28, 1547, when they assembled in the hall to hear the news that Henry the Eighth was dead.

We come into it by an inner and an outer vestibule, through beautiful doorways of the thirteenth century. The outer doorway has two lovely pointed arches, set in a greater arch enriched with a double row of fine little carvings. It is the survival of one of the noblest arches in the abbey, and one of the groups of small carvings running round. At the top of the steps is one of the loveliest entrances to any place in London as we stand in the hall and look back at it.

A fascinating piece of thirteenth century grouping, it has an outer arch with a double trefoiled arch inside it, and in the round tympanum above the two smaller arches is a modern sculpture of Christ in majesty by Sir Gilbert Scott. In the two spandrels above are four figures of angels in trefoils, evidently wrought by a master; the detail is exquisite. Beside these, standing in niches, are two of the most precious medieval figures in England, Gabriel and the Madonna. They stand about six feet high, and are graceful with the arresting beauty of the best medieval sculpture, finely preserved. The Madonna has a book open in one hand and the other hand is held up in surprise as Gabriel, a noble figure in a swaying attitude, apparently explains

what is in the book. There is a record of the payment of 53s 4d for two images for the Chapter House, and it is believed that was the sum paid for Annunciation figures about 700 years ago.

Round the main arch of this medieval doorway runs a band of delicate foliage enclosing figures, and on the round pillars of the doorway are modern capitals finely carved, though one on the left, with three lions carved on it, is original.

The Chapter House, rather like the one at Salisbury, and the biggest in England except Lincoln, is an octagon 56 feet across, the roof vaulted in eight bays supported by a central pillar, which is modern, by Sir Gilbert Scott. The roof is also modern, and the outer walls have been renewed. Big modern windows fill the bays, each window 39 feet high and nearly 20 wide; the central circle in each tracery is ten feet across and has a portrait, the seven being Bede, Anselm, Roger Bacon, Chaucer, Caxton, Shakespeare, and Queen Victoria in her youth. In the panels of the windows are twenty-five kings and queens and twenty-four abbots of Westminster. Between the abbots and the kings are historic scenes.

It is the medieval floor and walls that are famous here. The floor is as old as our first Parliament, and on these tiles walked the first members of our House of Commons. The walls were painted a hundred years later, about the middle of the fourteenth century, and by a remarkable process of chemistry and astonishing human patience important fragments of the paintings have been brought to light.

Laid about 1250, the floor of the Chapter House is the finest of its kind in existence, and nearly all original. The tiles are set in bands running east and west, and have an astonishing variety of patterns, with roses, dragons, centaurs, royal arms, traceried windows, sitting figures playing with a little dog, an ox with a hart, as well as musicians and hunting scenes. The figures are sketched with great vigour and are clearly the work of a master hand. On scores of the tiles is what is known as the Westminster Salmon, referring to the tithe the abbey used to claim from the Thames fisherman. It is believed that all these tiles were designed between 1240 and 1260 by William the Monk, one of the leading artists of Henry the Third in his rebuilding of the abbey. William was paid the high price of two shillings a day, double the wages of the ordinary master craftsmen of the king. His pictures are full of life and quaintness; his horses gallop and there is movement everywhere; and the glazing of the tiles is as bright today as when they were laid. There are thousands of them, at least 5,000, and more than a hundred have the Westminster Salmon. Hundreds have quatrefoils and circles with dancing lions in pairs; altogether there may be over 2,000 lions dancing.

Round the wall of this octagonal hall, once covered with pictures, are some of the most valuable survivals of medieval painting. It is believed that they come from the end of the fourteenth century, except the animals and birds below, which are perhaps a century later. There are still recognisable about 200 figures.

It is one of the remarkable achievements of our time that these figures have been brought to light. For years the clever craftsmen who remove the grime of centuries from medieval paintings, without removing an atom of the paint itself, were working on these walls, and slowly group after group of paintings were revealed where for generations nothing had been seen. The paintings may be divided into four groups: the Last Judgment, the Apocalypse, the Angel Choir, and groups of animals and birds.

The Chapter House, which has been a Parliament House and a Record Office, has now a little of the interest of a museum. In the vestibule is a Roman coffin with a cross on the lid believed to be Saxon, suggesting that the coffin was used for a second burial; and near it is a fine painting of the lovely wooden figure of William de Valence. In show cases are charters and manuscripts, among them a household book of Margaret Beaufort, mother of Henry the Seventh, who lies near her famous son. Here also is kept the RAMCroll of honour, of which a page is turned once a month by the youngest recruit at Millbank. On the wall of the vestibule are tributes to two famous Americans, a bust of James Russell Lowell, the poet, and a tablet to Walter Hines Page, Ambassador in London during the war, when he wrote to President Wilson a series of letters which President Wilson did not read, but which have passed into history. There is also a window in honour of Lowell, with two saints, a Knight of the Round Table, and scenes of the Pilgrim Fathers and the freeing of the slaves.

Westminster School

Ashburnham House which was next door to the Abbey is now part of Westminster School, and its scholars use the rooms, we may hope, with legitimate pride that so much richness should belong to them. It has been built up on fourteenth century foundations, having once been the Prior's Lodging, and has still complete or fragmentary doorways and windows from the days before the abbey as we know it existed. There is a medieval window in the kitchen. There are even eleventh century stones in the walls, and the great hall has a hammerbeam roof of eleven bays resting on wall plates 500 years old, though the roof itself may be later. There is a marvellous staircase with panelled walls in bays divided by pilasters which support a cove and cornice, above which is an elaborate oval lantern round which runs a gallery

capped with a dome of plaster. All this decoration is seventeenth century work, and it is seen again in the Busby Library, named after the famous headmaster who was here from Charles the First to William the Third, and refused to take off his hat to the king lest the boys should think the king greater than he. It is said that the timbers of some of the oak tables are from ships of the Great Armada.

One Night in Queen Anne's Gate

Number 55 Broadway

This snow-white building, famous for its enterprise and notorious for its sculpture, towers in the form of a cross above its neighbours, each wing climbing in steps to a central tower which reaches a height of 176 feet, the flagstaff reaching 60 feet higher. The sculptures on two sides by Mr Epstein, supposed to represent Night and Day, are among the ugliest things in London, much worse than the reliefs of the Winds creeping round the walls higher up.

Here also is Christ Church, a green oasis which leads us into Victoria Street, the street which everybody knows, everybody uses, but surely nobody loves. It is undistinguished. It was cut through what was known as Palmer's Village, and leads from the Abbey to Victoria Station, its chief frontage being the great shop windows of the Army and Navy Stores, and its most interesting spectacle the curious Strutton Ground with its little market always thronged.

Christ Church is the nineteenth century successor of Broadway Chapel, built in Charles Stuart's time. The feature of the church is its glass and all who come will thank the unknown benefactor who on New Year's Eve in 1926 surprised the vicar with a sealed envelope containing sixteen £100 notes 'for the windows.' The work was given to Mr Martin Travers, who has enriched the five windows of the sanctuary apse with most attractive portraits on a light background. The central picture is of Christ giving the keys to Peter, with a church on a rock behind. On one side is St Oswald with a raven, a charming St Elizabeth, Stephen with a martyr's palm, and St Alban, our first martyr. On the other side are Mary Magdalene, the Confessor with a model of the Abbey, St Francis in the dress of his Order, and the centurion of Calvary (Longinus) attired as a Roman soldier. An aisle window of the Madonna and Child is also by Mr Travers. The west windows are copied from Burne-Jones, the centrepiece being a fine Ascension.

The immense block of flats not far from the church was the first great block of flats built in London, the ugly Queen Anne's Mansions, the only blot on the vista from St James's Park.

Looking over the grounds of Buckingham Palace is the GHQ of a movement which has made the world a new place for a multitude of boys and girls; in the Chief Scout's old room is his famous Mafeking flag.

The Squares of Belgravia

Following the garden wall we come at once to a little oasis of seclusion cut off from the roar of Victoria – Victoria Square. It is the smallest and least spoiled of all the squares in Westminster, still charming with its dainty pilasters and their acanthus capitals, and the lovely balconies on their dainty brackets, from which twenty-six small faces are for ever looking down. Following the garden wall to Hyde Park Corner, we turn left into the area of three famous squares, Eaton, Chester, and Belgrave.

Belgrave Square is nearly five acres, and has many charming houses with porches, friezes, sculptured figures, and pillars with carved capitals. Eaton Square is six acres, and has on one side the remarkable spectacle of 100 columns running continuously from end to end, with balconies over them all the way. Some of the balconies still have the little screens dividing them. At one end of the square is the Church of St Peter, with its portico of great columns and its tower gleaming white, though it crowns an interior of gloom with the roof disappearing in the dark. There is an attractive iron chancel

Flats in Belgrave Square

screen with the pulpit neatly worked into it, a triptych with twelve panels round Our Lord as Light of the World, and a white marble figure of the second Bishop of Truro, George Howard Wilkinson, who was vicar here. The walls have scores of tiled memorials to worshippers, some of them with well-known names.

Chester Square, long and narrow with a lawn shaded by trees, has been largely forgotten by time. St Michael's in Chester Square is the church of the midweek broadcast service which began in the dark days of 1931 and was sometimes heard 5,000 miles away. Spacious and very wide, it has a big east window with ten figures under canopies, shining effectively above an alabaster reredos with a carving of Christ between scenes of His teaching and the raising of Lazarus. But the great interest of St Michael's is the Chapel of Remembrance, designed by Sir Giles Scott. On its panelling are the names of the Fallen, and in the apse is a beautiful altar picture of St Martin dividing his cloak, thought to be from the brush of the great Van Dyck. A rich silver cross stands on the altar, two wooden crosses from the battlefield hang on the walls, and there is an array of Great War flags, among them the red ensign carried by Sir Henry Wilson in the Retreat from Mons, and the white ensign under which Captain Gordon Campbell won his first victory on a mystery ship against a submarine. The chapel windows show our four patron saints and the arms of Empire countries and wartime Allies. In a transept are Burne-Jones windows of Faith and Hope.

We leave the squares and cross by Ebury Street into the Pimlico end of Buckingham Palace Road, with the railway in front of us. Here is the great Motor Victoria, where, if we would rather go by road than train, we can find a coach for anywhere. Hereabouts is one of Westminster's four public libraries, with a collection of thousands of old maps and drawings and a selection always on exhibition. Two of them are believed to be the oldest drawings of Westminster in existence.

Round Victoria

Down the road is Victoria Station, the centre of a seething mass of people, buses, and trams, with glaring kinemas about it and little shops. Outside it are the two small Grosvenor Gardens, with Marshal Foch sitting superbly on his horse in one of them, and by the other a memorial for the Rifle Brigade, with three figures by John Tweed.

Near the station, down Wilton Road, is a queer statue poised over an archway which is supposed to be the famous dwarf Jeffrey Hudson, who was popped in a pie to please the king. From hereabouts we work our way back to the river through the maze of roads and squares behind Victoria, some

lined with houses that have seen better days, with fine old porches, painted columns, balconies, and lovely capitals. On our way we come upon three notable buildings, Westminster Cathedral with its striking red brick tower, the remarkable Horticultural Hall, and the little Greycoat Hospital. Their school has a turret, a clock, and a bell on its gabled roof, and above the gateway a boy and girl in the old uniform stand in niches with the arms of Queen Anne between them. The old wainscoted dining-room and the familiar board room are still as they were, and there are portraits of Queen Anne and bishops of olden days hanging on the walls.

Westminster Cathedral

We come now to a cathedral hemmed in by houses and lost except to those who look for it, the Roman Catholic Cathedral of Westminster. Except for its red brick tower, capped with white stones and a small black dome (below which are perched a number of curious stone birds), this marvellous place lies almost lost to the crowds that throng the streets round Victoria, yet it is one of the mighty monuments of our generation, covering 50,000 square feet, built with more than twelve million hand-made bricks.

Facing the great west door, half-a-minute from Victoria Street, we come upon the arches and turrets and domes, red brick and white stone eddying, as it were, always over the whole of this impressive example of an early Byzantine church. In the arch of the great doors sits Christ, between Joseph and Mary, with an open book, saying, I am the Gate. Kneeling on either side is Peter with his key and the Confessor with the ring he gave to a beggar.

At the entrance are sculptured medallions of two Archbishops of Canterbury. By the small door through which we enter are medallions of four great figures, and above the doorway with Peter and the key is Edward the Confessor with a model of Westminster Abbey. This is his first cathedral. By this porch is the lift which takes us up the campanile, one of the highest points of London at which we can stand. In the dim blue vastness of the domed interior we see again, as we saw outside, arch after arch and dome after dome, the play of arches, someone has said, that never seem to sleep. There is no church we know in this country that seems so big and makes man seem so small. We are looking at the unfinished masterpiece of its creator, the Doncaster wine merchant's son, John Francis Bentley.

The great swing door brings us under the organ loft with a beautiful trellis screen of oak and bronze. Standing between pillars of red granite from Norway, with golden angels trumpeting above us, the eye runs along the nave to the choir and the high altar, in front of which hangs a crucifix ten yards long.

We may not like the gloomy brickwork all too slowly being covered with mosaic; we may not like the grey panelling of the walls; but after we have walked about this place and lost the feeling of its gloom, and found the little chapels covered with mosaics and enclosed with gold and silver gates, we feel that it is wrong to judge this great achievement incomplete; some day it will be wonderful, and we are seeing it grow, bit by bit. There must be five million tiny pieces of mosaic to be fixed in the nave alone.

The domes and bays appear to hang in shadow until the fourth dome above the sanctuary is reached, and then on a bright summer's day the sunshine streams through a crown of twelve lights and the windows in the apse. So it will be with the whole as time completes this place; the gloom will pass away, and millions of little bits of glinting gold will throw their light from the great roof. The walls will be rich with colour, and those who see it all will reap the rich reward of this most patient labour.

On the pillars of the nave are fourteen scenes on the way to Calvary by Eric Gill. They have a quiet dignity, and the figure we remember most is beautiful: it is the Mother of Jesus kneeling before Him on the road to Calvary.

The great nave, seating 2,000 people, has chapels all round it, beginning on the north with All Souls, in which the mosaics epitomise the Roman Catholic teaching of Purgatory.

Next is the Chapel of St George with a sculptured panel of our patron saint, and with the handsome wooden shrine of John Southworth, one of the last Roman Catholic priests to die at Tyburn for his faith.

Now comes the Chapel of St Joseph, near which is a small statue of St Anthony of Padua; and on the wall, a little beyond, is a mosaic portrait of Joan of Arc, made by Christian Symon and given to this cathedral by a number of devout Englishwomen.

Still going east, we come upon the golden gates of the chantry in which lies the marble figure of Cardinal Vaughan, founder of this cathedral. His body is at the college he founded at Mill Hill, but his red hat hangs over his figure here, in one of the stateliest corners of this great place. Just beyond, enclosed by a rich bronze screen made in Somerset, gilded and surmounted by a pelican, with altar rails of bronze and enamel plaques, is the Chapel of the Sacrament, with the sacred tabernacle behind a veil of white silk suspended from golden wedding rings bequeathed by their wearers.

The chapels on the south side of the nave begin at the west end with the Chapel of St Gregory and St Augustine, the brightest and most cheerful of them all. It is a remarkable mass of mosaic, with half a million tiny pieces glittering in the roof and probably as many more in the walls, all the work

of Clayton and Bell, whose windows are so famous in our English churches. Set in the gold mosaic of the roof are six saints.

In five panels above the altar stand St Gregory and St Augustine, with Paulinus, Justin, Laurentius, and Mcllitus. Above them are two mosaic groups. One is of Gregory sending out Augustine, Gregory enthroned in white and gold; the other shows the reception of the missionary by Ethelbert and Queen Bertha, who sit under a tree listening to him. In the arches separating the chapel from the aisle are two charming painted panels of familiar tales. One shows St Gregory in the marketplace at Rome, moved by the beauty of the little Anglo-Saxon slaves, and declaring that they should be called not Angles but Angels. The other is the story of the Judgment of its two great blocks, one block the hospital, the other the Nurse's Horne and the Medical School. Going forward through these streets, keeping the river on our left, we turn to the river front at the foot of Vauxhall Bridge near the RAMC Barracks, outside which stands Matthew Noble's bronze statue of Sir James McGrigor; he was the head of Wellington's medical staff in the Peninsular War.

There is another statue on the limits of Westminster beyond Vauxhall Bridge, of William Huskisson, the first man killed in a railway accident (by George Stephenson's Rocket), dressed as a Roman Senator with a scroll in his hand. He stands in Pimlico Gardens and is by John Gibson.

We are now at Millbank and the Thames spreads out before us with the finest stretch it has on its way through London.

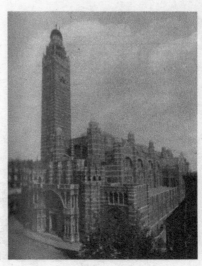

Westminster Cathedral

The Tate Gallery

Looking out across the Thames, half a mile beyond the Houses of Parliament, is the stately home of the Tate Gallery of modern British art. The gallery has an imposing colonnade approached by wide steps, and above it all sits Britannia looking down, a lion and unicorn lying at the corners of the pediment, and winged lions and sphinxes adorning the walls. On platforms on each side of the porch are great bronze figures, one of Perseus rescuing Andromache, by Henry Fehr, the other of the Punishment of Dirce, by Sir Charles Lawes-Witteronge. On the lawns below is a statue of Sir John Millais, and a bronze symbolical of Truth by Frank Dobson. Over the hall rises a low dome, to be dwarfed by the spacious dome crowning the new sculpture gallery of coronation year.

Two columns in the hall record the generosity of Sir Henry Tate, who gave sixty-five pictures for the gallery to begin with. Lord Duveen and his father have built handsome galleries for the Turner and Sargent collections, the watercolour collections, and for a small foreign collection, and thanks to this munificence the gallery has become increasingly representative. It houses the Chantrey Bequest, most of which has a room to itself: a portrait of Chantrey bought from his Bequest faces us as we come in. Leaving the gallery we walk by the river back to Parliament Square, but not too hurriedly for so great a walk, for we are in the midst of the biggest transformation London has seen in our time.

The Tate Gallery

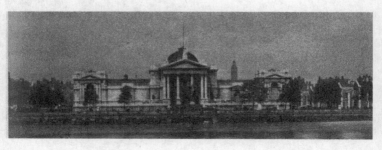

The Riverside

The Marvellous Buildings of Millbank

Anyone on Westminster Bridge will be conscious of a distressing contrast between two vistas. Eastward as the river sweeps round on its way to St Paul's the view is blocked by the unredeemed ugliness of Charing Cross Bridge and the sad sight of Waterloo Bridge no more than a heap of wood and stones. But if we turn from the east and gaze upstream we find that 'westward, look, the land is bright.' While men have talked on the east men have worked on the west. Beyond the Houses of Parliament two new palaces have arisen, vast palaces of industry, the finest promise London has of what it will be like in fifty years to come. The two buildings are Thames House and

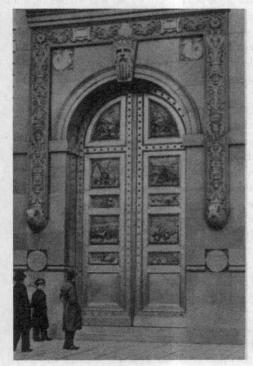

The wonderful doors of
Imperial Chemical House

A panel on the door of
Imperial Chemical House

Imperial Chemical House, now approached by Lambeth's beautiful bridge
(this also set up by Lambeth while the rest of London was wondering if a
bridge was possible at Charing Cross).

The architect of this vast place was Sir Frank Baines, who built up his
visions on a great scale as architect for the Office of Works. We see this great
house as an impressive building in the style of the English Renaissance, faced
with Aberdeen granite and Portland stone, crowned with a white roof and
lit from 1370 windows.

But it is the doorway of Imperial Chemical House which is its wonder of
wonders, a treasure of London that all may see and worthy to compare with
the fourteenth century doors of the Baptistry at Florence, of which Michael
Angelo said that they were fit to be the gates of Heaven. The beautiful
ornament on the granite of the doorway was carved by pneumatic power.
It is a projecting band running round the doorway, resting on two stately
corbels and with a striking keystone of Edward the Confessor.

The doors are 20 feet high, half as wide, and weigh five tons, being all
metal, faced both ways with silveroid, an enduring alloy of nickel and copper.
The opening of the doors is under electric control; they cannot be affected
by a violent gust of wind and cannot be opened from outside. There is no
lock on them. Each door is divided into six panels, those on the left showing
primitive man and his ways of life and labour, those on the right showing
the modern developments of man's activities. The top panels, rounding off
the arch, show primitive man overcoming a mastodon, which is falling into
a pit-trap and being subdued by flint arrows and spears; the companion
panel shows man in control of domesticated animals, shearing sheep by

electrically-driven clippers and carrying away the wool by motor power. Next come two panels showing primitive man using flint and wooden tools, crossing a gorge by a twisted fibre bridge, and building tents of reeds and wattle and daub, with a model of Stonehenge in the distance; the companion panel to this shows man with the great Mount Wilson telescope, and in the distance a model of Imperial Chemical House. Now come narrow panels showing transport now and then – men in dug-out canoes paddling across a lake, reindeer drawing a sleigh made of boughs, and strong men supporting a hugh log on rollers, the modern panel showing an express crossing a viaduct, an oil-driven ship, an autogiro, and a giant airliner. Next come two square panels of Agriculture, primitive and modern, both bringing out in a

The Victoria Tower from Millbank

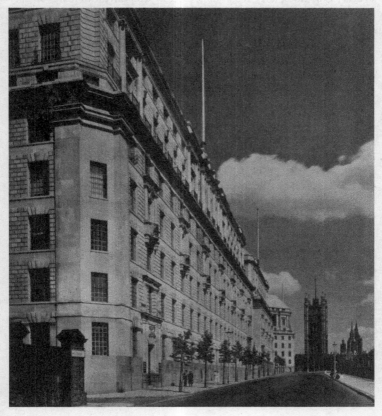

striking way the high quality and the vivid expressiveness of the sculptor's work. The primitive panel shows men ploughing with a flint or a sharpened stake, manipulated by eight men with the help of poles; the modern panel shows a multiple machine which cuts, threshes, and bags the grain, and there are men with petrol tins standing by. Two more narrow panels show primitive crafts such as pottery and weaving, a remarkably fine scene with workers sitting on the ground, and the modern industries compared with it are represented by a cotton mill. The bottom panels are of primitive and modern Science, and on the left we see the Stone Age way of marking the longest and shortest day by a shadow from a trunk, irrigation carried on by a water-wheel as in Egypt today, and a figure sky-gazing through a crystal. In the modern panel here Michael Faraday is lecturing in the Royal Institution, with over 100 people sitting in the seats where old and young children still sit every Christmas; it is a remarkable piece of sculpture, with scores of faces recognisable, among them in the first rows being Tyndall, Huxley, Crookes, Darwin, Wheatstone, and Kelvin.

Having set up Imperial Chemical House, Sir Frank Baines and his army must needs advance, and their next job was next door on a building twice as big, in two vast blocks linked by a bridge, with a river frontage of 560 feet and frontages to all the streets round them of a third of a mile. The cubic space of these blocks of Thames House is over 11,000,000 feet, and these blocks and their neighbour form an industrial monument on a scale and a standard unique in the world.

The Streets about the Abbey

We may walk back to the Abbey with the majestic Victoria Tower drawing our eyes that way; but let us turn into the little streets and saunter through them. Turning by Lambeth Bridge we shall find ourselves in Smith Square, once a quiet little place where rich men lived and now with mighty offices

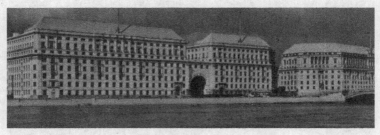

Millbank, with Thames House and Imperial Chemical House

(the GHQ of the Labour Party), 500 windows looking down, and shrubs and trees struggling for existence. In it is the Church of St John, built by Sir John Vanbrugh's pupil Thomas Archer, and still keeping its eighteenth century dignity. To north and south it has imposing fronts, and its four round towers look across to the Abbey and to the Victoria Tower of Parliament, a stone's throw off. The interior is typical of the fashion 200 years ago, with wide galleries on fluted pillars, an ornamental ceiling, and handsome panelling in the sanctuary. The carved pulpit stands on a very slender column, and the bowl of the elegant marble font is borne on angel wings. There is a medallion portrait of John Jennings, rector for fifty-one years, and a memorial to Maude Alethea Stanley who died in 1915, a pioneer (as we read) of social work in the nineteenth century, and originator of Clubs for Working Girls.

Hereabouts are two fine halls in memory of a group of splendid women: Millicent Fawcett Hall and Mary Sumner House. Close to these buildings is Sir Herbert Baker's Christian Science Church, and at a street corner here a statue of St Paul under a fine canopy marks the home of the Society for the Propagation of the Gospel. We should find our way back into the precincts of the Abbey from the little streets that have had their names up for 200 years; one of the stones we can read quite well, Cowley Street 1722. It is a lovely little corner all unguessed at by the multitude which passes through the crowded streets not far away.

Here we saunter on into the cloisters of the Abbey and through Dean's Yard and are back in Parliament Square again, to continue our riverside walk by the Victoria Embankment.

A Walk Along the Embankment

London's mile by the Thames is not the lovely walk a riverside way should be. Somehow the Thames Embankment has missed its glory; it has nothing of the delight of the Mall or of Birdcage Walk. But if we take the Embankment as a gallery of monuments there is no road in London that can equal it. Here are tributes in scores to men and women famous in our annals, and to the heroic spirit of our race. Here are things of beauty that delight us every time we pass them. The seats rest on camels and sphinxes, and there are 400 dolphins on the lamps. The Embankment, linking our two great cities west and east, is wearisome enough as a thoroughfare, but it is unrivalled if we think of it as Memory's Processional Way, in which we come upon those whom the people delight to honour. Let us walk along it from west to east, beginning under Big Ben and walking on the left to Blackfriars.

We come first to Scotland Yard, the red brick building with the bust of its architect, Mr Norman Shaw, high up on the river front, but the first man

we meet on the pavement is Samuel Plimsoll, fashioned by Mr Blundstone, with two figures and a ship on the pedestal.

Turning into the Embankment gardens we come upon three bronze figures, of whom one can never be forgotten, for he gave us the most precious book in our language. He is William Tyndale, by Sir Edgar Boehm, and it fills us with pity to think that so gentle a man should have suffered so tragic a fate for opening the Bible for the English people. Next to him is Sir Thomas Brock's statue of Sir Bartle Frere, of South African fame in the days of President Kruger, and beyond him is Sir James Outrain wearing the Star of India; he is sculptured by Matthew Noble, and there is a sitting figure in relief on the pedestal. General Outram was one of the noblest soldiers who ever served his country.

We have now arrived at the ugliest thing seen on the Thames, Charing Cross Bridge, for which London pulled down the noble suspension bridge which crosses the Avon at Clifton. The Clifton Suspension Bridge was here when the railway came, and was removed to make way for this foul structure sprawling across the river on something like huge drainpipes.

Under the bridge, past the excellent Underground station which has become the centre of so many free shows, and Hungerford House, the LCC engineer's office with a charming sculpture over the door of a woman sitting with an eagle and a heraldic lion, we come to the gardens that reach back to the farthest limit the Thames has ever reached, the old Watergate of the Duke of Buckingham's house, where he would take the boat to go up river. It has two lions guarding it, and is of interest not only as a landmark but because it was designed by Inigo Jones and built by Nicholas Stone.

The gardens in which we have arrived, stretching from Charing Cross to Waterloo Bridge, from the ugly bridge we have left standing to the beautiful one we have pulled down, have a variety of monuments, the worst of them the awkward Robert Burns sitting thinking of his native Scotland, the statue only redeemed by the lovely words he is supposed to be saying. There are two full figures and two busts, the full figures being Sir Wilfred Lawson by David McGill and Robert Raikes by Thomas Brock. Raikes stands as if teaching his Sunday School children from a book, and Sir Wilfred Lawson, with figures of Temperance, Peace, Fortitude, and Charity about him, stands as he was so often seen amusing the House of Commons. The two smaller portraits are Sir Arthur Sullivan and Henry Fawcett.

In the middle of the gardens is one of the daintiest monuments of all, in memory of the work of the Camel Corps in the war. It is an arresting sight. The camel with his unwilling head bent round a little stands on the top of the block, a soldier on his back padded round with kit. On the pedestal are

two bronze reliefs, one of a camel lying down while its rider gazes over the desert at the rising sun, the other of two soldiers running, and below them the names of a gallant little band of British, Australian, New Zealand, and Indian men of the Camel Corps who gave their lives for us in the burning desert and the waterless ways, with fever always at hand.

Close by is a seat and a lily pond to Lord Cheylesmore, Soldier, Administrator, Philanthropist, and Friend, ingeniously arranged so as to utilise the back of the loveliest memorial on this side of the Embankment, set up by the grateful Belgian people in honour of the British nation. It looks out on the throng for ever passing by, but none can look at it too often, for these bronze groups set on a stone wall by Sir Reginald Blomfield are impressive figures. They show a woman with two children bringing a tribute of flowers, and on the stone wall behind are figures of Justice and Honour.

High up in front of us, dominating the riverside with the keynote of twentieth century architecture, is the white mountain of Shell-Mex House, with a clock rivalling Big Ben for size, except that it has no proper face, and a tower rising 190 feet above us, with four heads looking down at the corners, the heads of strange figures roughly outlined in stone. Dwarfed by its great neighbour, the Savoy Hotel keeps its ancient dignity behind the gardens. It is a famous building with a stately red front that stands next door, with only Savoy Hill to divide it from Waterloo Bridge. Here is the Institution of Electrical Engineers, once known to all the world as 2LO, the cradle of Broadcasting.

Beyond Waterloo Bridge we pass the magnificent stone front of Somerset House with masks on its keystones and lions at its gates, and at the end of

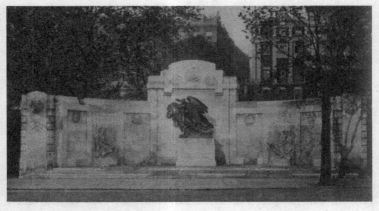

Belgian Memorial on the Embankment

Shell-Mex House

this noble facade, the finest front to the Thames hereabouts for a hundred years, we come to the splendid figure of a man who has a great right to be here, standing in a little stone bay with a small instrument in his hand. He is Isambard Kingdom Brunel, who made the first Thames Tunnel; his statue is by Baron Marochetti.

We are at one of the most charming spots by London's river, the best bit of the Embankment, beginning with another small garden and leading on to the Temple. The garden has three bronze memorials, and two lovely figures at the gate. Standing on a stone pedestal is Mr W. E. Forster, the pioneer of popular education, who carried through Parliament the Bill which founded Board schools. Set in a small bay is Mr George Wade's charming memorial of Lady Henry Somerset, who gave her life for social reform and temperance. Looking down this garden from the end is the lovely figure of John Stuart Mill, sitting with his hand on a book as Thomas Woolner fashioned him; he is one of the best figures on the Embankment, and charmingly does he

complete the group as we see him through the gateway guarded by the two bronze wrestlers of Herculaneum.

The little neighbour of Electra House is one of the daintiest buildings in the world, the neat office built by the first Lord Astor for the management of his estates. The windows are models of leaded quarry-glazing, the upper range flanked by oriels. All the details of this building stand examination, and it is curious to find as we look into it two cupids on one of the lamp standards talking by telephone. High above the lovely roof floats the loveliest weathervane in London, a gilded copper model of Santa Maria, the caravel in which Columbus sailed to America, where Mr Waldorf Astor made the wealth he spent in England.

The staircase rises in three flights to a gallery on the first floor, and is solid mahogany. The seven lovely figures on the newel posts were the work of Mr J. Nicholls, who loved them so that he would not let them go from his bedroom until he died. They represent characters in The Three Musketeers. Round the gallery (which has pillars of solid ebony) are statues of characters from Fenimore Cooper, Nathaniel Hawthorne, and Washington Irving; we noticed Rip Van Winkle with his dog. Below the stained glass ceiling, which is coved and panelled with carved pendants, is an oak relief by Nicholls with eighty-two characters from Shakespeare.

From the gallery we come into the great hall, 71 feet long, a magnificent room with a hammerbeam roof. The walls, panelled in irreplaceable pencil cedar, are finished with a frieze in which are fifty-six portraits carved by Mr Hitch. We notice among them such people as Alfred, Anne Boleyn, Henrietta Maria, Bismarck, and Voltaire. Above the frieze are twelve full figures standing under canopies on the hammerbeams. They are carved in mahogany and gilded. On the inside, by the door, is a beautiful carved head and nine panels in silver gilt by Sir George Frampton, showing nine heroines in the story of King Arthur. The east and west windows of the hall have stained glass of sunrise and sunset by Clayton and Bell. In the beautiful Council Chamber, with a floor of Spanish mahogany which looks like a single piece, are oak panels running round above the bookshelves with figures of the arts and sciences between. The great chimneypiece is of white marble, with two lovely figures on each side.

We are now passing Temple Gardens, and the small marble head of Queen Victoria marks the City boundary. For convenience we will continue our walk for a little way into the City. We pass the Middle Temple Library, with its flying horse, its little holy lamb, and three winged angels, the big block of buildings at Middle Temple Lane, with lovely chimneys and symbolical and fanciful sculptures on the front, the gardens with the Charles Lamb

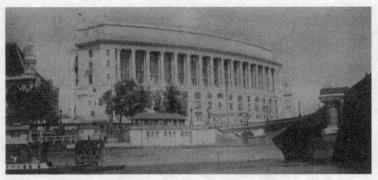

Unilever House

fountain seen through the railings, and the lawns running up to the red brick house in which he was born. We come to Hamilton House, with a figure in relief with sword unsheathed, symbol of preparedness; Telephone House, with a running boy above its roof (the old home of our national telephones when they were private property); the beautiful Sion College, with its angels and oriel windows, and the heraldic lion on Reuters building next door to it; the City of London School, with Milton and Shakespeare, Bacon and Newton, and Sir Thomas More outside; and at last the great Unilever House, a veritable triumph of a building, built as if for ever, with two groups of sculpture by Sir Reid Dick representing Courage and Controlled Energy. We are at the City end of the Embankment, with Queen Victoria looking to the City, her back turned on Westminster, and we cross the road and walk by the river wall to the other queen who stands a mile away, where we began.

We may peep over the wall and see the Fleet River pouring into the Thames, but the first memorial we come to is at the entrance to the President training ship, where are two copper tablets to the officers and men of the Royal Naval Division. At times we may see an Admiral's flag flying from this training ship, for every Admiral appointed to the Admiralty for any special work is officially appointed to HMS President, the nearest ship available.

We come now to the seventeenth century Watergate opposite Temple Gardens, known as the King's Reach in recognition of the Silver Jubilee of King George. This shining expanse of tideway curving from London Bridge to Westminster is dedicated to King George, and the memorial panel is placed in the open arch which breaks the parapet. On either side are bronze figures by Mr Doman of boys pointing to the river, one with a pennant sitting on a tiny ship with a sea-horse on its prow, the other riding on a dolphin, with a trident in his hand. Above each boy are bronze heads of Father Thames.

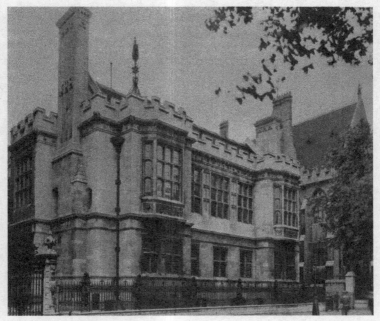

Accountants Hall, Embankment

Now comes the Submarine Memorial, a bronze panel with a grim section of a submarine showing seamen dragged down by sinister figures with nets, daughters of the sea god; at the sides are figures of Truth and Justice (so far removed from submarines).

A bronze plaque a little way on, facing the gardens in front of Accountants Hall, has on it a familiar face in the Fleet Street of last generation, W. T. Stead (by Sir George Frampton). He looked down on this spot from the window of his editorial room, and all his life he showed the qualities represented by the small figures on this bronze, Fortitude and Sympathy. He lies at the bottom of the Atlantic, one of the 1,200 victims of the iceberg that destroyed the Titanic. Farther on is a novelist of those days, Sir Walter Besant, whose bust is a copy of the one in St Paul's. And now we come to the oldest monument in London, the oldest standing in any street in England, the famous Cleopatra's Needle.

This great column is thirty-five centuries old. It stands 70 feet high and is 8 feet wide at the bottom and 5 at the top, then ending in a pyramid 7 feet high. It weighs 166 tons, being ten times as heavy as the biggest stone at Stonehenge.

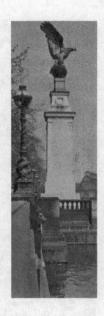

Left: Cleopatra's Needle

Right: Royal Air Force Eagle

Alas for the plans of mice and men, it was wrecked in the Bay of Biscay, and on one side of it as it stands today are the names of six seamen who perished in a bold attempt to succour the crew of the obelisk ship Cleopatra during a storm. The bronze sphinxes are by Vulliamy. The damaged patches at the base are the marks of a German bomb.

Just beyond Cleopatra's Needle, facing Charing Cross Station, is Sir George Frampton's bronze of W. S. Gilbert, who, with his friend Sir Arthur Sullivan, left behind him the greatest stock of pure delight ever created for the English stage by a single partnership. With his bust are little figures of Tragedy and Comedy. Beyond the bridge is a bronze of the engineer who saw the Embankment in his mind before any man walked on it, Sir Joseph Bazalgette, maker of this great highway.

Now we come to the lovely golden eagle with its wings in flight and its feet on a globe, a bronze memorial of the RAF by Sir William Reid Dick, with the words, 'I bare you on eagle's wings and brought you to myself'; and, last and noblest monument in this famous mile, worthy of its superb position, is Thomas Thornycroft's bronze group of Boadicea in her chariot. She is driving furiously to save her people from the Romans, and is a majestic figure.

Turning back a little way down the Embankment we come to Northumberland Avenue, pausing here to look at its great new Empire

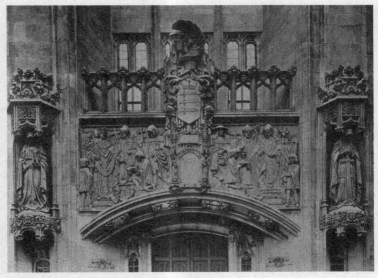

The balcony over the doorway of Middlesex Guildhall

Mosaics over the altar of the Lady Chapel

House, the home of the Royal Empire Society. In each of the thirty-six rooms, of which Queen Elizabeth was given a key when she unlocked them as Duchess of York, is stone or wood from some quarry or forest in the Empire overseas, and on a stately front are medallion reliefs with ships, horses, flowers, fishes, suns, and faces. The keystones are lions; there is a lion at a window and the flags by the doorway have golden heads of lions on their masts. Over the door are two finely sculptured men bearing up a balcony. The building is by Sir Herbert Baker. The Society which has its home in this fine building has about 20,000 members, and its equipment is unique in the Empire. There is no other place where a reader can so easily consult a thousand papers from all parts of the British Empire. Across the Avenue, at the corner of a building once the home of the SPCK, is a figure over a doorway, representing Christianity.

In front of us is the most famous open space of Westminster, where agitators, wild men, and loyal citizens meet at times, the People's Forum in the heart of London – Trafalgar Square.

Trafalgar Square

Trafalgar Square

Trafalgar Square, with Nelson looking down from the top of his great column, might be more beautiful, but it could hardly be more famous. Nelson is the height of three men at the top of his great column, which rises 184 feet, half the height of the Cross on St Paul's, and is set on a base of 48 feet square of brickwork resting on 6 feet of concrete 12 feet down. The first step of the pedestal is 33 feet wide, and the column is of solid granite blocks to the foot of the statue. The granite came from Devon. The fluted shaft is 10 feet wide and ends in a bronze capital made from the guns of the Royal George. One group of the leaves on the capital weighs nearly half a ton. The figure of Nelson is in three pieces; it is 17 feet high and the biggest piece weighs 30 tons. On the platform on which his pedestal rests fourteen men had dinner before the scaffolding came down.

On the four sides round the base of the column are tremendous bronze reliefs by four sculptors (Watson, Woodington, Ternouth, and Carew); the column itself was designed by William Railton, and Nelson was carved by E.H. Baily. The four reliefs show the Battles of St Vincent, Copenhagen, and the Nile, and the death scene on the Victory. There are about fifty figures in them and we see Nelson receiving the swords of Spanish officers at St Vincent, and at the Nile refusing preferential treatment from the doctor after being wounded.

In the centre of the Square General Gordon stands in bronze with his cane under his arm and a Bible in his hand, his foot on the broken barrel of a gun. It is by Hamo Thornycroft, and on each side of his pedestal is a bronze relief showing Charity and Justice, Fortitude and Faith. Fortitude's shield is inscribed Right fears no Might.

On the four pedestals at the corners of the Square stand two soldiers and a king: Chantrey's George the Fourth sitting on his horse with no stirrups; Sir Henry Havelock standing with his hand on his sword; and Sir Charles Napier holding his sword and a scroll.

The empty pedestal is waiting for a hero: surely it is the very place for the Chief Scout on his horse? The two fountains, supplied by a well 380 feet deep, were added to the Square as an afterthought and designed by the architect of the Houses of Parliament, Sir Charles Barry.

Along the top of the Square is a surprise for many Londoners who, having known the Square all their lives, come someday to examine it. Let into the wall are our imperial measures. If we are in any doubt about a length, here we may come to find it true, for set in the stone are brasses by which we may check an inch, a foot, two feet, a yard, or a chain. There is also the standard measure of 100 feet with little brasses let in from end to end. Here they are so that all the nation may know them beyond dispute.

But not yet is the interest of Trafalgar Square exhausted. But for one or two tasteless exceptions it is dignified all round, with Canada House transformed from Sir Robert Smirke's old Union Club on the west, South Africa House on the east with its stately front, its charming balcony, and the little gold springbok leaping out; the charming National Gallery running along the top with its famous pepper-pots on the skyline; and the lovely old columns of St Martin's with a little tower and a tall spire, a fanciful thing pierced with circles and alive with sparrows sitting round in rows. The Admiralty Arch leads into the Mall and in front is the broad stretch of Whitehall, with Charles looking down to where his scaffold stood, and the towers of Westminster rising majestic beyond. Trafalgar Square has all this, and yet perhaps we may think it has something more captivating still, for it

The lamp from the *Victory* at Trafalgar

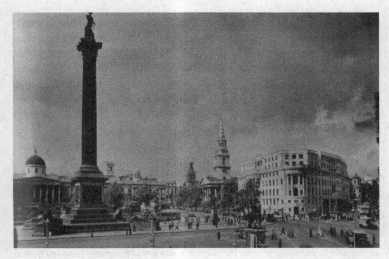

Above: Trafalgar Square

Right: Nelson on his column

has four historic and beautiful octagonal lamps set on stone pedestals, one of which is a tiny box for a policeman, the smallest police station in England fitted with a telephone to Scotland Yard. There are street lamps about us made from captured cannon, but these four lamps thrill with a history more stirring than that. They once swung proudly on the *Victory*.

Round about the Square, within a minute any way, are a dozen sights to see. There is the Eleanor Cross, King Charles's statue, and George Washington standing with his bundle of sticks at the corner of the National Gallery. It is a bronze copy of Houdon's statue at Richmond in Virginia, showing him bareheaded, booted, and spurred, resting his right hand on a cane and his left

on this mass of sticks made by the sculptor much too big. However that may be, they were here as fasces, the insignia of the Roman magistrates, long before Mussolini thought of making such things the symbol of the Fascist power. At the other end of the National Gallery the Royal College of Physicians backs on to Canada House, with three great figures in medicine standing in niches behind six round columns: Thomas Linacre of the court of Henry the Eighth; Thomas Sydenham, the great friend of John Locke; and William Harvey, the immortal discoverer of the circulation of the blood. Hereabouts are three of the most deservedly popular places in London, the National Gallery itself, the National Portrait Gallery next door, and St Martin-in-the-Fields, from which services have been broadcast to the ends of the earth. In front of the Portrait Gallery, looking up Charing Cross Road (home of the second-hand bookshops) Sir Henry Irving stands in bronze, a magnificent figure by Sir Thomas Brock. In the middle of the road close by stands Nurse Cavell in nurse's uniform in front of a melancholy block of stone on which are carved her famous words: Patriotism is not enough. I must have no hatred or bitterness towards anyone.

On the back of the pedestal is a lion standing on a rock, and on the sides are the words, Humanity, Devotion, Sacrifice, and Fortitude.

Canada House

From the two sides of Trafalgar Square Canada and South Africa face each other. Canada House, joining the Royal College of Physicians, has been refaced and reconstructed. Designed by Sir Robert Smirke in 1820, it was refashioned by Mr Septimus Warwick. The old staircase is still here. The main doorway has a portico of four columns and magnificent bronze doors with the maple leaf in their design. From this doorway in Cockspur Street is a vista of 100 feet into the building, the ground floor being open throughout. The floor is of black and white marble, and ten yellow columns hold up the ceiling. In the office of the High Commissioner is a finely-cut crystal and candelabra of forty-eight arms in five tiers. On the first landing is a bronze statue of General Wolfe, and there are paintings of George the Third, Edward the Fourth, and George the Fifth. Facing Canada House across Cockspur Street is the P&O Office, with two fine bronze figures guarding its doorway; and a few doors west is a fine bronze figure of St Olaf in a niche of Norway House. Here is the shipping quarter, with windows that are a traveller's delight, especially by night, and down the steps out of Cockspur Street is an astonishing glimpse of London's Old Mews.

We have four great visits to pay before we leave Trafalgar Square: to the new South Africa House, the old St Martin-in-the-Fields, and those two

galleries unsurpassed in London which join each other at the top of the square, the National Portrait Gallery and the National Gallery of Art. We will begin with South Africa House.

South Africa House

South Africa House has given itself an island site which for a generation cried out for a worthy occupant. It has a splendid frontage facing three ways and it takes its place finely with those friendly neighbours at the top of the Square, the National Gallery and St Martin-in-the-Fields. The great stone mass of the building is relieved with carving of great dignity. In the pediment is a relief of the Good Hope, the ship which took the first Dutch Governor to the Cape. The keystones of the first floor windows are carved with South African plants, and below the windowsills run heads of South African animals, all these the work of Mr Joseph Armitage. There are eight heads on a large scale of animals such as the lion, elephant, antelope, wildebeest, and buffalo, greeting us as we go by, and higher in the walls are forty-four smaller heads. Over the great portico facing Trafalgar Square is a keystone of a springbok with the sun caught between his horns, and over his head is the Southern Cross carved in stone with the Good Hope above it. At the narrow point of this triangular building is the finest sculpture of all, a statue of Diaz, who sailed to the Cape 450 years ago; he has with him the little ship he sailed in.

But it is the golden springbok with wings, looking as if it would leap at any moment and go bounding down Whitehall, that everybody knows as the sign of South Africa House. It comes from the imagination of Mr Charles Wheeler, who set Ariel on the new Bank of England as the Young Lady of Threadneedle Street.

We may all go inside South Africa House, which is more interesting than half the kinemas. The central hall has two domes, carved in the spandrels with the arms of the old Dutch Republics and the British Colonies now in the Union of South Africa. On the landing is a copy of the bronze relief made by Mr John Tweed for the front gable of Cecil Rhodes's house, Groote Schuur. At the foot of a staircase into the basement is a small fountain cut out of a block of Transvaal green marble, fed by a bronze satyr. In the reading-room is a frieze of heraldry suggestive of the romance of South Africa, and everywhere is appropriate symbolism on the walls and ceilings. The walls are lined with South African marble of green and dove-grey, suggesting a stormy sea. There is a great variety of wood in the panelling and furniture, and the floors are paved and skirted with Dutch tiles patterned with flowers.

One of the most attractive of the decorations is the magnificent tapestry facing us as we enter from Trafalgar Square. It is a fascinating scene at which

all visitors pause. Fish of all colours and kinds swim in the curling blue and green waves round its coast. Sea-goat blows to sea-goat along the Tropic of Capricorn, and the god of the winds fills the white sails of the ships which brought the first explorers. The southern half of Africa is shown from the Cameroons in the west to Abyssinia in the east, with two fiery suns marking the line of the Equator curving across the top of the map. The land is the colour of ripe corn, or, as this is Africa, perhaps we should liken it to gold or to the burned sand of the Tropics. The little picture symbols run from the more civilised south with its cities and farms, flowers, sheep, and ostriches, to the tropical blues and greens of a forest of the Belgian Congo.

The whole history of South Africa is in the symbols. We recognise the cross which marks where Cecil Rhodes lies on the Matoppo Hills, the flashing diamonds of Kimberley, the native weapons of the Zulu War, the scales from Bloemfontein's Court of Justice. A lion and a zebra walk through the Kruger National Park; a gorilla looks out from the Congo forest; and here, too, is that romantic swallowtail butterfly, the Antizox, which has never been captured.

All the many-hued flowers of the veld seem to be crowded into this rich border, with the names and arms of the great men of South Africa, while the arms of Stales and towns add to the heraldry. It is all as lovely a bit of colour as ever hung on a wall.

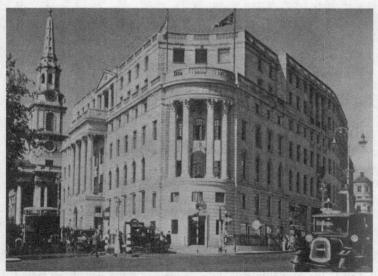

St Martin's spire and South Africa House

St Martin-in-the-Fields

We come now to a place known through the broadcasting world, the First St Martin-in-the-Fields. Proudly it stands by the Square, broadcasting to the millions its message and the music of its bells, alive with every kind of good activity, its crypt open every night to scores of London's homeless.

It is one of our finest churches, the masterpiece of Wren's friend and disciple James Gibbs, whose bust (by Rysbrack) is inside. There had been a church here for centuries, and the fields were still green in Cromwell's day, but St Martin's as we see it comes from 1726. Its architecture should be admired from across the square, where the splendid proportions of the classical design are best seen. The impressive portico is one of the best in London, and above it the royal arms remind us that this is the parish church of Buckingham Palace, so that the name of a royal baby born at the palace is entered in the register here.

The bells are chimed before the broadcast services and would be famous anyway as the oldest peal of twelve in the country. Some of them go back to 1584, and there is an interesting tradition that they were the first to ring out a naval victory, perhaps announcing to London the defeat of the Armada.

On the door-handles (as on the lamp-posts hereabouts) we see St Martin dividing his cloak. He welcomes us to an interior full of interest, though unhappily so dark that it must always be lit by day. The roof is unusual for curving down in the shape of an ellipse, an arrangement James Gibbs thought 'much better for the voice.' It is panelled in blue and gold, and adorned by fretwork. Royal boxes, like open windows, look down on the sanctuary, and between them is an east window of the Ascension with expressive faces. The pulpit is carved and inlaid, and has a stairway perhaps by Grinling Gibbons, with delicate twisted balusters. The font is a marble urn on a twisted pedestal, and has a cover of 1689 with two doves and festoons of flowers. We may think, as we stand here, of the great men christened in the earlier St Martin's, of such immortals as Francis Bacon and John Hampden; and of Charles the Second and General Oglethorpe, founder of Georgia.

There are mosaics of the Annunciation in memory of Lord Frederick Cavendish, a victim of the Phoenix Park murders.

Plain in architecture but warm in welcome, the crypt is like a second church below the first. It is one of London's Ever Open Doors, and is used for worship when the crowd is too great for the church itself. In the crypt is a rare little Children's Chapel, domed and coloured like the vault of heaven, and among the interesting things kept here is a fine model of the church by its architect, waiting to light up for a penny, an old chest, a

kneeling Tudor figure, a row of ten kneeling children, a whipping-post of 1752 from Trafalgar Square, and a tablet to a lady of 1687 whose early death led her friends to write of her:

A friendly neighbour and a virtuous wife,
Doubtless she's blessed with Everlasting Life.

The Portrait Gallery of the English-Speaking People

We do not know in all London a lovelier way of spending an hour than by stepping out of Trafalgar Square into the Portrait Gallery. Its two long corridors with their lines of marble faces are charming, and the little rooms running off them are full of colour and humanity, small stirring places that delight the eye and do not overwhelm the mind.

The pageantry of kings, the scarlet coats of generals, and the simple dignity of tinkers and scholars and dreamers, the little groups of familiar faces in white marble and bronze, the spacious canvases of famous scenes, are unsurpassed in our galleries.

Here are nearly 4,000 portraits of men and women and children famous in our story, most of them single portraits but a thousand of them in groups. They are the work of 750 artists, and no other country in the world has a record so vivid, so complete, of those who fill the pages of its story. We feel that if such galleries would learn from kinemas the art of using doors and windows, flinging their portals wide and flooding them with light, with perhaps a commissionaire in scarlet to tempt us in, they might well rival kinemas.

The gallery is on three floors and the arrangement is chronological. A lift will take us to the top, where are the chief portraits from the fifteenth to the end of the eighteenth century, as well as the leaders of public life in the next two centuries. On the first floor are men and women of the Arts, Letters, and Sciences of the eighteenth century, and in another wing down a flight of steps are similar groups for the nineteenth. On the ground floor are drawings and paintings of our own century and miniatures of all periods.

While the architecture of the gallery makes no claim to special merit, it has a gallery of medallions on its outside walls worthy of note. There are eighteen of them. Over the portico are the three figures of Carlyle, Macaulay, and the fifth Earl Stanhope, and on the north side are William Faithorne, the engraver; Edmund Lodge, the famous publisher of portraits; and James Granger, the collector of portraits. In the tympana of a dozen windows are three literary figures (Thomas Fuller, Lord Clarendon, and Horace Walpole), two sculptors (Chantrey and Roubiliac), and seven artists: Holbein and Van

Dyck, Kneller and Lely, Lawrence, Reynolds, and Hogarth.

From our National Portraits we pass to our National Pictures; the National Gallery is next door, looking across the Square from its familiar and delightful portico.

The National Gallery

It stands on a natural platform looking down on Trafalgar Square, a modest-looking building 460 feet long among great neighbours rising higher and higher with the passing of the years. From a distance its small central dome and the tiny domes at the ends look like pepperpots; set among the towering masses of stone now rising all about us it would look hardly more than a doll's house. Even those who do not go indoors to see its priceless pictures should mount its steps and look out at London from its portico, where all day long a ceaseless line of traffic comes from north and south, east and west.

Over the door are two figures, one sitting on a horse and the other on a camel; on their right is a symbolical figure between two angels, and on the left are three fanciful figures in niches.

The original building has been many times enlarged, the Royal Academy has removed to Burlington House, and the Tate Gallery was built for the works of British painters and modern foreign artists. Today we can walk about these rooms and follow the progress of painting from the days of the Caesars to the close of last century in a magnificent series of about 2,000 pictures of every famous school. The chief pride of the Collection is the Flemish and Dutch group, with masterpieces of Rubens and Rembrandt at various periods of their lives. The great Italian altarpieces would give distinction to any gallery. The artists of Venice are represented by works as famous as any in Italy.

The English School as represented here is worthy of its high place in the history of the world's art, with lovely portraits by Reynolds and Gainsborough, landscapes by Constable, and wonder paintings by Turner, who left his masterpieces to the nation.

The great entrance hall is itself worthy of attention, with two square pillars of light green marble from the Simplon Pass. Ascending the steps, we pass between marble walls of exquisite texture from the African quarries which gave their splendour to the palaces of Caesar. The columns are of jaspar-like stone from Algeria, and we see it again in the doorways of the first rooms we enter. An elegant bronze sculpture of Fame blowing his trumpet, by Pierre Biard, welcomes us to the hall.

The Italian paintings are in the central rooms; the Flemish, Dutch, and Spanish in the rooms on our right, and the German, French, and English in those on our left.

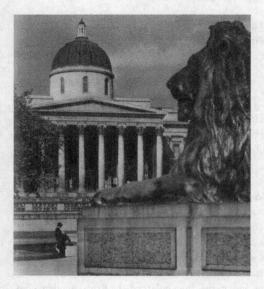

The National Gallery

One curious story is told of a brightly painted family by Michael Sweertz. Looking closely at this picture we notice that there is a join down the centre, and the story is this. A few years ago nothing was known of Sweertz except some fine engravings; his paintings had all disappeared. In the last year of last century the left half of this picture was given to the National Gallery but was ascribed to Vermeer, and ten years later the right half appeared in Paris. It was purchased, and the canvas was completed as we see it.

Perhaps a word should be said in tribute to the delightful arrangement of the gallery. It has lovely peeps through some of its doorways, and we should not miss the long vistas between the rooms, such as that from end to end of the new wing, or that from Mrs James Baillie and Family on one wall to the white Madonna of the Girdle, with the little blue angels about her, seven rooms away.

Whitehall, the Street of Government

Whitehall

We may begin our walk down Whitehall with King Charles sitting on his horse, fashioned by a man who knew him, Hubert le Sueur. It has been said that this is one of the three best equestrian statues in the world, and every Londoner will believe it. It shows the king in armour and bareheaded. It is not necessary to create legends to make it interesting to us, for it is appealing in itself, a natural and beautiful thing, and is the centre of the bitterest chapter in the story of our throne. Those who are curious enough to look will find the sculptor's name round one of the horse's hoofs.

We must ignore the curious fact that Whitehall begins as Charing Cross and ends as Parliament Street; we will walk down as if it were one, though it was only in this century that there was swept away from the bottom of it the narrow little street in which Edmund Spenser died for want of bread. Today for most of us all this is Whitehall and the Street of Government, not always worthy of itself but the seat of power for centuries and the heart of the government of one-quarter of the human race.

Most of Whitehall as we see it is of the last three centuries, though all about are ancient foundations, and the Banqueting Hall is by Inigo Jones. On the right are the fine new buildings of two banks, and opposite them is the little Craig's Court, with the last private houses in Whitehall now taken over by the Post Office. It was Harrington House, built in 1702, and its fine Queen Anne front has been saved. Here too is Old Scotland Yard, the name left for confusion's sake since the police moved lower down. It was once the home of Scottish kings, home of the architects Christopher Wren, Sir John Vanbrugh, and Inigo Jones, and home of John Milton when he was Cromwell's Latin secretary. Next to Old Scotland Yard is the twentieth century office from which our Crown Lands are controlled, and we are now at Whitehall Place with the great War Office across the street. Facing all this is the front of the Old Admiralty which for more than 200 years has survived all change. The stone screen in front with the curious two-winged seahorses is by the Adam brothers; it was said long ago that 'Mr Adam's handsome screen properly veils the clumsy pile of the Admiralty from the street.' The lovely sea-horses on the screen are by a Dane who worked for

the Adam brothers, Michael Spang. The building itself has two deep wings and a portico on four heavy columns, behind which is the room in which Nelson lay in state the night before his funeral in St Paul's.

Next door to the Admiralty is the famous front of the Horse Guards, with the clock tower rising above the eighteenth century archway through which we walk to Horse Guards Parade. There is an interesting glimpse of the Guards Memorial as we look through the arch, but here it is the two immovable sentries sitting on horseback in their little houses who captivate the passers by. The Changing of the Guard is one of the favourite sights of the town.

Looking down on the Horse Guards is the great square mass of the War Office, started last century and finished in this, costing £1,000,000, with two miles of corridors leading into a thousand rooms, and with four domed towers (set on two tiers of columns) over 150 feet high. It was designed by William Young, and it has eight pairs of sculptured figures, each of which, by a curious economy, is duplicated, the four subjects being Peace and War, Truth and Victory. They are by Alfred Drury. Peace is shown by figures of Sorrow and Joy, a widow and child and a winged messenger and a child. War shows its horror and dignity, one gazing at a skull and one a helmeted figure. Truth, looking down on Whitehall Place, is in company with Justice, and Victory, looking down on Horse Guards Avenue, is in company with Fame.

Across the street (Horse Guards Avenue) is the Banqueting House of Whitehall Palace. In this noble building, a masterpiece of one of our master architects, our history has more than once been decided. Through this hall an English king passed to the scaffold. Within these walls the English crown was refused by an Englishman and accepted by a Dutchman.

The palace of Whitehall, extended by Henry the Eighth and the scene of his festivities, grew out of the palace of the Archbishops of York. It is an apartment of great magnificence, with a glowing ceiling by Rubens which may be taken as a memorial of the House of Stuart, for it shows them in their glory and has survived their fall. It is divided into nine compartments, oval pictures enclosed in rich gilded mouldings. The centre scene is the Apotheosis of James the First, a picture hardly in keeping with Macaulay's picture of him. Other scenes suggest the idea of peace and plenty, harmony and happiness, and there are scenes of the birth of Charles the First and his crowning as King of Scotland, with corner paintings of the triumph of virtue over vice. It was Charles who ordered the ceiling, and he paid three thousand pounds for it to Rubens.

The Treasures of the Banqueting House

The Banqueting House is now the museum of the Services, the treasure-house of military and naval history. Even those who do not know the stately front of the Banqueting House will recognise the entrance to the United Service Museum by the two great figureheads at the door. Every boy in London knows them, standing here looking across to the Horse Guards, one a huge figure about ten feet high from HMS Orion, the other a gorgeous bulldog from the Paddle Sloop Bulldog, built at Chatham nearly a century ago.

The museum has two of the most crowded rooms in Whitehall, the crypt full of models and dioramas, and the great hall hung with about a hundred tattered flags and packed with material of the deepest human interest, which should be given far more space. There are 8,500 exhibits, and they cover every variety of interest to soldiers, sailors, and airmen. They trace the development of the Army and Navy and Air Force, and set out in a graphic way the positions of the fleets and armies at Trafalgar and Waterloo. They show in models (with switches to light them up) historic battlefields, and the trenches and underground workings in the Great War. There is every kind of uniform, countless badges and medals, and in one exhibit alone a thousand little toy soldiers. Perhaps the most spectacular of all the exhibits are the splendid little ships down in the crypt; they are admirably made and fascinating to look at.

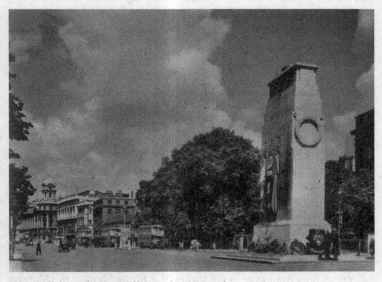

Whitehall from the War Office to the Cenotaph

Although this is probably one of the least visited of all our museums, it is difficult to exaggerate its varied interest. Here we are in touch with hundreds of things that are a part of history, and few rooms in London can compare with it for the human appeal it makes even to those who have no interest in war and are not greatly concerned with all its apparatus.

Behind the Banqueting Hall are Whitehall Gardens, now used for Government Offices; at Number 3 Sir Robert Peel died. It is for these Gardens, lower down, that the new Government buildings are designed, though for the moment the work is postponed. Hereabouts in the middle of Whitehall are its only two street statues, the Duke of Devonshire bareheaded in bronze, wearing peer's robes, looking across to the Horse Guards, and the Duke of Cambridge in bronze, by Captain Adrian Jones. He sits on his horse as a Field-Marshal, wearing his orders and medals, and on one side is a Guardsman and on the other a Lancer. He is outside the War Office, which he controlled for so long, and from which he was removed by one of the most conspicuous acts of political courage in our time. He was, of course, the cousin of Queen Victoria, and he would not go – until Sir Henry Campbell-Bannerman made it impossible for him to stay.

The old front of Gwydyr House remains, and on the river side of Whitehall there is nothing else interesting; we cross over to the great block of Government Offices beginning at the Horse Guards. The building with the heavy portico and the round dome is the Scottish Office; it belonged to the father of Queen Victoria's first Prime Minister, and the dome was added by the Duke of York who stands so high on his column. Beyond is the Treasury, with 100 yards of frontage reaching to Downing Street.

Downing Street

We have now arrived at the house in which the Prime Minister lives, usually with the Chancellor of the Exchequer next door. Poor as it is, it is rich beyond the ambitions of Dictators, and the simple door of Number Ten is the proudest threshold in the land.

The steps at the end of the street lead us down into St James's Park; the great stone buildings casting their shadow on the little red brick house belong to the Home and Foreign Office group. The Home Office looks into Whitehall (on to the Cenotaph), the Foreign Office into the Park with the India Office sharing its view, and the Colonial Office is also in the block. Beyond them is the quiet oasis of King Charles Street, into which we come under a sculptured archway, and at the end of which stands the statue of Lord Clive looking down the steps into the park. The immense block of offices reaching from here to the corner of Whitehall houses the Ministry of Health and Education. They were not built until this century, and they

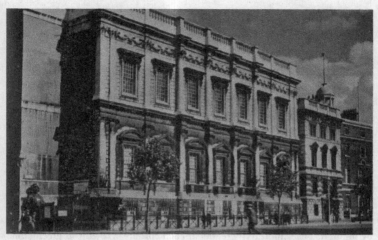

The Banqueting House of Inigo Jones, home of the United Service Museum

form a dignified modern front for Parliament Square, with the Abbey on the other side.

These vast blocks of Government Offices between Downing Street and Parliament Square are linked by the three-arched bridge guarding an entrance to King Charles Street. They have great quadrangles with hundreds of windows looking down on them, and it is a remarkable sight to see their galleries of statues standing in groups high up on projecting ledges of stone. Some stand at leisure as if they are about to move. There are over a hundred statues on these great blocks, many of them symbolical, many portraits, many utterly unknown. We understand that nobody knows who the thirty-one statues on the courtyard side of the Home and Colonial Offices are. At the corners of the India Office are river gods with attendants. The central front has four Governor-Generals: Lord William Bentinck, Lord Auckland, Lord Hardinge, and Lord Ellenborough; with four others below them: Lord Dalhousie, Lord Canning, Lord Elgin, and Lord Lawrence. There are two symbolical figures on each side, and round the corner facing King Charles Street are two statues of Indians. In the quadrangles, standing on the cornices, are fourteen figures of Indian racial types, and above the street are eight statues representing our native allies in the Mutiny.

Above the first row of windows in the India Office are eleven busts of Anglo-Indian notables, among whom we notice Macaulay. Ten statues on the Foreign Office are believed to represent foreign countries. Besides these statues are many

busts set below the windows. The King Charles Street bridge has three sculptured groups looking on to Whitehall from above the central arch, fine keystone heads on each side of the arches, and splendid figures in all the spandrels.

The Cenotaph

Looking down from the balustraded parapet of the Home Office sits Britannia (by Sir Bertram Mackennal) crowned with two lions beside her for Strength, and two figures representing Truth and Justice. She looks down on the most poignant monument in London, the Cenotaph, set up by the Empire in memory of its million dead. Here on Armistice Day come the King and the Princes and the Cabinet to share in the Great Silence. As far as the eye can see Whitehall is crowded with humanity, and the scene is repeated in the heart of the City, while everywhere the traffic of London is stilled until the guns boom out that life and work may begin again. The Cenotaph is a pylon 33 feet high, crowned by an altar. The sculptured wreaths at each end are wrought in green stone from South Africa. Flags hang at the side, and the inscription is simply The Glorious Dead.

Turning back along Whitehall we reach Trafalgar Square again and make our way into the parks by Admiralty Arch.

The Little Parks and
the Palaces

St James's Park

It is one of the delights of London that we can pass almost in a moment
from the traffic of the streets into some quiet place, a byway, a garden, or
a park. It is like a calm after a storm. Out of the stress and strain of life
surging through Piccadilly, or round Charing Cross, or past the Abbey, or
even in the crowds that are always round Victoria, we can pass in a minute
or two into one of the rarest little parks in Europe. It is rare for its own sake
and for its associations, for there has never been a famous man in London
who has not loved this place and walked by its lake and stood on its little
suspension bridge and sauntered up and down.

Ten Downing Street

St James's Park, with the Green Park as its neighbour and a very part of it, is not to be surpassed in any of the world's capitals. We can walk under trees and along green grass from Trafalgar Square to Piccadilly with beauty all the way.

It has a dozen ways in and out, mostly leading to famous places. We may come down Constitution Hill from Hyde Park Corner and arrive at Buckingham Palace, or reach the same point from Victoria. We may slip into it from just outside the Abbey and find ourselves by the walls of the Foreign Office; we may walk into it between the immovable sentries in Whitehall or by the steps at the Duke of York's column in Waterloo Place; or we may saunter through Ambassador's Court at St James's Palace or by the gate at Marlborough House. The Park is ringed with beauty, fame, and history.

A Walk Down the Mall

We will come in by none of these ways, but by the Admiralty Arch. In front of us is the Mall, our great Processional Way with Buckingham Palace at the end just over half a mile.

We walk down it between a model British fleet, scores of little ships crowning the lamp-posts, with a green sward on our left and the raised terrace of the great houses on our right; it is Carlton House terrace, home of prime ministers and famous folk, but the corner houses at the white steps are private houses no more, and even a business firm has now invaded this historic group.

On the right of the Duke of York steps is the Union Club, and on the left is the old German Embassy, where the swastika used to be seen flying in this great scene of English liberty. The Embassy took in two next-door neighbours and became the biggest diplomatic house in London, a piece of German territory with palatial rooms in which a thousand people could be entertained. Farther down, the last of this row of stately houses, actually not of the terrace, but standing alone in Carlton Gardens, is the house where Lord Northcliffe died in a little shelter built on the roof, and next to that, with its garden in front of it, is Marlborough House, where Queen Alexandra died, adopted as Queen Mary's home after the death of King George the Fifth. Set in its garden wall is Sir Alfred Gilbert's Alexandra Memorial looking into the courtyard of St James's Palace, where the Horse Guards change and kings are proclaimed. Now comes what was once a great private house and is now the London Museum; we may turn to the right and saunter in these historic scenes, or walk on to the spacious circus about Buckingham Palace, as fine a scene as London has. Or we may keep by the houses and go walking past the noble front of Bridgewater House

and the eighteenth century Spencer House next door, with the stone figure of a woman looking down on the park, and on until we reach the Ritz Hotel and find ourselves in Piccadilly, where the park turns round to Hyde Park Corner and comes down Constitution Hill (its entrance guarded by Peace riding on wings and horses), and find ourselves back in this spacious place again, passing the palace and the Victoria Memorial, and walking on to Birdcage Walk, which bounds St James's Park and has the loveliest peep of its flower beds. It was part of the park in the days when it was a marsh with a leper hospital, and when Charles the Second used to keep his aviaries here. Here Swift would walk to get thin and Matthew Prior to get fat. Here Oliver Goldsmith escorted his cousin Hannah and Dr Johnson loitered on his way to Buckingham House.

It brings us to the Abbey end of the park, and we turn left outside the railings and find ourselves on the great parade behind the Horse Guards, with the Admiralty looking into it on one side and the Prime Minister's back windows on the other. We have been round the loveliest little park that London has.

London's Loveliest Bridge

Certainly there is nothing to surpass the suspension bridge across the middle of the lake. By day or by night there is no better peep in London. One way we have Buckingham Palace, with all the dazzling lights reflected in the lake by night; the other way is the loveliest mass of buildings our eyes fall on in London, with the Foreign Office so tranquil in these troubled days, the old block of Downing Street beside it looking across to the conning towers from which the Admiralty can speak to the Fleet, and, in between, the long white mass of the Horse Guards, backed by a massive group of roofs and turrets and domes that look like some huge Kremlin or some Oriental scene of grandeur creeping into our London. From the bridge it looks like that, and yet this massive block is not one but three great buildings with two streets between; we are looking at the Horse Guards with the width of Whitehall beyond, and the great domed War Office running down the length of a street, and then another street, and then the roof of the National Liberal Club and its next-door neighbour looking on to the Embankment.

The Art Gallery of the Park

But we must explore the monuments set up round the park. A rare little gallery they are, in bronze and iron and stone, cherubs and children, fishes and dragons, birds and flowers, plain men and great soldiers,

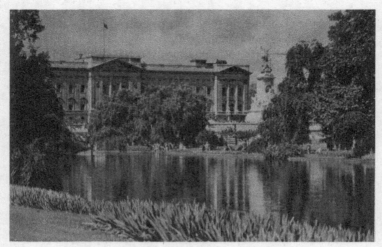

Buckingham Palace from St James' Park

scenes of battlefields and marvellous guns, touches of poetry and beauty, heroes of peace and war. We will walk round and see them all.

The Admiralty Arch, in memory of Edward the Seventh, was designed by Sir Aston Webb. Over it is the Admiralty Library, and it is linked with the Admiralty by a bridge. In the centre of the three arches is a pair of splendid gates in which the lion and the unicorn guard the Processional Way. There are fine stone heads on the windows, a crown on the centre keystone, and ships on others, and the capitals of the columns are carved with winged cherubs looking down the Mall from the inside are groups of sculpture at each end, with cherubs holding the crown above them; the figures have lovely faces and represent Gunnery and Navigation. Walking down the Mall we come to the magnificent figure of a hero to whom every English boy should raise his cap, Captain Cook. He stands in bronze, carrying a scroll and a telescope and wearing a three-cornered hat, and on the pedestal is this tribute to the man who made life at sea safer:

Circumnavigator of the globe, explorer of the Pacific Ocean, he laid the foundations of the British Empire in Australia and New Zealand, charted the shores of Newfoundland, and opened the ocean gates of Canada, both east and west.

A little way beyond a soldier stands in bronze with his bayonet fixed, guarding a wounded comrade; it is Mr Adrian Jones's Royal Marine Memorial for the South African War. There are four dolphins at the corners

of the pedestal, and on each side is a bronze relief showing the Marines storming a kopje and repelling an attack at Peking Legation. Still farther on, facing the Duke of York's steps, is a lovely bronze group set in a stone bay on a raised platform. It is Peace controlling a war horse, by Mr W. R. Colton, and on the frieze round the plinth are bronze panels showing the firing of a gun and the transportation of munitions by horses and mules.

Admiralty Corner

Coming back towards Captain Cook and taking the little path down by the Admiralty we come upon a king of England dressed as a Roman, looking much more dignified than on the day when he was caught running away and argued with the Faversham fishermen as to why they should let him go. He is James the Second, sculptured by Grinling Gibbons, his arm outstretched with a scroll in his hand, and crowned with a laurel wreath. Down the path, at the corner of the Admiralty, is the stone fountain in honour of the Royal Naval Division. It is by Sir Edwin Lutyens, and has two basins one above the other on a massive square base; round the sides are twenty carved badges, some lovely ones, among them that of the Artists Rifles with two charming profiles of a man and woman, the Royal Irish with a harp and an angel, others with Drake's little Golden Hind and a perfect gem of Nelson's Victory.

The new Admiralty, linked with the old Admiralty in Whitehall and reaching across the Mall by the Arch, is a domed and turreted building from whose conning towers our First Lord can be in touch with every ship of the British Fleet. In excavating for the building at the beginning of this century fossil plants were dug up from the Ice Age. On the great domes are eight pairs of lions and four single ones at corners higher up, and on each of the lamps rising from the balustrade around the building are two helmeted Britannias between two lions.

Horse Guards Parade

Looking across Horse Guards Parade, towards Whitehall, is the Guards Memorial by Gilbert Ledward, a striking group of five Guardsmen in front of a cenotaph. They are in bronze, fashioned from German guns captured by the Guards in the Great War, and on one side is a panel showing a gun in action. Far away across the parade, outside the back gate of the Prime Minister's house, is a solitary figure, a bareheaded man in a simple service uniform standing with his hands crossed. He is Lord Kitchener, by John Tweed. In front of the Horse Guards are two British soldiers on their horses and two guns on their carriages. They are Lord Wolseley by Sir

The Admiralty

Goscombe John, and Lord Roberts by Harry Bates. Both guns are historic and marvellously wrought.

Even the lamps are interesting here. Round the Admiralty are the lamps with bronze-winged lions and a helmeted Britannia between them, and at the corner by Downing Street is one of the most artistic lamps in London, presented by the Royal Academy. It has on it charming water babies riding on dolphins, one with a fish, one with a bunch of seaweed, and one with a small trident, and the lamp is crowned by a figure of a child of the sea blowing on a shell.

Looking down from the steps of the quiet King Charles Street, which runs between the Government offices, Lord Clive stands holding his sword, a meditative figure, with three bronze reliefs showing him at the Siege of Arcot where a gun is being fired on the town, sitting alone under the trees on the eve of Plassey, and receiving the Grant of Bengal from the Rajah, who sits under a canopy.

If we walk down to the Palace by Bird Cage Walk we pass Mr J. H. Mabey's little stone figure of a boy with an urn kneeling at the gate which leads to the bridge. On our left is Wellington Barracks, the headquarters of the Guards, who have a chapel enriched with mosaic in memory of Edward the Seventh, and a memorial to the 15,000 officers and men who fell in the war.

The Victoria Memorial

We are back at Buckingham Palace, looking down the Mall from the Victoria Memorial. Set between two parks and two palaces, ringed round with Empire gateways, balustraded walls, and stately beds of flowers, is an

island platform of white marble crowned by a golden figure of Victory with Courage and Constancy attending her, all in bronze at a height of 82 feet. Below sits Queen Victoria in state robes looking down the Mall, and round the pedestal behind the throne are fine marble groups of Justice and Truth and Motherhood. At the four corners below are ships' prows, and below these is the round marble platform on which we may walk. All round the platform, except where the great steps come, are low walls with friezes of sea nymphs and sea gods, and from these walls strange figures in bronze pour out water into the great basins. At the top of the two flights of steps are pairs of bronze figures standing with lions, a smith with a hammer and in his leather apron for Manufacture and a woman with a sickle for Agriculture, facing the Palace, and facing the other way Progress with a torch and Peace with an olive branch. On each of the low walls is a group of two reclining figures representing Painting and Architecture on one side and Army and Navy on the other.

Round the great space in which the memorial is set stand stone piers guarding the roadways, with boys holding shields of Dominions and Colonies, having with them figures of a leopard and an eagle for West Africa, an ostrich and a monkey for South Africa, wheat, fruit, and a seal for Australia, and big stone vases for the Malay States and Newfoundland. New Zealand is represented by the two bronze figures facing the palace, and Canada's contribution to this memorial is the set of magnificent gates on the Piccadilly side. They stand at the foot of the Broad Walk through the Green Park, facing the old gates of Devonshire House a quarter of a mile away, and are truly magnificent. The four pairs of small gates and the big central ones are hung on piers carved with queer masks and lovely heads, and the gates themselves are capped with golden crowns held up by cherubs, the centre gate having a crowned lion on the top. The four lamps on the gates are also capped with crowns, the outer ones held by lovely gold cherubs in bonnets. There are crowns and lions everywhere, and worked into the gates is the maple leaf of Canada, with fishes and ships and buffaloes.

The King's Palace

Buckingham Palace, fixed in the affections of this generation by the remarkable meetings which took place here between George the Fifth and his people, is old and new. Round the forecourt of the Palace the railings are capped with nearly a thousand golden fleur-de-lys, and the great gates are the most magnificent of the four sets of gates in these parks. The in-and-out gates are at the sides; the centre ones are never opened. All the gates rest on piers carved with dolphins, cherubs, lions, and unicorns, and have

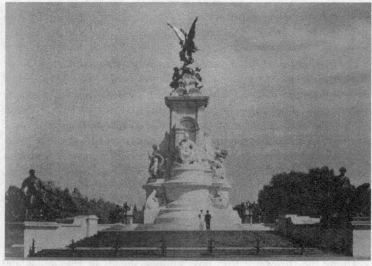

The Victoria Memorial at Buckingham Palace

magnificent bronze coats-of-arms with pendants of small golden medallions of St George on his horse killing his dragon, six of these in all. On the centre gates are groups of cherubs circling round the lock.

The palace is not thrown open. The gardens and the lawns, laid out for about 40 acres on the site of the old mulberry orchard, are made beautiful with an ornamental lake, in which are two islands linked by a rustic bridge, and a pavilion with eight frescoes from Milton's Comus. The palace and its gardens, covering 40 acres, stand on an island site a good mile round.

St James's and Pall Mall

We leave St James's Park by the Marlborough Gate in the Mall, walking between St James's Palace and Marlborough House. On our right is Sir Alfred Gilbert's memorial to Queen Alexandra, looking across the road to Friary Court, where the King is proclaimed the first day after his accession, and on most mornings just before eleven a little throng of lookers-on sees the Changing of the Guard.

The Alexandra Memorial is in the wall running round the garden of Marlborough House, and a yard or two farther on is Marlborough House Chapel, where a Danish service is held every Sunday in honour of the country of Queen Alexandra. The house itself was built by Wren for the great Duke

of Marlborough and his Duchess Sarah Jennings, who became such a power in the days of Queen Anne that at last she had to be overborne, and ended her quiet life in seclusion, leaving a fortune of three millions. Edward the Seventh lived here as Prince of Wales for nearly forty years, George the Fifth was born here, and Queen Alexandra died here.

Her memorial stands in a niche, the wall having been cut out to allow it to face the charming little quadrangle where so many pageants take place. The group shows the three crowned figures of Faith, Hope, and Charity, the central one holding by outstretched hands a slim little form with a rather tired head. Swinging lines of drapery connect the figures. Behind is a threefold throne with Gothic canopies, and behind these a bronze background of heavy lamp-stands and panels, the panels set with delicate low-relief work.

Tiny figures stand on the steps of the throne, and at the foot is a most charming device – four little cascades of water curving over an invisible barrier and giving not only an effect of life and movement, but the impression of solid, glimmering jewels.

The Chapel Royal is open to visitors on Sundays by writing for tickets. It is a small chapel, 62 feet long, with a roof of copper and a ceiling probably designed by Holbein, which has been carefully preserved so that it now reveals its blue panels ornamented with heraldic coats; we noticed the initials H and A, which are believed to be those of Henry the Eighth and Anne Boleyn.

We are at the point where St James's Street meets Pall Mall, one of the most famous spots in London. On our left we may saunter through passages and courts about the palace, on our right the long vista of Pall Mall ends with the black and white dome of the National Gallery. In front of us, at the top of the hill of St James's Street, the traffic of Piccadilly is rushing past. We will turn left, past the palace, down Cleveland Row into Cleveland Square. There is a great house in the centre of the square, leaving us one of the narrowest streets in London to walk through, with charming balconied houses leading round to where the great Bridgewater House stands overlooking Green Park. It is an impressive house, its stone walls black with the grime of nearly a hundred years, its great eaves reminding us of Italian palaces. It is the home of the Earl of Ellesmere, and has one of the most precious collections of pictures in any private house. One of them, by Raphael, is known as the Bridgewater Madonna.

London Museum

Opening off the square is another square known as Stable Yard, with a captivating arcade from which we look into the Mall. Looking down on the old stables, with their enchanting roofs, is the great pedimented portico of what was one of the most fashionable homes in London, and is now the London Museum. It may be said without challenge that London has for its museum one of the finest houses in its hundred square miles, and from the basement to the roof it is filled with captivating things.

The great hall is open to the roof, which rises until it comes to an imposing cupola supported on twelve figures. The magnificent staircase goes both ways and forms a splendid gallery, and round the gallery and on the floor above it run the rooms now filled with London's treasures. It is as if we were spectators in the great procession of London life for twenty centuries to go down to the basement here and walk among these ancient things, the prehistoric stones and bronzes, the little street of history and the little street of shops, pausing at the shop windows, captivated by the tradesmen's signs, and the queer wooden figures, the thousands of knockers and candlesticks and snuff boxes, and Mr Thorp's fascinating models of bridges and houses and churches and palaces. We walk up the staircase and see the glorious costumes of the centuries, Queen Victoria's wedding dress, Wellington's coat at Waterloo, Oliver Goldsmith's crimson suit, the old top hats; and then climb to the top and walk through the rooms of a seventeenth century house, and see the story of old Covent Garden before our eyes, and the Speaker's chair from the old House of Commons.

The museum is compact in a basement and three floors, and it covers London life in almost every phase.

Round St James's Street

St James's Street is filled with clubs and the fine shops that have grown up with them. When the Abbey wanted a new hat for its wax statue of Nelson they sent for it to Lock's, who had his measurements on their books. The wine merchant's shop close by is older still. Almost at their doors is the delightful Pickering Place, reached by an oak panelled passage with a wooden floor, bringing us to a tiny courtyard with a few charming houses round it, a bronze relief of a gentleman whom we may imagine to be Mr Pickering, and, soaring high in the heavens above it, the massed buildings which seem to be looking down on this little haven of quiet and bidding it make haste, for soon it must be swallowed up. At Number 8 St James's Street we find Byron's portrait on the wall, marking the site where he woke and found himself famous. Walking up on the right we come at 28 to the

famous Boodle's Club, occupying two houses. It has seen George the Third, George the Fourth, George the Fifth, and George the Sixth go by, and has kept its lovely front, with a row of charming medallions, as if London had never changed. So, too, has White's at the top of the street. For more than 200 years it has been a great club, and its bow window is one of the things that every Londoner knows. Down on the other side is club after club, the Devonshire made new, the famous Brooks's at the corner of Park Place, the Royal Societies and the New University Clubs, and, lower down, the Conservative Club and the Thatched House, which carries on the name of an ancient tavern once standing here. Between them is the street that leads us to St James's Place, where the banker poet Samuel Rogers lived at Number 22, and where everybody of note has been at sometime or other, for here have lived such men as Addison and Warren Hastings and a host of famous folk for many generations. In St James's Street itself Sir Christopher Wren and Edward Gibbon died.

Running off St James's Street is a mass of streets between Pall Mall and Piccadilly where we may saunter more or less and look in old shop windows at pictures and beautiful things. Here is King Street with Christie's famous Auction Rooms, and the centenarian St James's Theatre with its painted green columns; in this street Louis Napoleon was living when he went back to France to take the throne. King Street runs by Pall Mall; parallel with it by Piccadilly is the long unlovely Jermyn Street running through to the Haymarket; in it Sir Isaac Newton, Sir Walter Scott, Lord Nelson, and Mr Gladstone lived. Through these two streets runs Duke Street, where lived Edmund Burke, and just beyond it is the best of all the London squares still left, St James's, with a dignity worthy of its name and reputation. It has changed since Dr Johnson walked round it at night wondering where he would sleep, but much of it is old. In the middle of its garden is a bronze of William the Third galloping on his horse, nobly set so that he is seen from St James's Street on one side and from the lovely red columns of the Haymarket Theatre on the other. He is the centre of one of the longest vistas in London streets. Here, when they set up John Bacon's statue of the king, was the most fashionable square in London, with ducal houses round it; now Norfolk House is the last of them. But the square has great consolations. At one corner is the greatest working library of English writers, the London Library, with its 450,000 volumes and 50,000 prints. At another corner is Chatham House, home of three Prime Ministers, the dark red brick building which is now the Institute of International Affairs. One of the newcomers into the square is a block of offices with a frieze of sculptured panels by Mr Newbury Trent; they represent London street criers, and are a delightful group.

Walking from the square and keeping east we cross the lower end of Regent Street where it runs into Waterloo Place, and walk through Charles Street (notice the lovely lamp with the cherubs round it outside a bank) until we reach the Haymarket, a haymarket indeed for about 300 years.

Our own time has seen the rise of the great block of the Carlton Hotel and His Majesty's Theatre (the scene of the triumphs of Sir Herbert Tree), but the loveliest little theatre front in London just across the road is more than a centenarian, its colonnade of red columns being the work of John Nash, builder of old Regent Street.

Running off the Haymarket by the theatre is the quiet little Suffolk Street in which Richard Cobden died; we take it and turn round with it and are at the east end of Pall Mall, where George the Third is galloping on horseback with George Washington behind him, with the great shipping offices about us, and the massive banks and clubland in front of us as we turn west again. If we take the narrow turn out of Cockspur Street a set of steps will lead us into an almost incredible corner of London, with galleried stables and a hayloft survival of olden days, and other steps will bring us to Carlton House Terrace; this sleepy hollow in the heart of London lies between these great offices and these rich houses. We come out in Waterloo Place, where, facing each other, are the United Service Club and the Athenaeum, old neighbours of a hundred years and more. Over the United Service Club is a sculptured frieze and over the pediment sits Britannia; round the Athenaeum is a frieze based on the Parthenon sculptures at the British Museum, a charming procession in white on a pale blue ground. A statue of Minerva by E. H. Baily is over the doorway.

Next door to the Athenaeum is the Travellers Club, and beyond this is the famous Reform, built by Sir Charles Barry after the Farnese Palace in Venice. This building, covered with about a hundred years of London soot, has the finest hall of any London club, open to the roof, with a gallery running round it and a great array of pillars and pilasters. Its noble library has probably the best collection of books in any political dub. Its walls are hung with portraits of famous men who have used these rooms (Macaulay, Cobden, Gladstone, Bright, and all our Liberal Premiers), and there is a noble collection of marble busts. Everywhere the ceilings are carved and gilded with tens of thousands of tiny ornaments and flowers. Next comes the Carlton Club with its magnificent new front, and with the Junior Carlton looking at it across the way.

Beyond the Carlton is the great caravanserai of the motor world, the RAC, joining up with a solemn and sombre house belonging to the old

Pall Mall. The time came when the great house was divided into three, but always it has been known as Schomberg House, and it is of thrilling interest to us because in the western wing the immortal Gainsborough lived and died. There is a relief of Art with her brush and palette on the porch, and in a corner under the canopy is a face with the smile of a man who knows more than he will tell.

Across the road is the Army and Navy Club, and just beyond Schomberg House is the Oxford and Cambridge, built by Sir Robert Smirke. High on the front of this club is a charming row of seven plaster groups on a blue ground, showing Homer with a lyre; Bacon expounding his philosophy; Shakespeare between Tragedy and Comedy; Minerva and Apollo on Mount Parnassus with the Muses (centre); the blind Milton (with an angel behind him) dictating to his daughter; Newton with a globe; and Virgil reciting his poetry to a group of peasants.

Now at Marlborough House, we may walk back through Pall Mall to look round Waterloo Place, noticing on our way how often these houses have elegant little brackets at doorways and windows, carved mullions, and lovely buttresses. Some of them are already up eight storeys, as high as the LCC will let them go, but, however magnificent the great ones may be, it is the little ones at which we stop and stare. Some of them are captivating.

The Vistas of Waterloo Place

Back in Waterloo Place we have wonderful vistas. When we stand on the island group of sculpture with Florence Nightingale, behind us is Piccadilly Circus, in front, beyond the fine bronze group of statues, are the towers of Westminster, on our left is the National Gallery, and on the right the court of St James's. Here, between the gaiety of Piccadilly Circus and the solemnity of Westminster, we are in the grip of great emotions, War and Tragedy.

In front of us are two of the most moving figures an Englishman can look upon, Sir John Franklin and Captain Scott. Round about them are brave soldiers. Sir Colin Campbell by Marochetti stands with his helmet in his hand, his right hand raised with his thumb in a telescope sling, and below him sits Britannia on a British Hon, holding an olive branch and crowned with laurel. In the midst of them all is Edward the Seventh on his prancing steed by Sir Bertram Mackennal, and high up, rearing his head into the sky, is the Duke of York on his column, with an impressiveness to which he is hardly entitled in this gallant company.

It looks down beyond the soldiers and the explorers on the lovely figures of Florence Nightingale and her friend Lord Herbert, guarding the Crimean

Duke of York Column

War memorial. It is not impressive, with its huge figures of a Scots Fusilier and two Guardsmen in their caped greatcoats and bearskins, a mourning Britannia stretching out her arms with laurel wreaths from a great stone block behind; but it is saved by the bronze figures of the statesman and the nurse. Lord Herbert, by John Foley, is in his peer's robes, and on his pedestal are three bronze reliefs with about thirty figures, showing Miss Nightingale at a hospital, Lord Herbert reviewing volunteers, and the testing of the first Armstrong gun. His monument was removed from Pall Mall in 1914. On her red granite pedestal are four bronze reliefs with forty or fifty figures in them; they show her in the Crimea, superintending the transport of wounded men, visiting a hospital, interviewing military chiefs, and attending a conference of nurses.

All round the Place are banks and clubs with noble frontages. Outside the Athenaeum and the United Service Clubs are mounting stones set up by desire of the Duke of Wellington in the days when the streets were filled with horses. Just behind the Athenaeum are the gardens of Carlton House Terrace, with the lovely bronze statue of Lord Curzon at the corner; and there are many who will remember that in these gardens, on the fifth of August 1914, the wife of the German Ambassador was seen sitting among the trees for the last time outside the Embassy, weeping as if her heart would break.

We walk up Regent Street from Waterloo Place, leaving behind us the towers of Westminster and the leisured haunts of clubland in Pall Mall, and in one minute we find ourselves in the central scene of London's gaiety, Piccadilly Circus.

Piccadilly

Piccadilly Circus

By night it is one of the wondrous sights of the world, floodlit with hundreds of thousands of candle power.

It has three or four fronts fit for any site in any city; it has the most marvellous Underground Station in Europe, and it has, enthroned in the centre of it, a delightful cupid worthy of the Golden Age of Greece.

Eros rises as a winged archer above a bronze fountain with two octagon basins set on steps, the basins decorated with little cupids. It was the first aluminium figure in the streets of London, if not anywhere.

The Circus we see as we pass by is only half of it; we must come down the steps to see the wonderful sight a few feet below these streets. It is one of the busiest and most fascinating scenes in London, its booking-hall ringed round with shop windows, automatic machines, ingenious mechanical maps showing where the trains are at the moment, and Stephen Bone's attractive picture map of the world. Below our feet is one tube railway above another, and before our eyes are five escalators for ever working, travelling 100 feet a minute through two big funnels which take them 86 feet down to the Baker Street line and 102 feet down to the Piccadilly Tube.

Walking down on the right, we come to the heavy Piccadilly Hotel, a depressing spectacle, but the first building to begin the great transformation. Beyond is one of Piccadilly's two famous bookshops (Sotheran's), and just past that is one of London's great surprises, an oasis of old-world leisured life a stone's throw from the streaming life of Piccadilly. It is what is called Albany, a remarkable piece of the eighteenth century left in the heart of London, and likely to be left, we understand, for generations yet. We may go through it only by favour or to call on a friend, but all may see the red brick courtyard with the window-boxes giving it a country air, and those who pass through the covered way to Vigo Street will be astonished by the little gardens on each side and the oldfashioned houses in which Byron wrote poems, Bulwer Lytton wrote novels, Macaulay wrote history, and Gladstone entertained his friends.

We stop in our walk at Burlington House, known the world over as the Royal Academy. There is still a wall here which ran round the garden of the

old Burlington House; it is alongside the Burlington Arcade, which for over a hundred years has been notable for its 'small shops and large beadles.'

Burlington House has three arches on to Piccadilly, and beyond its fine iron gates a spacious quadrangle on which look down the windows of learned societies. Three keystone masks look down on Piccadilly. The main arch has sculptured panels of cherubs, dragons, birds, flowers, and death's heads, and there are sea-horses on the iron gates.

On both fronts are many statues. Those looking down on the quadrangle, from over the door of the Academy, are Michael Angelo in the centre with four figures on each side: William of Wykeham, Wren, Reynolds, Titian, Raphael, Flaxman, Leonardo, and Phidias. There are eleven line keystones and the bracket figures at the doorway are charming. At one end of the portico is a memorial to the Artists Rifles, with two bronze profiles. The statues on the other front are an imposing gallery looking down on the street. In the centre are Galen, Cicero, Aristotle, and Plato, Archimedes thinking and Justinian teaching, and on both sides are rows of figures, one in niches and one on the parapet. Along the parapet the six figures are Galileo, Goethe, Laplace, Hunter, Hume, and Davy (with his lamp); below are Leibnitz, Cuvier, Linnaeus, Locke, Bacon, and Adam Smith with a book. There are two reliefs of mermaids in the towers, and sitting over the portico are Newton, Harvey, Milton, and Jeremy Bentham.

The quadrangle has all round it the rooms of the Royal Society, the Royal Astronomical Society, the Chemical Society, the Society of Antiquaries (with a half-veiled face as a keystone), the Linnean Society, and the British Association, all claiming kinship with the immortals sculptured round the walls. In their midst is the great Sir Joshua, with his stick, as Alfred Drury fashioned him.

We may go into Burlington House at any time, for here is one of the most interesting free exhibitions in London, the Diploma Gallery in which all Academicians deposit a picture on their election.

The supreme treasure of the collection is one of a group of French and Italian masters purchased by the gallery, the crayon drawing by Leonardo of the Holy Family. This superb cartoon, which some think the most beautiful of all Leonardo's works, and which, because of the nature of its materials can never be dimmed or darkened by time, was drawn for a king four centuries ago but was never sent to him. The face of the Madonna has a beauty and sanctity probably unsurpassed in art, the gesture of the Child is inimitable, and the tenderness in the features of St Anne adds the completing touch to a composition which is almost too good for praise.

This drawing is faced by two works of Michael Angelo, one a cartoon of Leda and the Swan, the other a marble plaque of the Madonna and Child and

St John in high relief. Michael Angelo left it unfinished, but it is a lovely and delicate thing, and we can pay it no higher praise than to say it is not unworthy of companionship with Leonardo's masterpiece. The room containing these and other Continental pictures, including a vast copy of Leonardo's Last Supper, has also two chairs of unusual interest, for they belong to Sir Joshua Reynolds and Sir Thomas Lawrence, their sitter's chairs. Rather dingy now, with upholstery worse for wear, we cannot look at them without imagining the galaxy of beauty, rank, and fashion, that, sitting in them, looked into the eyes of these immortal painters who were endowing their sitters with fame. In one sat Samuel Johnson's portly frame, and also Mrs Siddons. Kitty Clive lounged in it playfully at ease. The Diploma Gallery has been fortunate also in being able to preserve the palettes of Sir Joshua and Constable.

The collection of Diploma pictures is of remarkable interest. Sir William Orpen's painting is the famous one of a Paris chef. Charles Sims is represented by one of his dainty fancies, Clio and the Children. John Swan's Tigers are a reminder that no one could paint animals as he did; W. L. Wylie, incomparably the best marine painter of his day, has his Portsmouth Fishing Fleet; Sir George Clausen has one of his magnificent barns.

The most characteristic room is the eighteenth and nineteenth century gallery, which begins splendidly with Constable. Near his biggest picture, the Lock at Dedham, gleaming with all the magic of his sunlight and summer breeze, are hung fourteen smaller studies and sketches of sky and coast, trees and landscapes, sufficient in themselves to warrant the painter a master.

He is the worthy introducer to those who followed him at some distance and inaugurated a less permanent but more popular standard of painting. Among them are Philip Calderon, John Petty, Sir John Millais, Lord Leighton, W. P. Frith, Sir Lawrence Alma-Tadema, G. H. Boughton, and Frank Dicksee. Whatever their place in the Temple of Art, their presence in the Diploma Gallery forms an invaluable record of the history of taste. In this record are also minor works by acknowledged masters such as Turner and Gainsborough, Sir Thomas Laurence, Sir Edwin Landseer, and Sir Joshua Reynolds, as well as the famous painting by Sir Henry Raeburn of a Boy and Rabbit, whose merit none can dispute.

On to Hyde Park Corner

A little way on is Bond Street, linking Piccadilly with Oxford Street half a mile away; if we are fortunate in this Speed Age we can make the half-mile journey any afternoon in half-an-hour. We pass Albemarle Street, with the famous publishing house of John Murray, visited by Byron and Scott, and with the impressive columns of the Royal Institution at the top of the street; and at the

corner is the gold medal building of Westminster Bank, one of the best of all Piccadilly facades. In Dover Street the Albemarle Club occupies the old town house of the Bishops of Ely, and at Berkeley Street we come to a corner that has seen great changes. The famous Berkeley Hotel still stands, secure in its pride, but it has lost its proud neighbour Devonshire House, which was sold for a million in 1919 and has been replaced by spectacular show-rooms for cars and flats for rich people. Beyond it is Stratton Street, but no more is the white cockatoo in the window of the lovely corner house; the house has gone, and the white cockatoo, and the Baroness Burdett-Coutts, richest lady in the land. Here are more luxury flats and luxury shops until we come to another of our surprises, the charming corner every Londoner knows as In-and-Out.

Up Whitehorse Street is the remarkable survival of old London known as Shepherd's Market, built by Edward Shepherd 200 years ago, and beyond are the great houses looking over Green Park.

The Busiest Corner in the World

We have reached the busiest corner in the world, with more than 80,000 vehicles passing every day round three islands. Looking down on it all, its back to Green Park and its face to Hyde Park Corner, is the loveliest sculpture group in London, Peace riding on wings and horses above the stir of the town.

She stands high above the gate of Constitution Hill, with the peace of the Green Park behind her, guarding the way to the King's palace. Peace is standing in her chariot, a lovely figure with flowing draperies and great wings, holding high a wreath, and the driver is suddenly drawing in his four horses, which are rearing with the unexpected check.

The arch itself was set up by Decimus Burton; the Quadriga was given by Lord Michelham in memory of Edward the Seventh. It is one of the most superbly placed statues in London and a continual surprise to the visitor. Coming along Knightsbridge by the hospital walls Peace is suddenly there before us, poised in the air. As we come up Constitution Hill she is a beautiful vista all the way. At first we do not always see the little figure of the driver bending over his horses, but as we catch sight of him we feel that the whole group has a fine suppressed movement, and we almost expect the wreath to drop from the hands of Peace.

The arch crowned by the Quadriga has living rooms inside it and four pairs of columns outside. There are two sculptured panels at the sides and the gates have two circles with the royal arms in them and a small row of rose, shamrock, and thistle along the top.

Across the great space is the familiar colonnade leading into Hyde Park,

which has been there more than a hundred years with the stately columns set up by the builder of the Quadriga Arch, and crowned with the romantic frieze of Greek horsemen and warriors copied from the Parthenon marbles. They crowd along their narrow platform in an endless procession of footmen and horsemen in chariots, as when wending their way up the Acropolis to the festival in the temple of Athene. There are about a hundred figures in the frieze, half on horseback, and they are the work of John Heming.

Set on one of the islands round which the traffic swirls, the Duke of Wellington sits on his horse Copenhagen, which carried him at Waterloo. At the four corners are a Grenadier, a Highlander, a Welsh Fusilier, and an Inniskilling Dragoon. The monument was fashioned from twelve French cannon captured in his victories, and it is in eight pieces, weighing 40 tons.

On two other islands stand two memorials of the Great War, a figure of David leaning on Goliath's sword, by Derwent Wood, in memory of the men of the Machine Gun Corps; and the immense memorial to the Royal Artillery in memory of 49,076 dead. It is the work of Charles Sargeant Jagger. There are those who think it a pity that this great gun should be set up here, but as a monument there is only one word to describe it: it is superb. All round run the impressive panels unsurpassed on any monument in London, pitiful scenes of courage and terror and death.

The face of Hyde Park Corner is to be changed by the rebuilding of St George's Hospital, but it will be changed with a new and splendid dignity. We may be sure that there will remain the little figure of John Hunter over the gateway of the Medical School, for, though it is much overlooked, it is a famous sculpture by Alfred Gilbert; it shows the great surgeon half-length in bronze, his right hand pointing to a small anatomical figure he is holding in his left.

Down Grosvenor Place, which leads us to Belgravia, is one of the new buildings which render so great a service to London with their sculptured fronts; it is part of the headquarters of Gas, and has a row of medallions showing progress in the industry. Gas Industry House, built by Sir Aston Webb and Sons, has a room decorated by Mr Grey Wornum, architect of the headquarters of the RIBA, and the medallions on the front are by Mr Walter Gilbert. They show Vulcan sending out his messengers with Fire for the use of Coal and Coke; and the messengers delivering the fire to Juno, goddess of the Home, presiding over the great inventions which bring comfort and well-being to the home. We see Gas turning water into steam, and there are plaques of various gas emblems.

We walk back to the Circus by the railings of Green Park along what used to be known as the sulky side of Piccadilly. At a break in the railings, a little beyond the Porter's Rest (set here by a kindly old gentleman in 1861) we come to the beautiful gates of Devonshire House, set up as a memorial of the greatest houses in Piccadilly, and looking down the broad green walk to the Victoria Monument in the Mall. The gates, with the arms and mottoes of the Dukes of Devonshire and a sphinx at each side, have a brass plate which tells us that they were probably made about 1735, were bought by the Duke of Devonshire in the year Queen Victoria came to the throne, and were bought again by the Victoria Memorial Fund and set on this site.

Near where the reservoir stood is now the station of the Piccadilly Tube, its entrance in the shadow of the Ritz Hotel with its massive and gloomy arcade extending to Arlington Street. Beyond Wolseley House is St James's Street, with a peep of the Palace at the bottom and of the clubs between, and farther on run great shops and small shops (with the pillared front and old-world windows of Hatchard's bookshop, where John Hatchard between 1797 and 1849 turned his £5 capital into £100,000). We pass Prince's Arcade and come to the Royal Institute of Painters in Water Colours, always an attractive gallery, the lovely gold medal office of the Midland Bank, and then to one of Wren's masterpieces, St James's Church, with a pulpit out of doors and indoors Grinling Gibbons carving that will hold us spellbound.

It is a Wren church with a later tower which leans a little, as if bowing acknowledgment to the good manners of the Midland Bank next door, which was designed by Sir Edwin Lutyens to be in harmony with Wren's building. The open-air pulpit stands out from the church wall facing Piccadilly.

The fine interior (in which the breadth is half the height and the height is half the length) has a gallery arcade with Corinthian pillars, and decorated panels above, and it has the marvel of Grinling Gibbons carving at its best. Amazing in beauty and realism is the adornment of this altar, with the pious Pelican on her nest in the middle, and about her an abundance of fruit and leaves and flowers, shells and little festoons, all so exquisitely chiselled in cedarwood that Wren himself, coming to see the work when it was done, said no altar in England, nor any abroad, was more handsomely adorned. The communion table has a share of riches, and the altar rails are fine in marble and bronze.

The carving of the gilded organ case is also by Grinling Gibbons, and so is the white marble font, one of the few examples of his work in stone. The stem is the Tree of Good and Evil, with Adam and Eve and the serpent; the bowl is supported in its branches and has scenes of baptisms, and the Ark with the dove flying back. The pulpit stands on three fluted pillars and has

a wealth of detail, with panels containing Bible figures. The vestry has its old fireplace with an enormous royal arms, portraits of three rectors who became archbishops, and a seventeenth century chest of metal.

We pass the first of the great popular cafes that have changed the face of London for all who eat, and we are back in the bustling Circus. It is but a little walk from the Circus to Trafalgar Square, where we may turn and start our journey through the Strand.

A Walk Along the Strand

The Strand

It is South Africa that has given the Strand a fine beginning, with its great house looking on Trafalgar Square and Whitehall and the Strand and St Martin-in-the-Fields: no government in the Empire has a finer setting for its London house. On its Strand front is a cross which is probably meant to mark the site of the Golden Cross Hotel which stood in this place so long. Facing it in the courtyard of Charing Cross Station is the lovely Eleanor Cross, a copy of the last of that pathetic series set up by Edward the First to mark the resting-place of his Queen Eleanor on her last ride through our countryside. Below are coats of heraldry, and above are eight statues of the queen with a kneeling angel at the foot on each statue. The figures are all under canopies, and four show Eleanor as a sovereign and the others as a gracious lady.

Charing Cross Station, standing on the site of the old Hungerford Market, is one of London's gateways to the Continent. Just beyond it on the right are the streets sloping down to the river; at the bottom of Buckingham Street is the old water-gate at which the Duke of Buckingham used to arrive at his house by boat. On the left are the wide openings in which appear the church of St Martin's and Charing Cross Hospital (dealing with 1,000 accidents a week), and at the hospital corner stands Rhodesia House with fourteen statues in niches on its walls, Mr Epstein's much criticised group.

The transformation of the Strand has already reached the famous site of the Adelphi, an area of about three acres covering the slopes from the Strand to the river from Charing Cross to Adam Street. Much of the area has long been a magnificent site thrown away, with streets built on arches and land worth a fortune yet used as workshops and stores. Hereabouts since then have been the homes and haunts of artists and writers and Bohemians of every sort, and of learned societies, of the Royal Society of Arts, the Institute of Naval Architecture, the Little Theatre, and the Savage Club. One of these institutions has a claim upon all who love beauty. The Royal Society of Arts, one of the three oldest learned societies in England, has been in its beautiful Adam house since 1775.

Beyond it is the great arch of Shell-Mex House with the Savoy Hotel next door to it, and opposite is a peep of Covent Garden market up the street. Then comes the wonderful Strand Palace, the pioneer of the great group of popular twentieth century hotels where we may call and expect to find almost all the world and his wife. High up on the Strand Palace are sixteen rams heads, and on the roof a pair of eagles with outstretched wings. The great people's hotel looks across to its charming neighbour with the lovely figure of the Count of Savoy in its courtyard, an elegant bronze and gilded figure by Mr Lynn Jenkins. It stands on the site of the great palace of Peter, Count of Savoy, whose statue guards it 550 years after his house was burned down in Wat Tyler's rebellion.

The dominating note of the Thames Embankment is the greatest office building in the Strand. The Hotel Cecil, named after the home of the Cecils which stood here in Tudor days, was pulled down to make room for Shell-Mex; it had been built as the greatest hotel in Europe at the end of last century. This remarkable block of offices has a noble entrance from the Strand, and its courtyard is one of the sights of London by night.

The little byways on the right lead down to the river, and the little streets on the left lead up into Covent Garden; the lane on the right before Waterloo Bridge is Savoy Hill, with the Chapel Royal round the corner. On the left is the Lyceum Theatre, the scene of the triumphs of Sir Henry Irving and Ellen Terry. We will look into the Chapel Royal of Savoy.

The Chapel of Savoy

It has a ceiling patterned in quatrefoils, an ancient piscina, and a rich reredos covering the east wall, with Peter and Paul under elaborate canopies, and a fourteenth century Madonna which was rescued a few years ago from the grime of centuries. Kneeling on the chancel walls are two charming little Tudor ladies, saved from the fire which ravaged the chapel in 1864. An unusual bronze lectern has a fine medallion of St George and is a tribute to Sir Henry Irving's actor-son Laurence, who went down in the Empress of Ireland in 1914. The font, much ornamented in medieval style, is in memory of two artists buried here, the historical painter William Hilton, and Peter De Wint who is famous for his water-colour landscapes. There is a brass to the Victorian statesman Hugh Childers, and a beautiful bronze relief of the author and actor Henry Esmond.

Here we may stand and see Nelson on his Column at one end and Alfred on the Law Courts at the other, and in the middle of the road is the lovely little church of St Mary-le-Strand, guarding the island site, the Island of Three Continents.

Aldwych begins with the gay trumpeter on the dome of the Gaiety Theatre and ends with the massive Australia House; it has become a London home of Australia, of America, and of India, and set in the midst of them is Marconi House standing for the universe. The Strand has been called the highway of the world; it begins for us with South Africa House, it leads us to the Island of Three Continents, and it ends at the Courts of Justice, the attribute of all mankind.

The Island of Three Continents

For some years this site lay waste, a wildflower sanctuary of great interest to botanists, and it was an American brain which realised the infinite possibilities of developing this shabby bit of the Strand. Mr Harvey Corbett planned the building in New York, setting the house two-faced on ten acres of sloping ground, throwing out its wings to India House on one side and to Australia House on the other. Looking one way it has the fine vista of Kingsway; looking the other it casts down its eyes before the church of St Mary-le-Straud, to which it has been a kind neighbour, sending electric current across the road to run the clock at its own expense.

High up under the domed arch of the Kingsway front two figures of Youth join hands above the words 'To the Friendship of the English-speaking Peoples,' and on the Strand front the signs of the Zodiac are carved round the arched portico, with two charming medallions in stone of the Viking ship Discovery which went to America a thousand years ago and the Santa Maria which took Columbus there in 1492.

Bush House has a fine interior, and from a balustraded gallery on the first floor we may look down into the long cool entrance hall with the little telegraph office where cable boys wait in a row, looking like pages in a lord's ante-room in a forgotten London.

The Wonderful India House

Next to Bush House is London's wonderful house of the beautiful East – India House, standing in the curve of Aldwych Island, is one of Sir Herbert Baker's delightful creations.

At the main entrance and its adornments the East has joined hands with the West. The Swedish granite columns above the doorway are a reminder of the Asoka columns which are so usual a feature in Indian architecture. They rise on corbels carved in the shape of elongated elephant heads, grave and solemn, and are crowned by elongated tigers, sitting up high and aloof. Between the lovely guarding tigers are the Star of India and the English royal arms, and above these carvings runs a panel of lettering – the word India in English, Devanagari, and Urdu characters.

The beautiful carvings of India House

On either side of the entrance come other features of Indian architecture; panels of tracery where you might expect a window, the tracery cut out of dark Belgian marble and left unpolished. On a level with the lower tracery the delightful roundels begin, carved in stone and then painted, running the length of the facade, turning the corner of the building, and going down toward the Strand.

There are twelve of these medallions, each representing the arms of an Indian province. There is the tiger for Bengal, the ship for Bombay, the Fort St George for Madras, fishes and bow and arrow for the United Provinces, five rivers and the Sun above them for the Punjab, snakes for the Central Provinces, the Bodhi Tree for Bihar and Orissa, a peacock for Burma, a rhinoceros for Assam, an elephant for Delhi, camels for Baluchistan, and a young Moon over a gateway for the North-West Frontier.

We see the twelve symbols again, exquisitely inlaid in marble, on the floor of the octagonal domed entrance hall, with the swastika, symbol of enduring things long before Herr Hitler took it as the symbol of passing things, enclosing the Star of India in the middle of the twelve.

We can stand on the star inside the swastika and look up and see the spot high overhead where the mounting galleries, with their white marble balustrades, carved in Delhi in rare tracery, narrow to a lantern with the deep blue of the summer sky for a roof.

On the dome above which the traceried lantern rises are four scenes of Indian story, artlessly divided one from the other by fantastic trees. One shows Alexander giving back the sword to King Porus, another an Indian monarch reviewing the officers of his Amazon army (lovely creatures), another Asoka the Emperor sending his daughter with the

St Clement Dane's
in the Strand

Bodhi Tree to Ceylon, and another a Mogul emperor looking at the plans
of a new city.

Beneath this dome the hall divides into eight carved segments, and these shapes
have given the four painters the chance of making three more sets of pictures. In
the vaults are pictures of day and night and the six seasons which make up the
Indian year: spring, summer, the rains, coming autumn, autumn, and winter. In
little medallions are the eight stages of life as seen by Indian philosophers: days of
babyhood, childhood, the student days, courting days, marriage, working days,
retirement, and Nirvana – the end. Most delightful of all are the animals, birds,
and trees of India shown in the lower spaces.

Out of this hall of fantasy and charm spring the stairs, doors, and corridors
that lead to the working and administrative departments of India House. On the
first floor is the library, panelled in padauk wood. The bookshelves are mainly
round the gallery, whose tracery is divided into panels by wooden uprights on
which perch Indian birds. Over the clock is a painting by Mr Sen showing
Buddha seated under a tree and his disciples with their begging bowls gathered
round him.

All the woodwork is of Indian timber. The rose-red walls of the gallery
and the white traceried balustrades remind a traveller of India, and so

does the magnificent museum into which we pass from the painted hall. Here is a great array of work all done by hand, by the patient delicate-fingered workers of the East: carpets, laces, scarves, furniture, scores of things which are a delight to the eye and an education in rare and dainty craftsmanship, while on the walls, completing the Indian atmosphere, are paintings illustrating Indian legends and traditions. In one a young woman is playing on a fivestringed instrument, and antelopes and deer come running up, charmed by the music. In a second, beside a river where ducks swim among the lotus, kneels Prince Selim at the tomb of his beloved slave-girl, against a background of fascinating flowering bushes. Another picture shows a daughter pointing out to her aged father the new moon, which indicates that his month-long fast has come to an end. The last scene is of an old woman leading four young women, one of whom wears anklets and a ring on her toe, to present their gifts to the goddess under a banyan tree, while a frisky squirrel runs up the tree-trunk beside the idol. There are in all about a hundred figures in these paintings.

Australia House

Amid the changing history of the Strand, the ordered tradition of centuries, rises a rock-like building staring out to the new age, and one of the remarkable facts concerning it is that almost every cubic inch of it has come across the world. Australia House, the London GHQ of an empty continent, stands at the eastward end of Aldwych Island. Girdled with young trees, fortress-like in its solidity, it has already taken root in London's great highway. Its architects made the happiest possible choice of a style considering that their next door neighbours are the Bush House of Today and St Clement Danes of Yesterday. They chose a classical style tempered by eighteenth century French graces, and in their design flung up the great horses over the entrance and put the reins into the hands of Phoebus to remind us that the spirit of Australia is forever driving onward into the mounting dawn.

The first thing we see is Sir Bertram Mackennal's bronze group of these three sun-horses high over the doorway. Then the eye travels down the Doric columns upholding the platform on which the horses stand to the groups of stone sculpture looking at a distance like gnarled roots from which the columns might have sprung. Carved by an Australian sculptor, Mr Harold Parker, these groups stand for Australia's past and present. One, with Burke and Wills dying in the wilds, stands for the struggle of the country before her pioneers had opened up the continent; the other, a shearer and a reaper, for the prosperity of an established Commonwealth. Between the two columns is a stone balcony, and above it Australia's coat-of- arms. Along the balcony

level of the main facades in the Strand and Aldwych runs a colonnade of heavy columns, standing in couples, and between them, sunk far in as if the colonnade ran round a temple wall, are some of the hundreds of windows. The travelling sun lights up the recesses between the pillars and shows charming formal patterns in stone which run along the capitals and architraves. This is the chief delight of the exterior of Australia House – the endless play of upright and horizontal lines, the tremendous columns, the rugged strength, and the daintiness of the hands of classical ornament laid like sculptured ribbons on the stone.

The dominating feature of the building is its main entrance, square cut, deep, and massive. In it are set a fine pair of gates with the crest of the Commonwealth, through which we pass into the outer vestibule; then through other iron gates in rich gold and dull black, where we see far ahead the Melbourne Place doorway, its ceiling lines giving an oval effect like a circle viewed at a distance.

The heart of the building is the Exhibition Hall. Here, after the austerity and grandeur of the exterior, we have a bewildering vista of richness of marble and gold, marble walls and floor, moulded capitals and arches, graceful stair balustrades in iron and bronze that slowly mount and swing away from the floor. Different coloured marbles have come from Australia to make the huge stars and circles on the floor and to line the cream walls, and Australian black bean wood was brought over for the exquisite woodwork.

The eye is drawn to the main body of the hall with its gleaming fruits, its show-cases of rare trinkets made in the workshops of Australia, its stuffed birds and animals, its peculiar treasures. The light falls as down a single shaft from great circles in the roof. The hall is shaped into six bays divided by grey marble pillars with gold reliefs. On the inner spandrels of the entrance archway are charming mouldings of birds and animals, with trophies of work and progress behind them, and on either side of the gates set in the archway is a Grecian lamp, with an alabaster flame rising in the bronze bowl.

Huge alabaster bowls hold the light that brightens the rich vestibule, where twin staircases spring away and mount to balconies. One balcony has a young smiling face with a star carved on it, the other a gorgon-like head. From these balconies the stairs, with their simple balustrade of lines and circles, slide away upwards and reappear in gracious curves. The great beauty of the interior is largely due to the background effect of oval shapes.

Upstairs the building is handsome, and in keeping with the whole. Plain marble pilasters guard the doorways, and from the pilasters spring

a charming device – a long ornament leaping the cornice moulding and flattening itself on the roof. There are twelve of these huge marble leaves lying out along the ceiling.

Tucked away by Australia House is the excellent Melbourne House, also a product of the Commonwealth except for its English architects (Trahearne and Norman). It has a beautiful outdoor stairway, and on its keystones are a kangaroo with five stars and a wicket-keeper who has just caught his batsman out.

Marconi House

Marconi House was one of the first modern buildings to adorn itself with magnificent sculpture, and has a series of statues by Mr Hibbert Binney representing Progress at the time of the birth of the Wireless Age. Progress itself is represented by a winged figure with a trumpet, and an arm outstretched. Three stately female figures stand for Painting, Sculpture, and Architecture, one with a palette, one with a column, and one with a hammer. Three others represent the Chemist, the Electrician, and the Astronomer, and three more Engineering, Mining, and Weaving. The Empire is represented by Australia with a handful of wheat, South Africa with an ivory tusk, Canada with a pair of snowshoes, Malta with a battleship – all splendid figures, and two other corner pieces have full statues representing the Comedy and Tragedy of Life.

We have looked at the Island itself, but have still to walk round it. On its Aldwych crescent are the great buildings leading up to Kingsway, the wedge-shaped block facing Waterloo Bridge built by the Morning Post in the ambitious days before the war; the Strand and Aldwych theatres with sixteen stone figures adorning them; the Waldorf Hotel with the great stone panels of happy children running below its eaves; the peep of the magnificent Opera House which began with such high hopes and has surrendered to the films; the General Buildings, with stone sculptures by Albert Hodges of Figures of Humanity and Insurance, lead figures of Justice and Plenty, Commerce and Protection, and two pairs of helmeted cupids.

On its Strand front the Island has much rubbish, but also the splendour of the facades of King's College gateway and Somerset House, and the daintiest of all the architectural creations of the Strand, the superb exterior of St Mary's Church.

The entrance to King's College is by Somerset House, of which at present it forms a structural part. Looking through the gateway arch we see the distant columns which look down on the Thames beyond. Supporting the royal arms are figures of Holiness and Wisdom. The College, which has thousands

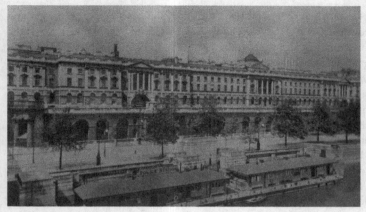

Somerset House

of students attached to London University, has some of the instruments used by Sir Charles Wheatstone, one of the founders of our telegraph system.

Somerset House

Somerset House, built round a quadrangle and running 500 feet down to the Embankment, is one of London's famous spectacles, and its work concerns us all. In it are the offices of the Inland Revenue, the Registrar who counts us all and notes our comings into this world and our goings out, makes a note of our marriages, and keeps our wills. (Here for a shilling we may see Shakespeare's will, or Milton's, or Newton's; on Shakespeare's his name appears three times).

The Thames frontage has two entrances with huge lions, and broad terraces 50 feet high which lead the eye up to a dome, guarded by figures in full panoply and adorned by a relief of a sea goddess with her attendants. The Strand entrance, cramped by shops and hoardings of advertisements, is a copy of the old Inigo Jones building, with nine arches on which are bearded heads as keystones, eight representing English rivers from the Medway to the Tweed, and the ninth Father Ocean himself. In the pediment above are the arms of England, supported by trumpeting Fame and the Genius of England, below which stand four Romans representing Temperance, Justice, Prudence, and Fortitude. A beautiful Italian-like arch runs into the courtyard, the inner side of it adorned by figures of four women with spears and cornucopias, carved by the architect's friend Joseph Wilton, who meant them for the four quarters of the Globe. Mermen support the royal arms in the pediment above them.

On each side of the courtyard are stately buildings capped with vases and crowned with clock towers, while facing us against the southern sky is the dome our eyes leap to from the Thames Embankment. On each side of the three great doorways a massive carving juts from the wall, each with two curious figures, perched on a vase so as to hide its rim with clusters of mermen, fauns, and Pacific Islanders; they stand for the Age of Discovery we associate with Captain Cook. Suggestive of the new importance of the sea to England when this quadrangle was laid out is the bronze statue of George the Third on the fountain here, for the king leans on a ship's rudder with a lion on one side and a ship's prow on the other, while Neptune below is leaning against a cornucopia as he pours his floods from a vase.

In the centre of the courtyard is a simple square column with coloured flags, the peace memorial to 1,240 men of the Civil Service Rifles who fell in the war; the roll of their names is inside the column.

The Roman Bath

Down a little lane east of King's College is the oldest of all the possessions of the Strand, the Roman Bath. Once, it is supposed, in the home of a Roman patrician, this bath is now in a vaulted chamber a little way down Strand Lane. On our left we pass the old Watch House of St Clement Danes, now a dwelling in white and green with a verandah, but once the house of a watcher whose duty was to prevent the stealing of bodies from the graveyard. On our right are the backs of King's College, the pillar-supported chapel attracting attention.

To enter the Spring Water Bath we pass through an iron gate, down a few stone steps, and along a narrow passage. There is nothing visibly romantic. The floor is 30 feet below the Strand level and 17 below that of the garden close by. The shape of the bath itself is oblong, with an apse, and the length is 15 feet 6, and the breadth 6 feet 9. The bricks, from which the marble lining has disappeared, are hard Roman tiles. A piece of masonry at one end suggests steps. The water, which is sometimes used for baptisms in the church of St Clement Danes, is extraordinarily cold, and rises from a deep-running rivulet flowing from Highgate. The bath, believed to date from early in the second century, was saved from destruction by the public-spirited action of the rector of St Clement Danes, Mr Pennington-Bickford.

Captivating all eyes hereabouts is the charming exterior of St Mary-le-Strand, its steeple ascending in graceful and diminishing tiers, looking down so elegantly on its island in the river of traffic. Inside the church are paintings of the Annunciation and the Passion by Robert Brown, the artist who helped Sir James Thornhill to paint the dome of St Paul's. The elaborate ceiling is

slightly curved. The left arch to the apse is odd in being capped by a pediment on two pairs of fluted pillars. There is a little gallery high up over the door. The massive pulpit is decked with fine eighteenth century carving. A screen near the organ has two beautiful panels with flowers and corn.

Between the two island churches of the Strand, looking towards Australia House, stands a man who sat in Parliament for the Strand and made his name illustrious in the English-speaking world, William Ewart Gladstone. As we pass on to the end of the Strand we come to its second island church, St Clement Danes, which has now the Law Courts on one side of it and on the other little narrow ways, Essex Street with the gate at the end leading down to the river and a bronze relief of Sir Algernon Methuen at Number 36. Here is the fine front of the office of the United Kingdom Provident Institution. It was one of the first of the new buildings in the Strand, and is rich in sculpture bearing on the purpose for which the building exists. Above the doorway are figures of Temperance and Providence, and over the east and west windows are Justice and Truth, and Security and Industry. Prosperity sits above a corner window, and high on the corner turret are Watchfulness and Benignity. Figures in low relief on the second floor represent the Virtues. Indoors the rooms and windows are enriched with bronze friezes, stained glass, and painted ceilings. Running round the general office (a circle 50 yards round) are deep bronze friezes representing the life of mankind. In the stained glass windows are such subjects as Providence our Instructor and the Light of Truth. One of the ceilings has symbolical scenes in which we see Providence protecting Childhood, Purity, and the Fruits of the Earth from the Evil Powers, and Hope represented by a number of cupids. The architect of this fine building was Mr H. T. Hare, the outside sculptures are by Mr Poole and Mr Schenck. The bronze frieze is by Mr Lynn Jenkins and the painting by Professor Moira.

Dr Johnson's Church

The Great Fire stopped short of the church, but in 1680 it was taken down except for the tower, Christopher Wren looking after the building. The old tower was allowed to stand after being cased with new stones and capped with obelisks. Its clock chamber and its fine spire, with three stages all growing smaller, climbing to the anchor on the vane, were added in the eighteenth century. One of the eleven bells hangs at the top of the spire; it comes from Armada Year, and repeats the hour after it has been sounded first by the tenor bell. The carillon of St Clement's plays the well-known tune, and every springtime oranges and lemons provided by the Danish Colony are distributed to children here.

Few churches of the time are more richly furnished with fine woodwork. The vaulted ceiling is sumptuously adorned with gold stars on a blue ground. There are masses of roses and thistles in the vaulting of the apse, and cherubs and festoons on the oak encasing the pillars on which the galleries rest. A low screen guarded by praying angels leads to the chancel, which has a wonderful display of rich carving, the stalls having figures of angels and the Four Evangelists. A fine rector's desk is seventeenth century and the pulpit is said to be the work of Grinling Gibbons, though its angels are new. A fine big sixteenth century chest has iron bands and spiked studs.

All but two of the windows are bright with colour, and one is interesting as the window of the flower sellers of London, who look on this church as their own. The window shows them sitting by their baskets with the children, and near it is a shrine they gave in memory of war heroes.

A brass on a pew tells us that here Dr Johnson sat; his seat is in the gallery just above the pulpit, and near it is a window in his memory, showing Johnson with his Dictionary among a group of friends: Garrick with his dog, Boswell with his book, Goldsmith with his Vicar of Wakefield, Burke with one of his books, and Elizabeth Carter, the scholar of whom Johnson said she could make a pudding or translate Epictetus. There is a portrait plaque of the founder of the first English picture daily (William Thomas).

St Clement's is a church of wide and curious interests. Its Danish interest is maintained by the Danish Colony; it has a special interest in our Southern Commonwealth, Australia House being across the way; the Men of Devon ring the bells, conduct a service, and compose their own hymns at a service they hold every year.

More ancient than all these, however, are two quaint customs still kept up – the Beating of the Bounds of the parish on foot and by boat, and the Quit Rent paid to the King for land near the church. There are twenty-five boundary marks bearing the anchor of St Clement of Rome, two of them near the Roman bath, all of which are beaten; and, as for the Quit Rent, it is paid in six horseshoes and sixty-one nails; the same shoes and the same nails having been presented by the City Solicitor before the King's Remembrancer for 500 years. It began as the rent of an old forge paid by Walter le Brun, a farrier, in 1235 and somehow the custom has been carried on.

Looking into Fleet Street from within the railings of St Clement Danes, the last church east in Westminster, stands a queer little figure of Dr Johnson. He is by Percy Fitzgerald, and is looking at an open book, though never did he look like this walking down Fleet Street. He is best seen in the twilight, and we should see him as we walk up Essex Street with the lights flickering round the little silhouetted figure standing among the trees. There is a medallion

of Boswell on the pedestal, and a small stone figure keeping him company in his little garden.

The Splendour of the Law Courts

The white mass of the Law Courts, to which we now come, marks the sunset splendour of the Gothic revival which gave us the Houses of Parliament and hundreds of buildings.

We see the Courts as a mass of white stone, but under the stone are thirty-five million bricks. The head of the master builder who made them all, Henry Bull, looks down on the quadrangle, with the architect not far away.

There are few more captivating fronts than this, so crowded with shapely and beautiful things, and the whole building is worthy of its Strand facade. It is worth while to walk the half-mile round it to appreciate the magnificence of the towers and turrets (sometimes free and sometimes clinging to the corners), the graceful arcades, and the shapely roofs. The arches enclosing the courtyard, with its green lawn, are admirable, as are the steps which overcome the awkward rising of 17 feet between the Strand and Carey Street. In this street is the Judges entrance (with a neighbourly bust of Sir Thomas More appropriately at a corner down the street). Perched on the gable against the sky above the Judges Doorway is a statue of Moses bearing the books of the Law, and down the steps on the right, passing under the bridge linking up the new wing, we see another statue against the sky, of Justice herself.

But it is to the Strand front that we come back, and who would not pull down these things that are in the way of the full view of this famous spectacle, with the great twin towers guarding the great doorway, the turrets and the pinnacles and the lovely rose window, and the statues standing aloft? The porch is worthy of the Middle Ages, with its deeply recessed doorway of four moulded orders, and with a stately arcade along the wall above it. On the soaring pinnacles stand Solomon holding his temple and Alfred with his scroll and sword, and high above the rose window on the gabled wall stands a colossal figure of Christ, one hand raised in benediction as if blessing the throng ever passing below.

Down by the pavement runs an arcade with an entrance into the open quadrangle, a decorated frieze running through it on which are carved three tiny sculptures from Aesop's Fables. From this quadrangle rises the bell tower, with the flag-mast on which the flag flies 70 yards above our feet.

The Great Hall brings to us a sudden sense of peace as we come into it from the roar of the Strand. The floor is a lovely mosaic, subdued by black and grey. Over the doorway is a noble gallery leading from five lancet windows,

and at the other end three lancets light up a smaller gallery perched above a double archway leading to the crypt. There are two still smaller galleries and five profusely decorated arches in each side wall, leading to twenty-four Courts and 1,000 rooms. The doorways are linked with arcading of great beauty, and a frieze runs below the lancet windows adorned with tiny heraldic shields. Two huge paintings face each other across the hall: one shows the opening of the Law Courts in 1882, a group of remarkable interest for those who more or less dimly remember the event, for not one of the thirty or forty figures in this picture is alive today. The painting is rich with the red robes of judges and the gold braid of State trumpeters, and a proud man Mr Gladstone looks as Prime Minister. The picture facing this has four figures only, a little procession symbolical of the majesty of the Law, showing Lord Chancellor Hatherley with his attendants bearing the mace, and the seal in its embroidered bag.

In this great hall are two famous judges in marble: Lord Russell of Killowen shown sitting as he was so often seen, whether defending Parnell in a speech which lasted for days or trying Dr Jameson and his raiders; Sir

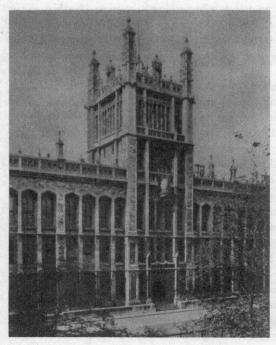

The Record Office,
Chancery Lane

William Blackstone standing with his Commentaries on the Law, a statue given by America as a tribute to the founders of the laws which enshrine the freedom of the English-speaking peoples. Lord Russell is by Bruce Joy, and Blackstone by Paul Bartlett.

There is a simple bronze memorial with the names of the staff of the Law Courts who fell in the war, and among all these sits the architect himself, pondering one of his 3,000 drawings. He is by Henry Armstead and round the base of his monument runs a bold relief with figures of masons, carpenters, and bell-founders, working to carry out his great idea. If we would seek his monument we have only to look around.

We are at the end of the Strand and at the gate of Fleet Street, with the fearful griffin of Temple Bar warning us that here the Lord Mayor is king. One narrow wedge the City of Westminster thrusts into the City of London; it runs at the back of the Law Courts and takes in the Record Office and a piece of Lincoln's Inn Fields with the Royal College of Surgeons in it. We must look at these two famous places before we leave these eastern limits of the western city.

The Record Office

Fortress-like, set in a garden with a sunken way, the Record Office is one of the least known of London's great buildings, being so unhappily hemmed in between Chancery Lane and Fetter Lane that the beauty of its Gothic design, its towers and pinnacles, its windows deep between the massive buttresses, is largely hidden.

In a canopied niche at the top of the central tower, gleaming white when the sun shines on it, is one of the highest statues in London, Joseph Durham's Queen Victoria. Below it a projecting clock symbolises Time Passing by way of contrast to the massed records of Time Past within the building. At the tower's base is the main entrance, spacious and impressive.

High up on the east side of the Chancery Lane archway, in niches one above the other, are statues of Henry the Third (who founded here a house and chapel for converted Jews) and Edward the Third (who in 1377 gave the house and chapel to the Master of the Rolls, who in 1837 surrendered them to the Crown). Built into the wall on our left as we look at these statues is the two-centred arch of the old Rolls Chapel, with tapering corbels, moulded imposts, and foliated bases, but minus its crown and much weathered.

The literary search room, open to students, is octagonal with a dome-shaped roof and walls lined with books, a small replica of the Reading Room at the British Museum. Pens and ink are not allowed, and pencil sharpeners are provided in the corridor.

The muniment rooms, with locked iron doors, iron racks, and slate shelves, are ranged along lofty stone-paved corridors. In one room representatives of the American Library of Congress have been busy photographing documents of historical interest.

For the general public the interest centres in the museum, open unhappily only two hours a day from Monday to Friday. Built on the site of Rolls Chapel, it is a fine lofty hall, oriented as the chapel was and occupying the same space. The windows along the south side and at the ends are filled with heraldic glass of Masters of the Rolls since 1371, four bishops who were preachers in the chapel, Charles Stuart's brother Henry (Prince of Wales), Lord Chancellor Ellesmere, Robert Cecil, George the First, and others. Some of the glass dates from 1611, seven panels having been in the chapel. The arms of the Deputy Masters are on wooden shields on either side of the west window. In a south corner is a statue of George the First dressed as an ancient Roman, and in another corner is a bust of Sir Samuel Romilly.

The monuments preserved from the old chapel are of unique interest. On our left as we descend to the museum is the group of Richard Aldington of

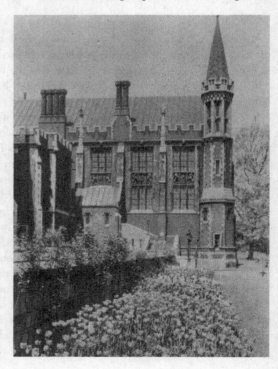

Lincoln's Inn Library

Lincoln's Inn, his wife Jane, and their three daughters, mainly of alabaster finely carved, and flanked by columns of black marble. Richard and Jane are facing one another, he in armour clasping a helmet, she wearing a long robe and holding a book, and each is kneeling in a rounded niche. Beneath them, on a projecting panel, are their daughters in relief.

The alabaster monument of Edward Lord Bruce of Kinloss, a Master of the Rolls who came with James the First to England in 1603, still bears traces of painting. Lord Bruce is shown reclining in a fur-lined robe with a wide collar, his head resting on his hand, his elbow on a tasselled cushion. On either side of a small altar three children kneel on cushions. The most beautiful monument is by the great Torrigiano, showing Doctor Yong, Tudor Master of the Rolls and Dean of York; he is wearing a red gown and a square cap. In the lunette above him is a fine head of Christ.

The Record Office has an immense number of exhibits and documents, many of them richly bound and glowing with colour as fresh as if produced yesterday. In the centre of the hall is the Conqueror's Domesday Book of 1086; a smaller volume and a large one with their ancient covers between. The huge chest which once contained them is cased, lined, and bound with iron, and parts of its three locks still remain. Thirteenth century epitome of Domesday with tiny pictures in the fly-leaves showing scenes from the life of the Confessor is in another case; one of its pictures shows a soldier wearing a helmet similar to those worn in the Great War.

The visitor should not miss the embossed leaden cisterns in the corridor, where also is the fourteenth century bell of the Rolls Chapel.

The great Lincoln's Inn Fields building with six massive pillars is known to every surgeon in England, for they must all pass this way for examination. It is the Royal College of Surgeons, built by Sir Charles Barry before the burning down of the old Houses of Parliament had given him the opportunity for his more famous masterpiece.

In this fine building is a museum which has grown out of the collection of curious things made by the great John Hunter. It may be visited by anyone with reasonable credentials, and it is full of interest, as the building itself is full of surprise.

The Backway to Mayfair

The Backway to Mayfair

Leaving Lincoln's Inn Fields and crossing Kingsway we will work our way for a mile or two through that remarkable piece of London still waiting to be redeemed, the great area that lies between the Strand and Oxford Street. It runs through London's backyard and brings us out at its front door. It is the backway to Mayfair.

We cross Kingsway into Covent Garden Market, just within Westminster's border; a queer sight it is when we look down one of the little streets and see the traffic of the Strand going by. Here is old-world London mixed together: Drury Lane with its famous theatre, its walls older than Waterloo, a national playhouse since Nell Gwynn sold oranges here; the Royal Opera, famous for 200 years; and Covent Garden Market where things were bought and sold 300 years ago, and where the present market buildings have stood a hundred years. Today Covent Garden is a mess which has survived a score of schemes for its rebuilding.

Covent Garden Market

It is in the early hours of the morning that this higgledy-piggledy place is touched with beauty. Then it is a blaze of colour and filled with the scent of flowers, banks of lilies, stalls hidden with roses, and in due season every English flower that blooms. During the day the flowers take their turn with oranges and lemons and pomegranates and pineapples, and every kind of fruit. The flowers coming here in a year are worth millions, the fruit far more, and the vegetables most of all.

The theatre and the Opera House have little architectural distinction. The Opera House has an impressive front of five great columns, rich capitals, and a frieze of scenes from opera. The theatre has a small Shakespeare statue outside with a drinking fountain and a bronze bust in memory of Sir Augustus Harris. Inside are sculptures of Shakespeare, Kean, Garrick, and Balfe, with a relief portrait of Sir Henry Irving. Close by is the Fortune Theatre, with a lifesize figure of a girl clinging to the wall above the doorway.

Far more interesting than any of these places is Covent Garden's church of St Paul. Severe in architecture, the portico facing the market is no longer the entrance and we do best to approach this place of memory from Bedford Street.

By the altar are two striking panels in blue and white, with groups of singers copied from the terracottas of Della Robbia. The vestry has a mahogany clock with a movement by Thomas Tompion, Father of English Watchmaking.

Before we leave the market area we may turn down Southampton Street and see at Number 27 a wreath with a medallion portrait of David Garrick in it and two full-length figures beside him.

At the end of the Lane, by Charing Cross Hospital, we bear round to St Martin's Lane, where is the Coliseum. It was the wonder of London on the day it was opened, astounding the public with its revolving stage. At night the great ball above it revolves with its shining lights; it crowns a tower which is borne up by four lions, and has four groups of sculpture at the corners and eight stone figures which seem to carry the huge ball on their backs.

A little way up St Martin's Lane is crossed by Long Acre, the long unlovely street where Cromwell lived six years, and, taking it to the left, we find ourselves in Charing Cross Road with its theatres and second-hand book shops. There are millions of books to choose from. Here also is the Hippodrome, with a horse and chariot crowning its dome. This half-mile of bargain shops for ever thronged with bargain hunters runs through the heart of that square mile of Westminster which would astonish thousands of Londoners if they would spend a morning in it.

Soho

The heart of this great area, the streets between the eastern half of Shaftesbury Avenue and Oxford Street, is Soho, first densely populated by Protestant refugees who poured into this country fleeing from persecution.

Hereabouts, in Dean and Wardour Streets, is the famous seventeenth century church of St Anne, with a curious clock-turret built about 1800. We come into its churchyard from Wardour Street and find in the tower a most interesting group of memorials. One of 1816 is to David Williams who worked for sixteen years to found the Royal Literary Fund, which has helped thousands of authors and their families in distress. A second, by an odd chance, is the gravestone of the great essayist William Hazlitt, who died in Soho in the grip of poverty. A third is the memorial of that strange figure of adventure Baron von Neuhof, who was educated in France, served in the Swedish Army, took part in Jacobite plots, and in 1736 managed to get himself crowned as King Theodore of Corsica.

The church (which is famous for its musical services) has some old woodwork used again in the stalls, a great monument high up in the

Left: Liberty's Tudor front

Below: Frieze of the Accountants' Institute in the City

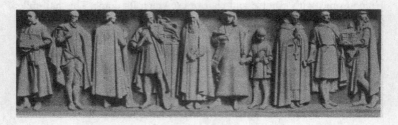

sanctuary, a bust of Canon Wade who was rector forty-six years, and an inscription to one of its curates, Henry Whitehead, who played a noble part in the cholera epidemic of 1854, when there were 700 deaths in ten days within 100 yards of St Anne's. There are several effective windows, and truly fascinating is a new one of the Nativity, in which with the central figures we see the ox and the ass, lambs and chickens, and even a rabbit peeping in.

In Poland Street the rebel Shelley lodged after being expelled from Oxford. At 75 Dean Street lived Sir James Thornhill who painted the dome of St Paul's, and in the same house lived Edward Baily who made Lord Nelson 17 feet high for the top of his column. Here still are those old squares that make so brave an attempt to keep the tide of life from flowing into them, some failing quite, some half succeeding. At the back of Regent Street is

Golden Square with George the Second standing like a Roman as if he were addressing Parliament, a mournful little statue Dickens called it, the guardian genius of a wilderness of shrubs. Here, too, still stands a church with peace all unsuspected by the passing throng of Regent Street, St Thomas's with an eighteenth century atmosphere, a gallery on wooden pillars, and attractive carving on screens and panelling and on the font. In front of St Peter's School in Great Windmill Street is a bust of Lord Derby, the Prime Minister.

Leicester Square

At the back of Oxford Street is Soho Square, So-Ho, the battle cry of Sedgemoor, last battle fought on English soil, for here lived that Duke of Monmouth who was captured in a ditch and sent to the scaffold. On the site of a great gambling house is now the church of St Patrick, where we called in the Christmas season to find sermons being preached in nine languages in one week. The church has attractive coloured statuary, and its red brick campanile then looked across the square to the house where Sir Joseph Banks lived for forty-three years, holding something like a scientific court. St Patrick has a neighbour in the French Protestant Church with a terracotta front, built by Sir Aston Webb, reminding us by its presence of the Huguenot exiles who settled in this part of London.

Home of Colour and Beauty

We have come by the back stairs to Mayfair, but we arrive magnificently if we come into Great Marlborough Street and find ourselves in front of Liberty's. On one side rises high the wonderful Radiator Building, a daring experiment in black and gold, and looking up at it is the beautiful Tudor front of Liberty's.

This famous shop, the renowned home of colour and beauty, has two fronts – one to fit in with the scheme imposed by the Crown Commissioners in the rebuilding of Regent Street, and one which Liberty's built to please themselves in Great Marlborough Street. It is delightful in its unexpectedness as we turn from the stately Regent Street facades and find ourselves at this copy of an Elizabethan building, one of the loveliest fronts in London, leading into the loveliest shop. Its oak and teak timbers are from old three-deckers, the Hindustan, the Britannia, and the Impregnable. They are massive timbers looking as if they will last for ever. Inside they bear up fine galleries covered with hammerbeam roofs and enriched with linenfold, with carving everywhere in Tudor style. We walk on old ship timbers and look on beauty all round.

Towering among the lovely brick chimneys, the hand-made roof tiles, and the charming rain-pipes of the Tudor block, is a gilded model of the

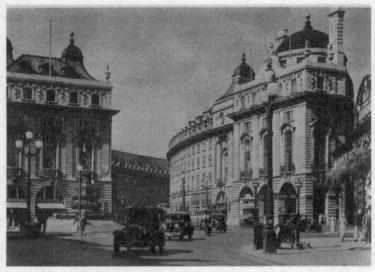

Piccadilly entrance to Regent Street

Mayflower, made of copper, four feet high. The two shops are linked by a bridge of three storeys running over Kingly Street, and a marvellous clock runs from the top to the bottom of the bridge, set in a beautiful oriel with a lovely coved bracket. At each quarter of an hour St George appears and chases his dragon round two or three times, and at the hour he catches him and strikes him with his lance at each note of the bell. It is one of the three finest public clocks of London – Selfridges and St Dunstan's in Fleet Street keeping it company.

The Regent Street front of Liberty's is a threefold mass with curved recesses between two towers, crowned with a sculptured frieze of great beauty. It is 115 feet long and its figures are seven feet high, the beautiful work of Charles Doman and Thomas Clapperton. It shows the wealth of the East and the West being borne by ship, camel, and elephant to the English market, and in the midst of it all sits Britannia, mistress of the seas.

St George's, Hanover Square

Modern London has left it so little breathing space that we cannot stand back to admire the eighteenth century dignity of St George's portico and steeple, but quite unspoiled is its interior, and exceedingly gracious, with much carving on screens and pulpit and sanctuary rails, and everywhere the cool dignity of oak.

The east windows are filled with sixteenth century glass from Flanders. It shows the characters in the Tree of Jesse, and is effective as a piece of colour. A modern window in the north chapel is original in design and shows the Holy City complete with walls and turrets and many mansions, and an angel watching at every gate. The chapel has a handsome altar cross, and on the windowsill when we called was an ancient wooden sculpture of a seated woman, still with some red and blue colour. On another sill by the font we found a vivid St Michael, standing with his spear on a demon.

We are in the heart of the richest shopping area in London, the select and aristocratic streets and squares bounded by Park Lane and Regent Street, Oxford Street and Piccadilly. Through the heart of it runs Bond Street, with a fame perhaps hard for a stranger to understand, though it has in it shops which are not to be beaten for quality in whatever they may sell. It is the narrowest important street in London, a bottle-neck holding up traffic half an hour on any afternoon. At a corner nearer Piccadilly is the most delightful piece of Bond Street architecture, the building designed by Mr Vincent Harris for Atkinson's, where a carillon of twenty-three bells plays every day at twelve and four.

In Park Lane

The Squares of Mayfair

As we walk about Berkeley Square it seems only the other day that Lansdowne House stood here, and nearly the only shop was the place where Victorian nursemaids took their charges for ices and Victorian young ladies went to inspect magnificent wedding cakes. Now only the shaded garden of the square remains, with the noblest plane trees in London, and its fountain with the marble figure of a woman by Alexander Munro; far far away are the family coaches and the ladies riding in Sedan chairs.

Grosvenor Square, rivalling its neighbour as the fashionable square for Victorian novels, has kept its Georgian character better than most squares, yielding slowly to change in the twentieth century as in the nineteenth, when it was the last square to give up burning oil in its lamps. There are still extinguishers for torches at some of the doors. A bronze medallion keeps in remembrance its famous landlord the first Duke of Westminster, but all round its big garden of trees great blocks are rising, side by side with old houses still keeping vases on their parapets.

On one side of the square run North and South Audley Streets in which are two churches of much interest, Grosvenor Chapel in South Audley Street, and St Mark's in North Audley Street.

St Mark's has a chancel somewhat ornate, but with a charming painting on the altar of the Marys at the Tomb. The altar in the peace memorial chapel has an unusual combination of painting and carving, the carving showing St George, St Andrew, and the Crucifixion, and the painting twentieth century figures symbolising Inspiration and Sacrifice, Suffering and Victory. Close by are two other splendid pieces of colour, a wonderful scene of the desolation of Ypres worked in tapestry by the vicar's wife, and a window with a kneeling angel in blue. In other windows we see Christ in red with his arms upraised, and a beautiful Madonna in memory of a mother and three sons killed in battle. The big font is notable for its curiously drawn scenes of baptism on the sides of the bowl. The chapel has a pulpit handsomely carved, and an unusual font in two colours of marble.

Walking onward, we come to the famous Park Lane, now passing through a great transformation. A few of its old houses are still left but the old charm has passed away and vast hotels on the American scale have banished all remembrance of the days when this was one of the enjoyable walks in London. The curiously attractive little building covered with traceried arches stands overpowered by the great new front of the Dorchester Hotel, and the vast fronts of the Grosvenor and of a block of flats carry on the new facade of this old thoroughfare. It has lost its character, and only here and there something witnesses to what it was.

The church has a striking front with pinnacles and two rose windows, copying the west front of Beauvais Cathedral. Something of the cathedral atmosphere it has, with marble columns and a big clerestory, vaulted aisles and chapels, and thirteen altars. It is one of the richest interiors in London, resplendent with carving and statuary, paintings and mosaics, fine brasswork, and marble of every kind. Hardly a yard of these walls is without decoration.

The great chancel window has tracery copied from the famous east window of Carlisle Cathedral, and shines with a beautiful mellow light. The glass shows a Jesse Tree and has about forty figures. Behind the high altar (designed by the elder Pugin) are two Venetian mosaics of the Annunciation and the Crowning of the Madonna.

Every one of the side chapels has something to linger over. Sometimes it is the altar rails, or an altar frontal in brass. Sometimes it is a splendid reredos, or a picture, or a marble figure.

Standing above the communion rail is a coloured figure of the Madonna with a beautiful face, and very notable are some of the statues designed by Mr Romaine Walker, in which the colour is obtained by the use of naturally tinted marbles. Among these are St Margaret richly robed, St Frances of Rome clasping a child, and St Ignatius preaching at the entrance to his chapel, which has a good figure of Francis Xavier.

There are two treasures far older than these nineteenth century walls. One is a Della Robbia plaque of the Mother and Child, lovely in its expression of peace on the face of Mary; the other is a painted triptych which came to light in a Farm Street lumber room. It is thought to be by a Dutch artist of the sixteenth century, and shows in fine detail a central scene of the Madonna with St Anne.

On a tablet on the wall is the most coveted honour of English fighting men, the YC won at Alma by Sir Luke O'Connor, who rose from the ranks to command the Royal Welsh Fusiliers.

Towards the bottom of Park Lane is the Poet's Fountain by Thomas Thornycroft, with marble statues of Chaucer, Shakespeare, and Milton on a round pedestal, Comedy, Tragedy, and History sitting below them with masks, and winged Fame poised above all, dazzling in bright gold.

The Marble Arch

At the top of the lane, the meeting-place of four great roads, stands the Marble Arch, which changed its address in the year of the Great Exhibition. Till then it stood at the entrance to Buckingham Palace; now it stands at the head of Oxford Street a few yards away from a little brass plate which

tells us that this was Tyburn Hill. Chantrey's statue of George the Fourth in Trafalgar Square was made for it, but never fixed. The arch was designed after an arch in the Roman Forum, and made of marble from Michael Angelo's quarries at Carrara. It was originally intended to symbolise the victories of Trafalgar and Waterloo in its picture panels, but the arch was made an arch of peace instead, with four reliefs representing (on the north side) the three kingdoms and the Genius of England inspiring Youth, and (on the south side) Valour and Virtue, Peace and Plenty. On each face are four Corinthian columns, an ornamental keystone above the central arch, and angels with wreaths in the spandrels. There are six keystone masks over the arches and three sets of gates, the great central gates, the superb work of Samuel Parker, being among the finest in England. They are of bronze, 21 feet high and 15 wide, weigh five tons, and cost 3,000 guineas. Both the gates have a lion on the top and St George on horseback with a lion on his shield. It stands magnificently at one of the key-points of London, and should be seen from the gates of the park with the white marble walls of hotels and kinemas rising like a mountain behind it.

One monument which has been moved from a prominent place (at the meeting of Knightsbridge and the Brompton Road) is the fine bronze equestrian statue of Lord Strathnairn by Onslow Ford.

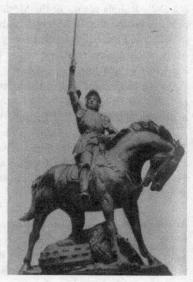

St George at Stanhope Gate

Westminster in the West

Hyde Park

We come now to Hyde Park, as rare a sight as any city has in the heart of it. From the Marble Arch this favourite open space of London runs one way down to the famous colonnade at Hyde Park Corner, and the other way along Bayswater Road in a straight line to Kensington, then turning down to near the Albert Hall, and back in another straight line to Hyde Park Corner. It has two

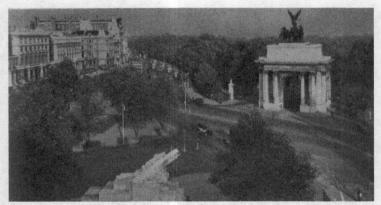

Hyde Park Corner

The Serpentine in Hyde Park

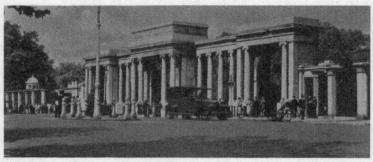

The Colonnade Gateway of Hyde Park

famous sheets of water, the Serpentine and the Round Pond, Rotten Row (the fashionable mile for riding), the lovely Fountains at Lancaster Gate, the little sunken garden outside Kensington Palace, the Albert Memorial, and a gallery of sculpture of which no city need be ashamed.

Its sculpture begins at the famous entrance from Piccadilly, where the colossal Achilles stands rather as if he were defying the world, with Byron looking from Hamilton Gardens across the way. Achilles is a monument to Wellington set up by the women of England, the statue having been cast from cannon captured in his victories. On the way to the Marble Arch, at the Stanhope Gate, is a magnificent St George with his sword uplifted, his horse trampling down the most appalling dragon ever seen, breathing fire with its tongue out, a broken shaft stuck into it. It is the Cavalry Memorial by Adrian Jones, who sought to express in this fine group the idea that the dragon of the Great War had ravaged the world and was dead, conquered by a hope in something better.

Not far from the Stanhope Gate is a fountain given by an Indian Maharajah, and near the gate farther on, by Mount Street, is a fountain with a boy kneeling on a dolphin.

Looking on to Rotten Row are two lovely pieces of sculpture in bronze, a copy of a figure by Andrea Verrocchio at the Palazzo Vecchia in Florence, and a most beautiful Diana by Countess Gleichen, she stands on a stone basin borne by four bronze caryatids, and is a lovely figure shooting an arrow. Near the Serpentine is a bird bath with a figure of a girl carrying a fish under each arm, by W. R. Colton. The one blot on the sculptor's contribution to this beautiful park is in the bird sanctuary not far from the Serpentine Bridge.

Peter Pan statue

Kensington Gardens

Two of the most delightful corners of this rural piece of Westminster are in Kensington Gardens, the Fountains by the Marlborough Gate on Bayswater Road, and the Round Pond reached from the Broad Walk. Near this point is the Victoria Gate, at which is a small animal graveyard where sleep about 300 pet dogs.

The Fountains, worked by a pump in an ornate little house, is one of the happiest spots in London on a summer's day. Here are five small ponds with flagged walks all round them, and four fountains playing. Looking on them sits the famous Dr Jenner, a fine figure in bronze by Calder Marshal, and all round the balustrade are ornamental vases with ram's heads, pelicans, dolphins, and festoons. At the end of the flags is the head of the Serpentine (known on this side of the bridge as Long Water). The Fountains are raised above the lake and the flagged walk ends with the balustrade crescent-shaped in the centre, where sit two lovely sculptured women with water pots on their knees and swans at their feet, and four mermaids between them bearing a fluted basin on their shoulders.

From these Fountains we catch sight of the granite obelisk to John Hanning Speke, the African explorer who accidentally shot himself on the morning when he should have reported a discovery to the British Association; and

on our walk to the Round Pond we pass the ever-delightful statue of Peter Pan.

The Round Pond on any day in summer is a captivating sight with boys and girls racing their model ships. The pond covers seven acres, and there

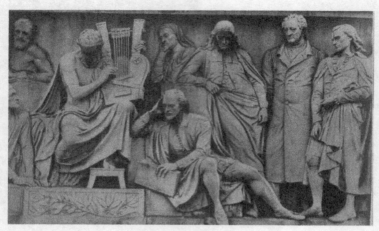

Sculptures on the Albert Memorial

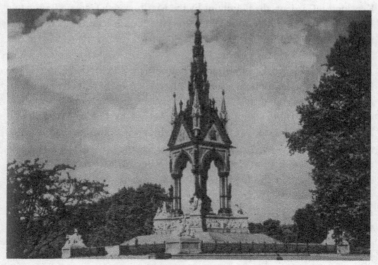

The Albert Memorial in Kensington Gardens

is no finer merry-go-round in London when the children take possession. From the pond in the centre of a great avenue we see the colossal bronze group by G. F. Watts known as Physical Energy, a horseman shading his eyes as he looks out, the horse prancing.

The Park and the Gardens are full of lovely peeps and secluded nooks. The ranger lives in an old farmhouse. The old Cockpit has become an amphitheatre where folk dances are performed. By the Fountains is Queen Anne's Alcove, and a stone marks the place of St Agnes's Well.

But it will seem to thousands that the loveliest corner in all these 600 acres is at the back of the Broad Walk, behind the white marble statue of Queen Victoria fashioned by her daughter, Princess Louise. The garden is flagged, and there are three noble lead tanks in the pool with formal vases of flowers and sloping beds all round.

It was in Hyde Park, of course, that the Crystal Palace was set up for the Great Exhibition of 1851. From the profits of the Exhibition the waste lands of South Kensington were made into the wonderful place they are today, and there we now go, for one corner of Museum Land, the most famous corner of what most of us think South Kensington, is in Westminster. We come to the Albert Memorial, the Albert Hall, and the Imperial Institute, winding up our journey at the western end of London's famous city.

Before we leave the Gardens we must see the beautiful gates hereabouts. One set, dividing the Gardens from Hyde Park, is magnificent, enriched with crowns and stags and winged cherubs; but the main Queen's Gate is enchanting with two bronze groups given by a Frenchman who loved London. They show a doe with her fawn playing at her feet, a perfect touch of forest life in this delightful corner under overhanging trees.

Now we come to the Albert Memorial, which some think the most beautiful thing they have ever seen and some think otherwise.

The colossal bronze figure of the prince, now stripped of its dazzling gold, is 13 feet high and weighs nearly ten tons, and he sits in a gorgeous shrine inlaid with 12,000 pretty stones, looking like a toy rather than a work of art. It has been said by an expert that the canopy (crowned with a cross at a height of 175 feet) would not stand an hour but for a clever piece of internal mechanism which holds it up, and that this elaborate structure is not architecture, but a clever mechanical device.

Into this west corner of Westminster comes a group of buildings of much interest, gathered about the border which divides the city from Kensington. It takes in the Albert Hall, the School of Mines, the Imperial Institute, the Organists College, the Royal Geographical Society, and the School of Needlework. We will look at them.

Across the road from the Albert Memorial is the Albert Hall, still the biggest hall in London.

Outside the Hall is like a great box with diminishing stages, balconies encircling the walls, and porches on three sides. Round it runs a frieze of Minto ware, a procession of hundreds of people from early times to the mechanical age, illustrating the victories of Art and Science. The frieze is about six feet deep and 800 feet long, and is the work of women students of the School of Art in Kensington. There are in this great frieze old-time singers and players, a knight and his minstrels appearing before a king, medieval craftsmen at work, Christopher Wren with his hat off before the king and standing with his little spaniel in front of St Paul's, a shepherd boy with his horn and oxen at the plough, vineyards and wheatfields, sailors with early ships and drivers with early engines, ancient man with his crude lever, and the steam engine with its beam.

The Royal Geographical Society's offices are at the corner of Exhibition Road, and we meet here two famous explorers. By the door is F. W. Pomeroy's bronze bust of Sir Clements Markham, presented by the Peruvian Government in gratitude for his services as historian of their country; and in a niche of the wall, looking down on the street, stands Shackleton, magnificent in lifesize bronze, dressed ready for the Pole.

The Organists College, linked with the Royal College of Music, is a very odd building in the shadow of the Albert Hall, its walls a mass of moulded panels in orange and white, adorned with a frieze of children singing and playing, the procession leading up to a quaint panel over the entrance which shows the successful students receiving their awards.

The Royal School of Art Needlework, looking across Westminster's border to the great Science Museum in the royal borough, is one of the daintiest buildings in Museum Land. Its red brickwork is enriched with stone, it has ironwork balconies in front of its windows, and at the entrance are fine twisted pillars through which we may come into the little hall and climb the marble stairs if we are interested in exquisite needlework, old or new. It is one of the few places here where we can either stand and wonder or put our hands into our pockets and buy.

The School of Mines, behind the Imperial Institute, has a fine domed entrance at the sides of which are groups of statuary and busts of Sir Charles Wernher and Sir Otto Beit, the famous diamond merchants who were also great philanthropists.

The Imperial Institute and its Scenes of Empire

In the road behind the Albert Hall is the Imperial Institute, the gigantic building designed by Thomas Collcutt to develop a great imperial conception born in the days of Queen Victoria's Jubilee. Today it houses much of London University, and the rest of it is controlled by the Department of Overseas Trade.

Dominating Museum Land as it rises from its lawn, it has a frontage of 600 feet and a great array of domed turrets and towers, the central tower rising 280 feet. Many of its gables are adorned with lions and cherubs, and the walls are enriched with balconies and bands of carving. A fine green dome with a lantern crowns the splendid central tower, in front of which is the entrance reached by impressive flights of steps and guarded by four haughty lions. Above the arch is a band of mermen and mermaids and sea-horses, and in the carving at each side are ships and sea, and a woman winding thread.

Tucked away in one of the wings is the half-mile of galleries which draw to this place 600,000 people every year; in them we can make a fascinating trip round the Empire by touching switches which light up a hundred vivid scenes in natural colour, all set out as on a stage with figures so real that we almost wait for them to move. With most of them are the products of

The Imperial Institute

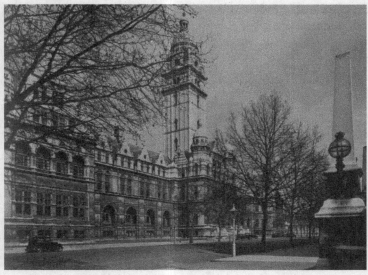

the lands they represent, their story told from the crude state to the form familiar to us, adding romance to the linoleum on our floors and tracing the lustre of artificial silk to Travancore.

India, Ceylon, and Malaya in Asia; the Sudan, Uganda, Nigeria, Rhodesia in Africa; Canada, Australia, New Zealand, and the East and West Indies display their plains and mountains and rivers, their character, and the life teeming on their surface. Every Dominion, Crown Colony, and Protectorate, from Hong Kong to British Columbia in the northern hemisphere to the Falkland Islands and desolate Tristan da Cunha on the edge of Antarctica, has its place. Here are British North Borneo and British Guiana on opposite sides of the globe; here the Seychelles, the Gold Coast, Newfoundland, Palestine, the West Indies, all brought vividly before us by photograph and diorama.

The City

The Temple at the City Gate

The Temple at the gate of the City lies in the historic Square Mile but is not of it. As the City belongs to itself, like a kingdom within a kingdom, so it is with the Temple, the sanctuary of the legal world. It is now the home of two Inns, Inner and Middle Temple, the rough dividing line being Middle Temple Lane, which runs from Fleet Street to the Thames Embankment. The Inner Temple Gateway stands close by and leads us to the famous church.

The Inner Temple Gateway has over it the charming Prince Henry Room, which is part of the City. The gateway was built in 1610, but has nothing notable except the little house for the watchman tucked away inside. Middle Temple Gateway has a fine Wren front of 1684, with a little holy lamb above the date, an iron balcony, and great doors with hundreds of studs. There is a little gold lamb on the wall inside at the top of the Lane, looking across to the shop below the overhanging storeys, with the six iron columns Dr Johnson used to grasp as he passed. The shop has a wooden front; it has been a stationer's for 200 years.

We will walk down the Lane and see Middle Temple first. We come to Brick Court on the right, built in 1704, with Oliver Goldsmith's portrait on the house where he died, little lambs on the keystones, and broken pediments above the doors. We pass through into Essex Court, with four crooked trees and a little wig shop, and a covered way through to the Strand where Outer Temple used to be. Beyond lies New Court, built by Wren from part of the garden of Essex House; it has a solitary tree, more little lambs on the lamps, and an iron gateway into Devereux Court, where a bust of the third Earl of Essex (commander at Edge Hill) is high up on the wall, with the words below it, 'This is Devereux Court, 1676.' There are ten lovely heads under the window hoods, and passage ways into the Strand and Essex Street; but we come down the steps into Fountain Court, a delightful spot on a summer's day, the most visited corner of the Temple.

In front of us are the Temple Gardens, gay with flowers and bright with magnolias; we may walk along the gardens down to the river, passing the buttressed end of the Great Hall and coming to the Library. The Library, built in 1861, has lovely stained windows, an open hammerbeam roof, and 60,000 books, and one of its most interesting possessions is an order for troops to move forward for Waterloo, signed by a General who fell there.

But we must come back to Fountain Court, which lives in poetry and pictures, and in Dickens, and in the hearts of all devoted Londoners. If it is summer we find the fountain playing and people lunching round it; if it is evening we shall feel that it is one of the quietest spots in any great city we know, a place to dream in. Black and gold sundials look down on it from the red brick houses, and looking down on the porch of the Hall are the red and gold shields of two judges and a Temple Treasurer.

It is Middle Temple Hall that all the world comes to see here, and well it is worth the world's trouble, for it is a famous place. The Hall has been refaced outside (in 1757), but the interior has its ancient charm and is of almost unique beauty. The open hammer-beam roof is one of the finest of its kind, and the oak screen with the minstrel gallery above it is unrivalled; it is thought to be the work of Huguenot refugees, and has two doorways and six pillars.

It is one of the sights of London that nobody should miss, famous everywhere among woodcarvers. The screen itself was probably carved in 1570 and the two pairs of doors were added in 1671. The doors are marvellously carved and crowned with fleur-de-lys. On each side of them are muscular figures bearing up the arches of the doorway, and in the spandrels are graceful figures reclining with wreaths and branches of palm. Great fluted columns support a gallery, the pedestals of the columns sculptured with little figures of Hercules, and there are other figures between the great panels of the screen. Above the cornice is a rich riot of delicate decoration along the front of the gallery. Little symbolical figures are set in niches, and the main uprights are carved with satyrs. Above a row of small arches a long line of grotesque faces crowns this wondrous screen and looks down on this historic hall.

The hall is 100 feet long and 40 wide. Its windows have ancient heraldic glass and the walls are hung with portraits. In the recess to the left of the dais is a graphic picture of the Judgment of Solomon.

We come down the steps into the lane again and walk down towards Temple Gardens, passing a door sacred to the Benchers, leading into Parliament Chambers. It has ancient carved doors from a vanished hall which stood until 1674 in Pump Court, and they open on to a long corridor hung with ancient armour and weapons. In the noble central chamber is a line array of portraits. A pedestal outside the door is covered with tiles from the old floor of Temple Church, and on the pedestal is a fragment from a Greek tomb of the third century, with an inscription telling us that the tomb has been set up to her husband by a girl innocent and rich, and she will not allow any other to be placed therein.

At the bottom of the lane we pass under the arch of a block of chambers with much carving round them, two lions holding up a gold banner, heads on keystones, caryatids, and medallions, and, what may seem a little curious, the Middle Temple's holy lamb in company with the Inner Temple's flying horse.

We come now to Inner Temple Hall, built by Sir Sydney Smirke in 1870. It is 94 feet long, has a roof modelled on Westminster Hall's, and is panelled with oak blazoned with heraldry going back to the sixteenth century. At one end is Sir James Thornhill's painting of Pegasus Springing from Mount Helicon, and there is a portrait of Mary Tudor by Kneller and many others on walls and windows. The screen, over which is a minstrel gallery, is beautifully carved, and in front of it on either side of the entrance are four bronze statues of knights in armour. The Library joins the Hall, and they make a delightful front with Pegasus flying over the clock tower.

We are now in the great open space of the Inner Temple, usually packed with motor cars, but still with the iron rings on the terrace where the barristers used to tie their horses. Running down one side is Paper Buildings, and on the other the most attractive line of houses in the Inner Temple, King's Bench Walk. It is charming, with the delightful doorways of the seventeenth and eighteenth centuries, some of them by Wren, and some with lovely capitals. The Walk leads down to another garden gate, and at this corner of the garden is a curious figure of a kneeling Moor holding up a sundial. He has been brought here from one of the Inns that have vanished, and is over 200 years old, the work of the Dutch sculptor John Van Nost. At the top of King's Bench Walk are Mitre Court Buildings leading into Mitre Court, with the little flagged garden which leads us up a few steps into the old Serjeant's Inn; but we pass under the tunnelled way into Tanfield Court, to see the lovely garden front of the Master's eighteenth century house, and we find ourselves in front of Wren's Cloisters, a little un-Wrenlike but still Wren's. We pass between the sixteen arches into four other Courts, pausing to admire the clever way in which a tiny old bookshop manages to get five windows, to dodge a set of stairs, and to turn round two corners. In this shop lawyers' wigs were made for 400 years. The passage beside it leads us to Fig Tree Court, with no tree and no figs but with four ways out. One way is to Elm Court, with no elm but with windows daintily hooded and festooned. Pump Court has two trees, the pump at which Charles Lamb used to drink when he was 'a little Rechabite of six,' and a black and gold sundial which has been telling the world since 1686 that 'Shadows we are, and like shadows depart.' Hare Court also has a pump and a tree, but little more except its chambers and its memories. We come back to the cloisters, and Temple Church.

The Norman Church

Except for St Bartholomew's and St John's in the Tower, Temple Church is the oldest in London, the finest of the live round churches left in England from the days of the Crusaders, who built them in the style of the church they loved in Jerusalem, the Holy Sepulchre. The porch has been refashioned and has one round and two pointed arches, but the doorway within it is a gem of Norman building, with a fine array of recessed shafts and mouldings, and the flower of Norman ornament is in its lovely decoration of foliage and roses, chevrons and queer faces. In it hangs a massive door about 400 years old, covered with scrolled hinges and ironwork ornament; it swings to our touch yet weighs two tons and a half, and is opened by a key which weighs five pounds.

It opens on to a forest of clustered columns and an arcade of pointed arches circling round us in the nave and straight as an avenue in the choir, where they branch into the lovely vault of the roof, with old painting looking like leaves and dotted with the crests of the Templars, the little holy lamb with the flag and the winged horse Pegasus. The mosaic of red and blue glass shining in the triple east window is a delightful vista from the west doorway. Over this doorway is a fine Norman window. The Round is covered with a conical roof, and its aisle has lovely vaulting. Round the wall runs a seat with an arcade of sixty pointed arches and capitals of which no two are alike. Some of the heads are said to represent souls in purgatory; they are an extraordinary collection, with vivid expressions. Over the arcade is the triforium, its Norman arches linked with each other on marble shafts, and above are the Norman windows of the clerestory.

A small Norman doorway leads to a stairway at the top of which is a tiny cell in the thickness of the wall, four feet long and under three feet wide, lit by two slits in the stone.

But it is on the floor of the Round that the eye of every visitor falls. Here lies an impressive array of Templars, perhaps the best preserved collection anywhere. Most of them wear chain mail and coats, with shields and swords, as on their crusades. The most famous of all is Geoffrey de Mandeville, Earl of Essex, the bold baron who fought King Stephen and plundered Cambridge.

Later we may come and find ourselves locked out, the Temple wrapped in silence, its 320 people secure within closed gates.

The City's Riverside

From the Embankment to the Tower

The City's riverside begins at a spot marked by a tablet on the railings of Temple Gardens, and runs to within a stone's throw of the Tower.

Coming along the Embankment from Westminster, we notice the change on the lamps, which now bear the City arms, and there is a medallion of Queen Victoria where the famous Square Mile begins. On the right we come to the training ship President, which rises and falls with the tide so that sometimes, walking down Temple Avenue, we see it rising up in front of us and at other times hardly see it at all. The group of buildings facing it are a great insurance office, the old home of the telephones when they were private property, the new Carmelite House, the headquarters of Reuter's, the beautiful Sion College, and then the City of London School and the vast Unilever House which has transformed the corner of Blackfriars.

Telephone House, from which the whole telephone system was administered when this century began, has a lovely figure of Mercury high above the roof. Its next-door neighbour is the extension of the original home of the Daily Mail, which started its sensational career in the old building just behind it. The new building rises austerely from its own little garden and can turn out half a million papers in an hour. Its beautiful silvered bronze doors tell the story of how it is done, having eight panels showing a ship bringing paper from Newfoundland, 45 miles of paper on a lorry bringing it to the press, the types of press on which it is printed, the telephone wires, and a monoplane showing how the news is collected. Reuter House, with a lovely oriel and a doorway in medieval style with quaint faces and roses, joins the lovely building of Sion College, a fine block of brick and stone rising from a little lawn, with turrets and gables and a dainty oriel, and richly traceried windows with stained glass. Its archway is finely carved in sixteenth century fashion.

Sion College itself, begun as a library 300 years ago, is now housed in this gracious Gothic building designed by Sir Arthur Blomfield. It is one of the loveliest facades of the old Embankment. Inside arc over 110,000 books, one of them, its chief treasure, being the York Breviary, the only copy known of the Service Book of York. Its 450 vellum leaves were written with words and music over 600 years ago.

Looking across the street to Sion College is the City of London School, an imposing pillared building. On the front are statues of Milton, Shakespeare, Bacon, and Newton, with Sir Thomas More round the corner. The school was founded by John Carpenter, the town clerk of London who was a great friend of Dick Whittington, and 500 years ago left money for the education of four poor boys. There is a portrait of John Carpenter in the porch of the Children's Newspaper, facing the school, and across the street called after him is the Guildhall School of Music, with its own theatre.

The Embankment ends with the colossal building like a fortress, as indeed it is, a bulwark of industry almost unparalleled in this country, Unilever House, housing the London staff of Port Sunlight and all its allied industries. It stands on the site of Henry the Eighth's Palace of Bridewell and is in itself a palace, on which a million pounds has been spent. Its beautiful rounded front faces all who cross Blackfriars Bridge, and the building stands impressively at the entrance to the City. The ground floor has a windowless wall 25 feet high as a protection from the roar of traffic, and from the fourth floor to the cornice rises a majestic colonnade. High up at the ends of the building are fine stone groups carved by Sir Reid Dick, representing Controlled Energy, and showing men and women restraining powerful horses. On the keystones below are a merman and a mermaid, the work of Gilbert Ledward. By the main entrance are impressive bronze lamp pylons with reliefs showing the collection in the Tropics of raw materials for the business housed in this great place. He also designed the big bronze gates here, each leaf weighing a ton and a half; when made they were the biggest in England cast in one piece. The enrichments on the gates are suggestive of the oil palms of West Africa. In the arch over the doorway are the signs of the Zodiac, and Professor Ledward's delightful bronze panels of the seasons.

Queen Victoria, having after many years turned her back on the Thames and now looking into the City, stands with the orb and sceptre at the end of Blackfriars Bridge, widest of all the bridges across the river. From a pipe beneath it runs the old Fleet River, as we may see from the subway steps. New Bridge Street now covers its course, with Farringdon Street across Ludgate Circus.

We have seen modern London's fine front to the Thames; we will now follow its original waterfront in Thames Street, so full of association, but now perhaps the drabbest street in London. Not even the City Corporation can adorn this street or brighten its gloom.

Red flags waving front warehouses warn us not of Communists but of cranes, and mysterious passages with quaint names lead darkly to the Thames. Puddle Dock, first of many inlets along this shore, was probably

the wharf of the earliest Baynards Castle, built by one of the Conqueror's henchmen to guard the west end of the City as the Tower guards the east.

By the turning to St Paul's Pier we come to the red brick church of St Benet, with the tower, cupola, and lantern rising 115 feet. The seventeenth century altar table is one of the finest in the City, winged angels supporting a rich cornice, and under the table is a figure of Charity with her children.

A fine length of the Roman wall, eight feet wide and built between piles, was found 16 feet below the pavement where Brook's Yard joins Thames Street, and remains of several Roman buildings have been found along the river here.

Wren's classical tower of St Mary Somerset worthily carries on the Roman tradition, and adds a touch of welcome brightness to this grimy street. The church to which it belonged has been pulled down, and the tower now contains a rest-room for working women of the City. From it Broken Wharf leads to the river at the spot where stood the town house of Sir Thomas Sutton, founder of Charter-house. Queenhithe Quay, nearly the oldest dock in London, affords a splendid view of ships passing Southwark Bridge, while the chimneys of Bankside power station stand up strangely on the farther bank.

Huggin Lane has the graveyard of the vanished church of St Michael, and the rectory next door has the top of the old spire capped by a weathervane in the form of a three-masted ship. In Little Trinity Lane is the seventeenth century hall of the Painter-Stainers Company, its beautiful doorway carved with festoons, its court room windows with some seventeenth century glass, its walls hung with paintings by famous artists.

The Byways, City Halls and Churches

Round the corner on Garlick Hill is the magnificent church of St James Garlickhithe, built by Wren long after the last garlick was sold on the river bank here. It is one of his finest churches, though the rough stonework of the tower strikes at first a strange note. The lantern is a graceful piece of work, and the splendid clock bracket stretches towards the road. It has the date 1682, and is capped by a modern figure of St James.

The interior, with parquet floor and gilded ceiling, is palatial, and has colonnades supporting a rich cornice. The gallery rests on two seventeenth century classical pillars, unusual because they are iron. Above them is the organ by Father Smith, with saucy cherubs perched on the pipes, waving palm branches and blowing trumpets with all their might. There are cherubs on the white marble font, fruit and flowers on the screens, and a dignified pulpit with a massive sounding-board. The seventeenth century altar table

is carved with doves. The lion and the unicorn are fighting for the crown on the front of two of the pews, their gilded wooden figures flanking rich iron sword-rests used when the Lord Mayor comes to church. The pews have hatstands, and there is a peg in the pulpit for the parson's wig.

Here is one of the gruesome relics we come upon at times in the wonderful City. In a cupboard in the vestibule is preserved a mummified man, reminding us of the duke's head we see in another City church, or the mummified boy found in one of these churches and preserved at the Royal College of Surgeons.

The Vintners Hall has a beautiful modern front looking on to Thames Street, the fine bronze doorway having a pair of swans in the fanlight. The Vintners and the Dyers have the right to keep swans on the Thames, and mark their beaks each year at a ceremony know as swan-upping. The court room here was built nearly 500 years ago, and has a Rubens painting of St Martin. A piece of tapestry made in 1466 shows the saint dividing his cloak with the beggar, and another treasure of the Company is the ancient pall used for funerals of its brothers. The rich collection of plate includes an exceedingly rare salt cellar of 1569 with decorative figures, and the Milkmaids Cup of about 1650. Chaucer's father belonged to the company, and the poet lived at his father's wine shop, where Cannon Street station now is. The hall is at the corner of Queen Street, which runs from the direction of the Guildhall to Southwark Bridge. It is the newest and least used of the City bridges; about vehicles cross it every day.

The fine modern buildings of Thames House and Vintry House are both rich in carving, among which we notice fish and dolphins. Vintry Ward School is in Brick Lane, and, though now made into business premises, it still keeps the old niches with figures of a boy holding his hat and a girl with a book. Three Cranes Lane near by was the resort of Ben Jonson and the wits of his day, and Pepys tells us how he dined here with his poor relations. In this lane Oliver Cromwell's widow hid seventeen cartloads of household goods brought from Whitehall Palace.

In College Hill is the church of St Michael Paternoster Royal, where Dick Whittington sleeps. The church was rebuilt under Wren's direction by his master-mason Edward Strong. The steeple has a lantern, the tower a pierced parapet, and there are quaint heads over the south windows. The interior is admired for its seventeenth century woodwork. Cherubs and fruit and flowers adorn the pulpit. The gilded reredos looks like a classical portico. Above it is a picture of Our Lord with Mary Magdalene, and at the sides are Moses and Aaron in stone. The lectern is unusual for having a carved figure of Charity with three children standing on the back of a grotesque figure

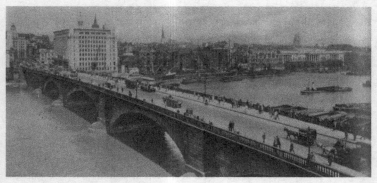

London Bridge and Adelaide House

of Envy. Some of the stalls and pews are enriched with friezes, and on two of them are iron stands, one for the Lord Mayor's sword and one for hats. Among several fine old doors is one partly filled with ironwork, bringing us into the lady chapel. There is a splendid candelabra made in Birmingham in 1644, and two handsome seventeenth century chairs.

The Tallow Chandlers Hall is round the corner in Dowgate Hill, a street called after a Watergate which led to the Thames. The hall, rebuilt after the Fire, has a beautiful panelled reception room; it has also a candle first lit at the coronation of Queen Anne. Much of the hall was made new in the ninth century. The seventeenth century Skinners Hall just below is adorned with a row of pilasters guarded by a pair of dogs in the pediment. The famous cedar room has a magnificent fireplace, and the massive staircase has paintings by Frank Brangwyn. Two strange animals prance beside the coat-of-arms over the doors. Round the corner in College Street is the fourth of this cluster of famous halls, the seventeenth century building of the Innholders. Its fine plate survived the Great Fire because, by chance, it had been moved to the Master's inn at Smithfield. The St Julian spoons are unique, like apostle spoons with the company's patron saint in place of the apostle.

Joiners Hall is remembered by Joiners Hall Buildings, where a doorway leading to a yard is carved with a queer narrow head below two stalwart wreathed men with clubs. Down Cousin Lane, past the narrowest block of buildings we have seen, is Dowgate Dock, curiously remote, but bustling with life a thousand years before the docks of today were thought of. Here we can see the River Walbrook up which the Romans may have sailed; now it runs through a pipe.

Plunging through the gloom of Cannon Street Station, we reach a garden on the site of the church of All Hallows-the-Less, once called All Hallows-on-

the-Cellars. Between the garden and the street is a curious little building set up before the days of policemen; it was for the parish watchman. From Swan Lane we have a view of Southwark Cathedral, and now we come to London Bridge. Gone are the days when London Bridge was one of London's spectacles, packed with medieval houses and shops. Some of the old stones remain, but the bridge was rebuilt last century by John Rennie and his sons.

On one side of the approach is Fishmongers Hall, with a pair of prancing horses above its columns. There are portraits by Romney, and a statue of Sir William Walworth carved in English elm. But the greatest treasure of the company is displayed in a glass case in the entrance hall; it is a magnificent fourteenth century funeral pall embroidered by nuns, on which is St Peter enthroned among angels.

Across the road stands Adelaide House, stark and defiant, as if scorning the critics who have condemned its stone ribs rising with clean simplicity to London's sky. Its deeply-set windows alternate with panels carved with stars as they climb to the great cornice. Over the entrance (which has sturdy black pillars) are the arms of the Australian States and a figure of a woman holding a globe.

Adelaide House has blocked for us the view of St Magnus the Martyr. Standing by the river's edge, it has one of Wren's finest steeples, climbing into the sky with a lantern and a cupola and a spirelet just peeping over the roof garden of Adelaide House; and projecting from the tower is an ornamental clock given in Queen Anne's time by Sir Charles Duncombe, the richest commoner in the land.

The church is handsome with white pillars and has a full share of the seventeenth century art that delights every visitor to the City churches.

The pulpit and its great canopy are richly carved; the reredos has the pious pelican and paintings of Moses and Aaron, two unusual columns support the gallery, and there is a sword-rest with much painted heraldry, and a striking modern figure of St Magnus holding the church in his hand.

The organ has a distinction of its own, having been something of a sensation when it was new in 1712. It was the first to have what is called a swell organ, a group of pipes set apart in a box that can be opened and closed to vary the volume of sound. Such a device is now used in organs everywhere.

Billingsgate

Billingsgate Market is a little way along the street, its main building set up sixty years ago, with Britannia of Billingsgate looking down from a pediment. The Coal Exchange, on the other side of the road, has a round little tower. The floor of the Rotunda is inlaid with 4,000 pieces of wood and represents a mariner's compass, the black oak used in it coming from the Tyne, where it had lain five centuries. The City arms are also worked into the floor and the mulberry wrought into the blade of the dagger came from a tree planted by Peter the Great when he worked at Deptford Dockyard. The Watermen's Hall has stood on St Mary-at-Hill for 160 years with its fine front of dignified pillars and a beautiful fanlight. The Custom House has a long plain front to Thames Street and a magnificent front to the river, though we found this disgracefully hidden by huts erected during the war.

Up Beer Lane is the famous church of All Hallows-by-the-Tower. It is one of the most complete old churches in London and one of the most historic, for, although the Great Fire almost passed it by, it has the marks of the Great Fire of London lit by Boadicea. We can see them in its foundations, for we may go down into them to the Undercroft and see pieces of Roman pavement and walling of a Roman room that has come to light, with cooking pots, drinking vessels, and lamps. There is also here a fine model of Roman London, with hundreds of tiny houses and buildings and a trestle bridge over the Thames; and a diorama shows the last foes to come up the river.

But today it is the holy of holies of Toc H, and here burns for ever the first Toc H Lamp of Maintenance, from which all lamps of new branches are lit. It stands in a magnificent casket on the tomb of Sir John Croke, lavishly adorned with shields and Tudor roses and with the brass portraits of Sir John, his wife, and their twelve children in the dress they wore at the time he died in 1477. Close by the ever-burning lamp lies the fine bronze figure of a soldier in his greatcoat, symbolising the sacrifice of Youth in the war.

Here also is one of the most precious possessions of Toc H, the wooden cross from the grave of Gilbert Talbot at Hooge. Above it is a Red Cross flag which hung for two years above a dressing station on the Ypres Canal; the pennon borne on the field by Lord Plunier; the parchment leaves of a book with the names of those who worshipped in the first little Toc H chapel at Poperinghe; a sword carried in France by Edmund Street, DSO, and the sword and the rugger cap of Sidney Woodruffe, the first VC of the New Armies.

The windows are bright with pages of heraldry, the east window having a fine scene of the Presentation in the Temple in memory of the four first builders of Toc H. The east window of St Nicholas Chapel has a charming

picture of old London of Charles Stuart's day, with a fascinating study of towers and spires rising above gabled houses, a little ship sailing by the Tower, and the spire of old St Paul's; and at the foot are two men holding ships before the altar – Edward Grobbe of 1278 and John Rolff of 1452, who bequeathed their barges to the church.

All Hallows has one of the best brass portrait galleries in any City church, beginning with one of the oldest known, showing William de Tonge, who died in 1389.

This church which carries us back to Roman days has arcading taking us from early Norman days to the fifteenth century, for the western pillars and their capitals come from 1087, others were made new in the thirteenth century, and the slender pillars in the chancel are fifteenth. There are rich panelled pews, a chair with a carved panel of the Sower, a pulpit with a Jacobean canopy and a handrail of Sussex iron, some sixteenth century figures of saints, and a seventeenth century reredos and altar table, the table with four eagles at the foot. The font cover is supposed to be by Grinling Gibbons, as is the organ case. The choir stalls marked last century's Jubilee of Canon Mason and are carved with angels watching the life of the countryside, a squirrel cracking a nut, a bee coming from the hive, a butterfly from its chrysalis, and mice playing round a tree. There are three sword-rests of eighteenth century lord mayors, and a lead cistern of 1705.

Two small crypts have been found and restored, one reached by a flight of steps and now with eight Flanders crosses round the walls, and pictures of Assisi and St Francis, the other a seventeenth century burial vault made into the Oratory of St Clare, whose small figure is in the window; she was the friend of St Francis.

Up Seething Lane is Pepys's church of St Olave in Hart Street. St Olave's is one of the few City churches the Great Fire passed by. It has a charming fragment of early Norman days, but much of it is fifteenth century. It is an amazing little place to find in the hubbub of the City, with a stately vaulted roof rising from walls of lovely light stones in crazy fashion. Its canopied pulpit is carved with flowers hanging from stalks, there are two studded old doors, four sword-rests, and many brasses and monuments. Set into a pillar are figures of two brothers in red cloaks and ruffs, Andrew and Paul Bayninge of Shakespeare's day. The battered figure of Sir John Radcliffe of 1568 is in armour, and it is thought the stately kneeling Tudor lady in a flowing gown may be the mother of Sir Philip Sidney. A Florentine who died in exile here in 1582, Peter Capone, kneels in armour, and the rich merchant Sir Andrew Riccard stands in a big marble monument; he was knighted by Charles the Second. Sir James Deane kneels with three wives in Tudor dress. The physician Peter Turner has a painted figure of 1614. Tobias

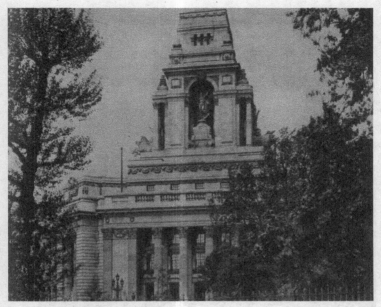

Port of London Building

Wall and his wife are seen in the height of fashion in their busts of 1744. In brass are the portraits of John Orgone and his wife. Lord Mayor Richard Haddon kneels in brass with his two wives and their five children of 400 years ago. In the tower is the figure of a woman resting on bales of merchandise, a monument to Monkhouse Davison and Abraham Newman, partners in an eighteenth century grocery business which sent tea to America.

The GHQ of the PLA

This magnificent pile, designed by Sir Edwin Cooper and opened in 1922, strikes a note of dignity and grandeur worthy of this famous site, and in its magnificent tower gives to Dockland a feature akin to the Victoria tower in the westward reaches of the Thames. The doorway is guarded by four Corinthian columns rising to a height of three storeys and supporting a balustraded balcony, like a veil hiding the eyes of the windows behind it. The pillars and pilasters flanking the other doorways are of the same noble height. The heavy cornice runs unbroken round the building and nearly all the ornament lies near the level of the capitals.

Ten times the tower changes its shape as it climbs. Seen from the river the chief feature of the tower is the lofty niche in which is a figure of Father Thames with a sea serpent at his feet. The keystone of the arch is carved and the relief is carried on in the spandrels and the capitals of the small pilasters. In the westward niche of the tower is a companion group with a winged figure of Prowess standing in a galleon drawn by sea-horses. In

The Docks – A glimpse of the Royal Albert

London Docks

the eastern niche the pace is slower – an oxen chariot in which a woman stands aloft bearing a torch. She is the Triumph of Agriculture and one of her attendants called Husbandry leads the team. All these fine groups are by Mr Doman who also carved the massive figures on each side of the portico. One represents Commerce, a gallant figure with account books under his feet and in his hand a basket of merchandise, and near him are scales, the Lamp of Truth, and other tokens of fair and honest dealing. The other is a romantic lady representing Navigation, her hand gripping a steering wheel and her feet resting on the globe round which the Signs of the Zodiac go prancing eternally.

It is pleasant to go round this great building looking for details. The lamps are charming and we counted on them sixty sea lions and rams' heads in bronze. There are stone heads and other ornaments adorning the corner entrances and the windows which break the long line fronts of Pepys Street and Seething Lane. There are two bulls, six rams, six lions, and two fascinating owls perched on the top of a galleon. The windows are a beautiful shape, many of them with balconies. One of the most charming details of all we come upon as we enter the building by one of the five superb doors of the main portico, each door having for a handle an exquisite little mermaid sitting on a sea-horse, with a tiny galleon over her head on which is the date 1921. There are twenty of these bronze fantasies and they are the most fascinating door handles we have seen in London. The mermaids draw us in away from the heavy outer walls of Portland stone into a superb cream marble vestibule rising to two storeys. Here we see before us four more double doors into the great rotunda which is the secret heart of the building, 110 yards round and 67 feet to the top of the great dome of light that covers it. All the corridors and doorways of the building meet in this great hall, a hive of industry encased in marble. There are marble pillars over 16 feet high guarding doorways and windows, and decorated panels above them telling the story of the trade of the sea. Above the four main entrances are medallion portraits of Cook, Drake, Hawkins, and Nelson. High in the middle of the roof, supported by eight slender oak columns, is a magnificent clock with four faces. The dome above all is studied in little panels in white plaster and has a lantern like a great flower. Up in one of the higher storeys are medallions of George the Fifth and Queen Mary who opened the building.

Between the windows are carvings representing trade and sea power, and amid all these carved shapes is one piece of fine colour, de Laszlo's portrait of Lord Devonport, first chairman of the Port of London Authority. From the finely moulded ceiling hang two superb chandeliers with thousands of cut

crystals gathered from all parts of the world. There are several paintings of merit in this great building and a few portraits, and one picture we remember is a faded map of the riverside with a table of names of the Courts, Alleys, Yards, Rents in the hamlets of Stepney and Spittle Fields. A long rope winds round the hamlets with ships on it to show that it is the Thames.

The Wonderful Docks

The London Docks are nearly all on the north bank, only the Surrey Docks (chiefly concerned with timber) being on the south. On the north the Docks begin almost under the shadow of the Tower and within sight of PLA House, continuing with St Katharine's Docks, in tortuous waterways behind the river, through East and West India Docks, Millwall Docks, till they end with Tilbury Docks, made to receive the biggest liners coming to the Port.

To most of us Dockland is an undiscovered country, but in these days all may see it comfortably with the help of the PLA, which organises visits to the docks by steamer during summer. The best way to reach the heart of the docks is by train from Fenchurch Street to Royal Albert Docks, where a visitor with a permit (easily obtained by writing) is guided to what is most worth seeing.

George the Fifth Dock, opened in 1921, cost £4,500,000. There are over 100 cranes with a reach of such capacity that they can discharge three ways at once, reaching over the ship's farther side as well as on the wharf. Any one can lift three tons, some up to 25 tons, and the biggest, a floating crane called the British Mammoth, lifts 150 tons. From the top of the Mammoth on a clear day Hampstead and Sevenoaks can be seen.

Even in the smallest dock is half the world reflected, the produce of the Seven Seas and the Five Continents, and seeing the docks as a whole it seems as if the world's produce is spread out like a carpet on the floors of quays and warehouses and great sheds. There are three acres of floor space alone for showing carpets from Persia, India, Turkey, and China.

The Beautiful Trinity House

Hereabouts is the beautiful Trinity House erected at the end of the eighteenth century as the headquarters of the Trinity Brethren, who have controlled the lights and buoys round our coasts for four hundred years and more.

In the entrance hall are many models of lighthouses and lightships, with two huge globes given by an admiral of Charles the Second. At the top of the stairs is a fine picture, 20 feet long, of the Elder Brethren. The first floor is called the quarterdeck, and on it is a relic from old Eddystone lighthouse, the grandfather clock which struck every halfhour to warn the keepers to trim the

great wax candles we see here, weighing half a pound each. The most magnificent apartment is the court room, its splendid painted ceiling suggesting the security and prosperity of Britain arising from the power of the navy and the spread of commerce. There are many portraits and busts in the rooms, several busts by Chantrey, and portraits by G. F. Watts and Hubert von Herkomer.

In Mark Lane is the Corn Exchange, with its big sale rooms extending from this street to Mincing Lane, famous for sugar and spice and tea. Here is the Clothworkers Hall, with an elaborate front and rich ironwork gates, and with gilded statues of James the First and his son.

Remarkable Steeples

At the back of the hall, reached by a narrow passage from Fenchurch Street, is a little churchyard which has lost a church and found a crypt. It still has the fifteenth century tower of the lost church of All Hallows Staining, now overtopped by three plane trees, and keeping it company is a Norman crypt which has been brought from Lambe's Chapel, Monkwell Street, and reconstructed here.

The Bakers Hall is in Harp Lane on the other side of Great Tower Street. It is hidden behind buildings, and all we can see are the marble walls of a corridor etched with scenes in the history of the company. Down Idol Lane is the church of St Dunstan-in-the-East.

It is most famous for Wren's sensational steeple, perhaps the most striking skyline in London, a slender needle supported by four flying arches rising from the pinnacles of the tower. The rest of the church is nineteenth century. In a corner is the reclining figure of Sir William Russell, a charitable alderman in flowing Queen Anne wig, long close-fitting coat, and buckled shoes, and opposite are little soldiers standing by the stone of James Burkin.

On the wall of the sanctuary is a roll of honour designed in ebony and ivory by Sir Herbert Baker, and in the vestry is a wood model of the church as designed by Wren. At the corner of Rood Lane and Eastcheap is the church of St Margaret Pattens.

The Patten Makers still meet in the church once a year. Their flag with arms of three pattens and knives, and the motto 'Women receive support from us' hangs from the gallery. There are old pattens in a case, and a copy of the old notice requesting women to remove their pattens and men to wipe their feet.

A shop with a fine front of 240 years ago keeps company with the church, whose story begins with a wooden chapel of the eleventh century. The church rebuilt in Tudor days was destroyed by the Fire; in the one Wren built in its place he attended service, sitting in one of the fine canopied pews which

has C. W. 1686 in a medallion. He gave the tower his tallest leaded spire, climbing to 200 feet. In all London there are only two steeples higher, the stone ones of St Bride and Mary-le-Bow.

Much of the woodwork has been made new with the old material. Quaint and pleasing is the imposing gallery with its fine stairway. The pulpit is notable for its inlaid work, and on the wall are the old pegs on which wigs were hung on hot days. Two carved chairs and chests are seventeenth century. The reredos has rich carving which may be by Grinling Gibbons and a tapestry of the Upper Room at Emmaus. Two pictures on the wall (Pontius Pilate and Joseph being sold at the well) are in needlework of 130 years ago.

From St Margaret's we look down a narrow street to the projecting clock of St Mary-at-Hill. This church is entered from Love Lane, and with its grimy brick tower gives no promise of what we are to find inside, where all is neat and trim. The body of the ancient church was burned in the Great Fire and was rebuilt by Wren, but the old stone tower carried on till 1780.

The interior is an oblong with a roof like a cross, in the middle of which is a small dome on four columns. Its striking feature is the woodwork, some of it seventeenth century. There is a gallant display of richly-panelled pews; old chairs, and a great carved reredos. The canopied pulpit has an imposing stairway of eleven steps, its rails and banisters carved, and specially fine is the carving of the back board, its trailing bunch of flowers and fruit good enough for Grinling Gibbons, but signed W. G. R. 1849. The oak font cover, enriched with angels and cherubs, is said to have been saved from the Fire. The seventeenth century stone sculpture of the Day of Judgment now in a vestibule was once over a gateway. In the nave are six fine sword-rests, one of the best collections in any City church. A famous man remembered here is John Brand, the beloved antiquary who wrote of the folklore and customs of our land; he was rector here twenty-two years, and sleeps near the altar.

The Monument of the Great Fire

Pudding Lane, where the Great Fire started, is overshadowed by Wren's Monument, London's memorial of that great event, the highest and finest column of its kind in the world. The four dragons on the corners of the pedestal are by Edward Pierce. The striking relief on the west front is the work of Caius Gabriel Cibber, the Danish sculptor who carved the Phoenix above the south door of St Paul's. We see Charles the Second and his brother in Roman costume, protecting the stricken City and encouraging its rebuilding. The languishing spirit of London is sitting on the ruins with burning houses above her and a dragon below. Time is raising her up, and

a woman nudges her to look up at Peace and Plenty sitting in the clouds. At the command of the king Science, Nature, and Architecture descend to help London; and above the figures of Justice with a coronet and Fortitude with a reined lion is a graphic scene of rebuilding showing labourers ascending scaffolding. Here also is the curious sight of Envy gnawing a heart and Liberty waving a cap.

At the back of a wonderfully paved yard up Abchurch Lane is St Mary Abchurch. It has a tower rising 140 feet with its cupola, lantern, and spire, crowning the church which Wren built after the Fire. Hiding away in a narrow lane, it is almost square inside, with white walls and a richly-painted dome pierced with windows in which are Faith holding a flaming heart, Hope with an anchor, and Charity with children. Above these are angels and cherubs singing and adoring, thought to be the work of Sir James Thornhill. The dome is a fine sight when flooded with light. Reaching almost up to it is the elaborate reredos with pillars and a pelican with outspread wings; it is notable for its lovely festoons of fruit and flowers, said to be (like the pulpit carving) by Grinling Gibbons. Over one of the richly carved doors is a brass pelican, and the Four Evangelists adorn the seventeenth century cover of the font. The lion and the unicorn are on two pews; the high pews along the walls are finely carved, and on the official pews are two elegant sword-rests. There is an ornate monument to Sir Patience Ward of 1696, Lord Mayor of London and a zealous Whig.

Opposite the station is the church of St Swithin, London Stone.

London Stone

Sandwiched between two streets, the church takes its name from the famous Saxon bishop and the ancient stone embedded in its wall. From the octagonal top of the square tower rises a spire to 150 feet, built, like the rest of the church, by Wren. Above the panelling of the walls the trim interior is white and gold, including the rich domed roof resting on eight pillars and powdered with gold stars on a blue sky. A fine old ironbound chest is kept open to show the intricate works of the lock, enriched with flowers and covering the whole lid inside. The seventeenth century pulpit has lost its great canopy, but the splendid iron sword-rest remains. There are wooden mullions in the windows. The ornate monument with weeping children is to Michael Godfrey, a Bank of England governor who was brought here in 1695 after being killed by a cannon ball at the Siege of Namur.

The Founders Hall is up St Swithin's Lane, and is entered through a plain office building. Over the door are arms showing a pair of candlesticks and a motto, God the only Founder. The century-old Salters Hall near by

somewhat resembles a country house, its forecourt planted with trees. The magnificent iron entrance gates are cunningly fashioned with birds and beasts. In a house on this site lived Henry Fitzaylwin, who became the first Mayor of London in 1189. A graceful iron sign hanging over the archway marks the entrance to the famous house of Rothschild.

Back in Cannon Street we come to the fine modern building of the London Chamber of Commerce, and in Sise Lane is a marble monument on the site of the lost St Antholin's Church. Between two columns is a panel with a relief of this beautiful building by Wren.

Near by is a church of his still standing, St Mary Aldermary. The lower part of the tower is a relic of this building, the second stage is 300 years old, while the top was built about 1700. The panelled corner turrets rise smoothly to high and solid-looking pinnacles.

The most amazing feature of the interior is the fine ceiling of fan tracery, not of stone but plaster. The fine oak doorway at the western end is beautifully carved. Also of seventeenth century oak is the splendid pulpit enriched with carving of fruit and flowers. The very unusual sword-rest fixed to one of the clustered pillars in the nave is 1682; it is of richly-carved oak, not iron, and is capped by a lion, and a pair of flying cherubs holding a crown.

Everything is here as it has always been, the pews coming up to our necks when we sit down, the pulpit with its splendid sounding-board, the marble font with a cover like a richly carved bell, the handsome gallery, the

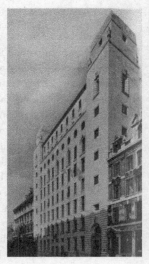

Faraday Building

altarpiece with flaming urns. Pews for the churchwardens and the clerk are enriched with friezes, and on the civic pew a lion and unicorn prance gaily with sword-rest between them.

The peace memorial of St Mildred's is a Te Deum window given by Lord Wakefield, who gave also the splendid bronze monument to one of our half-forgotten heroes, Admiral Arthur Phillip. It is on the wall of the church outside, and has a bust of the admiral, a model of his ship, and two scenes of his landing in New South Wales, where Sydney now stands.

Lower down Queen Victoria Street is the church of St Nicholas Cole Abbey. It was probably the first City church Wren completed after the Fire, and the tower, with a leaden lantern and an iron balcony, is a curiosity he never repeated. The outside walls are capped by stone balustrades, and inside they form a square room lit by a beautiful red roundel by Burne-Jones. The Italian sanctuary lamp is seventeenth century work from Rome, and of the same century is the fine brass chandelier which hangs gleaming from the middle of the square- panelled roof. Kept on some disused bread shelves is a piece of Roman tessellated pavement with some floor tiles from the medieval church on this site.

The beautiful pulpit of seventeenth century oak looks well with its saints on gilded panels. The sixteenth century lectern from Rome almost hides in its carved scrolls a tiny ivory figure of St Michael not less than 1,000 years old. About 400 years old is a Flemish painting of the Madonna above the altar in the small lady chapel, and on another wall is a little Crucifixion attributed to Van Dyck. By a door hangs a Spanish painting of the Infant Christ in a frame 400 years old, and on a bracket is a tiny St Nicholas bringing to life the three little boys in a pickle pot.

On the same side of the street is the College of Arms, a dignified seventeenth century building round three sides of a courtyard. Its finest apartment is the panelled Court Room, with its throne enclosed by oak balustrading. In this building the Heralds trace pedigrees, build up coats-of-arms, and arrange the conduct of certain royal ceremonies. In the library are the sword, dagger, and ring of the King of Scotland who fell on Flodden Field, and there is a wonderful medieval roll portraying in gay colours a gorgeous tournament at Smithfield. Here are two draft copies of the arms granted to John Shakespeare in 1596. In Bell Yard at the back of this building is an inscription marking the place from which the only existing letter to Shakespeare was written; the letter is now at Stratford.

Faraday Building, the World's Switchboard

Since then the words of Shakespeare have gone all round the world, and here is a house that will send ours round the world in a flash. It is Faraday Building, the world's telephone exchange, a great white building, buttressed by massive towers, where the telephone operators speak every language in Europe.

Across Queen Victoria Street is the GHQ of another worldwide power, the Salvation Army, the most remarkable movement the world has seen among the poor. In the library of Bible House is a unique collection of the Scriptures, some written on papyrus, and in the Committee Room is a portrait of Lord Shaftesbury by Millais, and E. M. Ward's picture of Martin Luther.

Up the steps next door, looking down on Queen Victoria Street, is St Andrews-by-the-Wardrobe, a fine church probably unsurpassed in the City for sober dignity. The earlier church on the site had for a neighbour the building which housed the king's wardrobe. The brick walls have grown old gracefully, and hide within them wonderful seventeenth century woodwork, the most striking piece being the lofty reredos capped by flaming urns. The sanctuary is flanked by high screens of gilded ironwork, and there is a handsome iron sword-rest on a pillar of the gallery.

The great east window shows Joshua commanding the sun to stand still, and is said to have been refused as a gift by the Guildhall. A smaller window shows St Anne teaching the Madonna, and is the work of Mr A. K. Nicholson; his brother Sir Charles planned the chapel it lights. On its little altar is a pair of seventeenth century candlesticks.

Its altar picture shows the landing of St Augustine, its curtains are embroidered with the prancing Kent horse, and a pair of iron candlesticks were made in the ancient Kent smithy at Plaxtol. A curious old piece of metal is the copper canopy of the 250-year-old bishop's chair.

The seventeenth century pulpit is rich and of great dignity, and its huge sounding-board once echoed to the thunderings of the famous preacher William Romaine, who still fixes his eye on the congregation from St Anne's chapel, where his bust caps a carved relief of Faith pointing a telescope to a figure of Christ in the clouds. It was John Bacon who carved this queer sculpture and his son carved the reclining angel in memory of Romaine's successor, William Goode. Next to it is a bust of the grave-looking Isaac Saunders, who died in the pulpit; a relief shows him being borne by angels to a crown of glory.

Close by in Water Lane is Apothecaries Hall, with a gilded archer riding on a dragon over the door, a unicorn lying on each side. The Hall is panelled in black oak with a gallery to match, and has a handsome screen, a sketch

of John Hunter by Reynolds, portraits of James and Charles, and one of Keats. It has also a catalogue of plants with notes by John Ray, serving to remind us that for 200 years the Apothecaries owned the Physic Garden of Herbs which we may see at Chelsea.

Hereabouts also is Playhouse Yard, now overlooked by the office of the first daily paper to be printed by steam, the greatest newspaper in the world, The Times, spiritual citadel of our civilisation.

A Walk Down Fleet Street

Fleet Street

Let us take a walk down Fleet Street and see this place which fills the world with laughter and pity and fear, and often with the love of something that is fine and true. We shall find it a surprising place, a little narrow street that has widened itself and made itself new since this century began, so that only the Cross and the Crown are the same, a street that has now begun to change itself once more, so that one day it will have a noble dignity. Even now it has two buildings by Christopher Wren and one by Inigo Jones, a little flagged garden and a green lawn, a patch of tulips every Spring and four small trees, three queens looking down, and a great glass house. There are few streets in London with such a group of interesting possessions.

Fleet Street begins at the Griffin, once the ugliest thing in London but with many rivals now. In the days before ours the street began at Temple Bar, a little gilt model of which hangs on a building near the Griffin. That is all London has of the Temple Bar which was carried away into Hertfordshire in 1879. It stands 30 feet high, and on the pedestal are statues of Queen Victoria and the Prince of Wales, heads of the Duke of Clarence and the Lord Mayor of the day, and below them two bronze reliefs with about a hundred figures, showing the Queen riding to the City in the first year of her reign and again in 1872, when the Prince of Wales recovered from a serious illness.

We will begin at Number One, opposite the Griffin, on our right. It is the white stone bank of Glyn Mills, though it still bears the name of the old Childs Bank which had Nell Gwynn and Samuel Pepys and Charles the Second on its books. Almost next door is the gatehouse of the Temple, built by Wren, with a little holy lamb above the door and the date 1684. It leads us down to the heart of noisy Fleet Street's quiet neighbour, the beautiful Temple, but we come on to Fleet Street's oldest building, Prince Henry's Room.

Best seen from the corner of Chancery Lane, the house was built in 1610, and, excepting Crosby Hall, reconstructed in Chelsea, it is probably the oldest house of its period in London. It is an excellent example of early Jacobean architecture, with bay windows, half-timbered front, and an open gallery below the gabled roof. The front overhangs and has six carved posts, with decorated panels of the Prince of Wales's feathers between them.

Prince Henry's Room, reached by an eighteenth century staircase, is on the first floor. Its chief features are its plaster ceiling and the original oak panelling on one side, divided by pilasters and with a carved frieze; the other panels are of painted fir. Within the starshaped border in the centre of the ceiling are the Prince of Wales's feathers and the letters P.H., identifying the room with Prince Henry, brother of Charles Stuart. He was made Prince of Wales in the year the house was built, and had he lived there might have been no Charles the First, no Protector, no Commonwealth. Charles thought of him and spoke of him on his way to the scaffold, recalling that he had planted a tree in Spring Gardens.

On the right as we enter is a window commemorating the legend that the Council of the Duchy of Cornwall once met here. Its two central lights contain the coat-of-arms of Prince Henry and those of George the Fifth when he was Prince of Wales, copied from the Garter plates at Windsor. The ornamental framework is adorned with rose, thistle, and shamrock, and the lilies of France; in the case of Prince George the lilies are replaced by the leek of Wales. The window on the left has an artistic treatment of the LCC seal designed by Walter Crane, a crowned and robed figure symbolical of London, flanked by Labour and Science.

Just past Prince Henry's Room is a bank with three squirrels on a window, the sign of the old bank where Warren Hastings and Lord Clive used to call; and beyond is one of the old Fleet Street taverns with a gilt cock outside and the wooden seventeenth century bird indoors.

Mitre Court is not so dull as it looks, for it brings us to a paved garden with a privet hedge round it and straggly hyacinths and daffodils in spring, and just behind it is Serjeants Inn, where are still many Georgian houses, one dated 1669 and one with a medallion telling us that Delane, the famous editor of The Times, lived there from 1847 to 1878. Serjeant's Inn belongs to the Norwich Union, which has ingeniously wound itself about the gateway and has sculptures of Justice and Insurance.

Now we are at Bride Lane and come to Fleet Street's church with the steeple that is often called a bride cake, though it rises 200 feet in tiers of open arches and is the highest spire that Christopher Wren designed, a lovely thing. It has a dozen eighteenth century bells.

The handsome iron gates of St Bride's were set up by the Newspaper Society in memory of Valentine Knapp, and lead us into a churchyard planted with the plane-tree friend of London and gay with daffodils in spring. We come into a nave and chancel like one great hall of white and gold, great arches adorned with gilded roses and cherubs, brass candelabra everywhere, box pews overflowing into the aisles, rows of flowers on the

rounded roof, and panelled galleries, one bearing up the organ in all the golden splendour of gilded pipes, cherubs, and trumpeters.

St Bride's has still one link with the old church destroyed by the fire, a font bowl of white marble on a grey stem. It was made in 1615, and is the only visible monument the Great Fire left for this church. The brass lectern has three scaled animals looking up at a squat eagle. A great eighteenth century mace is ornamented with cherubs and flowers and a harp. There is an eighteenth century banner which once belonged to the schoolchildren of St Bride's; and among the memorials is one to Thomas Weelkes, a sixteenth century composer of madrigals, and one to James Molins, surgeon to the last Stuart kings. The only stained glass window has the Descent from the Cross, with St Bride and St Peter looking out. In Bride Lane, on the dingy wall of a school, are two statues of children dressed as when they came to school 200 years ago; we leave them and are soon at Ludgate Circus, with obelisks to two lord mayors, Robert Waithman the Welshman, who was a linen-draper on this spot, and the famous stormy petrel John Wilkes. Just here was London's first pillar-box. On our right is New Bridge Street running to the Thames, and on our left Farringdon Street covering the Fleet River; we have seen countless bricks carried down a hole to wall it in. In Farringdon Street stands the Memorial Hall on the site of the old Fleet Prison; it is the memorial to 2,000 parsons who refused to obey the tyrannous Act of Uniformity.

His plaque is on the wall of Ludgate House, once the chief home of Thomas Cook and Sons, who set above it the weathervane of a ship, the reliefs of children symbolising travel, and the fifteen heads of races of mankind. Ulster House has a carving of a popinjay and two heads of abbots, because it stands by Poppins Court on the site of the hostel of the abbots of Cirencester, known as Popyngaye of Fletestrete. Near the popinjay is a cormorant on Mersey House; it is part of the Liverpool Arms. Passing the glass house in which Lord Beaverbrook throws stones, we come to the greatest building in Fleet Street, the home of the Daily Telegraph, as sound and solid as the paper it produces. It has massive fluted columns relieving its front of stone and granite, and flaunts a gaily coloured clock 19 feet high. Over the door are two figures of Mercury going east and west, between the windows are five panels of swallows, and 90 feet above are decorated heads representing Journalism of the Past and of the Future. In the stone balcony above the clock is Fleet Street's little lawn of grass.

On a double gabled building close by is a statue of Mary Queen of Scots in a niche, strange companion for Queen Elizabeth farther on. Beyond them stands the fine office with Fleet Street's Four Green Trees, a touch

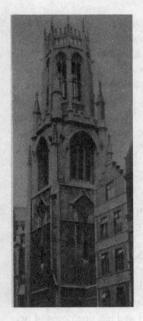

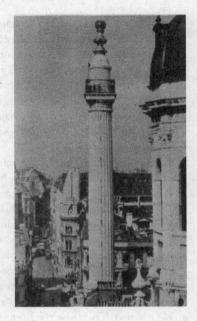

Above left: St Dunstan's, Fleet Street

Above right: The Monument

Left: Fleet Street, looking west

of individualism that must greatly please Sir Ernest Benn, who put them there.

We are passing those narrow alleys which will take us out of Fleet Street in so many ways (there are about thirty ways out altogether); Red Lion

Court, Three Kings Court, St Dunstan's Court, Wine Office Court, all have their tales to tell. In Gunpowder Alley Richard Lovelace (who could not love his love so much, loved he not honour more) died in poverty. In Bolt Court Dr Johnson lived when he came away from Johnson's Court, bringing with him his black servant, his old Welsh lady Miss Williams, and the surgeon Robert Levett. Most of the house is eighteenth century, the old staircase and panelling having been made complete when the house was given to the nation by Mr Cecil Harmsworth, who has made it secure for all time as a Johnson Museum.

Back in the street again we reach the long and narrow Fetter Lane, where the Great Fire ended on its progress west after burning for four days, devouring St Paul's and eighty-four churches, forty-four halls, and 13,000 houses a tragic toll for a blaze beginning with a pile of taggots standing by a baker's oven in Pudding Lane. Fetter Lane is dull but has two quaint survivals of Old London. One is the Moravian Chapel, tucked away in an office building; the other is Nevill s Court, from where Keir Hardie went to the House of Commons in his cap to start the Parliamentary Labour Party. The court has still its seventeenth century houses. Its near neighbour Clifford's inn has lost its ancient charm, all that remains being an old gateway. It is sandwiched among buildings and has fine peeps of two of them one of the stately Record Office, and one of the lovely crown of of Dunstan's, to which we now come.

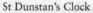

St Dunstan's Clock

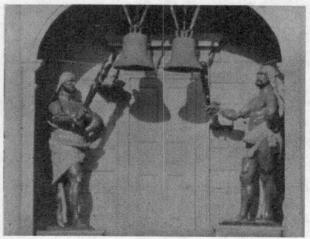

On the dark walls of the recesses of St Dunstan's are monuments saved from the ancient church: the sixteenth century brass of Henry Dacres and his wife; an unknown man kneeling in alabaster on a bracket; Gerard Legh with a memorial supported by two caryatids; Elizabeth North kneeling with her three children; busts of William Morecroft and Cuthbert Featherstone; and a bust of Thomas White, founder of Sion College. Two monuments of the last century are a tablet to Hobson Judkin, the Honest Solicitor, set up by his grateful clients, and a head of a rector, Edward Auriol.

As a monument St Dunstan's is most attractive outside, where its graceful lantern, the Crown of Fleet Street, rises on a skyline made splendid with the turrets of the Record Office and the Law Courts. Down below is the famous seventeenth century clock with the two wooden giants striking the time. The clock was made in 1671 and is now back in its little house above Fleet Street, thanks to Lord Rothermere, who came into possession of it and returned it to the church. The huge painted figures strike every quarter of an hour. Just below them is a bronze bust of the most famous Fleet Street man in our time, Lord Northcliffe.

Our walk down Fleet Street is ended. We are at Chancery Lane, with famous craftsmen looking down on us from the corner (eight of them, and all immortals) and, glancing at the figure of a troubadour high up on the wall, we come back to the Griffin, journey's end.

St Paul's

Ludgate Hill

Across the bottom of Ludgate Hill runs a railway which could easily be spared, serving two stations a few hundred yards apart. We pass under it and come to the yard of an old coaching inn called La Belle Sauvage, with the seventeenth century sculpture of an elephant with a castle on his back, the arms of the Cutlers. It is now the home of Cassells, the famous publishers. Just beyond runs the Old Bailey, with the Central Criminal Court at the other end, and facing it the little Seacoal Lane which sounds so curious but in ancient days was a lane running down to the River Fleet, though in Oliver Goldsmith's time it was but a slum, in which he lived in poverty. At this point of Ludgate stood the medieval gate with the statue of Queen Elizabeth looking down from it, as it now looks down a quarter of a mile behind us from St Dunstan's.

We come to the church of St Martin's, with the slender black spire like an arrow pointing to the dome of St Paul's; it rises from a balconied lantern resting on a cupola. Wren rebuilt the church with its walls against the remains of the City wall, planning it like a Greek cross with four pillars supporting barrel roofs. In the middle of the cross hangs a brass candelabra from the West Indies, over 200 years old. Enhancing the seventeenth century air is the dark oak round the walls, and the pillars, the gallery, the pulpit, and the reredos. A chair, three tables, the font (with its Greek inscription reading the same both ways, and its cover like a crown), are also seventeenth century, and there is a Jacobean chest, an old ironbound one, a sword-rest with the City arms, a marble pelican in her piety, and a dull brass plate which escaped the fire, showing a man in a gown who may be Thomas Berry, a fishmonger who died two years before the Armada came. There are three oil paintings of Michael, Gregory, and Mary Magdalene, patron saints of this church and of two others now gone.

By the church is a little alley leading to a placid backwater of the City, where a fine plane tree keeps company with Stationers Hall, built in 1670. Until 1923 all publications were registered here for copyright, the register going back to 1557. Among many library souvenirs is the composing stick of Hansard's Debates, and the handle of a knife with a hollow for powder. From the stock-keeper's room, with its rich panelling and painted shields,

we pass into the main hall where is a rich old oak screen and an array of modern glass. One window has a charming scene of Caxton showing his printing to the king and queen, who have a child with them. We see Caxton again in other glass, as well as Shakespeare, St Cecilia, Cranmer, and a fine figure of Tyndale in his study. The Court Room is a beautiful chamber in cream and gold.

We are here at Amen Corner, a sheltered nook of Old London, with seventeenth century houses clothed in creeper, looking charming in the spring and more charming still in autumn, where live the lucky canons of St Paul's. In one of these houses died Richard Harris Barham of Ingoldsby Legends fame. The gateway from the corner leads us to one of the curious mazes of the City, the little streets and squares of Paternoster Row. We are sandwiched in between Newgate and Cheapside and St Paul's Churchyard, and hereabouts (opposite the nave of the Cathedral) stands a tall brick house designed by Wren, now partly bank and partly club, but once the Chapter House. The Deanery is on the other side of the Cathedral, a two-storeyed brick house built in 1670 from Wren's design. We come out in front of the Cathedral with Queen Anne looking down the hill (England, Ireland, France, and North America at her feet), and with a tablet in the ground which has now corrected the mistake it made for years about the reign of Queen Victoria. We are now at the City's holy of holies, St Paul's.

It stands amid streaming London's central roar, and we lift up our eyes to this majestic thing, and this world is a little less with us. The dome of St Paul's is the noblest spectacle that London looks on. It crowns the greatest city in the world, the chief glory of this great place to which the nation comes in joy and sorrow, the national fane to which we bring the soldiers and sailors who give us security and the artists who give us beauty.

We may come to it for its monuments, or to try to realise its vastness, or to climb to the highest point at which we can stand and look down on London, or to try the curious experiment of whispering round the dome; but we come to it most of all for something that stirs the emotion within us, that brings up the vision of the way we came and of the figures that have come this way, growing into our immortality. Here lies the most romantic figure in English history, his dust somewhere unknown beneath the dome, Philip Sidney.

We will look at it first as an architect looks at it, as one of London's supreme buildings. It is considered the finest Renaissance cathedral in Europe, perhaps because it is the work of one man; one master builder and one bishop set up this place.

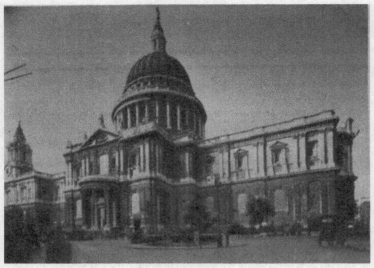

St Paul's

The Wonderful Dome

It is easy to take a familiar sight for granted, but the west front of St Paul's is one of the noblest structures in the world. It rises at the top of Ludgate Hill and is raised on a platform reached by twenty-two steps, the whole front being 60 yards wide and the portico built in two storeys – six pairs of columns in the lower tier and four pairs bearing the pediment. On the apex of the pediment stands St Paul with the vast dome behind him, and on each side rise two towers to a height of 210 feet. In one of these beautiful towers is a peal of twelve bells, and in the other Great Paul, weighing 17 tons, the biggest bell in England, ringing for five minutes every day. The spectacle of these towers with the majestic dome behind them, carrying a lantern, a ball, and a crown 365 feet above the street, is a sight not to be forgotten.

All round the cathedral are statues and groups of sculpture. On each side of St Paul on the apex of the western front stand Peter and James, in the pediment is the Conversion of Paul at Damascus (with square companion tablets below), and along the cornice below them sit the Four Evangelists. Pilasters enrich the walls, with the windows projecting, and the design runs round the whole cathedral except at the transepts, where columns curve out above flights of steps to form the stately porticoes, and four corner wings project to give special strength to the dome. A beautiful balustrade runs

right round except where it breaks for the transept pediments, which are crowned with statues of the Apostles. In the pediment of the south doorway is a phoenix, and over the north doorway are the Stuart arms, carved by Grinling Gibbons.

The great dome is one of the wonders of architecture, three domes in one. There is the leaded dome outside (wood underneath), its ribs gathering as if to support a lantern of supreme grace; the dome we see inside, a blaze of colour with its painting and mosaic; and the dome that no man sees, its shape a cone, its material a mass of bricks 18 inches thick, its weight 700 tons. It has a steel chain round it nearly as long as Ludgate Hill.

Round the drum on which the dome rests runs a wonderful range of columns, some apparently free, some joined by masonry, and round the top of this colonnade runs a stone gallery where we may stand and look out over London. It is nearly 150 yards round. The lantern above the dome has paired columns facing north, south, east, and west, rising above a golden gallery, where also we may stand, and crowned by vases behind which another tier of stone rises to carry the ball and cross.

The ball is six yards round and will hold ten people; we can climb 560 steps and see it from the golden gallery, or fifty-six more to the ball itself. It is interesting to remember that early last century the ball and cross were taken down, and a big business it was. The cross was removed fairly easily in sections, but the ball was found to consist of multiple sheets of copper strongly fastened with immense copper bolts. It was got down at last, however, and thousands of people gathered to see this great ball rolled down Ludgate Hill.

We are well rewarded for our climb up to the dome if the day is clear, for then we see the Surrey hills to the south and the heights of Highgate to the north, a spire by Wimbledon Common breaking the skyline westward, and eastward the river winding past that other masterpiece of Wren, the marvellous Greenwich Hospital by the river, and the Observatory on the hill.

Inside St Paul's

Entering by the western doors we find ourselves in a spacious vestibule with a wonderful view up the nave, and beyond the choir to the windows of the apse, gleaming behind the reredos, On our right is the oval chapel of the knights of St Michael and St George, the walls emblazoned with their banners; and on the left is the chapel of St Dunstan (with a mosaic of the three Marys) and the tiny chapel of All Souls, where lies in great serenity one of the romantic figures of our time, Lord Kitchener.

St Paul's has nothing more beautiful than this little domed chapel with its lovely iron gates and its walls of light stone. It is the first thing we see by the north-west door, charming when flooded with daylight and mysteriously beautiful when the golden glow of artificial light spreads over it. On the altar is a silver figure of Our Lord, and a fine crystal cross with the signs of the Four Evangelists in silver on the arms. Two silver candlesticks at the sides of the altar were made from the trophies won by members of the Royal Rifle Brigade who fell in the war. In a shining recess with a rich golden grille is the roll of Honour of the Royal Engineers of all ranks who did not come back, their names in richly-bound books, of which one has a jewelled cover with a golden panel of St George.

The Whispering Gallery

We pass into the wide space under the dome through one of the eight great arches on which it rests, swinging wide, open, and free over the four main divisions of the church. At the four corners the arches enclose sub-arches along the tops of each, the cornice runs its course round the church, the gilded balustrade being a step higher, and the whole arrangement turning a problem of engineering into a display of decorative beauty. Above the eight arches is a gallery famous for its wonderful power of carrying sound, so that it is known as the Whispering Gallery. We may stand here and whisper at the wall and the sound will come back, having travelled a hundred yards; the walls are so smooth that they reflect the sound waves unbroken and undiffused round the vast curve, as if it were a calm lake.

The transepts stretch from door to door across 250 feet, their end walls revealing the ornamental details which enrich all the walls of St Paul's within and without, fruits, flowers, peeping cherubs, and all the devices the revivers of the architecture of ancient Rome delighted in. Beyond is the choir and its aisles, in all essential features a repetition of the nave and its aisles, though the small domes are gilded. Magnificent screens fill in the arches, while down the choir runs the glorious stall-work of Grinling Gibbons. Hidden by a reredos unworthy of this glory is the apse, one more triumph of art and engineering, for it must be the eastern bulwark stemming these tremendous stresses the dome imposes on the structure.

The monuments of St Paul's, with one or two exceptions, are as works of art entirely unworthy of this famous place. We will walk round and see them for their historic interest.

The Monuments of the Nave

The masterpiece in the nave is the famous bronze of Wellington, the beauty of which is unhappily overwhelmed by its great marble canopy. The Iron

Duke lies on the lofty tomb with twelve columns about him, and below the pediment are bronze panels of Virtue keeping Vice beneath its feet, and Truth plucking out the tongue of Calumny. Across the aisle is a small but beautiful bronze of Gordon, one hand on his breast and one on the Bible, and a relief showing him wearing his fez with a group of Arab boys; round the base is an inscription to his last surviving brother. Close by is one of the loveliest tombs in the nave, on which Lord Leighton lies in bronze with figures of Painting and Sculpture at his head and feet; both are charming, with draped heads, and Sculpture has in her hand a tiny copy of Lord Leighton's Sleeper Awakening.

There are four big figures at the four key-points of the dome: Haxman s Joshua Reynolds with a little Michael Angelo on the pedestal; Dr Johnson standing as if thinking; John Howard holding a big key, with a relief of a man whose chains have been broken; and Sir William Jones, a judge under the East India Company, with a charming medallion of an Eastern scene. Sir Henry Lawrence is lifesize with a relief showing him at Lucknow receiving three children brought for his greeting. Nelson stands on a pedestal with Britannia pointing him out to two boys. General Cornwallis is facing Nelson with a stately Britannia, a mourner, and a bearded Indian on the pedestal. Earl Howe stands with a lion at his feet and a ship behind him, and two women apparently recording the news that Gibraltar is relieved. The great Admiral Collingwood, who finished the Battle of Trafalgar, lies with an angel bearing him away in a lovely ship, with five tiny reliefs of children playing carved on the sides of the vessel. General Andrew Hay is seen falling at Bayonne, a fanciful figure catching him as he falls, with a soldier lamenting. Sir John Moore is being buried darkly at dead of night, with his martial cloak around him, and Sir Ralph Abercromby is being lifted from his horse. Lord Heathfield, Defender of Gibraltar, is standing like an English soldier and is shown below like a Roman warrior. General Napier is here with Charles James Napier, a fine figure in a cloak, described as a prescient general, a beneficent governor, a just man. Lord Duncan, who won the famous victory over the Dutch fleet at Camperdown, is holding a sword in both hands. Admiral Rodney stands with an angel at one side, and History recording his great deeds. Sir Thomas Picton is helmeted as a Roman, with a British lion and two winged angels offering him a laurel wreath. Earl St Vincent has below his statue a small figure of Fame, writing his title for his victory off Cape St Vincent. General Ponsonby of Waterloo has his sword broken and his horse is down. General Dundas is being crowned by a lovely figure of Britannia with a lion, a figure with a floral bowl, and a child with a spray of palm; and looking across the north door towards him is Robert

Faulknor,'who fell a year after him while fighting the French. He did a wonderful thing. He had lost most of the mast and the rigging of his ship and, watching his opportunity, he found the bowsprit of the French ship coming athwart his own, and with his own hands seized and lashed it to his capstan to make the two ships one fighting power.

These are the famous warriors with notable sculptures, and there is a host of others: a white bust of Lord Roberts; General Hoghton falling at Albuera; two angels with medallions of two of Nelson's captains who fell at Copenhagen – Robert Mosse and Edward Riou; a Chantrey of Bernard Bowes falling in battle; a relief of John Gaspard Le Marchant who fell at Salamanca; a Chantrey battle scene in memory of Henry Cadogan; a marble figure of Sir William Hoste, a sailor; reliefs of two soldiers, Captain Edward Lyons and Granville Gower Lock, and of Commander Richard Burges who fell in 1797. George Westcott, a captain who fell at the Battle of St Vincent, is being caught by an angel as he falls. Near Gordon is a bronze panel of Sir Herbert Stewart who went to Gordon's relief, and not far away is the curious doorway tomb of Lord Melbourne with his brother Frederick – two angels at a door, one with a sword and one with a trumpet. On each side of it are brass tablets to the crew of HMS Captain, which foundered off Cape Finisterre in 1870; the ship is engraved on it, and the story is told of its foundering through faulty construction.

A small group of men famous in peace are remembered about the nave and aisles. Henry Hallam the historian stands with a pen and his hand on some books, Mountstuart Elphinstone, another historian, stands with books, and facing Hallam is a bronze relief of Sir Arthur Sullivan with a figure of Music playing a lyre. Balancing this is a relief of Sir John Stainer, his face set in a wreath with a scene showing a fire on an altar. The immortal Turner has a fine statue, his lovely face half smiling, and a broken pencil in his fingers. Sir Astley Cooper stands holding a book. The first Protestant Bishop of India, Dr Fanshaw Middleton, is blessing his people, and Charles Cockerell, surveyor of the Cathedral, has a fine head in bronze with two kneeling angels in a laurel wreath of fame. On the transept wall by the choir is a pathetic bronze relief in memory of Scott and his comrades; it shows them pulling their sledges.

There are in the nave a few regimental memorials of note. One is in the bay behind Lord Leighton's tomb, where the cavalry of the Crimea, Light and Heavy brigades, are recalled with four ancient flags floating above. By the door of the south aisle are two reliefs to the Coldstream Guards, a regiment older than the cathedral. The South African War is recalled in the south transept where a huge bronze angel supports a soldier standing for

the 4,300 soldiers of the Dominions who fought for the Motherland in the country which was to become so loyal a Dominion itself. In this transept also hang bright banners of all the Dominions and India, with the Union Jack and the Royal Standard, in memory of the Jubilee of George the Fifth who came here to give thanks.

The Richness of the Choir

We come now into the richest interior of St Paul's, the choir and its aisles. It is a captivating sight with the wonderful roofs in richly coloured mosaic gleaming with gold, an astonishing mass of colour with the richly moulded windows adding to the arresting effect. Sir William Richmond, in conceiving this great scheme of mosaic, provided for everything, culminating in the figure of Our Lord in majesty on a rainbow throne; it is the glory of the apse.

In the three round domes of the roof above the choir are mosaics of the Creation. On one hawks and eagles wing their way about a golden sun, singing birds, peacocks, and swans completing the harmony. In the next are fishes, with sea monsters spouting silvery fountains of water, and other creatures are swimming in deep blue sea. In the third dome golden eagles spread their wings above palm trees, and the lion and the tiger, sheep and cattle, walk in the tropical forest. On the supports of the dome are twelve angels making a line of beauty along which the eye is carried to the dominating figure of Our Lord, with the thorns in His crown bursting in blossom. Under His feet the sun and moon grow dim, and the Recording Angels are standing about. In the smaller domes over the aisles are seraphs whose wings meet in a roundel.

Under the choir windows are panels of Bible history, all in mosaic. We see Cyrus, conqueror of Babylon and liberator of the Jews, watching the Return from the Captivity; Alexander, who joined Europe and Asia with civilisation along which the Gospel was to spread; and the great forerunners and prophets until we reach David, with Solomon building the Temple. There is a wealth of colour and imagination in the decorations of the spandrels in the main arches, the subjects ranging from Creation to Calvary. The great tiers have been enriched with colour and gilding, and at the triforium level on the chancel arch we see Adam on one side and

Eve on the other giving the beasts their names. At the other end of the choir, best seen front the apse, Noah is giving thanks and Abraham is blessing the king.

But it is the more intimate craftsmanship that appeals to us here. The ironwork of Jean Tijou and the woodwork of Grinling Gibbons both appear

to have reached the height of their achievement in this choir. The screens and gates in the south aisle, all by Tijou, are made of the last iron from Sussex; they are magnificent in black and gold, with golden figures of the prophets, Peter and Paul in niches, and the Four Evangelists in medallions. The stalls of Grinling Gibbons, with the bishop's throne, are richly panelled and have carved pillars surmounted by a wonderful cornice, with two rows of cherubs among scrolls and festoons. Wren designed the organ case and Gibbons carved it with flowers and angels; the seventeenth century organ has been rebuilt and now has 4,822 pipes and 102 stops; it is one of the best organs in the world. The altar and the white marble reredos belong to our own time. The altar frontal was made by disabled men, and the candlesticks are copies of those from old St Paul's which were made for Cardinal Wolsey. The reredos rises 70 feet high and sets out events from the Nativity to the Resurrection, but it is not worthy of St Paul's.

Here the quality of the monuments is much finer than in the nave. Dean Milman lies in marble with his hands crossed, and Bishop Temple kneels in bronze, a copy of his magnificent figure at Canterbury. Bishop Creighton by Hamo Thornycroft stands in his richly embroidered cope. Canon Liddon lies with his hands in prayer and his feet on a dragon. Bishop Blomfield is a sleeping figure on his low couch, with his staff on the floor. Bishop Jackson lies in robes of simple folds, inclined towards us. Bishop Heber is a big figure with a scene of his life sculptured on the pedestal. In a niche on the wall is the very odd monument of John Donne, the poet dean of Charles Stuart's day, and the figure is of remarkable interest not only because it is by Nicholas Stone but because it is the only complete statue saved from old St Paul's, and on it are the marks of the Fire. Dean Donne is shown standing on a vase with his head peeping from a shroud, the story being that, when asked to sit for his portrait, he agreed if the artist would paint him in his shroud, and Nicholas Stone copied his monument from this curious picture.

St Paul's is not rich in ancient glass, and it has few great windows; but there are some to note. One is to the Earl of Meath, founder of Empire Day, and in it are figures of a kneeling Scout and a kneeling Guide, each with a flag.

Facing St Cecilia across the cathedral is the most beautiful window of all: it is by Douglas Strachan and is rich in blues and greens. It shows Dunstan blessing the union of Wessex and Mercia, whose representatives kneel and dip their flags for King Edgar, who touches them with his sceptre and makes himself King of All England. A window given by the Drapers Company has a fine Crucifixion scene, and another gives thanks for the recovery from a serious illness of the Prince of Wales in 1872; it shows the restoring of the

widow's son. The six windows in the apse are bright with decoration, the upper series showing the twenty-four Elders of the Church, and the lower series the life of Our Lord, with angels and emblems. Sir William Richmond designed the windows of the clerestory above the choir to be in keeping with his mosaics, and we see his sparkling reds and blues in the series of Saxon kings and saints high above the transept doorways. Over the west door is the Ascension, and the chapel of St Dunstan has Our Lord with the doubting Thomas.

It is perhaps not too much to say that there is no place underground in England of wider interest than the crypt of St Paul's. In this vast vaulted place of aisles, recesses, and chapels, extending beneath the whole of the cathedral, are the graves and monuments of our famous dead.

In the Library of St Pauls

We come to the library on our way up to the Dome, and it has many treasures. Its floor is cleverly laid with 2,000 pieces, with not one nail or peg. There is some fine woodcarving. In the glass cases are precious manuscripts and relics, one of the three copies of Tyndale's Bible still in existence, Roman ware found in the foundations, Wren's white waistcoat embroidered with blue velvet, and the cap of one of Wren's workmen, who must have lost it, for it was found some years ago when it became necessary to renew the great

Below left: St Paul's from Fleet Street

Below right: Paul's Cross

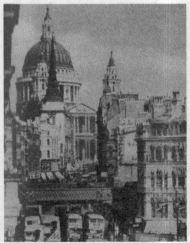

steel cable which is bound round the drum to resist the outward thrust of the dome. There is near at hand Wren's first model of St Paul's, and a copy made about 1150 of a charter of Canute confirming the privileges granted to the cathedral by his predecessors.

It has always been felt that St Paul's should be cut off from the noise and vibration of the traffic about it, for it rests on foundations of London clay and has never been too secure. Remembering these feet of clay, a man who loved the cathedral resolved that it must be protected. He dreamed that this could be done in either of two ways – by strengthening the foundations or by leaving them alone. Leaving them alone meant an Act of Parliament restricting the rights of 160 property owners round the cathedral, so that they should do nothing that might injure the foundations. Everybody laughed, but Canon Alexander fulfilled his dream, and the Act was passed. The foundations will be left alone, and, as for the traffic, the cathedral is free from it on one side, where we may saunter at will in the churchyard. In the old burial-ground, with a few tombs still peeping from the shrubs, stands a handsome column representing the old Paul's Cross; it springs from the centre of a base representing a pulpit, on which are bronze heads of a child, one a fountain. On the other side of St Paul's is a little garden between the south wall and the street, and in it are a few fragments of the old cathedral, capped with lead to save them from weather. Two oblong masses which seem puzzling were part of the buttresses of the medieval chapter house, which was built here within the cloister.

And now we leave the greatest building in the City, and pursue our way into the Newgate area, beginning at the Holborn end.

The Gardens of Staple Inn

The Old Houses of Holborn – Staple Inn

Newgate

The City's Holborn Gate

We come to the loveliest front of old houses in London at what is called Holborn Bars, the point where Gray's Inn Road runs north to King's Cross. Here, leaving the timbered houses of Staple Inn which give Holborn's greeting to the City, we walk east for a few yards to find behind Furnival Street the beautiful little Hall of the Mercers School, once the Hall of Barnards Inn. It is Elizabethan, and only 12 yards long, with a dainty oak lantern on its roof and heraldic Tudor glass in some of its windows. Over two Tudor fireplaces hang banners of the Mercers Company. In the Assembly Hall of this school is a group of ancient and modern portraits and an oak tablet with the names of eighty-three old boys who fell in the war. In the middle of the roadway outside is the City's peace memorial to 21,000 Fusiliers, Albert Toft's rather determined figure of a soldier.

There is a more gracious memorial in the courtyard of the Prudential buildings; it has two winged angels crowning a wounded soldier, and round the pedestal four women representing the three Services, holding a ship, a plane, and a gun, while the fourth stands for the National Service, in which the Prudential distinguished itself by raising millions of pounds. There are 790 names on the pedestal.

Close by is a bronze head of Dickens, who wrote part of Pickwick on this spot. On the building itself are hundreds of coats-of-arms linked with foliage and sometimes blossoming into little cupids, quaint gargoyles also reaching out halfway up. Across the road, on the corner of Fetter Lane, is an open Gothic tower on a block of offices, and in the circus beyond is Prince Albert on horseback, lifting his Field-Marshal's hat as if greeting the City. On the base sits a figure of Peace looking west and a figure of History looking east, and on the sides are reliefs of the Prince at the Royal Exchange and at the Great Exhibition.

We walk on to Holborn Viaduct, built in 1867 to carry the road across the valley of the Fleet. The Viaduct runs for 1,400 feet, with a little bridge over Shoe Lane and a big one over Farringdon Street. At the beginning of the Viaduct is St Andrew's Church, reached now by a flight of steps going down instead of up as in the days before the Viaduct. Though traffic runs unceasingly by, there is peace in its little garden of shady paths and trees,

almost unnoticed under the high wall, but loved by workers in seek of rest. Set in the wall is a sculpture of the Day of Judgment. It was Wren who made the church we see; he kept the old tower with its medieval arches, but gave it a new stone dress and raised it to 110 feet. Its fine peal of eight bells are of the metal that rang for Agincourt, and the medieval sanctus bell is still here. There is an old sword-rest, and a photograph of a sampler worked in 1715 by Elizabeth Nicholls, a charity girl.

Back on the Viaduct, we cross over Shoe Lane and are at the famous shrine of Nonconformity which rises from the lane below, the City Temple, with a double portico of four columns and figures of Hope gripping an anchor, Faith with a cross, and Charity holding a child's hand. We are now at the bridge, at each end of which sits a lion with statues of Commerce, Agriculture, Science, and Art, standing on the parapets. The four corner buildings with stairs descending to the street below are part of the design/ and each has a niche with a distinguished citizen in it, Thomas Gresham, William Walworth, Hugh Myddelton, and the first mayor. Charming little galleries arc thrown out from the corner buildings, with dragons holding spears between their paws. Now comes the railway station, and facing it across the road is the tower of St Sepulchre's, in which lies one of the heroes of the British Empire, Captain John Smith.

It looks across to the striking golden figure of Justice with sword and scales, crowning the fine buildings of Old Bailey; if buildings remember it remembers the notorious Newgate Prison in the days when sightseers slept in the churchyard to be ready for the executions next day, and the big church bell tolled for the passing of wretched folk hanged for coining and horse-stealing and a hundred other crimes. In the church is a handbell which was rung outside the condemned cells on the eve of execution.

Founded perhaps in the twelfth century and rebuilt in the fifteenth, the church was reconstructed by Wren. Though it still wears a fine fifteenth century dress outside, and has a seventeenth century air within (where great columns support richly decorated ceilings), it was all much restored and altered about sixty years ago. The fine pinnacles of the tower climb to 150 feet, as high as the church is long. Among the old woodwork are two carved pulpits, the reredos and altar table, and the organ case richly carved. A monument of 1676 has coloured busts of Edward Arris and his wife. But it is a small brass on the floor that is perhaps the most romantic thing we see; it marks the grave of John Smith, one of the splendid men on that long roll of heroes who laid the foundations of the Empire, part of the dream of Raleigh for Virginia, its first Governor, his life saved by the famous Pocahontas.

St Sepulchre's hopes one day to have a window worthy of John Smith.

Behind the church is the delightful little watch-tower built before England had a national police. It was the home of a city watchman, and has round windows at the top; now it is the home of St Sepulchre's sexton.

The Old Bailey

From St Sepulchre's porch Snow Hill runs down to Farringdon Street, and has a police station which deserves a passing look. It has a projecting window four storeys high and a delightful frieze. A door or two away is a portrait of Dickens on an office, with a statue of Squeers, and Nicholas Nickleby in his tail coat, and terracotta panels showing a mail coach leaving the inn which once stood here. Back up the hill we see in front of us the golden figure of Justice, bearing her sword aloft, on the coppered dome of the Old Bailey. It is by F. W. Pomeroy, and is 22 feet high. Facing the Old Bailey stands the quaint Magpie and Stump Inn with a dainty coloured sign and a timbered storey, and by it is Britannia House with a colossal sculpture of Britannia bearing a locomotive in her hand. But it is the great Central Criminal Court which dominates this busy corner. Built at the dawn of the twentieth century at a cost of £250,000, it is on the site of Newgate Prison, and some of the prison stones are in the walls. Over the entrance is Mr Pomeroy's statue of the Recording Angel, supported by figures of Fortitude and Truth. On certain days we may view the upper and lower halls of this great place, with their rich marble walls and mosaics by Sir William Richmond and Mr Gerald Moira.

Part of the ceiling in the lower hall has gold stars on a blue background, and round the walls stand several statues. Here are James the First and his fateful son, who has folded arms. Lolling against a pillar is Charles the Second with a spaniel at his feet. William the Third stands admiring his wife's embroidered petticoat. William the Fourth and George the Fourth complete the group. On the wall is this historic inscription:

Near this site William Penn and William Mead were tried in 1670 for preaching to an unlawful assembly in Grace Church Street. This tablet commemorates the courage and endurance of the jury, Thomas Vere, Edward Bushell, and others who refused to give a verdict against them, although locked up without food for two nights, and fined for their final verdict of Not Guilty. The case of these jurymen was reviewed on a writ of Habeas Corpus, and Chief Justice Vaughan delivered the opinion of the Court which established the right of juries to give their verdict according to their convictions. Marble stairs lead us to the magnificent upper hall, with plastered groups of Piety, Mercy, Justice, and Temperance below the golden

dome. There are groups of mosaic figures on the ceiling representing law-giving in ancient times and modern scenes of justice. There is a statue of Elizabeth Fry in her oldfashioned bonnet, recalling the days when she would go into prison cells here, calm and unafraid, though the Governor dare not go alone; on the pedestal is a bronze relief showing her visiting the cells. On the ground is a medallion of John Howard, and near it a bust of the famous Mr Justice Hawkins, Lord Brampton, so well known in these courts.

We come back and turn up Newgate Street, only to be drawn round a corner by the attractive frieze over the Cutlers Hall in Warwick Lane, where the romantic Guy of Warwick used to live; he is on a stone panel which has been here about 300 years. The Cutlers frieze is by George Tinworth, the famous terracotta craftsman, and it shows thirty-three men and boys at work producing cutlery. The front of the doorway has a gilded elephant with a howdah on its back, a copy of an oak carving of 1659 inside the Hall. Farther down the Lane is Warwick Square, for ever busy producing books; we like the name of one of its offices, Little Paul's House.

Here Lie Four Queens

Back in Newgate, we pass a wing of the new Post Office block with emblems of Mercury on its front. Here stood Christ's Hospital, the famous Bluecoat School now down at Horsham. Here Charles Lamb and Coleridge came. Hereabouts is a quiet garden made from a churchyard which had lost its church; we can sit in it and look up at the west front of Christ Church, Greyfriars; its handsome square steeple looking into the garden. Here were buried four queens and a host of lords and ladies, and here they brought the Crazy Maid of Kent, Elizabeth Barton, after hanging her at Tyburn. Here still in the chancel of Wren's church is part of the medieval paving in marble squares of different hues. After the grey friars came the Bluecoat boys, to whom we find a group of memorials under the tower, including one which says, 'Here lies a benefactor; let no one move his bones.' On a buttress is a bust of Charles Lamb, who would sit on one of the peculiar seats at the end of the benches. Once a year the Bluecoat boys come to a service here with the Lord Mayor, and a sermon is preached to them from the Grinling Gibbons pulpit. It is thought he may have fashioned the marble font with the delightful cherubs. There are mitres and crowns on the organ, which has known the touch of two immortals, Handel and Mendelssohn. It has grown from an instrument by the famous Renatus Harris, and has over the keyboard a gilded panel with David playing his harp.

There is excellent carving, vivid and bold, in a group of panels on the choir stalls, showing the Last Supper and the Four Evangelists.

Other handsome possessions are two seventeenth century candelabra, and the iron gates in the tower.

Two modern oak memorials face each other in the nave, one a fine tablet to the founder of Rugby School, Lawrence Sheriff, buried here in 1567, the other a tablet with a portrait medallion of Richard Baxter, happily given by Anglicans and Free Churchmen together. Here this remarkable man lies. He gave up the gaiety of Court life while still in his teens, became master of a grammar school, and then a Puritan minister. He was an army chaplain in the Civil War and a royal chaplain at the Restoration, but his equal distribution of his sympathy did not save him from the brutality of Judge Jeffreys, who called him a dog and threw him into gaol. In Panyer Alley across the road a naked boy sits carved above a false claim that here is the City's highest ground.

We are now in Aldersgate Street, with the Central Telegraph Building high above us, a double colonnade in front of its George the Fifth hall. A bridge across Angel Street links it with the GHQ of the GPO, which has a frieze of sculptured faces round the cornice and a foundation stone telling us that it was set up in the jubilee year of the Penny Post. The keystone of the arch to an inner court has the head of the Postmaster-General of that year, Arnold Morley, and behind the building in King Edward Street stands Sir Rowland Hill with a pencil and a notebook in his hand; he is by Onslow Ford.

Those who think of our Post Office as reaching the highest point of organised State efficiency that has yet been reached may think it a little dramatic that there should be on this very spot a monument which takes us back to the days when the speed of a horse and the power of the wind were man's swiftest means of communication.

In the yard where all may see it is a Roman bastion, the most impressive piece of London's Roman wall. We come 20 feet down steps to it, to find the bastion resembling a great horseshoe against the curving wall. At the base the masonry is seven feet thick and has the characteristic layers of red tiles used by the Roman mason. There is a strange remote dignity about this relic of the Past at the foundations of the vivid Present, with its electric railways, telephones, and wireless all housed in this place. Across from the Aldersgate front of the Post Office is St Anne's Lane, taking its name from the church, a delightful building by Wren with decorative timber columns supporting the ceiling. There is an oak reredos, high panelling, a richly carved font, and an old wall monument with busts of Sir John Drax, a sugar planter of Barbados, and his son Henry.

The Heroes of Everyday

This little spot was once the churchyard of St Botolph's, which stands at the corner; today it is known as Postman's Park and is dedicated to the courage of plain people. It was the idea of G. F. Watts that there should be some memorial of the heroic deeds of common folk, and here there has been set up a covered arcade along which are written the words 'In commemoration of heroic self-sacrifice,' the walls being covered with tablets recording about sixty names with the story of some brave deed. It is a much-loved garden where the postmen who deliver letters and hundreds who receive them sit and rest.

St Botolph's Church has dull outer walls with a beautiful interior, its painted pillars imitating marble. It has the base of a clustered column from the fourteenth century, but most of it is eighteenth and nineteenth. The inlaid pulpit is remarkable for being supported on a pillar fashioned like a palm tree, and the east window for having imitation gold lace curtains drawn back to reveal the Garden of Gethsemane. There is a medallion bust of William Webber, a rector of last century, and a cameo by Roubiliac of a young girl who died in 1750. The oldest monument is an Elizabethan tomb with an engraved panel showing Sir John Packington kneeling on a cushion with his wife and their daughter. A bust of young Elizabeth Richardson shows her with a wide Stuart collar under her curly hair, and Elizabeth Ashton of Restoration days is holding a book with her hair falling over her shoulders. An eighteenth-century relief has a sorrowing father bending over the tomb of his daughter, a cherub is drawing a curtain from an eighteenth century portrait of Zachariah Foxall, and near the pulpit is a relief of Thomas Henry Ellis, who lived here for half of last century.

Close by is the modern Hall of the Ironmongers, replacing the old one which was destroyed by a German bomb. It has something of the old-world atmosphere, with gabled windows projecting over a black and white storey, and in the shallow panelled porch are niches with statues of St Lawrence with the gridiron and St Eloy with the blacksmith's anvil. There are magnificent iron gates, and in the courtyard is a brick pedestal with an open bronze globe such as the old navigators used to read the stars, the whole crowned with a delightful model of a medieval ship.

The Oldest Church in a London Street

To the left of Aldersgate is Bartholomew Close and the great church and hospital which bear its famous name.

The Tudor gateway as we see it is a gift from the Great War to London, for until it was struck by a German bomb nobody living had seen its timbers.

Today it has been restored in memory of three friends who worked for forty years to bring back the lost beauty of St Bartholomew's; perhaps we should add a fourth, for the rector who lives above the gateway has been a marvellous friend and has raised £100,000 during his rectorship.

With this money the oldest church in London outside the Tower has been rescued from the rubbish heap. We have seen horses in the cloisters where today is nothing but beauty. Once there was a printing office in the lady chapel, where Benjamin Franklin set up his printing machine. Once there was a smithy in the north transept, and the blacksmith could be seen at work by peeping down from the triforium. In another part of the triforium was a school.

It is remarkable that so great a church could fall so low, and this salvation and transformation was the dream of three men who worked to bring it true. They were the two brother architects Sir Aston Webb and William Webb, and Mr Frederick Dove. It was a great day for St Bartholomew's when they brought Old London to life again about her walls, the Lord Mayor attending in his scarlet robes and his gold chain, bringing the sheriffs with him. It was like a touch of ancient glory back from Rahere's day.

To the north of the City was a stretch of marsh ground extending in patches to Moorfields, and the ground was reclaimed first for Rahere's Hospital and then for his Priory.

The most beautiful possession of the church today is Rahere's tomb. He died in 1143 and his body lies just below his figure on the tomb. A guardian angel at his feet holds a shield with the arms of the Priory, and on the front of the tomb are painted shields. The roof of the tomb is beautifully vaulted, and its elaborate canopy with its tiny sculptured faces and its angels is the loveliest part of the tomb.

This impressive place is but a fragment of the church Rahere built. The great nave has disappeared, and what exists is the choir with its apse and the lady chapel behind, but its great columns are Norman to within a few inches of the roof. When the fifteenth century raised the roof a foot to add the clerestory windows, it left the Norman columns standing and set slightly pointed windows within them. There are fifteen great Norman arches round the floor and fourteen in the triforium. There must be altogether forty Norman arches in this place, many of them divided by one, two, or three columns. Probably a unique feature in a London church is the oriel window Prior Bolton built in an arch of the triforium so that he might watch the altar from it; it is very beautiful.

In the lady chapel, with an iron screen designed by Sir Aston Webb, hang copies of Old Masters; below the chapel is a plain fourteenth century crypt,

severely restored. In the tower are five bells more than four centuries old. High up on a wall are the busts of an Elizabethan couple, Percival and Agnes Smallpace, the husband with pointed beard and the wife in ruff. In the south aisle are two seventeenth-century figures of Edward Cooke and James Rivers, both with Bibles. Near them is the altar tomb of Sir Walter Mildmay, founder of Emmanuel College, Cambridge, and one of the judges of Mary Queen of Scots. Two other notable seventeenth century monuments are of Sir Robert Chamberlane (kneeling in armour under a canopy with curtains held back by angels), and Elizabeth Freshwater.

One of the features of the restoration of the church has been a series of painted panels of the life of Rahere. They make a welcome note of colour on the choir screen, and are interesting not only as a fine piece of modern work in an ancient church, but for the introduction into the scene of the rector to whom this church owes so much of its salvation (Canon Savage), a verger, a churchwarden, a lay reader, and the artist himself, Mr Frank Beresford.

Five bays of the cloister have been rescued and restored since the Great War ended. It was here we found a stable once upon a time, and today the old Norman door swings on its ancient hinges to lead us into it. The door will soon be 800 years old and is surely the oldest door in London. Its discovery was a great surprise, for after the restoration of the cloister the door was discovered lying in the triforium. We imagine it must weigh at least a ton, for it is great and thick, but the workmen found the hinges and hung the door where now it swings as it was swinging to and fro before Magna Carta.

St Bartholomew's Hospital

Rahere had built the first hospital on the royal market of Smithfield outside the priory gate, and for twenty years he ministered to the sick himself. For four centuries the hospital had a master and eight brethren. When the hospital was closed at the Reformation its loss was at once felt, and the Lord Mayor petitioned for its reopening, the king then giving it a new charter. By the end of the reign work was in full swing again, and though the Great Fire passed it by it was found necessary to rebuild it in the eighteenth century. It has a noble front on Smithfield, and four blocks round a courtyard.

In a niche over the gateway is a statue of Henry the Eighth with figures of a sick man and a cripple above. At this gate we come to the parish church of the hospital, which is all the parish the church has.

We come into this odd little church through a fifteenth century tower with two medieval bells. The nave is a little octagon within square outer walls. On the floor by the door are brasses nearly 500 years old of William Markeby and his wife, and on the wall near the pulpit is a black stone in a

marble frame set up to his wife by Sir Thomas Bodley. The west windows
have seventeenth century enamel glass with saints. The east window has a
good group of people by Henry Holiday, and there are Bible windows by
Sir Edward Poynter. In the vestry hangs an old picture of St Bartholomew,
and near it are fifteenth century carvings of angels. Kneeling in a recess is a
Tudor surgeon at Queen Elizabeth's court, Robert Balthorpe. The services
held here are relayed to the patients in the hospital wards.

We pass from the church into the courtyard, with four cupids supporting
a bowl of a fountain and dolphins looking down on it. The hospital is as
famous for its possessions as for its good works. In its main staircase hang
two great paintings by Hogarth who was born close by, one representing
the Good Samaritan, and a colossal one of the Pool of Bethesda, with
figures seven feet high; he gave these pictures as an act of gratitude for the
hospital's service to him. It has been said that so remarkable is the great
picture of Bethesda that a doctor can point to an individual figure in it and
recognise the disease the artist has portrayed. In the great hall at the top of
the stairs are twenty portraits of doctors. The hall is magnificent with its
great fireplaces, its rich gilded ceiling, and a quaint window of Henry the
Eighth handing the charter to the Lord Mayor. In the office are two queer
figures of a wounded soldier and a wounded sailor which may have stood
outside wards reserved for members of the Forces.

Smithfield

We are here at West Smithfield, in the middle of which is a small garden
surrounded by a road circling round to the station under the market. In the
garden is a fountain with a bronze figure of Peace, a welcome note indeed
in Smithfield, famous through the world for its tragic story of men and
women burned alive because they were true to themselves. On a stone near
St Bartholomew's Gateway is an inscription telling us that within a few feet
of this spot John Bradford, John Philpot, and other servants of God suffered
death by fire for their faith.

The great spectacle of this space today is the marvellous Smithfield Market,
a long and impressive structure with ten towers and domes, flags flying, and
stone figures of women and heraldic creatures adorning the gateways. The
fronts of its shops are two miles long, and when all its shining hooks are filled
the rows of carcases displayed would reach for 45 miles, just the length of
the quay frontage of the London Docks. We are now but a little way from
Cheapside, our next walk.

Cheapside

The Halls of the Merchants and the Churches of Wren

Poets from Chaucer to Wordsworth have sung of Cheapside, and well they might, for it was the most important street of medieval London, with the handsomest shops and the richest people. Now it is lined with attractive shops, and as we stand looking down it from St Paul's it is delightful with the graceful tower of Bow Church.

Down Foster Lane is the church of St Vedast, with a gleaming white steeple by Wren. Seen best from the end of Newgate Street, the lovely square tower has three stages – one concave, one convex, the third a spire like an obelisk rising 160 feet. Over one doorway is a relief of Religion and Charity. Inside is a ceiling with rich mouldings looking down on seventeenth century woodwork, including screens, an altar table carried by angels, and the reredos and the canopied pulpit, their rich carving said by some to be the work of Grinling Gibbons.

Goldsmiths Hall is at the end of Foster Lane, a massive building with rich iron doors. When they were excavating for the foundations they found embedded in the clay a Roman altar with a figure of Diana. This hall is the place which, even more than the Royal Mint, approves the gold and silver of the realm. The Goldsmiths Company stamps all the gold and silver articles bought and sold in England, with marks denoting the standard, date, and maker, and with the leopard's head, oldest in origin of all the hall-marks (which take their name from having been stamped at the Hall of the Gold-smiths). The Hall, which has notable portraits of sovereigns and a staircase of many coloured marbles, is adorned on festival nights with the Company's incomparable plate. Their silver salts are their pride and glory; they have one of 1522 fashioned like an hourglass, the earliest surviving form of salt cellar of which barely a dozen are known. But of the later ceremonial salt cellars four belonging to the Goldsmiths are known all over the world.

The Coachmakers Hall is in Noble Street, a continuation of Foster Lane on the other side of Gresham Street. Three little golden coaches are in the coat-of-arms over the door, and inside is an eighteenth century screen from the old hall.

The modern hall of the Wax Chandlers stands by Goldsmiths Hall, and has a gay little coat-of-arms painted over its front door. The Haberdashers

Hall is facing it, with rich stone garlands carved over its entrance. Though a nineteenth century building it has all the dignity of a collegiate hall, with panelling and a painted oak screen of the seventeenth century. It is hung with flags and has a frieze of shields.

The century-old Saddlers Hall is in Cheapside, hidden behind modern buildings adorned with a little round balcony. This is one of the two oldest livery companies, its representatives of leather and law living up to the ancient motto, Hold fast, sit sure.

Wood Street was almost he last in London to retain its old signs, for they were not swept away till 1773. It still keeps at its corner the flourishing plane tree which the surrounding tenants are not allowed to rob of light by raising the height of their buildings. Here Wordsworth imagined poor Susan hearing a caged thrush sing its song. In Mitre Court, a little square off Wood Street, stood the home of Dick Whittington. At the lost church of St Michael in Wood Street the head of James the Fourth who fell at Flodden was said to be buried.

Still standing in Wood Street is one of the oldest and newest of the City churches, that of St. Alban, our first English Martyr. It is said to have started life as a chapel of Offa, King of Mercia, and is remarkable for having the combined work of Inigo Jones, Christopher Wren, and Sir Gilbert Scott. Wren built the tower and restored Inigo Jones's nave, while Scott designed the eastern apse. The graceful tower has eight pinnacles, and its carved corbels show fiendish faces gloating over the churchyard, in which were buried the dissected bodies from Barbers Hall. The ribbed plaster vault of the nave is gay with gilded bosses, and a forest of foliage appears above the twisted balusters of the organ screen, perhaps the finest feature of the church. The organ case, with its cherubs and pierced frieze, is partly seventeenth century, and of the same date is the pulpit.

A tablet on a building at the corner of Ironmonger Lane marks the site of the house where John Boydell died the year before Trafalgar. In a garden in the lane we can see the remarkable vicarage of St Margaret, Lothbury. Forming part of it is the tower and west front of Wren's church of St Olave Jewry, pulled down half a century ago. The doorway of the tower is the front door of the house. In the original church was buried Robert Large, the mercer who was Caxton's first master.

At the end of the lane is the entrance to Mercers Hall, with a curious seventeenth century carving of the Madonna over the door. The Mercers Company is the first in precedence of all the City companies, and the richest, and its hall has fine woodcarving attributed to Grinling Gibbons. The court room has a 400-year-old picture of Dick Whittington and his cat.

The Master's chair was made before the Great Fire, and is remarkable for having a detachable arm to allow a portly man to get out of it with ease. The famous Leigh Cup of silver was made in 1499. On Sunday evenings we can attend service at the chapel, in the porch of which Thomas Guy, founder of Guy's Hospital, was apprenticed to a bookseller.

Cheapside has now merged into Poultry, and on the site of Number 31 Thomas Hood was born in the last year of the eighteenth century. At the end of Poultry are busts of men and women over the roundheaded windows of the fine Midland Bank which Sir Edwin Lutyens has designed. It cost a million pounds, and several Roman piles were found beneath it. Here we cross to return on the south side and glance at the terracotta panels on Numbers 12 and 13 Poultry, representing four royal processions through Cheapside.

Bucklersbury, which comes from the Mansion House to Cheapside, was once the district of furriers and druggists, and before them of pepperers and grocers. Sir Thomas More lived here, and here was born his daughter Margaret Roper. Hereabouts Keats was lodging when he wrote most of his earlier poems, including the famous sonnet on Chapman's Homer.

Pancras Lane has the neatly gravelled little burial ground of the vanished church of St Benet Sherehog, of which one of the rectors was William Sawtrey, First Martyr of the Reformation. He was here in the fourteenth century, and in the first year of the fifteenth was burnt in chains at Smithfield for declaring that men were more worthy of adoration than angels, and that bread after consecration was still bread.

Bow Bells

We come to the church of St Mary-le-Bow, for centuries famous for its bells. Curfew was ringing from Bow Church 600 years ago. All the world knows how Bow Bells rang like a song of hope to Dick Whittington, so that he turned his steps to the City once more and lived to be Lord Mayor. A nine o'clock bell brought the end of the day's work to the City apprentices. Now there is a ring of twelve bells, and every true Cockney is born within their sound. They hang in one of London's most famous steeples, built by Wren when he made the church new after the Fire.

The name of the church comes from the fact that it was built on arches (or bows) in the time of the Conqueror, and the old vaulted crypt still extends under almost the whole church, though part of it is walled up; there are Roman bricks in its masonry, and the capital of one of its pillars is unique for its spear-head decoration.

Only one London steeple (St Bride's) is higher than this, which rises 222

feet. Of all Wren's parish churches, Bow was the costliest, and nearly half the £15,400 spent on it he put into the steeple. The tower is 32 feet square, the belfry adorned with pilasters and crowned by balustrades and scroll-shaped pinnacles with vases. Resting on the top of the tower is a stone cylinder surrounded by twelve columns, with a dome, a lantern, and a tiny spire climbing to the weathervane, a dragon nearly nine feet long, proud emblem of the City.

The balcony on the tower, looking out on Cheapside, was put there by Wren in memory of an old gallery built against the church, from which kings and queens from the time of Edward the Third watched pageants and processions.

The church is almost square inside, Corinthian columns marking the aisles and supporting the arched ceiling adorned with foliage and roses. The pulpit has fine Jacobean carving of leaves and flowers. The altar table and the rails are seventeenth century, and there are two old chests. A painting of Paul is said to be by Salvator Rosa. At each side of the reredos, with the Holy Family in a rich frame, are pictures of an angel blessing a knight and an angel comforting a mother; they are in memory of those who died for peace. An ornate monument has busts of Colonel Bainton of 1712 and his wife, holding hands. Thomas Newton, a rector here who became Dean of St Paul's, has a monument with his bust on a sarcophagus; he was a friend of Dr Johnson. On the west wall outside is a tablet (with lines by Dryden) to John Milton, brought here from All Hallows in Bread Street when that church was pulled down. Milton was born in Bread Street, and was baptised in the old church. On a building at the corner of Bread Street and Watling Street is a bronze head of the poet.

It was on the site of Wakefield House in Cheapside that there was found in 1912 the famous box of 300-year-old jewellery now divided between the London and Guildhall Museums. It is a dazzling collection, and is thought to have been the stock of a jeweller, hurriedly hidden in some troubled time.

At the Cheapside end of Friday Street stood the Wren church of St Matthew, where Sir Hugh Myddelton is buried, and the Mermaid Tavern, where Ben Jonson, Beaumont, and Fletcher, and perhaps Shakespeare, used to meet. At the other end is Cannon Street, where we can peep into the domed entrance lobby of the Cordwainers Hall. Cordwainers were shoemakers.

Old Change, running back to Cheapside, is so called because in the middle of the street was the King's Exchange, housing bullion to be coined. Now St Augustine's Church is here, at the corner of the narrow Watling Street. Small and plain, it has one of the biggest collections of plate in the City. The body of the building is the work of Wren, and part of the tower is his

design, with a medieval base and a leaded spire. The interior was rearranged by Sir Arthur Blomfield, and Mr Martin Travers restored the seventeenth century reredos, the painted pillars and pictured panels making a rich composition of blue and gold. Wren is believed to have designed the font, adorned with chubby-cheeked cherubs and elaborate foliage rivalling that on the handsome pulpit.

Guildhall and Cripplegate

Round the Old Guildhall

Its great white front rises at the end of a deep courtyard, a charming spectacle, with the Art Gallery on the right and the Magistrates Court on the left. It is the work of George Dance, who refronted the Guildhall in 1789, giving it three groups of windows rising in four tiers, with soaring pilasters enriched with ornament and crowned with carvings of the Great Mace. The middle pilasters rise higher than the rest, and between them are the City Arms, with a dragon on each side and the fur cap the Swordbearer wears. Behind rises the steep pinnacled roof of the Hall itself, crowned by a lantern with gilt dragons holding a spear at each corner, and a lovely spire with delicate ironwork.

As we step into the porch we are back in the fifteenth century with its ribs and panels and richly carved bosses. In one of the panels is a memorial to a Councillor and seventy-six of the staff who fell in the war.

Through a noble doorway we enter a hall which was rising when Henry was fighting at Agincourt and Harfleurs. For its paving Dick Whittington's heirs gave £35, and they also gave glass for the windows. The paving and the roof perished in the Fire of London, but two of the paving stones are preserved in the crypt and the original roof was copied by Sir Horace Jones when he restored the Hall in 1864. Even today we can see the marks of fire and smoke on the walls, one of the very few buildings in London still bearing signs of the Great Fire.

This wonderful hall is 151 feet long and 48 feet wide, so vast that the standard measures of feet and the links of chain measurement, set in brass in the floor, look small. It has eight bays, and at either end is a glorious original window, the eastern lighting the low dais below (the hustings of civic elections), the western a background to a gallery. High up in the walls are windows, but the most interesting window is low down. It still has the plain glass placed in it during the Civil War and the iron hinges on which swung the shutters of medieval days.

Decoration old and new enriches the great interior. Under a rich cornice runs a carved frieze of the arms of England, the City, and the twelve chief Livery Companies, sixteen of whose flags project above the frieze into the hall. Hundreds of carved and gilded Tudor roses adorn the huge arches

of the open roof. The dais has a richly carved background of oak with a moulded canopy and niches for statues, but peering above it are the tops of canopies carved in stone by medieval craftsmen, projecting in the centre and at each corner as if to shelter seats of honour. Modern oak again forms two small galleries on either side of the hall, one with four dragons mounting guard and eight carved brackets which support the gilded plate at Guildhall banquets.

Hardly ornamental, but representing an ancient legend of the dawn of our history, the famous figures of Gog and Magog look down from the west gallery. Barbaric giants of painted wood, 14 feet high, they were made in 1705 to replace the ancient wicker giants carried in the Lord Mayor's Show. Slung on the back of Gog are his bow and arrows, and he carries a pole with a spiked ball hanging from it. Magog is like a Roman warrior, with shield and spear. Both wear laurel wreaths.

Five great statues honour famous men. Chatham stands above a group of figures with a lion and a beehive in the foreground, designed by John Bacon; and facing him is William Pitt, who stands between a Muse and Mercury, with Britannia riding a sea-horse in front. Nelson's monument has a colossal Britannia looking down at his portrait on a plaque, while another

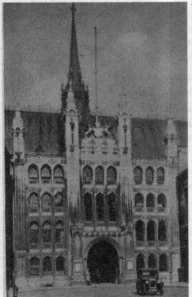

The Guildhall

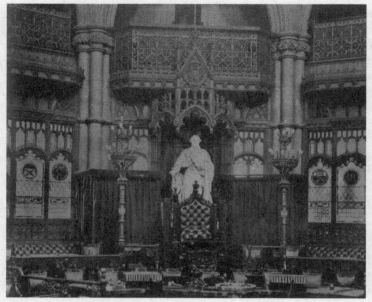

The Council Chamber at the Guildhall

figure writes Nile, Copenhagen, and Trafalgar on a panel; on the pedestal is a relief of Trafalgar. The Duke of Wellington, a huge statue by John Bell, stands between figures of War and Peace, while on the pedestal the duke is seen at Waterloo, tiny figures of Napoleon and his Marshals appearing in a corner. The fifth statue shows Lord Mayor William Beckwith, and inscribed on the pedestal in gold is the speech he addressed to George the Third, hinting that the Revolution which drove James from the Throne might be repeated if the king were not careful to respect the Constitution. The king, flushing red, was dumb.

More restrained than these great marble groups is Mr F. W. Pomeroy's memorial to the men of London who died in the South African War, a woman holding a wreath over their names.

Through a wide doorway facing the entrance we mount a few steps into a lobby with a wall painting of London washed by the Thames, and with six strong faces in marble ranged round the walls, busts of Nelson, Wellington, Havelock, Gordon, Cecil Rhodes, and the Duke of Cambridge. Cecil Rhodes is a characteristic study by Henry Pegram. Beyond is the spacious lobby on which gleam the wide golden gates guarding the Council Chamber.

Attractive as a picture gallery, this lobby's walls are adorned with Hayter's famous portrait of Queen Victoria in 1839, Northcote's dramatic Death of Wat Tyler, George the Third receiving the City's sword at Temple Bar, and a quaint French painting of the Lord Mayor presenting an Address to Louis Philippe at Windsor. Busts of Gladstone and Disraeli look down the room, which has also busts of Lord John Russell, Canning, Palmerston, Iddesleigh, and Joseph Chamberlain. Busts of Cobden and other famous freemen of the City are in the corridor round the Council Chamber.

This chamber, built in 1884, is a lofty dome-shaped hall of twelve bays, each containing a canopied and panelled screen set with glass. The screenwork is rich and ornate. Light and air enter through an oak lantern. Immediately behind the Lord Mayor's seat, under a rich canopy, is a statue of George the Third by Chantrey.

The Most Beautiful Room in London?

The golden heart of the Guildhall is the Alderman's Court Room, where sit the heads of the Government of the City. It is a truly palatial chamber, worthy of London's rich Square Mile. There are many who regard this seventeenth century room as the most beautiful in London. The panelled walls and the rich cornice are set with the carved and painted shields of old Lord Mayors. The windows glow with colour, the seats are richly carved.

But the supreme beauty of the room is in its ceiling, with an oval painting by Thornhill representing the City as a lady attended by Minerva, Peace, and Plenty. Four smaller panels have paintings of cupids, and the rest of the ceiling is covered with satyrs, boys, and beasts mingling with rich bands and scrolls of acanthus leaf. Above the black marble fireplace is another painting by Thornhill, showing Truth looking up at Justice, who is embracing Mercy. Three beautiful doorways lead into this wonderful room, and we pass by one of them back into the great hall to seek another doorway, old and scarred.

This is the way down to the eastern crypt, a place of beauty with six clustered pillars from which swing ribs of stone to make a vaulted chamber. Built early in the fifteenth century, it is the best preserved crypt in London. It has heraldic bosses 21 inches across. On the floor are big objects too big for the museum beyond; a huge fragment from the Roman Wall, a Roman burial urn, and a coffin 800 years old carved with a long trumpet and a lovely cross, with the words: Godfrey the Trumpeter lies here. Here, too, is a stone with the crowned head of Charles Stuart from the old Royal Exchange, and a superb mahogany staircase from a house.

The Guildhall Museum

Through a dark arch of the crypt lies the way to the Museum, where are a thousand things to interest us of the early days of London.

Through the Newspaper room, which is lighted by a window with a copy of Raphael's School of Philosophy, we enter the Guildhall Library, a magnificent hall reminding us of the glorious nave at Lavenham. The library is 100 feet long and 65 feet wide, well lighted by windows with gleaming heraldry, excepting for one at the end which represents in six scenes the introduction of printing and the founding of libraries. Below this window is a superb fireplace with a coloured frieze of a procession of symbolical figures of the Arts and Sciences between heads of Chaucer and John Carpenter. Boldly carved heads of twenty-eight men famous in our story look down from the spandrels of the great bays, and above them hang livery banners guarded by queer beasts. Almost touching us as we sit reading here is a white marble bust of Chaucer himself.

The corridor from the Library to the courtyard is full of colour from huge canvases, one of Robert FitzWalter on a white horse receiving the City's banner on the steps of old St Paul's, and one of a Solemn Joust on London Bridge in 1390. Crowded with brightly robed and uniformed people are George Clint's Guildhall Banquet to the Kings in celebration of the tranquillity of Europe (we noticed that it took place exactly a year before Waterloo); J. H. Nixon's Progress of Queen Victoria to the Guildhall in 1837, a gorgeous scene by St Paul's; and A. C. Gow's picture of sixty years after, the Diamond Jubilee Service outside St Paul's, surely a record in portraits. There is also William Logsdail's vivid Lord Mayor's Procession in 1888, three flunkeys in their superb livery being contrasted with a pathetic grannie and two children looking on a splendid painting. A marble bust of Tennyson is here with busts of Charles the Second and Sir John Cutler, and by the door is a bronze of Romulus and Remus and their foster mother wolf, as if to remind us that London is the true successor of the greatness that was Rome.

One of the brightest Art Galleries in London is at the Guildhall, small enough to be fully appreciated at one visit, yet with many pictures which will linger in the memory. This art gallery is very rich in groups. There are eighteen paintings by Sir John Gilbert (Cardinal Wolsey with the King and Wolsey on his way to Westminster Hall) and thirty Gilbert drawings; twenty fine architectural drawings by E. W. Cooke; thirty-one etchings of London by Joseph Pennell; and twenty studies by our great animal painter and sculptor, John M. Swan. Over these is a bronze statue of Nimrod hunting a lion by Briton Riviere, while in other rooms are a gem in bronze of Edward the First

by Sir Hamo Thornycroft, a superb Henry Irving as Hamlet by Onslow Ford, and a tragic Clytie by G. F. Watts.

Wren's Corner of Guildhall Yard

Standing boldly at the corner of Guildhall Yard is St Lawrence Jewry, one of the first churches to be rebuilt after the Fire. It was also one of the costliest, and its eastern facade is a fine example of Wren's work. St Lawrence has pride of place in the City as the church of the Corporation, who come every year in procession before electing the Lord Mayor. We enter through a vestibule fitted up as a small museum, and then through one of the splendid west doorways, each framed with fluted pillars and crowned by an angel. Between them towers the organ, its case and gallery a marvellous display of carving, with cherubs and musical instruments, and in one place an open book showing a tune by William Byrd.

Hardly changed since Wren's time is this fine interior. The ceiling with its flowers is handsomely panelled to represent the gridiron of St Lawrence's martyrdom, which we see again on the weathervane of the steeple. The pulpit and its sounding board are magnificently covered with delicate work and topped by gay little bunches of oak-leaves. The communion table is exquisite with legs carved as cherubs. The pews are the original ones, some with friezes pierced and carved; and for the Lord Mayor there is a great enclosure with a fine chair and an elaborate iron sword-rest made in 1678 by 'Smith the Smith.' The City flag hangs above, and the flags of Canada and New Zealand hang over two pews set aside for Canadians and New Zealanders. At the pew of the Girdlers Company stands a replica of their seventeenth century mace, here in memory of the reign of George the Fifth.

In the windows are many figures full of movement; but the best is of Sir Thomas More in his robes, reminding us of the lectures he used to give in the earlier St Lawrence's. There is a fine painting of St Lawrence giving treasure to the poor, probably by an artist of the Rembrandt School. There are busts of a seventeenth century alderman with his wife and daughter, and one of John Tillotson, who became Primate after winning an immense reputation as a preacher. Here he was buried in 1694.

But perhaps it is the vestry that delights us most of all. It is a superb old room and can have few rivals anywhere. Designed by Wren and carved by Gibbons, it is enriched from floor to ceiling. The ceiling is a masterpiece in plaster, framing a picture of St Lawrence being carried to heaven. His gridiron has become a celestial harp and his tormentors are driven back by an angel. Over the fireplace is a fine picture of the saint's martyrdom, almost terrifying in its realism. In the panelling is a seat made for Charles

the Second when he came to the Thanksgiving Service. The vestry keeps among its treasures three flagons made 300 years ago, and a grandfather clock made in a house on old London Bridge.

The bells of St Lawrence are a fine peal of eight, and it is remarkable that they have been overhauled in our own time by the firm that made them nearly 200 years ago.

On a modern building at the corner, where we enter Aldermanbury from Gresham Street (it is like going through the eye of a needle) are several carved stones showing the sign of the inn it displaced, the Swan with Two Necks. On a building near by is carved a pelican, and as we continue up the street we come to a place which should stir the imagination of every Englishman. It is the church of St Mary Aldermanbury with its gleaming tower, shaded by fine plane trees which are an unexpected touch of greenery here.

In summer the pierced parapet and pineapples are half-hidden by the trees, though above them rises the rather unusual clock turret on a tower with three lower storeys probably 500 years old. The spacious interior is of grand simplicity, its curved roof supported by two rows of impressive pillars. The east window has the Ascension, and over the altar in the peace memorial chapel is a seventeenth century picture of the Last Supper. The walls are curiously panelled with timbers of seventeenth century pews, and still in the chancel are two old chairs, graceful with their high backs, carved arms, and turned legs. The fine polished pulpit is mahogany, and came from the church of St Alphege in London Wall. The seventeenth century font with its baluster stem, was given by Richard Chandler, whose huge monument is high on the wall facing the door. Set in recesses are busts of Richard and his brother John, a pompous pair in long wigs, with twenty-one years between their ages. On the wall near by is a beautiful eighteenth century monument showing a woman sitting on a gun beneath a broken column; it is to John Smith, a young naval officer.

A bronze bust of Shakespeare stands on a red granite pedestal in the churchyard garden.

Near the church is the office of the Chartered Insurance Institute, fine among much that is commonplace, with white stone walls and a curved gable, mullioned windows with leaded panes, one big oriel window and a small bronze oriel by the pillared entrance.

Passing a back entrance to the Guildhall, we come to Addle Street, where is the old Brewers Hall which was rebuilt after the Fire and restored last century. Its imposing old gateway has pillars on each side, and sheaves of barley carved over the capitals. The splendid gates with two wickets are carved with acanthus leaf borders and have a grille of twisted iron ending

in fleur-de-lys. From the pretty courtyard a balustraded stone stairway leads to the Hall, whose stone windows are richly carved with grapes and hops and barley. A fine oak archway enriched with arms and figures opens to the panelled interior, with its musician's gallery, and the shining old tables and benches leading up to the Master's chair.

On a building close by is a seventeenth century carving of a chained bear, one of the quaint signs we come upon here and there on the walls in the City. From Addle Street we cross Wood Street into Silver Street, where the plain little painted Parish Clerk's Hall has its arms over a simple doorway.

The Wonderful Hall of the Barbers

A right turn from Silver Street brings us into Monkwell Street, with the Coopers Arms standing on the site of a house where Shakespeare lived in 1604. Here, too, is the fine seventeenth century Barbers Hall, a rose and crown and the arms adorning the roadside entrance to the courtyard. The entrance to the Hall itself comes from 1671, and is splendid with painted heraldry and a rich mass of carving under a canopy. An air of rich furnishing clings to the panelled corridor and the old stairway (with a huge brass candelabra at the foot), but it is the Court Room that astonishes us. Here a chandelier of glittering crystal hangs from a little dome crowning a ceiling lavishly decorated with flowers. The walls are hung with paintings, of which some are famous and almost without price. There is Lely's portrait of the Duchess of Richmond, the original of our familiar figure of Britannia; Reynolds's portrait of James Paterson, who was Clerk to the Company; and a fine head by Van Dyck of Inigo Jones, who designed this room. Its chief treasure is a great painting of Henry the Eighth granting a charter to the Barber-Surgeons, showing the king in the midst of about a score of figures, with his own three surgeons by him. It is a historic and pathetic picture, which Pepys once came to see, for it was the last work on which Holbein was engaged, being unfinished when he died of plague. With it here are portraits of kings and queens, of Thomas Lisle, king's barber in 1662, and Edward Arris, a surgeon of the same time; we see him again in a picture showing a dissecting scene. In an ante-chamber is a richly painted leather screen of which a strange tale is told. It is said to have been the gift of a man who as a youth was sentenced to be hanged at Tyburn, and hanged he was, presumably, but when his body was received by the Barber-Surgeons for dissection, it was found that he was not dead. He recovered, begged them not to kill him, was saved and sent abroad, and lived to send this screen as a thankoffering to those who had spared him.

At the end of Monkwell Street is a passage opening to an avenue of trimmed planes in the churchyard of St Giles's, Cripplegate.

This precious church was spared by the Great Fire, but it has suffered from other fires, for the City has always pressed closely round it, as the warehouses do still. It is plainly seen from Fore Street (the ancient way before the Wall), or from the churchyard, but the best view is from the vicar's gate, where we see the tower with its fine fifteenth century base and its upper storey of 1684 with a wooden lantern and a fine musical peal of twelve bells which play hymns and songs every three hours.

This church with so much history has in its churchyard a visible monument of the earliest days of our history, a bastion of the Roman Wall with flowers and plants creeping out of its crevices. The oldest monument that has escaped the fires of Cripplegate is that of Thomas Busbie, a rich cooper who died in 1575. His painted figure shows him in a black coat, his face full of benevolence, and his epitaph tells us that he gave the poor of Cripplegate every year four loads of the best charcoal and forty dozen loaves.

The church has other treasures worthy of notice. The altar, the balusters of the rails, the clock with the gilt figure of Time, the pulpit with festoons of fruit and flowers, the font cover with its gilded dome, and the lectern, are all early eighteenth century, and it is believed that some of this woodcarving is the work of the Richard Saunders who made Gog and Magog in the Guildhall. The fine oak reredos of 1704 has modern painted panels, and the north chapel has a seventeenth century reredos with carved angels and paintings of Moses and Aaron. Like the eighteenth century doors to the north lobby, it came from a lost church. Hidden under the reredos are tiles 600 years old.

The east window is oval, with some eighteenth century glass. A modern window with three panels of the Nativity is in memory of Edward Alleyn, the actor friend of Shakespeare and founder of Dulwich College.

Turning left on leaving Milton's church, our walk brings us up Red Cross Street and across the Barbican into Golden Lane, where two City buildings face each other. One is the Coroner's Court, a plain place of brick and stone; the other is Cripplegate Institute, also of brick and stone, imposing with pinnacles and pediment adorned with figures of three women. There is bronze statuary on the stairway, and at the top are marble busts of Defoe with curly wig and cravat, Cromwell as a soldier, Bunyan in buttoned coat and lace collar, and Milton with long hair and sightless eyes – four citizens of the neighbourhood.

We retrace our steps from the Cripplegate Institute (which lies at the northern boundary of the City) to Milton's church, opposite which is White Cross Street, where a sign, the City Greenyard, leads us to the stable with green doors behind which is housed the Lord Mayor's coach.

Through Cripplegate Buildings into the western end of London Wall, we find on our right the Curriers Hall, now the fine new building of the

Chartered Institute of Secretaries. Over the beautiful doorway with its rich mouldings is a charming two-storied oriel with rich carving of quaint figures and heads. A fine coloured iron sign with the Company's arms hangs by the door, and just inside is St George in mosaic, the peace memorial. There are two little oriels at one end of the Hall, and among the figures in the windows representing famous secretaries of faraway days are Moses with his Tablets, Laotze, and Aristotle. One window has a fine picture of the Court of the Exchequer of Edward the Third, showing the king in red on his throne with his counsellors about him; people are paying taxes, clerks are checking scrolls and counting money, and miserable debtors are in a cage.

On the same side of London Wall is the church of St Alphege, now perhaps the most curious church in the City, for it consists of little more than a fourteenth century tower fitted up as a chapel, its altarpiece a sixteenth century wooden relief of the martyrdom of Stephen.

On the wall is another carving, this time of alabaster, its pillared recesses showing the kneeling figure of Sir Rowland Hayward, first Protestant Lord Mayor, surrounded by his two wives and sixteen children. Another wall monument is to John Edwards, a pike-maker of 300 years ago. In a glass case are some medieval tiles and pottery, some iron relics of the Great Fire, and a bit of a German bomb which fell through the skylight of the lost nave.

Passing Aldermanbury again we come to Basinghall Street, leading to the Guildhall. At 39 is the Jacobean building of the Girdlers Hall, with three rooms. The Hall has richly panelled walls, a great Irish carpet on the floor, and on the wall a rarer carpet made in the Emperor Akbar's factory at Lahore, given to the Company 300 years ago. The Hall is specially charming when the old benches and tables reflect the light from the oak candelabra. From the Court Room, sumptuous with its moulded ceiling, panelled walls, and a mantelpiece with wonderful festoons of hanging flowers, we see the pretty garden with mulberry trees and an old leaden cistern. Contrasting with it is a drawing-room of delicate charm. At 81 Basinghall Street is the Coopers Hall of 1868, with a rich doorway. At 22 is the Weavers Hall, now used as offices. Near them is the nineteenth century Wool Exchange, with heads of rams on the capitals of four granite pillars at the entrance.

Continuing down Basinghall Street, past the Guildhall with its lantern and spires, clustered chimneys, and embattled walls, we turn into Gresham Street and then eastwards to Coleman Street, catching a grand view of Mr Wheeler's Ariel on the fine dome of the Bank of England. Here in Coleman Street is the church of St Stephen, with The Day of Judgment awaiting us at the gateway. It is a plaster copy of the oak original, which has been taken indoors, and shows Our Lord with angels above the clouds and Satan below,

the Evil One seeming to be trying to hold back some of the host of people rising from their graves. The Great Fire consumed the ancient church, and it was rebuilt by Wren; 250 years later a German bomb destroyed the east window. Buried among offices near the Guildhall, it is a plain building, low and long, with a tower and lantern hardly seen from the road; but it has some fine carving to show in its old woodwork. The beautiful pulpit has carved panels of acanthus and palm; great eagles and seated cherubs support a rare altar table; and the altar rails are lavishly adorned. Interesting relics are a sword-rest and a beadle's staff with a crown at the top.

At the London Wall end of Coleman Street is the Hall of the Armourers and Brasiers, a dignified building made new last century on a site the Guild had occupied for 600 years. On the parapet of the roof is a great coat-of-arms with a mailed knight at each side. There is a baronial air inside, with suits of armour standing like knights on guard. One suit was worn by Queen Elizabeth's Champion.

Leaving this Hall we cross London Wall and Fore Street into Moorfields, and then past Moorgate Station by Short Street into the northern end of Moorgate. In front of us is Britannic House, one of Moorgate's fine modern buildings, with enriched windows, balconies, pilasters, and festoons. Near by is Electra House, designed by John Belcher, with four cherubs supporting a globe which crowns the dome, and a beautiful bronze doorway enriched with sculpture by Sir George Frampton, showing one woman writing and one reading, an angel at the side of each, and groups of figures representing Industry and Science. Opposite Electra House is the site of the Swan and Hook, at whose livery stables Keats was born.

Another fine building is Ocean House, enriched with carvings of Neptune, sea-horses, and a lighthouse in a niche. It stands by a little passage leading to a quiet court where we find one of the most charming of London's modern buildings, the Institute of Chartered Accountants. We wish it had a space as big as Trafalgar Square. The work of John Belcher, it is Italian Renaissance in character, perhaps the best example of this style in the land.

This great building is as charming inside as out. On a corner is a fine projecting balcony resting on mermen, with clusters of pillars supporting a dome crowned by a sculptured figure. Pilasters adorn the stone walls, which are crowned by an exceedingly rich cornice edged with acanthus leaves and lions, and a magnificent frieze between the second and third storeys in which are 190 feet of carved figures is the biggest of its kind in London.

Aldgate and Bishopsgate

Aldgate

We begin at Aldgate Station, where across the road stands a seventeenth century inn with windows all awry and vines carved on the little posts by its doorway. Down the road towards the City, at the corner of Houndsditch (which, like so much of this eastern part of the City, belongs to the Jews), stands the eighteenth century Church of St Botolph, designed by George Dance who built the Mansion House, though the most striking feature of its interior was added last century by the architect of Westminster Cathedral, John Francis Bentley. He gave it the fine plaster cornice of angels holding shields of City companies, two long lines of canopied figures flanking the grim and gloomy east window in which the glass is a copy of Rubens's Descent from the Cross in Antwerp Cathedral.

Facing each other in the galleries of this church are two marble monuments. One has a niche with a painted bust of Robert Dow, the merchant tailor who paid for ringing the bell of St Sepulchre's for Newgate executions; in his round cap and ruffed gown he gazes across the nave, resting his hands on a skull. The monument facing his has an emaciated figure on a tomb, wrapped in a winding-sheet; it is to Lord Darcy and Sir Nicholas Carew, who lost their heads on Tower Hill for plotting against Henry the Eighth. In this church is an actual witness of the horror of Tower Hill, for in a glass-topped box in the vestry is kept the mummified head of the Duke of Suffolk, father of Lady Jane Grey.

Gathered about the busy cross-roads by the church are several points of interest. Close to the church is Aldgate Street Post Office, with a tablet marking the site of the gate over which Chaucer lived for twelve years as Controller of the Customs. Opposite the church is the Minories, a road of warehouses leading down to Tower Hill. Down Jewry Street is the Cass Institute, in which the first thing we see on entering is the peace memorial, a window showing a soldier in his sheepskin coat on the battlefields of Flanders. In the hall is a fine bronze figure by Roubiliac of Sir John Cass who founded a school for poor children over 200 years ago; as he signed his will a bloodvessel burst and stained his pen with blood, and every year children of St Botolph keep his memory by marching to the church wearing a red quill. The good Sir John wears

his sheriff's robes and a curly wig. At his side is a case of Roman relics found here.

Back a few steps to Aldgate we are at the meeting of the ways by Aldgate Pump, famous in the City for the phrase 'a draft on Aldgate pump,' meaning something of no value at all, for the pump is but an old stone pillar now, with a worn handle no longer used, though w emay press a button and water flows from the glittering brass head of a wolf.

The City's Noble Buildings

Bearing south into Fenchurch Street, the first building attracting us is Lloyds Register of Shipping at the corner of Lloyds Avenue. Founded in the eighteenth century for the classification of merchant ships, it now has many other duties, such as maintaining surveyors in the world's chief ports, and it issues every year a Register Book with full details of the world's ships. It is housed in a classical building with a projecting corner turret crowned by a ship as a weathervane, and striking friezes run round the corner turret and above the windows. Among the figures (symbolical of shipping progress) are women with sailing ships and steamships, mermaids, and men and women bringing merchandise. Standing apart are four fine figures of women holding ships. Inside the hall, with its splendid pillars, is a beautiful bronze Britannia standing on the prow of a ship, the peace memorial to the Fallen, by Arnold Wright.

We come now to Fenchurch Street Station, a drab matter-of-fact building in a little square, with four platforms reached by a flight of stairs, a gloomy gateway for the gorgeous East, yet from here we can go to India, Ceylon, Singapore, China, Japan, and Australia.

Continuing along Fenchurch Street, opposite Mark Lane, we notice the fine Cory Building with its richly carved entrance and cornice and fine bronze windows; and a little farther down is Plantation House, a magnificent new building towering above its neighbours in receding stages. Its impressive pilastered front has two tiers of columns, one rising above a rich bronze balcony of floral scrolls. There are coloured medallions of roses and heraldry in the handsome windows, and the fine bronze door is set in an arch richly carved with fruit and flowers.

Turning into Lime Street on the left is a narrow passage opening into a tiny court, where is St Dionis Hall, a two-storeyed vestry of a seventeenth century church. A long flight of steps leads us to the upper room, and the room below is richly panelled, some of the woodwork from the Wren church of St Dionis which stood here. Today this charming fragment of a lost church is a little place where City workers may come and eat their lunch, discuss the topics

of the day, and listen to debates. Close by, but almost unseen, is Leadenhall Market, distinguished by the pheasant which shows how the wind blows. It stands on land roughly in shape like a cross, covering the roadways with a glass roof. On the pillars at the entrance sits the City dragon. Under this market they came upon the foundations of the basilica of Roman London.

Coming back into Lime Street we notice a towering block of Insurance Offices giving a striking effect with its pillars soaring five storeys high, each pillar ending in shell ornament. Another striking building in Lime Street is a part of the Royal Mail Office which extends its fine front with a richly carved frieze down Leadenhall Street. Crossing over the road we come to the oddly-named church of St Andrew Undershaft at the corner of St Mary Axe.

It is Old Stow's Church, an excellent example of Tudor Gothic, and a typical town church of its time, with a tower older than itself, once overtopped by a maypole shaft which gave the church its name. We enter by a door with a fifteenth century lion's head knocker. Two rows of clustered pillars support the clerestory, above which is the original roof, the ribs of its square panels having 130 floral and heraldic bosses shining in gold. The roof was damaged by an air raid in the war and 100 panes of glass were broken, but the church has still more pre-reformation glass than any other in the City. In the top of the windows in the aisles is the original glass, showing the arms of those who contributed to the rebuilding. It is the great west window that is the glory of the church, filled with glass of the seventeenth century, showing Edward the Sixth, Queen Elizabeth, James and Charles, and Dutch William. They stand under canopies, all crowned except Edward the Sixth, whose crown rests by his side as he had no coronation. Below them are the arms of the Stuarts, and in the tracery are tiny figures of the Madonna and St Andrew.

The graceful font is by Nicholas Stone, and the oak balustrade round it is contemporary, but may have started life as the altar rail. The present rails, of splendid scrolled ironwork, may be the work of the famous Jean Tijou; they lay in a coal cellar for half a century. The fine iron sword-rest was rescued from a smithy; it now stands on a pierced screen forming a back to the pews, and on the top of the screen is an eighteenth century clock made in Leadenhall Street. The old organ, on which recline two angels, has had only three organists in 116 years, one of them Dr John Worgan, the Welsh composer, who was here for forty years.

On the opposite narrow way is the splendid P&O building in classical style with Doric columns, a balcony along the front, and vases along the great cornice. In a niche at the corner stands a figure of Navigation, a man holding a ship in one hand and steering with the other. Over the arch of the

doorway are mermaids with sea-horses, and at the steps are finely sculptured lamps and bronze gates enriched with ships in full sail.

Down St Mary Axe we come to the Baltic Exchange, a handsome twentieth century building. Its beginnings were in a seventeenth century coffee house concerned in trade with the Baltic, but nowadays it is the headquarters of merchants, shipowners, and brokers concerned with the chartering of vessels and the carrying of such floating cargoes as coal and grain, oil and timber. It has an impressive front with granite columns supporting a pediment on which sits Britannia by a lion, with a scene of Agriculture and another of Neptune with his ships and mermaids. The entrance hall is a lovely place, with floors, walls, and pillars of marble in delicate grey; but we may do no more than peep through the glass doors into the great domed and pillared hall where members do their business, for it is one of the holy of holies of the commercial magnates of the City. In a wing of the hall is a group of richly stained windows in memory of the fallen.

Retracing our steps to the eastern end of Leadenhall Street, we find the Church of St Katherine Cree. Unlike most of its neighbours, this fine City church, with a picturesque style of its own, escaped the Fire, yet comes for the most part from the seventeenth century rebuilding of the thirteenth century church. The lower part of the tower and the porch are early sixteenth century; the colonnade and cupola were added in the eighteenth to the low tower which stands at a corner of the street among the shipping offices. On the south wall is one of the biggest sundials we have seen.

A hall at Lloyd's

A mixture of Gothic and classical styles, the interior is striking with narrow aisles divided from the nave by arcades of rich arches and capitals. In the great east window is a fine Catherine wheel, filled with eighteenth century glass. The fine pulpit is early eighteenth century. There is a lovely Adam altar table, and carving on the organ (on which Purcell played) said to be by Grinling Gibbons.

In Creechurch Lane is the old sign of the Crown and Three Sugar Loaves, over the oldest tea-merchant's business in the world. We see the tombs of the partners in St Olave's Church. The tea thrown into Boston Harbour at the famous Tea Party came from this firm.

Here we walk back into Leadenhall Street to look at the splendid new buildings. On one side is the Cunard block, a severe eight-storeyed building which cost a million pounds, and opposite is Furness House. These towering shipping buildings dwarf everything around them. Furness House is classical. Africa House has a frieze showing rhinos and crocodiles, hippos and ostriches (one of them debating the point with a snake), and men and women bringing produce to load a camel. Here also is New Zealand House, built in the nineteenth century with an Elizabethan air, and at the other end of the Royal Mail House is the magnificent front of Lloyds.

Lloyds, the Watchers of the Sea

Lloyds is the most remarkable shipping organisation in the world. It has a richly adorned front, and soars upwards in diminishing stages. The entrance arch is one of the finest in the City, sheltering a square doorway richly carved, a balcony above it having an eagle at each end. Sculptured in the pediment are men and women on each side of a globe, with a ship, a lion, an eagle, and a beehive, symbolising the worldwide range and unceasing activities of this great house.

In what is called the Room, domed and decorated with plaster reliefs and portrait medallions, and with windows of stained glass, is the Rostrum at which hangs the famous Lutine Bell, saved from the wreck of a French man-o'-war in 1799, and now hanging in an iron frame to be rung once when a vessel is posted missing and twice when an overdue vessel is safe. Many hours of tense emotion have there been in this domed room.

At the western end of Leadenhall Street we turn into Bishopsgate where it touches Threadneedle Street, and catching the eye is the striking National Provincial Bank, a structure like a temple with a frieze between its columns and its parapet adorned with statues. There are groups representing Arts, Science, and Commerce, Manufacture, Agriculture, and Navigation; a group standing for Manchester showing the pickers of raw cotton and workmen

with goods; a group for London with a figure of Abundance and Father Thames, David with a harp for Wales, single figures for great towns, and St George with Britannia over all.

The Westminster Abbey of the City

We come a little farther up to St Helen's Church, in a court opposite the brick and stone Hambro's Bank. The Westminster Abbey of the City its people call it, for it has probably more important monuments than any other parish church in London. We reach it through the quiet graveyard, a paved path bordered by beds leading to the west end, where a bell turret is perched on the battlements above a pair of windows 300 years old.

We enter the nave down six steps, and are confronted by the most famous feature of the church, the arcade dividing it into two parts. The impressive interior is divided into two naves, and is a noble spectacle. These graceful arches, with their lofty clustered columns, are fifteenth century, most of the church being then made new. Two arches open from the chancel into the fourteenth century south transept, which is divided into two by pointed arches. Let into the wall are several canopied niches of the fourteenth century, and a small panel of Moorish marble said to be 700 years old.

In what is called the Nuns Aisle is an extraordinary fifteenth century Easter Sepulchre in the form of a high altar tomb, and recessed in the wall above it is a 400-year-old monument to Joan Alfrey. In the same wall is a doorway opening on to a narrow flight of steps in the thickness of the masonry, probably the night stairs from an old dormitory. Over the south door a portly stone cherub has been unkindly squeezed between the round arch and the pediment above.

There are beautiful oak screens of the seventeenth century, the same date as the pulpit, which is heavily ornamented with strapwork and medallions. In the chancel are a dozen fifteenth century stalls once used by the nuns, the arms carved with grotesque creatures. On a stone sill at the end of one of the rows is a remarkable wooden sword-rest consisting of two wreathed columns supporting an elaborate pediment capped by a coat-of-arms flanked by angels. It was made in the year of the Great Plague. A curious wood figure of a Jacobean beggar holding out a top hat supports an eighteenth century almsbox at the door; it is one of the oddest collecting boxes we have come upon.

There is a great array of tombs, in one of which lies the famous founder of the Royal Exchange, Sir Thomas Gresham.

At the other end of the arcade is the church's most magnificent monument, a tomb of great splendour, on which lies the famous Sir William Pickering,

ambassador of four sovereigns and once supposed to be a likely suitor for the hand of Queen Elizabeth. He has a long wooden sword and cruel spurs.

The church has a group of brasses unusual in London. John Leventhorp is in fifteenth century armour with his sword; he died in 1510. The seven sons of Hugh Pemberton, a fifteenth century merchant tailor, kneel in brass wearing fur cloaks. Thomas Wylliams has a purse at his waist and his wife at his side in costume of the Middle Ages. Robert Rochester is in armour with the SS collar, and there are two big brasses of a civilian and his wife, he with a string of beads falling from his girdle. Nicholas Wotton, a rector, has a brass of about 1500 with an unknown priest near him, and there is a brass portrait of a lady in a heraldic cloak showing a pair of snarling lions.

Near by St Helen's Church we pass the building dominating Bishopsgate, with a majestic archway running through the middle supported on eight columns. Here is the Leathersellers Hall and the Hudson Bay Office, the Leathersellers arms emblazoned on the gates and the Hudson Bay beaver creeping along an arrow 160 feet above the street.

One of the smallest churches in the City, St Ethelburga looks almost toy-like sandwiched between two towering buildings. The cockerel on its eighteenth century bell turret is the oldest in the City, 1671. The sanctuary has a window with seventeenth century heraldry and the east window a little fourteenth century glass from Ypres. Another window shows the bridge between life and death, and one has a historic scene with Henry Hudson and his crew receiving communion in this church on April 19, 1607, before leaving for sea in the Hopeful.

Entirely hidden by the church is a delightful garden with goldfish swimming round a fountain and City workers eating their lunch in a cloister. From here we cross the road to St Botolph's, with its balustraded steeple capped by a pineapple. The oak pulpit is eighteenth century, with a band of rich carving, and the fluted marble font of the same age is precious because John Keats was christened in it. In the Warriors Chapel are two flags of the Honourable Artillery Company, and behind an iron grille is their Book of Remembrance, open and floodlit. On the wall is the bust of William Rogers, social reformer. Here in a great lead coffin lies Paul Pindar, who lived in the beautiful house of which the oak front is preserved in South Kensington.

Behind the church lies a little school with a prim-looking boy and girl by the door, each with a book and a badge. They are a delightful pair of scholars. Across the road a little farther on is Bishopsgate Institute with its turreted front and carved archway; it was built from surplus funds of a nineteenth century bequest for providing flannel petticoats for poor women, and it has a library, a concert hall, and a fine gallery of prints and water-colours of Old London.

From Bethlehem to Liverpool Street

From here we may soon be in Finsbury Circus with the oval garden surrounded by colonnaded buildings. One is Britannic House, with handsome windows and a fine balcony, columns rising from it, and on the walls four statues by Hamo Thornycroft, Britannia and three Eastern figures. Here also are the fine fronts of Salisbury House and London Wall Buildings. Leaving the Circus between these buildings, we enter the eastern half of London Wall and find at the corner of Throgmorton Avenue the imposing Carpenters Hall, home of carpenters and innumerable pigeons – the birds are everywhere. It has colonnaded walls and windows and heads of famous builders on the front. The ceiling of its banqueting room is a copy of that for the original hall designed by Inigo Jones, and on the walls are copies of three sixteenth century frescoes, preserved from the old hall and now in London Museum. A little farther down London Wall is the Church of All Hallows, one of the small ones, new in 1765, with a dignified apse and a tower capped by a graceful Corinthian temple. Over the altar is a painting of Paul at Damascus, and with his head turned to look at the picture is the bust of Joseph Patience, an eighteenth century architect. The pulpit, reached from the vestry, has for its foundations a bastion of the Roman wall. In the churchyard is a fragment of the medieval wall, also standing on Roman work. Thus it is appropriate that this little church should have been built in a Roman style of architecture.

Looking across to this little church is Winchester House with huge Atlas figures supporting a cornice, and cupids holding up a globe at the corner. Walking east across Broad Street and Bishopsgate (noting the bishop's mitre on the wall where the old gate stood), we come into Bevis Marks, one of London's little known streets where, tucked away among Oriental warehouses, is the Synagogue of the Spanish and Portuguese Jews. On a keystone of the front are the dates 5461-1701.

We step back 200 years as we enter this little place, and are struck by the beauty of the fine candelabra, a glittering array of brass looking like a forest of golden trees. Each has a globe in which the church is reflected, the whole making a charming picture when the 150 candles are lit. There are seven candelabra in all, every one 200 years old. All these years the light has been burning before the Ark (only by accident would it be out). Men keep their hats on when entering, and women sit apart in a latticed gallery. The interior is a copy of the Synagogue in Amsterdam. Above the Ten Commandments are the words, Know before whom thou standest. Perhaps the chief possession of the synagogue is its collection of mantles from the sixteenth and seventeenth centuries. They are of remarkable beauty in rich velvet and

silk, embroidered with silver and gold. There is a Great Synagogue in Duke Street a little farther on, built in 1790 and sometimes called the Jewish Cathedral of London; if we call it so, that is eight cathedral churches in the capital. It has a bright interior, the Ark under a domed recess, a brass grille round the gallery, and fine old candelabra now glowing with electric light. Two flags here are companions of a third hanging in the Temple at Jerusalem; they are in memory of the men of the Jewish Battalion of the Royal Fusiliers who fought for us in Palestine.

A few paces more and we are back where we began, in Aldgate.

The Bank

The Very Heart of the City

Our tour round the City has brought us to its heart: we come to the corner to which all its roads lead, the most famous spot in this famous Square Mile. Here is a group of buildings it would be hard to match, the Bank of England, the Mansion House, the Royal Exchange, and the massive banks that gather about these like little mountains of masonry. It is the concentration of the City's wealth and power.

The Bank is the heart of the City; a hard heart perhaps, but truly a heart of gold. Established at the end of the seventeenth century to lend money to the Government, it now spreads itself over its island site of three or four acres, and every Londoner is glad to know that in adapting itself to the twentieth century it has kept its ancient walls. For a hundred years the walls of Sir John Soane have been familiar at this busy corner of the world, and Sir Herbert Baker, in putting up his new building for the Bank, has by

The Lady of Threadneedle Street

a wonderful stroke of genius fitted the new into the old. At one corner still stands Sir John Soane's charming little grouping based on a temple at Tivoli, and it is good to see Sir John himself standing in a niche of his own wall. We feel that the old Bank is the new one, although the new one towers so high and the old one lies so low.

It is the most magnificent building in the City, rising to a noble height with fine balconies, canopied windows, colonnades, and cornices. It is not a solid block as most of our great banks are now, but charmingly irregular, with here a wing and there a dome breaking from its central pile. From many points we see something splendid.

The Bank

Over the pillars of the doorway is a balcony with six figures in a row along the wall, women with horns of plenty, and men apparently standing for security with keys and a chain. Above this group is another balcony, with a fine colonnade and a pediment in which is sitting the new Old Lady of Threadneedle Street, her mantle blowing in the wind, on her knee a model of the old Bank, and at her side a pile of coins. On the Princes Street side the high wall is broken by two great archways, one having a bronze door with quaint sculptures of the sun and moon and two lions holding massive

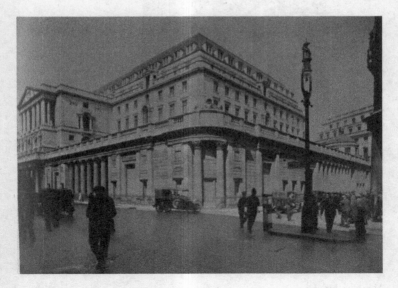

The Old and New Bank of England

keys; and at the end of this street we come to the corner where a group of nine pillars with a rich cornice supports a domed passage. An inscription tells us that the Bank made this way through Tivoli Corner for the citizens of London. This is Sir John Soane's little corner, which has been so admirably preserved. There are owls sitting under the wall lamps, Roman eagles on the prow of a ship, and Father Thames with watery hair under a bridge – all these adorning the arches. It is from the opposite side of the road in Gresham Street that we have one of the finest views of the Bank, with Charles Wheeler's golden Ariel lightly poised above the dome. Farther along at the Lothbury side splendid wings with colonnaded fronts rise to a fine balcony at which are four women, two with children and two pouring money from their horns of plenty.

The bronze doors of the Bank are a striking feature. The main doors weigh six tons, and Mr Wheeler has panelled them with rich medallions of

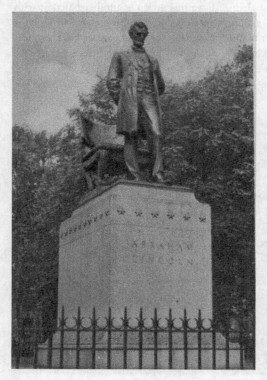

Abraham Lincoln

lions, serpents, a fierce head with snaky locks, a winged staff, and the king of beasts protecting piles of coins. There are similar doors on the Lothbury side in which are panels of a blacksmith and a labourer and more lions, with still more lions and symbols of security in a sculptured panel over the doorway.

Coming through the main doorway into the fine hall we have the impression that here is something worthy of the twentieth century and the spirit of things new. The great stairway from top to bottom of the Bank projects from the wall without any visible support, and it is remarkable to look up five storeys and down four – that is to say, the floor of the hall is about midway in the depth of the building.

The floor is of fine mosaic, and in the middle is a magnificent St George and his Dragon; we see it again carved in the keystone of the lovely dome above. Here also is Britannia copied from the watermark on every Treasury Note sent out by the Bank, and there is a charming touch in a panel showing two lions by a pillar of gold, with a background map of the south of England and the Channel. On this map is a tiny red stone which will puzzle many people; it marks the home of the great architect of the Bank, Sir Herbert Baker, who lives at Cobham in Kent.

The Royal Exchange

Across from the Bank stands the Royal Exchange, second successor to the building set up by Sir Thomas Gresham and opened by Queen Elizabeth. A remarkable building in itself, it is remarkable also for the fact that it seems to have no place in the life of the City today. To one who steps through its magnificent portico into its vast and impressive hall it is like a deserted palace, with two tiers of great arches rising to the glass-domed roof which floods the place with light. It is 100 yards long, and the twelve mighty columns of its portico bear up a pediment reaching 74 feet high, with a crowned figure of Britannia holding the charter of the Exchange, the Lord Mayor and civic dignitaries on one hand, and representatives of foreign lands on the other, a text below them reading, The earth is the Lord's and the fullness thereof. At this portico, 96 feet wide, a new sovereign is always proclaimed.

At the back of the building rises a tower 60 yards high, and in a niche in front of it is a colossal statue of Sir Thomas Gresham, with a golden grasshopper 11 feet long as a windvane. The tower has a peal of thirteen bells which play English, Scottish, Welsh, or Irish tunes four times a day. In recesses high up on either side of the north entrance are statues of Sir Hugh Myddelton and Dick Whittington.

We come through fine iron gates into the great interior, of which the floor is paved with some of the stones from the two older Exchanges. In the middle of the floor stands Queen Victoria as she was on the opening day, the sceptre in her right hand and in her left a small winged figure of Victory perched on an orb. In two niches stand statues of Charles the Second by Grinling Gibbons, and the young Queen Elizabeth in a richly embroidered skirt, and there is also a white marble statue of Prince Albert with his hand outstretched, looking towards a colossal bust of Abraham Lincoln.

The Great Gallery of Pictures

The story begins at the door with Lord Leighton's picture of the Phoenicians Bartering on the Coast of Cornwall. King Alfred is riding his horse by the walls of London, and the Conqueror is seated in his Norman hall granting a charter to the City. William Rufus is surveying the rising walls of the Tower. King John is sealing Magna Carta. Dick Whittington is giving charity. Philip the Good is presenting a charter to merchant adventurers. Trained bands are marching to the support of Edward the Fourth. Richard the Third is being offered the crown. The Skinners and Merchant Taylors are making up a quarrel. The Master of the Vintners Company is entertaining five kings. A picture by W. F. Yeames shows the foundation of St Paul's School, and next to it is Queen Elizabeth on a white horse coming to open this Exchange; she is shown with red hair. Charles Stuart in black with a white lace collar is arriving at the Guildhall to demand the Five Members, who were protected there. Stanhope Forbes has a picture of citizens escaping from the Great Fire, and another picture shows the founders of the Bank of England standing round a table in long coats and wigs. There are panels showing Sir John Houblon, first Governor of the Bank, and four other bankers with these famous names: Francis Baring, Richard Glyn, Abel Smith, and Nathan Rothschild. A portrait after Lawrence is of Julius Angerstein, who transferred Lloyds to the Royal Exchange and collected the nucleus of the National Gallery pictures, and there are also portraits of Anthony Gibbs and Pascoe Grenfell. In another picture Nelson is boarding the Victory, and two others show the burning of the second Exchange and the opening of the third. A group of war women workers is by Lucy Kemp-Welch, and other pictures of our time are the blocking of the Zeebrugge Waterway and Frank Salisbury's two pictures of George the Fifth and Queen Mary, once on the battlefields and once on the steps of St Paul's. Mr Brangwyn has a great picture of the fruits of peace streaming into London.

By the steps of the Exchange is Sir Aston Webb's dignified memorial to the London troops who fell in the war, a white stone column capped by

a bronze lion holding a relief of St George and the Dragon; there are two solemn-looking soldiers at the sides. A famous soldier rides proudly on horseback in this central scene, the Iron Duke fashioned by Chantrey from guns he captured from the French. His cloaked figure has neither hat, boots, nor stirrups, and he rides without a saddle.

At the back of the Exchange is a delightful bronze drinking fountain with a figure of a mother and two children, and near it is a bronze of George Peabody sitting in an armchair. He was the American philanthropist who gave a fortune to house English workers, setting up some of the first great blocks of dwellings in England, known as Peabody Buildings. He was a grocer's apprentice in Massachusetts, who prospered and came to London. His name is on the map in Peabody Bay, he having fitted out an expedition in search of Franklin. He was a pioneer among America's merchant princes before Mr Rockefeller and Mr Carnegie made giving so fashionable. Queen Victoria offered him a baronetcy and the Grand Cross of the Bath, but he refused both, and this statue was unveiled by the Prince of Wales just before Peabody died.

At the front of the Royal Exchange we come to the third of this wonderful group of famous buildings at the heart of the City, home of the Lord Mayor of London, the Mansion House.

The Mansion House

The portico is raised high above the level of the street, its lofty columns springing from an imposing basement storey, with steps on either side leading up to a platform in the portico. Here have been witnessed many historic scenes.

The great columns with the pilasters behind them support a massive pediment on which is a group of symbolical character with London, represented by a woman wearing a turret crown, trampling on Envy. On her right side a Cupid stands with a staff and a cap of Liberty, Father Thames reclining beyond. On the left of London kneels Plenty, emptying fruit from a vase, two little boys with bales of goods suggesting Commerce behind her.

The interior of the Mansion House has richly decorated walls and ceilings. On the staircase from the entrance in Walbrook are portraits of famous Lord Mayors. At the head of the stairs is a portrait of the architect by his son Nathaniel. The Reception Room, glittering with crystal chandeliers of great beauty, has on its walls tapestries of Guildhall paintings, and on pedestals are royal busts, the best of all Sir Reid Dick's bronze of George the Fifth. At the end of the room are two massive statues, one of Sardanapalus holding aloft a wine cup by Henry Weekes, and Caractacus by J. H. Foley. They guard the

entrance to the magnificent Egyptian Hall, 90 feet long and 60 feet wide. Here 400 guests can dine, others looking down from galleries. Eight columns support the vaulted roof, and between the columns hang gay banners. The side walls have eighteen niches which have been filled since the dose of the Great Exhibition with sculptures designed by British artists for that event. At either end of the hall are two windows with scenes of the death of Wat Tyler, the sealing of Magna Carta, a river pageant of Queen Elizabeth, and a land pageant of Edward the Sixth.

The Little Dome before St Paul's

In a narrow old street by the Mansion House is one of Wren's masterpieces, St Stephen's Walbrook, for designing which the parishioners gave him twenty guineas in a silk purse. Next to St Paul's it is considered his finest work, and is lovely enough to have inspired Canova to say that he would gladly come to England again if only to see St Paul's, Somerset House, and St Stephen's Walbrook.

The plain tower, which may be partly medieval, is redeemed by the handsome lantern, rising to 130 feet, the first of its diminishing stages adorned with slender pillars. The glory inside is the small dome over the central space, resting on eight arches and elegant pillars. Richly panelled and lavishly decorated, it is a wonderful sight when illumined, seeming to float like a crown of light when it is dark below. It is an architectural gem, considered by experts one of the finest domes in the world, a dome experiment by Wren before he built St Paul's.

Except for the pews, most of the woodwork is of Wren's day, and the elaborate font cover is attributed to Grinling Gibbons. A fine painting of the Burial of Stephen is by Benjamin West. An ornate memorial has small figures of John Lilburne (a grocer who died in 1678) and his wife. One memorial has the bust of Percival Gilburne, another seventeenth century apothecary; one has the bust of George Croly, journalist and rector here for twenty-five years of last century; and here, in his family vault, has been sleeping since 1726 Sir John Vanbrugh, who wrote gross plays and built fine palaces.

Facing the Mansion House is the National Provincial Bank, a stately pile with receding stages as it soars upward. It has three faces to show us, all lovely. On two faces by the doors and windows are niches with fine allegorical sculpture – a woman with a sword and shield trampling on a snake, an old man with his books and an olive branch, a man with a chest and its keys, a woman with her basket of plenty and a laurel wreath at her feet. The middle stages at the sides and the corners have fine colonnades with rich acanthus capitals, and at the corner is a splendid group of statuary with five figures.

Lost Churches

Passing now along the west wall of the Bank, we come to the beautiful Lothbury Corner, and in Lothbury is the lovely church of St Margaret, which serves six parishes as well as its own, the six having lost their churches. We see their patron saints in medallions round a sculpture of the Ascension here. It is an old church rebuilt by Wren after the Fire, its small spire rising 140 feet. When the earlier one was made new in the fifteenth century one of its benefactors was Lord Mayor Robert Large, the mercer to whom Caxton served his apprenticeship.

St Margaret's is proud of its big collection of seventeenth century wood-work, much of it richly carved, some from other churches. The charming chancel screen has tall hollow-twisted pillars, a cornice of acanthus leaves, and a great spread-eagle over the entrance. A low screen encloses the chapel. There is a high gallery and the pulpit has a striking canopy with carvings of an eagle and cherubs holding festoons. There are reredos paintings on wood of the Nativity and the Annunciation, and paintings of Moses and Aaron in the chancel. A gilded cross in the chapel is made of oak from Old St Paul's, there is an old chest, and three fine hanging brass candelabra are seventeenth century. Sir Peter le Maire's bronze bust was brought here from St Christopher-le-Stocks. Knighted by James the First, he was a director of the tapestry factory at Mortlake.

Near the church is the magnificent head office of Westminster Bank, towering so high that we must walk some way off to see its fine front. Over its great doorway is a cornice carved with griffins, with side panels of festoons on which we may see birds pecking berries. Above the high colonnaded balcony is a cornice crowned by a fine parapet on which three sea-horses stand out against the sky.

Now we come to the narrow and famous Throgmorton Street, generally crowded with hatless members of the Stock Exchange and their hustling clerks. The entrance to the Exchange is in Capel Court, a tiny alley off Bartholomew Lane. It is closely guarded by a top-hatted man called a waiter, and woe to the stranger who slips past him. The Drapers Hall stands at the other side of Throgmorton Street on the site of the old house of Thomas Cromwell; it is mostly modern and has a magnificent marble staircase. In it is a portrait of Mary Queen of Scots by Zucchero, and one of Nelson by Sir William Beechey. The windows look down on a beautiful little courtyard, enriched with masks over the arches and a sculptured group in the tympanum of each arch, all by Edward William Wyon. The masks are portraits of twenty historic or characteristic figures, among them Michael Angelo, Plato, Herodotus, and the Four Evangelists. The sculptured groups

represent the continents, Art and Science, such qualities as Justice, Truth, Faith, Hope, Charity, and Praise; and scenes of gleaning and pastoral life.

Round the corner is the Dutch church of Austin Friars, the nave of a priory church built 600 years ago. It has a seventeenth century sundial that never sees the sun, and by the door is an iron chest of the same time. Service is held here on Sundays in a curious screened enclosure, the congregation facing the organ, which is on a raised bench.

Crossing Old Broad Street and passing through Adams Court we come to South Sea House at the end of Threadneedle Street, a stone relief over the door showing eighteenth century merchants with their sailing ships and merchandise. Here stood that South Sea House where Charles Lamb worked with an Italian clerk named Elia, adapting his name for a nom-de-plume for his famous Essays. Hiding behind Threadneedle Street is the Merchant Taylors Hall, though it has little reason for screening its glories, for with its vaulted crypt of 1375 it may claim to be the oldest of the halls, and is bigger and handsomer than the rest.

It is but a short step from Merchant Taylors Hall to Cornhill, which has one of the most striking of the great buildings round about the Bank. It is the office of the Commercial Union, its impressive front crowned by a great pediment on which is a woman standing with a bird at her feet. There are three bands of symbolical carving by Walter Gilbert between the main windows, on which are reliefs of a winged sphinx on each side of an hourglass, a phoenix on each side of a volcano (the phoenix rising from a dragon breathing fire) and a snorting sea-horse on each side of a ship. There are magnificent bronze doors, with fascinating little panels on the surrounds showing the Labours of Hercules, which are repeated on the glass of the doors. The Commercial Union has a small museum of fire relics from the days of private fire brigades. There is a lifesize figure of an old fireman and an actual engine of 100 years ago. Close by this building is the Scottish Widows Office, with a sculpture of a man with a panting winged horse on the pediment, and at the high balcony two women sitting with a basket of fruit and a child. The striking Lloyds Bank building here has a fine row of thirteen columns stretching along its front, and a shield with Pegasus, the flying horse.

By these fine buildings run Popes Head Alley and Change Alley. The first is now a gloomy well, but before the Great Fire children loved it for its gay toy shops. Change Alley was famous for the wild scenes of speculation in the time of the South Sea Bubble, and is now a quiet passage below cliffs of white tiles. Our Cornhill horses can still drink water from the trough by the old pump, which tells us that it was erected by the united efforts of

'the Bank of England, the East India Company, and the neighbouring Fire offices, together with the Bankers and Traders of the ward of Cornhill.' Much labour, surely, to set up a pump!

Of the two old churches of Cornhill the finest is St Michael's, with a beautiful tower of gleaming white stone, rising 130 feet to the top of its stately pinnacles, one of Wren's experiments in Gothic. Its porch, with an elaborately carved entrance, was added by Sir Gilbert Scott, whose restoration transformed the classical appearance given to the church by Wren. Golden angels support the vaulted ceiling, and the windows glow with colour. The big gilded figure of a pelican with her young is seventeenth century, as are the altar table and two paintings of Moses and Aaron.

Among a collection of interesting things here is a seventeenth century pewter plate, a Roman tile found when Roman walls under the church came to light, and a silver-topped walking-stick said to have belonged to Thomas Gray, the poet, whose first journey was to this church, for he was baptised there on the day he was born at a milliner's shop close by, now an office with his portrait plaque.

On the same side of the road is a modern building with a bronze window frame strangely adorned with pound and dollar signs. In the middle of the cross-roads at the top of the street stood the Standard from which distances along our roads were measured. It has gone, but Wren's St Peter's still remains, flaunting a great key in greeting to the pinnacles of his church of St Michael a few steps away; it is the weathervane, 140 feet from the ground. Below the tower is a rough arch which may be thirteenth century, but legend tells us that the foundation of the church is almost three times as old as this. On a brass plate set in carved oak in the vestry we read how Lucius, 'first Christian king of Britain,' founded this church in 179. That is as it may be, but something real of that time was a Roman wall passing where a corner of the church now stands.

A doorway wedged in between two shops leads us inside, where arches and pillars and ceiling are richly adorned with mouldings, and are coloured blue, white, and gold. Colour fills the east wall, its eight windows showing scenes in the Life of Christ, the reredos glowing red and gold with symbols of the Four Evangelists.

The striking thing here is the woodwork, some of its rich carving said to be by Grinling Gibbons. The pulpit has flowers and cherubs and a tremendous canopy. The tall screen reaching across the church has open bays with slender square and fluted pillars, crowned by a rich cornice, and is said to have been designed by Wren's daughter. There is seventeenth century panelling round the walls, and some finely carved doorways of that time. The font escaped the Great Fire.

The old keyboard and stops of the organ, which have been replaced and are now in the vestry, are interesting for having been played on by Mendelssohn. The organ itself, said to have been one of the finest built by Father Smith, has been much altered. A great treasure in the vestry is a thirteenth century manuscript of St Jerome's Vulgate.

Round the corner in Gracechurch Street is Corbet Court, where, facing us in the wall of a building, is a little seventeenth century stone carving of the crowned Madonna, a sign of the Mercers Company.

This passage is at the corner of Lombard Street, which gets its name from the medieval Lombardy merchants and financiers who settled here. It is a grim but dignified thoroughfare of banks ancj financial houses, and is noted for the fine modern signs on many of the buildings. The Black Boy, the Cat and Fiddle, and the Jerusalem Artichoke all add a touch of levity to this solemn street.

Still standing for our delight is the beautiful church of St Edmund the Martyr. Designed by Wren after the Fire, it has a steeple with a projecting clock, carved stone urns, and curving wings of masonry. The nave is lit by a skylight in the middle of the roof, which was made new after being damaged by a German bomb. The altarpiece is unusually placed at the northern end. The old sanctuary screen, crested with intricate piercing and carving, has little garlanded urns on the corner posts. The pulpit and the font have beautiful examples of seventeenth century woodwork, the font cover bearing figures of the apostles.

Facing the church is the Royal Insurance Building, over its door a fine bronze group showing a winged sphinx between two seated female figures, one with an anchor symbolising the sea, the other with a torch to represent fire. The magnificent Martin's Bank is on the site of the office of Sir Thomas Gresham, his golden grasshopper hanging outside. Over the way is the Bankers Clearing House at the corner of Abchurch Lane, where Lloyd's Coffee House moved from Tower Street in the seventeenth century. Near by is St Mary Woolnoth.

Timbers of Old London Bridge

This fortress-like church in the centre of the City is one of the finest works of Nicholas Hawksmoor, the famous pupil of Wren. A Tube station runs underneath, and the weight of the massive little church is now borne on steel girders. Its most prominent feature is the wide pillared tower dividing it into a pair of balconied turrets. The square interior is lit by great lunettes, and has at each corner a trio of fluted columns supporting the heavy cornice. The oak front of the vanished gallery now runs round the wall. The striking altar canopy, carved with tassels,

is supported on gigantic twisted columns. Two sanctuary chairs are said to have been made of timber from old London Bridge. The only seventeenth century woodwork here belongs to Father Smith's organ, and from its gallery over the door hang long banners of the Goldsmiths Company in memory of Sir Martin Bowes, a lord mayor of nearly 400 years ago. His funeral helmet, gauntlets, spurs, and wooden dagger are in a glass case on the wall.

The fine oak pulpit, swelling with pride at its rich carving, has a magnificent canopy on two square pillars, beautifully decorated with gilded carvings of corn and flowers. We remember that William Wilberforce traced his conversion to the sermons John Newton preached from this pulpit. Newton's youth was spent in the slave trade, but he bitterly repented, and with William Cowper he wrote the Olney Hymns. He was rector here and an inscription he composed himself, near the pulpit, describes him as 'John Newton, clerk, once an infidel and libertine.' Three letters from him are framed below, and in a glass case are his Bible and a comfit dish he gave for the vestry. In another glass case is the neck of a two-handled Roman jar discovered in the foundations.

Our tour of the City is complete. We are at the heart of it, in the busiest centre of this Square Mile so crowded by day and so deserted by night.

Holborn

The Wonderful Temples of Learning

Well has Holborn chosen for its motto Many Pass Through and Gain Knowledge, for it is London's Student Quarter, its centre of learning. Here the new University, shiplike in shape, raises a white tower like a sail among Bloomsbury's green squares. Here is the greatest museum in the world, with incalculable treasure of the past and inexhaustible learning.

At the back of the Museum Sir George Frampton's two lions guard the door which leads us out from the storehouse of Past Ages to the bronze doors opening on the New Age, the new University of London, centre of learning for the biggest number of students gathered together anywhere. It is a majestic white building. There will be nothing in London like this place when it is finished. In it the University is to house its library, making it a veritable Tower of Learning.

White outside it is, and gloriously white within. Bronze doors embossed like a shield open on an interior simple and harmonious. Halls, walls, floors, passages, and pillars are of polished marble, cream and glinting, a perfect background for the handsome ironwork of the balcony round the Reception Hall, from which opens on one side an inspiring lecture room, and on the other the hall for feast and dance. The Senate Room, finest of all, is panelled halfway in walnut, the rest of the wall hung with pale coloured tapestry, the ceiling carved of unstained wood, the thick fawn carpet inlaid with white to mark the steps, and the seats and desks covered in blue leather. Each desk has its own light concealed, so that the only general light comes from four great standards. The Court Room is like the Senate Room; the Refectory is gay with long polished tables and many windows, and the smaller dining-room is gaily painted.

Only one room has an open fireplace, and the Cornish marble framing it must be remembered as the pathetic memorial of a tragedy – a broken dream, for it was put in the Principal's room as a compliment to the distinguished Principal who saw the beginning of this vast place but did not live to see it finished. While the tower was still rising Sir Edwin Deller was walking round with friends when a barrow fell down a shaft and crushed the life out of this man whose inspiration was in this great scheme.

Building began with the long classical front of University College which, though just outside Holborn, must be accepted as part of it. It has a dome

Above: London University

Right: Royal London House

with a fresco by Professor Tonks showing its foundation, and it has a weird witness of those early days in the actual skeleton of one of its founders, Jeremy Bentham, which, clothed as his tailor clothed him in life, is kept in the Science Library and may be seen. Of the new group of University buildings to collect round the central site the first on the spot was the School of Hygiene and Tropical Medicine, London's first school of postgraduate teaching, and Europe's centre of public health work. It has the names of famous pioneers carved round it, and on its window balconies are many weird things: – the pests which hygiene and tropical medicine have to fight, snakes, mice, lice,

flies, and fleas of formidable size, while over the main entrance the malarial mosquito looks out defiantly on the house of its conquerors. Over the door, against a background of snakes, is a relief of the design adopted by the School for its seal, Artemis in her chariot driving Apollo, who is shooting out the healing rays of the sun.

In the hall are portraits of men to whom mankind owes a debt that it can never pay. Here is Patrick Manson, who founded the work of this School in 1899 in a small house near Albert Dock, and upstairs is Ronald Ross. In the spacious and fascinating museum within these walls are a number of microscopic slides belonging to Manson and Ross, and they must be counted among the most precious possessions of any museum, for the work of these men has been of inestimable value to mankind. They were the conquerors of malaria.

In the hall is a sculptured portrait of Andrew Balfour, a director of the School, and a bust of a Parsee surgeon (Cawas Lalcaca) who nobly put himself in the way of an assassin's bullet meant for someone else.

The Green Squares of Bloomsbury

We must leave this University, rising up to dominate central London with its white walls and its mighty tower; and we will look into Bloomsbury's green squares. Trees and lawns are being planted in the University centre as part of its plan, the LCC refusing to allow a square to be swallowed up unless an equal open space is provided. These squares are the natural charm of Holborn.

Bloomsbury Square, the oldest of them all, was laid out by the Earl of Southampton, with whom John Evelyn dined at Bloomsbury 'where he was building a noble square or piazza, a little town' and Macaulay wrote that foreign princes were taken to see this Square as one of the wonders of England. Here lived John Nash, a little too ambitiously, so that he went bankrupt, and his house is now the headquarters of the Pharmaceutical Society, which has a museum and a bust of Jacob Bell, one of its founders. At Number Two is the Royal Society of Literature; and along the whole of the east side is a stately new building with a pediment of Peace and Prosperity, the other side opening on Southampton Row with a heavy colonnade for shops. In the gardens sits Charles James Fox with a copy of Magna Carta in his hand, a stalwart bronze figure looking towards the fifth Duke of Bedford, who stands in Russell Square with his hand on a plough, sheep at his feet, and four delightful cherubs representing the Seasons; Winter is huddled up in a shawl. Panels on the pedestals picture farm scenes, for the good duke did much for agriculture.

Russell Square is the biggest of all, and has huge hotels with arms wide open to the world; on their two spacious fronts are statues of five of our queens, one of our kings, and Charlemagne and Julius Caesar. In a little cul-de-sac is the stone figure by Gilbert Bayes of Joseph Priestley, the discoverer of oxygen, sitting over the doorway of the Institute of Chemistry. At Number 21 our famous reformer Sir Samuel Romilly came to his tragic end. Today the best known and most popular inhabitants of the square are the grey squirrels who make the gardens their home.

We pass from here into Woburn Square, which has the university student's church with a reredos of the Good Shepherd and the Four Evangelists, with a background of exquisite gold drapery. It was painted by Burne-Jones in memory of Christina Rossetti, who worshipped at Christ Church for twenty years while living round the corner in Torrington Square, and died in 1894 at a house caught in the University's great net.

Bedford Square has changed little, and its oval of grass and plane trees is still surrounded by dignified homes from the eighteenth century, a bearded keystone at every door. Number 11 was the home of Henry Cavendish, the strange man with a million of money who buried himself in science. It faces a sunken lawn running behind Gower Street, one more bit of green of Bloomsbury. At Number 25 lived Bryan Waller Procter, the poet, and here his daughter Adelaide was born. Number 16 is the Royal Agricultural Society; 34 is the Architectural Association, where are always prints and drawings of new buildings on show. Three squares lie on the other side of Southampton Row. Queen Square has a lead statue of a queen on its lawn, a quaint crowned figure in an embroidered dress bolding a sceptre, perhaps Queen Charlotte. On the west is the strange-looking church of St George the Martyr, with a coat of stucco and a spire of zinc; it was built in 1723. Number Six is the descendant of William Morris's workshop. Here the Art Workers Guild has a bust of him, with other portraits and busts of past Masters in their hall.

The site of William Morris's old home is covered by the National Hospital, and another hospital covers Macaulay's house in Great Ormond Street; between them is the Children's Hospital, whose new Nurses Home in Guilford Street has a frieze of goddesses representing health and medicine.

Red Lion Square has seen something of four centuries, for it is just old enough to have known the seventeenth. Here lived and died Jonas Hanway, who enraged the Hackney coachmen by bringing the umbrella to England and amused the Red Lion Square folk by carrying it round the Square whenever it rained. He helped Captain Coram with his Foundling Hospital close by. At one corner is the Conway Hall where the Ethical Society meets.

At Number Ten the Royal College of Veterinary Surgeons has a library of 6,000 books. On the west side stands the church of St John which we reach through a vaulted passage to come into the fine interior by Mr J. L. Pearson, who was chosen on the strength of this church to design Truro Cathedral. Its glory is in its fine arches, arcades, and vaulted roofs.

Holborn has a group of buildings not unworthy to be neighbours of the University. One of them, which we come upon with startling surprise as we cross the Westminster border at Great Queen Street, is a wonder from the street, though closed to all but the elect. It is the home of British Freemasonry, and the Mother Grand Lodge of the world. Conceived in the grand style, with long horizontal lines, it ingeniously covers a great triangular site in a dull area which must now five up to it. The tower, with its top open on great columns, is like a temple in itself, rising 200 feet. Beautiful iron lamps jut out at both entrances, and the sign of the Freemasons is inlaid on each top step, the sculptured arms of the United Grand Lodge of England being on the end below the tower. The winding staircase has impressive marble pillars and windows of the six periods of Creation, and at the entrance to the temple is a peace memorial window. A great processional corridor, with figures of Temperance, Fortitude, Justice, Charity, and Prudence in its windows, leads to the Grand Temple, and on the way we pass two beautiful bronze screens. The bronze doors opening into the Temple are among the noblest doors in London, having panels showing the building of Solomon's Temple.

The tower of the Freemasons Temple calls across Kingsway to the great tower of the Pearl Life Assurance Building rising like a monarch in the sad and tawdry company of Holborn's little shops and squalid streets. The base of the building is of solid grey granite, and above is a striking facade running from end to end, with richly carved windows between the columns. In the middle rises the fine tower crowned by a lofty dome. Under the tower are arches with splendid bronze gates, through which we may pass into the courtyard. Here is a stone pillar with St George in bronze, by Sir George Frampton. The saint has a wreathed sword like a cross, and his dragon is dead at his feet. On panels below are seen warships in action and a flight of aeroplanes.

The great buildings of the YMCA, and its companion the YWCA, are within easy reach of the British Museum, near the great street of furniture, Tottenham Court Road. The YMCA has a dome with many sculptured figures on the tower; and over the doorway is a helmeted youth armed for the race of life with a sword and a lantern. The YWCA across the street is a beautiful building by Sir Edwin Lutyens, with a dignified front which is a good neighbour to Bloomsbury's old houses.

Of Holborn's theatres the loveliest to look at is the Saville in Shaftesbury Avenue, with a fine classical frieze by Gilbert Bayes for which he was given the gold medal for the best sculpture of 1931. The frieze is 129 feet long, with a procession of delightful figures showing Drama down the Ages, beginning with minstrelsy and mystery plays, the tragedies of ancient Greece, the gladiators of Rome, satyrs and clowns, immortals from Shakespeare, figures from English comedies, Punch and Dog Toby, romance and melodrama, and characters from plays of our time. Mr Bayes has moulded his frieze in artificial stone which should resist the London grime and keep its face white. Another elegant little theatre is the Cambridge, in Seven Dials, the meeting-place of seven streets once unsafe for a policeman to walk through alone.

Holborn's most interesting church is St Giles-in-the-Fields, which has grown from the chapel of a leper's hospital founded by Queen Matilda. It has a balustraded tower and a spire rising 160 feet, and was rebuilt 200 years ago out of a tax on coal, one of fifty for which the Government found money in that way. The architect's wooden model is still by the west door and he put his name on the west wall outside. The architect of Scotland Yard has his bust on its walls, Sir Herbert Baker has his address on the Bank of England, and here Henry Flitcroft has his name. Hogarth drew his Idle Apprentice in the churchyard, and the church is in his picture of Noon. Two black spaces in the churchyard mark the plague pits into which thousands of bodies were thrown. Poor wretches walking to Tyburn were given a cup of ale from these church steps, and we may hope some of them drew a little consolation from the old carving of Resurrection Day on the lychgate, crowded with tiny figures rising from the grave. There is a ten-feet-high grandfather clock from the eighteenth century, an old processional cross with a brass figure of Our Lord, and an old rector's staff with a silver figure of Father Time.

There is a grand old chest of Sussex iron standing on claw feet, patterned all over, and with sixteen initials on it, presumably of churchwardens; an eighteenth century oak pulpit; two eighteenth century chairs with men in nightcaps carved on the arms; and a war memorial book in which the first name is that of a Prime Minister's son, Raymond Asquith, a regular worshipper here. There are many oil paintings of rectors and a gate-legged table 300 years old at which forty people can sit down.

Hereabouts, facing the open space by Princes Theatre, is an LCC Institute in Endell Street which has outside it a coloured mosaic of Time and Death walking hand in hand followed by Judgment, a copy of the picture by G. F. Watts.

A church by Nicholas Hawksmoor, Wren's assistant, is in Hart Street close by; it is St George's. Its tower, which is in Hogarth's drawing of Gin Lane,

has had a statue of George the First added by a loyal brewer, who resolved to present the king as a Roman. The interior of the church is classical with rich pillars and plaster ceilings. There is an old sanctuary table and fine old chairs, one carved with dragons and with grinning faces on the arms. A copy of a Raphael Madonna hangs on a wall, and there is a bronze angel mourning over a miniature tomb modelled in memory of a churchwarden, Alfred Gell, by his wife. A striking memorial of Charles Grant, a director of the East India Company, shows him sinking into an angel's arms, and his epitaph stirs our curiosity by saying that 'his noble works changed the face of the Scottish highlands,' which probably means that he introduced Sunday schools into Scotland.

The British Museum

It rises behind lawns gay with almond blossom in spring and is a splendid spectacle with its long front of 370 feet, with forty-four fluted columns, sixteen of them rising between the wings to support the gigantic pediment, in which are groups of sculptured figures. In them we can trace the growth of progress from low forms of life to the beginning of art and science. We see the tortoise, the crocodile, and the wolf, man struggling to be free from them and an angel offering him a lamp, and then the tiller of the ground, the artist, the sculptor, and the man of science, with actors gathered about the central figure of a woman with a staff and globe. The sculptures are by Westmacott. The entrance gates are of rich ironwork and on the imposing rails enclosing the grounds the main posts have fine claw feet and heads of lions halfway up. The lions of Alfred Stevens (originally made for the low iron railings that have now disappeared) are distributed inside the building.

There are colossal sculptured lions guarding the doorway of the new galleries which face the University, and at the main entrance, under a

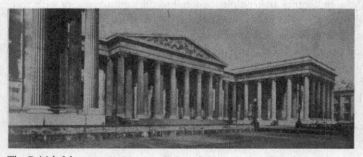

The British Museum

stupendous portico, are primitive sculptures brought from Easter Island. In the entrance hall is Roubiliac's statue of Shakespeare, and by the stairs is a statue of the curious sculptor Anne Darner, friend of Napoleon; it is a portrait by herself. This vast collection of treasure and learning began with a public lottery in the eighteenth century, the funds being used to buy the Duke of Montagu's house and two famous collections to put in it. They were the manuscripts collected by Robert Harley and Sir Hans Sloane. Soon the famous manuscripts of Sir Robert Cotton were added, and in the end Montagu House was pulled down and the new building designed by Sir Robert Smirke. This great round hall, reminding us of the Pantheon in Rome by its vastness and simplicity, was opened in 1857 at a breakfast party at which the Archbishop of Canterbury, the Speaker of the House of Commons, the Bishop of London, and the Dean of St Paul's sat down. The roof is a dome 100 feet above our heads and 160 yards round, bigger than the dome of St Peter's in Rome. The superintendent has a raised seat in the middle of the room, and all round him is the great catalogue of more than 1,000 volumes, with the name and author and date of every book available in English; it has about 4,000,000 entries. The bust over the doorway to the reading room is Panizzi, who started the great catalogue.

The history of this Round Room, for which a daily ticket may be had by any serious student, would make a remarkable story, for through its doors have passed at some time or other most of the writers and philosophers and thinkers of the last two generations. There are those who remember a Russian who would come here day after day, always deep in thought; his name was Lenin. Long before then had come another strange foreigner, the harmless-looking man with a great beard who through months and years sat in this room studying books on economy; he was Karl Marx. Through all the years of tyranny and revolution in Europe this room has been a quiet place where men from every land could come and choose what they would read from a million books. It is the most majestic temple of books in the world.

Kingsway

We leave the Museum and are in the busy streets again. Holborn has more mean streets than she would like to count, but many she has swept away, and from the heart of its most crowded street we look down on the biggest street London has made in our time, Kingsway. At the top of it is Southampton Row, which runs to Russell Square and the University, and hereabouts the tall two-decker trams dive underground to reappear on the Embankment half a mile away, an entertainment the children find as good as a switchback.

It is the only tramway tunnel in London, made by a sad mistake too narrow for general traffic use. Here stands the great domed building, designed by Matthew Dawson, of the London University School of Architecture, to house the Day Training College and the Central School of Arts and Crafts. Here is done painting, sculpture, stained glass work, decoration, textiles, and book production. There is an annual exhibition, and the work of the students is always on show. By the corner where Southampton Row meets Holborn is the Baptist Church House with a statue of John Bunyan in a corner niche. It was in a room here that the most famous Baptist leader of the last fifty years, Dr Clifford, died on the platform among his friends.

Kingsway proper is lined with trees. Its great buildings make a ragged skyline with their varying fronts, and at the bottom is the vista of Bush House, looking up from Westminster. The street has two churches and two most striking buildings. The churches are the small Roman Catholic Church of St Anselm and St Cecilia, bright with candles burning before the saints, and the Anglican Holy Trinity.

The two striking buildings in Kingsway are Africa House and the Stoll Picture House. The Picture House, running across the border into Westminster, is the lost dream of a great home of English opera. It was one of the first noble buildings to be set up in Kingsway, in the early days of the revival of great architecture before the war. It is lavishly adorned with carving on its pilastered front, and has a deep cornice; and along the parapet, sitting and standing, are about a dozen figures representing the musical arts. This magnificent place was built by Oscar Hammerstein as one of the many brave attempts that have been made to establish a popular Opera House for London. It failed, and the kincma came, and while queues were waiting outside this house for the latest films Oscar Hammerstein's widow was selling apples to waiting queues in New York streets.

But the building which compels attention in Kingsway is Africa House, with fluted columns and pilasters giving it a stately air.

Over the high entrance arch two lions lie face to face, but the glory of the building is in the magnificent group over the cornice. Here sits a helmeted figure with sword and shield raised on a dais, and at each side of her are two groups, one of an Arab and a camel, a lion on the lookout, and a crocodile creeping among the rocks; the other a big game hunter with his rifle, a native carrying ivory tusks, a huge elephant and bison breaking through the jungle.

Holborn has within its borders two of the four Inns of Court which make up the legal world of London. They are just outside the City, the other two being in the City but not of it. We will walk about the area of Grays Inn and

Lincolns Inn and then look round these sanctuaries of the Law. We reach them both by the long street from which Holborn takes its name, running east from Oxford Street. Here are one or two buildings of much interest.

The site of the Telephone Exchange in Holborn near Chancery Lane is a remarkable example of the historic interest of almost every acre of this part of London.

Just past Chancery Lane, down which a Tudor gateway opens on Lincolns Inn, are Southampton Buildings, where the Patent Office is tucked away with its library of 300,000 technical books, a great index which any inventor may consult, and a collection of specifications where the inventor who thinks he has found perpetual motion can search to see if someone has anticipated him. The library is in three tiers, linked by a spiral stairway, a fine sight from the topmost tier. Facing the Patent Office is a great office of patent agents, with statues of Britain, Europe, and Commerce over the doorway, Australia with her kangaroo, and medallion portraits of many famous people. Close by is one of the entrances to Staple Inn, which has in front of it a lovely row of black and white houses overhanging the pavement.

Holborn, so rich in green squares, is rich also in the possession of the little Dutch Garden behind these old houses. It is a charming place, especially if we come to it in daffodil time. This fine hall has an oak roof with crossbeams carved in strange designs, windows with heraldic glass of about 1500 (older than the hall itself), and in the oriel window a silver wool-pack on a green field. It is believed that Grinling Gibbons made the clock case, which has on the top of it a fine little bell turret. The Staplers who built this Inn exist no more, and the Institute of Actuaries are the fortunate inheritors of their small Hall. The estate belongs to the Prudential Insurance Company, which looks after the garden. The great office of this company is across the road and we look at it in our walk through the City.

Through a quiet courtyard at the end of Brooke Street we come to the Church of St Alban the Martyr, much talked of in Victorian days, when its priests faced a storm of indignation and were brought to court for following the practices of Rome in an English church. This church had been built on a scene of squalor known as The Thieves Kitchen, having grown from services in a room above a fish shop. It has a colossal triptych reredos with statues of St Alban and other saints, a gilt font cover soaring halfway up to the roof, a rood hanging over the chancel arch, a seventeenth century Madonna, and an oil painting of St George given by the artist, Sir James Linton.

But richest of all are the two chapels, one at the west to Father Mackonochie, the other at the east to Father Stanton. Tired of attacks in the papers, suspension by his bishop, and being brought before the courts,

Father Mackonochie sought rest in Scotland, and walked out one day with failing memory and did not come home. He was found dead in a snowdrift, his two dogs still with him, and they brought him here and laid him in this chapel. He lies in marble with a dragon at his feet and angels at his pillow. Father Stanton lies in a chapel full of rich adornment, with angels bearing shield about his tomb. He was much beloved by all the poor.

Hereabouts we come to another famous church in a remarkable corner of London. If we are passing Ely Place at twelve o'clock some winter's night we may think ourselves back in ancient London, for it is very likely that a voice will be ringing out – Twelve o'clock, and a clear frosty night. All's well. It will be the last night watchman in London going his round.

It comes into Shakespeare, for the Bishops of Ely had their town house here, and in Richard the Third Shakespeare makes the Duke of Gloucester say: 'My Lord of Ely, when I was last in Holborn I saw good strawberries in your garden there. I do beseech you send for some of them.' There are no strawberries growing now, good or bad, in Ely Place, but here still is the chapel of the town house, into which the bishop must often have walked from his strawberry garden. It was built about 1300. St Etheldreda's Chapel, the only famous building left in this curious little sanctuary, has removed the Stuart arms from the nave and hung them in the porch with an inscription saying that 'this emblem of regal supremacy was removed from the church on its restoration to the Roman obedience in 1876.' It is the only pre-Reformation church in London which has been restored to Rome. In the cloister is a bust of Cardinal Manning and beside him one of Father Matthew. The great west window is one of the biggest in London and has portraits of Bishop John Fisher and Sir Thomas More, with monks from the neighbouring Charterhouse wearing the ropes with which they were hanged at Tyburn. There is a graceful organ screen designed by the architect of Westminster Cathedral.

We are in the Italian Quarter hereabouts, and at 5 Hatton Garden is a portrait of Mazzini on the house where he lodged in his exile, keeping himself by teaching. At the top of Hatton Garden (centre of the diamond trade) are St Andrew's Schools, with painted figures of two scholars at the door, and just beyond is the Italian Chapel of St Peter with a long list of Italian names on its peace memorial outside and a bit of Italy inside, gay and painted and twinkling with the lights of many candles. In the middle of July Italians from all over London come here to pay homage, and every street round about is filled with flowers and shrines and flags. Here is Saffron Hill, near the eastern limit of Holborn.

Grays Inn

We come now to Holborn's two Inns, Grays and Lincolns, both 500 years old, both built round gardens, both with fine halls. Grays Inn is entered from Holborn by South Square, a seventeenth century gatehouse now faced in brick. Bacon stands on the lawn in South Square, fashioned in bronze by F. W. Pomeroy, who shows him robed and bareheaded and with a sword.

South Square has three rows of seventeenth century houses, and along one side of it stands the chapel and the hall, the block dividing the two squares. The chapel has been refaced, but has two blocked windows 400 years old, and an oak pulpit 300. In one of the windows are two glass shields of Jacobean time, and the east window has four modern figures, among them Bishop Juxon at the funeral of Charles Stuart, Archbishop Laud on the scaffold, and Archbishop Whitgift preaching. The newest glass is a fine Victory window by Christopher Whall. A wooden dove flying amid golden rays by the organ is probably 200 years old.

The Hall is famous for its magnificent hammerbeam, roof and is a noble example of Elizabethan architecture. Its windows have heraldic glass of the sixteenth and seventeenth centuries, and the walls are gay with heraldry painted on its Queen Anne panelling. Here hang portraits of three Stuart kings, with Nicholas and Francis Bacon,

Bishop Gardiner, and Lord Birkenhead. There is also a fine portrait of Queen Elizabeth showing her as a young woman. She is said to have given the oak screen at the west end of the Hall; it has four richly carved columns supporting a beam on which the decorated gallery rests. On the gallery balustrade are busts of women, and figures holding palms and wreaths recline in the spandrels of the arches. It was in this hall that Shakespeare's Comedy of Errors was acted at the Christmas of 1594.

Lincolns Inn

Lincolns Inn is on the other side of Holborn, reached by a gatehouse 400 years old, facing Chancery Lane. The Inn occupies Old Square, New Square, and Stone Buildings, Old Square being early sixteenth century and New Square late sixteenth; Stone Buildings is a fine lofty range with a balustraded roof and an imposing portico built in the eighteenth century, with Adam work indoors.

We come into Old Square to find in front of us the chambers built in 1609, with doorways renewed a little later, and the chapel finished by Inigo Jones in 1623, much repaired by Wren and altered by Wyatt. The chapel is remarkable outside for being raised on an open crypt, so that we may walk between its massive pillars under the vaulting. In this crypt lie Cromwell's

Secretary of State John Thurloe, and William Prynne, one of the victims of the Star Chamber, who was put in the pillory, had his ears cut off, and was branded. The outside of the chapel has been refaced and we see the marks of German bombs on the walls; they killed a servant of the Inn and broke all the windows. Some of the glass has been put together again.

The eastern half of the chapel was paved in Jacobean days with black and white marble squares, the walls being then panelled with oak and the altar rails fixed. The pews are mainly original and have carved heads at the bench-ends and the doors. The organ and the gallery are early nineteenth century. The canopied pulpit is made of old oak, and the altar table is made of wood from the ancient roof of St Alban's Abbey. In the north wall are two windows with seventeenth century glass by Bernard Van Linge, put together since the air raid.

Old Hall in Old Square was finished about the time Columbus found America, but has been taken down this century and built up with the old materials. The walls have massive buttresses, and a square oriel projecting at each end. The hall has its original oak roof and the magnificent seventeenth century oak screen on which has been set a projecting gallery. The lower bays of the screen are divided by massive pilasters capped by heads, the middle bay is carved with an arch curiously shown in perspective, and the upper bays have fine arcading. New Square is a great open space with rows of beautiful brick buildings round it built at the end of the seventeenth century, the upper storeys having been added and some of the houses modernised. The classical doorways of the houses have divided pediments, and some of the fronts are covered with growing vines and figs. In the middle of the square is a delightful garden, with a small pond to which wild duck have been known to come, and at the north end is a fine iron screen memorial to Colonel Brewster, a Volunteer belonging to the Inn.

In New Square stands the new hall, built in Tudor style 40 yards long. It is decorated with brick diaper work, and one of the gables has the architect's initials and the date 1843. The statue of Queen Victoria in the turret is believed to be the first ever made of her; she came with the Duke of Wellington to open the hall. The roof is carved and gilded, with elaborate pendants, and the glass in the windows is by Thomas Willement. Below the great window is an oak screen on which are six busts.

There is a fine statue of Lord Eldon by Westmacott. The remarkable possession of the hall is a great wall painting by G. F. Watts, who did it as a work of love expecting nothing for it, but received a gold cup and a purse of 500 sovereigns. The painting shows Justice, Mercy, and Religion enthroned above law-givers, from Moses to the reign of Edward the First.

The architect of this fine hall was Philip Hardwick, who also built the library next door, housing 70,000 books of law. Founded in the fifteenth century, it is believed to be the oldest and biggest legal library in the world. In it is Westmacott's statue of Lord Chancellor Erskine. Near the door is the roll of honour, and in a sixteenth century chest are kept a few curious things dug up in the foundations, including a Greek statuette in bronze and some of the old green jugs once used in the hall. On one side of the hall is a fine council chamber and on the other side a drawing-room, both miniature portrait galleries, with works by Gainsborough, Reynolds, Lawrence, Orpen, Sargent, and Solomon.

A fine gateway leads us out of Lincolns Inn into Lincolns Inn Fields. It is one of the biggest squares in Europe. Round it are many fine houses, old and new, the graceful seventeenth century Powis House finished by Wren, the interesting old home of Sir John Soane, the fine home of the Royal College of Surgeons (just inside the Westminster border), a bust of the second Lord Hambleden, head of W. H. Smith's, and the beautiful monument of Margaret MacDonald, with her arms embracing nine little children.

We will call at the house of Sir John Soane for an hour. He built the Bank of England, and built it so well that the new bank has preserved his walls. He built for himself this house at 13 Lincolns Inn Fields, and filled it with treasures, an extraordinary collection of things from all parts of the world. He established it as a public museum, and today it is open eight months of the year free to all who come.

The front of the house is charming, suggestive of its dainty interior and also hinting at something of its character, for there are outside two sculptures copied from the Erechtheum on the Acropolis at Athens, and four corbels from old Westminster Hall.

The rooms are crowded with something of almost everything a man could collect, and we could wish there were more room for them. The treasure from Egypt is the magnificent sarcophagus of Seti the First King of Egypt thirty-one centuries ago, famous for his colossal temples at Karnak and Abydos, and father of Rameses the Great, who spread his monuments all over Egypt and put his name on other people's. We may be sure that Rameses as a boy would stand by this coffin taking his last leave of his father.

It is an incomparable tomb fashioned from a solid piece of alabaster, transparent when a light is set inside it and flushed with the red of a rose when the sun shines on it through the dome. It is carved with hundreds of tiny figures not two inches high, and is one of the most beautiful things ever brought out of Egypt. It was discovered by the famous traveller Belzoni, who brought it out of its tomb 200 feet along a corridor hewn in the mountains,

beginning at the bottom of a 45-feet shaft.

The carvings all over it inside and out are an immense concourse of gods and people, good and evil spirits, birds, beasts, and reptiles, and good spirits are hauling the little craft in which the soul of Seti sails above the sky to the judgment seat of Osiris. The inscriptions under the pictures prepare Seti for his journey, informing him what he will see, what countries he will pass through, whom he will encounter; and they also provide him with prayers.

Kensington

Kensington Palace

It was reconstructed by Christopher Wren for William and Mary, and refashioned for George the First by William Kent, the Yorkshire painter and gardener who laid out Kensington Gardens. Old Nottingham House, which is part of it, is not open to visitors, but the Jacobean quadrangle close by, with its little gate and clock tower, is a very pleasant sight. It is of brick, roofed with green slates, and inside is beautifully panelled, with an enriched cornice and fluted columns. Above the archway at each end are festoons of flowers by Grinling Gibbons.

The State Rooms and some of the private rooms of the palace have renewed their ancient grace and dignity. We come to them by the Queen's Staircase, the stairs bringing us to Queen Mary's Corridor, 84 feet long, with two magnificent chimneypieces and oak panelling designed by Wren. Everywhere the panelling is an astonishing example of the beauty of the craftsmanship of that time; we see it in the cornices, friezes, and architraves.

Queen Caroline's Drawing Room is interesting for its fine view of Clock Court. From it a door leads into the Presence Chamber, where everything else is eclipsed by the overmantel of Grinling Gibbons. The King's Staircase, the chief approach to the State Rooms, was built by Wren and has a famous iron balustrade. William Kent painted the walls and the ceiling with a remarkable gallery of heraldic figures among a profusion of gods and goddesses. Among the portraits are those of two Turkish servants of the Court who were taken prisoner when the Turks reached the walls of Vienna in 1685. George the First was in the fighting, and, being wounded, was nursed by these Turks, who remained in his service. With them is Peter the Wild Boy, who was found in a forest near Hanover and brought to England, living here for sixty years.

The King's Gallery is the finest of all the State Rooms, 96 feet long, with the wonderful panelling and cornices of all Sir Christopher's rooms, and with William Kent's painted ceiling portraying the story of Ulysses. He also did the overmantel, which has in it a medallion of the Madonna by an artist of the school of Raphael. Set in the overmantel is a map of Europe with a dial hand worked by the weathervane on the roof to give the direction of the wind.

Leaving the seventeenth and eighteenth centuries, we pass through a doorway into the Victorian Era. Here Queen Victoria was born; we see her

nursery and toys. The furniture is of the style so much admired when the Great Exhibition was drawing everyone into Hyde Park. The window of the King's Drawing Room looks out on the Round Pond, and the walls have paintings of the Death of Wolfe by Benjamin West, and George the Third at a review, by Sir William Beechey.

What is called the Cupola Room, made in 1722, has painted walls and a slightly domed ceiling, and niches with six statues of classical gods. The chimneypiece is sculptured with the scene of a Roman marriage by Rysbrack, and in the middle of the room is a famous clock decorated with figures.

The Shops

Leaving the Palace by the stately Broad Walk or by the rural Palace Avenue, we come into the High Street. John Barker's puts on its twentieth century dress. Derry and Toms has a fine new building enriched by stone and metal, some of its decoration with allegorical figures and animals that never were on land or sea. Panels of stone and metal alternate in a fine frieze, telling something of the story of the building – a man mixing concrete, another with a pneumatic drill (silent, happily), carpenters and craftsmen doing a host of things. Pontings goes ahead, and of these three great stores it has been said that they have fifteen million customers. Harrods, greatest shop of all, is famous through the world, like a town in itself.

In the midst of these great shops stand the town hall and the parish church. The new church has a tower at the east end, impressive with the tallest spire in London, rising from a cluster of pinnacles to nearly 300 feet. An unusual porch with a vaulted roof and ten windows leads like a cloister from the busy corner to a richly moulded doorway, its door with fine hinges of scrolls and leaves. In the dim interior, with its lofty arcades, are some of the furnishings of the older church. The pulpit, carved and inlaid, has the monogram of William and Mary, who gave it. There is a marble tomb and a statue of a stepson of Addison, Edward, Earl of Warwick, who leans in Roman dress on an urn. A bust of Thomas Rennell, vicar, was made from memory by his friend Chantrey; and there is another bust of John Sinclair, vicar for thirty-three years. Much of the church plate, which includes a 400-year-old rose-water dish, is fine enough to be at the Victoria and Albert Museum.

The Town Hall

The town hall, now in its second half-century, is a stone building with a colonnaded front, dwarfed by the great shops. The vestibule is made famous by the fine sculpture of Artemis by Hamo Thornycroft, and here also are examples of the sculpture of John Bell, for whose work the town hall affords

a permanent exhibition. His Battle of Waterloo and the Eagle Slayer are in the vestibule; on the staircase is his great model of Peace contemplating the Map of the World, a work conceived for the Foreign Office but for some reason withdrawn and never placed. This is the original model and the idea is abandoned by the sculptor, there being no copy anywhere. There are statues of Lord Falkland and Lord Clarendon. Among the pictures are H. T. Wells's Victoria Regina, The Sisters by Ralph Peacock, Song by Herbert Draper, and one of the Mayor receiving the colours of the London Regiment at the beginning of the war. In the small hall are pictures by modern artists, including Byam Shaw, a son of Kensington. In the windows of the big hall is a gallery of heads showing Charles James Fox, William Boyce, Archbishop Whateley, Queen Victoria, Earl Camden, Sir David Wilkie, Thomas Gray, John Hunter, Joseph Addison, Sir Isaac Newton, Thackeray, Wilberforce, Macaulay, and Lord Holland.

Holland House

Leaving the heart of the shops and going straight on, we come to a house which has been one of the glories of Kensington for many generations, rivalling the Palace itself. It is Holland House, designed soon after Shakespeare's day by John Thorpe for a rich man who became Earl of Holland. A house of great splendour inside and out, it is now as it has been for over 300 years, with oriel windows, Dutch gables, square towers with cone-like caps, a stone balustrade running round it, and a private park of its own.

Hereabouts, at what was then called Little Holland House, came G. F. Watts to live, and at last to build a house close by in Melbury Road. Here it was that he conceived the great monument he called Physical Energy, a copy of which stands in Kensington Gardens, and here he had for his neighbours such famous artists as the Thornycrofts and the Prinseps, Holman Hunt, Burne-Jones, Marcus Stone, Lord Leighton, and Sir John Millais. It was at Number 18 Melbury Road that Holman Hunt died; the house was near a lovely place that we must visit now, the home of Lord Leighton.

Lord Leighton's House Beautiful

It is the house in which Lord Leighton lived and worked, the home he made into an artist's dream. Here he was for thirty years, and the house has been given by his sister as a memorial to him, and for the encouragement of Art.

The walls are hung with many of the artist's sketches and studies, and with paintings by G. F. Watts and other of Leighton's friends. There is The End of the Quest, by Sir Frank Dicksee; Santa Lilias by Rossetti, a golden study; and

the Death of Brunelleschi, painted by Lord Leighton when he was twenty, showing the dying architect at his window within sight of the dome of the Duomo at Florence on the day of its opening. In the studio, now used for lectures and concerts, is a plaster frieze of the Elgin Marbles.

The musical trickling of water greets us in the entrance hall, where we see the finely-draped figure by Thornycroft of Lot's wife looking back over her shoulder. At its side is a model of Lord Leighton's tomb in St Paul's. The entrance hall leads to another hall lined with blue tiles by William de Morgan, blended with medieval Eastern tiles, and here to welcome us is a head of Lord Leighton by Brock.

This second hall is the introduction to the Arab Hall, preparing us for its splendour. It is like a jewelled box, the walls glittering with the blue tiles brought by Lord Leighton from his travels in the East, which are in themselves a lesson in Persian art. The black and white floor is of dainty mosaic, and a thousand shafts of sunlight fall on a fountain through the wonderful latticed screenwork of the windows below, in which stained glass gleams like jewels. Eight windows glow mysteriously in red, blue, and orange in the dome. White and coloured marble columns have capitals carved with birds. Mr Walter Crane designed the mosaic frieze running round the walls, showing birds and animals and symbolical figures. Part of the staircase is a fine seat inlaid with pearl; in a lower room is an ingenious marble fireplace under a window, over which a shutter is drawn from the wall to serve as a great mirror.

A Group of Churches

Kensington has a fine group of churches, and an excellent system of libraries. In the Central Library, a small gabled building with a domed turret joining the townhall, is a collection of prints, drawings, and local photographs, and of famous people who have lived here, with a bust of James Heywood, founder of the first free library. In the reading room is a grandfather clock which ticked the hours away by the old Notting Hill tollgate. The Ladbroke Grove Library (Ladbroke Grove runs right through the north part of the borough) has a collection of original pencil sketches of local scenes by Herbert Railton, and in a glass case is the nucleus of a museum.

The churches include the famous Brompton Oratory, which was in effect the Roman Catholic Cathedral before Westminster Cathedral was built. It is an impressive building with a colonnaded front and a big dome, standing back from the Brompton Road, and near neighbour to the Victoria and Albert. Outside is a fine statue of Cardinal Newman, one of the founders, under a pillared canopy surmounted by the Madonna. The interior, with its

nine chapels, is sumptuously adorned with carvings and mosaics, coloured marbles and gold. In the spandrels of the central dome are mosaics of the Four Evangelists. A great wall painting shows St Philip Neri sending out a company of men, and another shows his tomb in Rome, of which there is a reproduction here under an altar. Two lamps copied from the seven-branched candlesticks of Jerusalem contribute to the lighting. The walnut choir stalls are inlaid with ivory. On pedestals behind huge pilasters are statues of the Twelve Apostles which stood for two centuries among the black and white marble of the Tuscan cathedral of Siena before they were brought here. The peace memorial is the Pieta in white marble. A Roman Catholic Church not far from St Mary Abbots is that of the Carmelites, built by Pugin but not inspiring. At the west end is a stone recording the escape of the Queen of Spain from a bomb on the day of her wedding.

An avenue of limes is an attractive approach to Brompton's parish church, overshadowed by the great dome of the Oratory. Built of brick and stone, with a little rock garden at the foot of its walls, it has a plain pinnacled tower, and is more pleasing inside than out. The soaring arches of the arcades carry the eye to cream and gold bosses looking down from the roof on the bright nave. The aisles are dim with richly-coloured glass. Under five lancets with bright glass in the east wall is a fine mosaic with figures of twelve saints and a company of angels with Christ in glory, sitting on a rainbow. Two great oil paintings in the chancel, the Wise Men offering gifts and the scene in the Temple with Simeon and the Child, are both of rich colour with golden skies.

In Redcliffe Square with its porticoed houses stands St Luke's in a fringe of lawn, a pleasing church in medieval style, with a tower and spire and some fine things inside. On the wall between the arches is a gallery of big stone sculptures of David with his harp, Isaiah with a saw, Alban with a sword, Tyndale with a book and staff, Huss and Ridley the martyrs, Cranmer in his mitre, Sebastian pierced with arrows, Ignatius with a scourge, and Stephen with stones. There are saints on the pulpit, and angels on the lectern, and much rich carving in alabaster. The carving of the organ case and screen, with cherubs and trumpeting angels and St George with a sword, is the fine work of William Aumonier. A charming window in an aisle shows David, Ruth and Naomi, and the Madonna. High over the chancel arch, glowing red and blue, are five lancets given in thankoffering for the safe return of the vicar, Henry Anderson, from the war. The bowl of the font (hewn from a single block of white alabaster) is held by a copy of a Thorwaldsen angel.

Round an island garden shaded by trees at the end of the Old Brompton Road is the famous area known as The Boltons, and pleasantly set in it is St

Mary's cross-shaped church, attractive outside with pierced parapets, and a spire rising from a central tower on which kneel eight angels. Its best feature inside is the group of four richly moulded arches on which the tower rests. Over the oak reredos in a transept, carved with the Crucifixion and figures of St George and St Michael, hangs a wooden cross from Flanders.

Perhaps Kensington's finest church in medieval style is St John's on Holland Road. Its west front is a mass of gables and pinnacles, with a big round window and a figure of the patron saint over the entrance to the baptistry. We see him again crowning the font cover, which has at the corners four figures with pitchers, the font itself showing four scenes of the Sacraments. The baptistry opens to the nave with an arch of lavish mouldings, resting on shafts which have between them sculptures of the Wise and Foolish Virgins with their trimmed and untrimmed lamps. Under the arch is a fine oak screen with saints and angels. At the top of the lovely arches in the nave (which rest on clustered columns) are coloured angels holding lamps to light the dim interior. Fine vaulted roofs spring from the walls. The high and elaborate chancel screen has a band of thirteen saints in niches, and a Crucifixion scene with six figures at each side. Similar screens run across the aisles. Fine mosaics of the Road to Calvary in rich stone frames are round the walls.

Huge blocks of flats rising like cliffs make a background for St Barnabas's Church in Addison Road, but it presents a charming front to the street as we approach, with gables and open turrets and pinnacles. Colour lends a gay touch to the wide and aisleless interior. The ceiling is cream, red, and green, and windows glow with a medley of colour. There is rich stone carving in the canopied sedilia and the fine canopied bishop's seat, in the reredos, and in the peace memorial panels of blue and gold. Very charming is a canopied alabaster wall monument with the figure of Christ in gold looking down on the sleeping bronze of a soldier of the South African War; and a memorial of wood, painted in medieval style in memory of the fine artist Byam Shaw, a choir boy and a sidesman here, has a panel of an artist sketching a woman.

St Paul's Church has nothing more pleasing than its setting in the lawns and gardens of Onslow Square, its lofty spire rising finely above the trees. The nineteenth century church of St John at Notting Hill has an imposing central tower with a lofty spire seeming to rise from a wreath of gables and pinnacles. It has a big terracotta reredos, effective with a Crucifixion scene and Peter with his fishing nets. Christ Church, in Victoria Road, stands in a small garden, and has an old painted panel in a gold frame showing the Crowning of the Virgin, given by Queen Victoria's daughter, Princess Louise.

Earl's Court Exhibition

The fine residential neighbourhood of Earl's Court is known to the world chiefly as an exhibition centre, and there has come into existence here one of the most remarkable buildings in England. We saw it rising, and the workmen looked like spiders on their web of scaffolding. It covers 12 acres and is like a Trafalgar Square roofed in, big enough to hold five Albert Halls. It is two storeys high. It has room for hundreds of stalls and 40,000 people in the aisles. There is a swimming pool 200 feet one way and half as far the other, with space for 25,000 people to watch events, and room outside for 2,000 cars. This vast place, London's permanent exhibition centre, is a romance of engineering in itself.

The Natural History Museum

One of the most striking buildings in Kensington, with a front of 675 feet to Cromwell Road, the Natural History Museum belongs to the old-fashioned days, an ornate terracotta structure of gables and towers (192 feet high) which gives us the impression of a glorified collection of a Victorian child's box of bricks.

Side by side with the spick and span walls of the new museums we have only to look at it to see at a glance what has happened to our architecture since the Victorian decorators passed away. On the walls and parapets are hundreds of sculptured animals, fanciful and real, and the same idea runs through the walls indoors, which have unknown thousands of little creatures moulded on them. Over the impressive Central Hall Sir Richard Owen presides at the top of the great flight of steps; he was the first director of the museum and is here three times, for there is also a bust and a Holman Hunt portrait of him. In this lofty hall of many arches sits Charles Darwin with his faithful disciple Huxley looking across to him, and scattered about the museum are one or two other sculptures of interest. Two are bronze busts on each side of the statue of Sir Richard Owen (F. D. Godman and Osbert Salvin); one is a bust of Sir W. H. Flower, a director of the museum, one is a Chantrey of Sir Joseph Banks, and one is a bronze of the heroic Frederick Courtenay Selous, explorer, hunter, naturalist, and great gentleman. His figure is by W. R. Colton. There is another bust of Brian Hodgson, a benefactor of the museum, and an interesting bronze of Henri Fabre showing the old naturalist as his friend Gaston Duprez used to see him so often, looking at an insect through a magnifying glass.

Covering four acres and constantly growing, this vast museum enshrines examples of everything that, having lived, has left in death a form perceptible to the eye or made visible by the microscope.

The Victoria and Albert Museum

The Victoria and Albert Museum looks what it is, a temple of magnificence, with a front 700 feet long and a tower shaped like a crown surmounted by Fame. The fine doorway has a richly moulded arch in which are set groups of figures and the words:

Above the arch is Queen Victoria, with Prince Albert below, and at the sides and in the spandrels are figures of Truth, Beauty, Knowledge, and Inspiration. Set in niches round the building is a gallery of famous men in art and craftsmanship. There are two groups of six and four groups of five. The six architects are: Charles Barry, William Chambers, Christopher Wren (with a drawing of St Paul's), Inigo Jones, John Thorpe, William of Wykeham; and the six sculptors are Alfred Stevens, Grinling Gibbons, John Bacon, Chantrey, Flaxman, and J. H. Foley. The ten painters are Turner and Constable, Reynolds and Gainsborough, Romney and Hogarth, Watts and Cosway, Millais and Leighton. The ten craftsmen are Caxton and St Dunstan, Chippendale and Wedgwood, Morris and Tompion, Roger Payne and George Heriot, William Torel by his forge, and Huntingdon Shaw in his smith's apron.

The building is designed as a series of courts with grassy courtyards, and has interesting decoration indoors by Lord Leighton, William Morris, and

The Victoria and Albert Museum

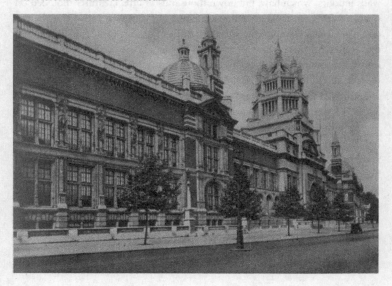

Sir Edward Poynter. Two Leighton frescoes of Art applied to Peace and War are in lunettes; William Morris decorated the small dining-room in green, and the grill room, known as the Dutch Kitchen, has tile panels by Poynter.

The Victoria and Albert, which has a Visitor's List now approaching a million people a year, has the greatest collection of precious things in all England, covering 12 acres and divided mainly into groups in a mile of galleries: architecture, ceramics, painting, engraving, metalwork, woodwork, textile, and Indian crafts. There is also a great library with 160,000 books of Fine and Applied Art and with 250,000 photographs. It has such rare things as Folio Editions of Shakespeare, manuscripts of plays by Beaumont and Fletcher, manuscripts of Dickens, and notebooks of Leonardo da Vinci. Associated with the library is a series of rooms showing book production, illustration, and decorative design. One of these rooms has the finest work of the so-called little masters of sixteenth and seventeenth centuries engraving. There are precious illuminated manuscripts set out for us to see, and book illustrations by such artists as Ralph Caldecott and Kate Greenaway. There are superb bindings. One of the very rare treasures of the library is a priceless fourteenth century missal from the French abbey of St Denis, once the great storehouse of ecclesiastical art, nearly all of which perished in the Revolution. On its left margin the Lord's Prayer is written in a circle no bigger than a sixpence.

There is also, near the main entrance, what may be called the Shop Window of the Museum, the Court of Recent Acquisitions. Changing from time to time, it is always interesting, and significant of the wealth pouring into this vast collection. The walls of the court are hung with tapestried maps of English counties, and near the court is the noble collection of sculpture given to the British nation by Auguste Rodin as an expression of admiration for France's Ally in the Great War.

The Geological Museum

We come now, walking up Exhibition Road, to a great place which will astonish the thousands who think it a dull place, the Geological Museum. It is not the most popular of these museums, and it makes no great pretence out of doors, but in some ways it is the gem of them all. It is only a genius who can make geology interesting to the man in the street, and genius is here on every floor and in every corner, and the architect has had his share of it. 'Everything is just right,' an architectural critic said of this place, and it is true. It is a classical building like a temple, a very striking feature being the fine front with its recessed balcony and its splendid Corinthian colonnade.

The Great Hall and its galleries are bright as day, with light streaming in from everywhere, even through the barrel roof, and at one end is a charming stairway like a bridge in lovely mottled marble of green and grey and rosy hues – all British, as are the great vases on each side. A dainty fountain plays in the middle of the floor, and an immense figure of Hercules towers beyond it, greater than it looks in this colossal hall. There are lovely seats where we may sit down and look on this fine spectacle, and those who will not come in on fine days might do worse than come to rest here when it rains.

With its plan not yet in its final stage, it has no printed guide to its million exhibits. Attached to the building are the offices of the Geological Survey, but we see nothing of that; it suffices that we have before us a story of 500 million years of the earth's adventures, attested by fragments of the changing fabric, and that geology, the story of the earth, with its biology, botany, mineralogy, and metallurgy, speaks to us here in terms of simplified magic, telling a tale of irresistible fascination if we will take a little trouble to understand it.

Apart from the things shown, there is at the disposal of all, free of charge, one of the finest scientific libraries in existence, where, as much at ease and at home as in a club, we have the choice of 60,000 books, reinforced by 26,000 maps, 12,000 photographs in albums (with perhaps another thousand enlarged, framed, and displayed about the museum), and, neatly filed and indexed, 26,000 printed copies of the lectures and papers read by modern masters of their subjects to the scientific societies of Europe, the raw material of the latest evolution in geological theories and ideas.

The hundreds of cases, each of two compartments, are grouped in series, and for each series a scholarly hand has written in homely terms the story of the section, and for every exhibit its popular and scientific names and its place of origin. Everywhere are photographs and drawings to excite and stimulate imagination, showing the almost incredible folding of rocks of all sorts.

The Science Museum

We come now to the Science Museum, which began with an iron building after the Great Exhibition, and has ended as one of the finest museums in Europe, with half a million square feet of floor space provided for. The eastern block has an impressive frontage of solidity and strength with twelve huge pilasters reaching from end to end. It was designed by Sir Robert Allison. Inside it is open to the roof with galleries all round, and is flooded with light, giving us the feeling of a ship packed with treasure. We imagine that for a boy there is no more enthralling place in London, but indeed it is true for any of us.

Here is brought before us an array of wonders in which we seem to see the wheels of the world go round. There is James Watt's garret and Professor Piccard's gondola, one the little workshop in which the old inventor thought out steam and all its powers, the other the remarkable sphere in which a man of our time rose ten miles high. Here are the primitive beginnings of the Electric Age, the beginnings of Wireless and of Television, the very first thing to be televised in the world. Here are hobbyhorses and the early bicycles, Puffing Billy, George Stephenson's Rocket, and an old mail coach and a sedan chair, a wonderful model of a gold mine, a miniature engineering workshop with fifty little machines and benches, miraculous calculating machines with the masses of figures that will all come right, and lovely painted balloons.

It is all very wonderful, but words are poor about a treasure-house like this. As we come in our attention is called to 300 collections from which we can pick out any subject that appeals to us, and if we are studiously inclined there is a library at our service with 260,000 volumes on the shelves, 500 periodicals in pigeon holes, and references to 13,000 more. If these are not enough the Science Museum has a set of bibliographies we may consult with forty million references.

Facing us as we enter is a fine bust of James Watt, and we remember the old story of the king coming up to him and saying, 'What have you here, little man?' To whom James Watt replied: 'What kings covet, your Majesty – Power.'

Power indeed is here. Let us look at it. We shall pass through gallery after gallery and storey after storey, exhibiting the tale of discovery and invention on land and sea and in the air for at least three centuries, till on the topmost floor we find our head among the stars, for here are astronomical instruments,

The Science Museum

models of the sun and all its planets, and the distribution of the stars about the Universe.

The India Museum

Passing by much that hereabouts comes into Westminster, we come to the India Museum, a branch of the Victoria and Albert though housed near the Imperial Institute. It is an astonishing display of exquisite work in metal and stone, wood and ivory, and in paintings and embroideries. Here we may read the story of the art, the religions, and the many races of the great Indian Empire; here in the setting of innumerable objects are the gods, temples, dresses, furniture, and ornaments of India, Burma, Java, and Tibet. The origin of this enthralling exhibition, so rich in all it teaches, was a small collection of Indian art belonging to the East India Company.

In the entrance hall are fine examples of house fronts in stone and wood, all finely carved; there are lovely doors with amazingly fine detail, a wonderful balcony, and exquisite oriel windows. Beyond is a long gallery with a seated figure of Buddha, the central figure of Buddhist art and religion.

Illustrating the life of Buddha is a series of frescoes from the first it o the seventh century, copied from those in the rock caves of Ajanta; in the scene of the temptation the Buddha sits cross-legged, erect and still, as he is shown in his statues.

There are casts of many details of Akbar's palace at Fatehpur Sikri, built of red sandstone in the time of Queen Elizabeth. Artists from every part of Asia were employed on it. A wonderful throne pillar, its top like an overhanging capital, was used by the Emperor when holding audience in the Hall of Council; concealed on the top of it he could give judgment secure from assassination. There are copies of carved panels in the palace, and of Akbar's fine tomb. After fifteen years Akbar's city, proving unhealthy for habitation, was deserted, and is now kept up by the Government. A fine colonnade of inlaid marble is here from the royal baths at Agra Fort.

Among the many gods and goddesses is a bronze figure of Siva, the destroyer and creator, his blown hair plaited with lotus buds as he dances his strange ritual dance in an arc of flame, crushing the demon of past evil under his feet. There is a full-sized model of the Sanchi gateway (about 50 BC), an astonishing mass of carving with hundreds of figures in many scenes; and on the capitals of the pillars are elephants marching.

Marylebone

It has at least six wonderful possessions known to all the world: a cricket field, a zoo, a waxwork show, an art gallery, a shopping street or a doctor's street (which you will), and the greatest single institution built up by mankind, which carries the voice of Marylebone to the ends of the earth. Where else in two square miles or so could be found a group of things more characteristic of our Age than these?

What Oxford Street Has Seen

Its famous Oxford Street, of which it takes one side, has been through great adventures, for it was the way to Tyburn, where men and women and even children were dragged to execution. The top of Oxford Street is now as fine a spectacle as any shopping street in the world can show. At the eastern end arc the magnificent marble halls of a corner house, behind which Marylebone's boundary sets off along Hanway Street, reminding us of that brave Jonas Hanway who carried the first umbrella in London while the world looked on and smiled – and got wet! The boundary then runs north to Middlesex Hospital, so long falling down and now built up to last so long; the noble home of a noble work, thanks largely to the wonderful gifts of one or two private citizens. The forecourt facing the street has balconies in the middle and side wings like enfolding arms.

All Saint's, in Margaret Street not far away, was once considered the most beautiful church in London, and is noted still for its ritual and music. The brickwork exposed inside and out was then a novel feature, and the carving on the capitals John Ruskin thought unsurpassed in modern times. There are wall paintings of Bible scenes by William Dyce, the founder of the Pre-Raphaelites, and rising to the roof above the altar are painted saints in tiers of gilded niches.

Margaret Street is crossed by Great Portland Street, noted today for its motor-car showrooms, but far more famous for having received the first wireless signals that ever were made. It has in it the Central Synagogue, built in Moorish style with a low tower and many pinnacles. The interior is lofty and imposing, with tiers of columns holding up the gallery, the clerestory, and the vaulted roof. The green and black reading-desk of marble and bronze is unique in this country, and very beautiful. The bronze chandelier was made as a peace memorial by Percy Macquoid.

A place which those for whom it exists would love to see stands across the street, the National Institute for the Blind, its windows filled with things blind folk have made. It has a bronze bust of Dr Armitage, its founder, and in cases round the walls is a collection of old and new apparatus: embossed books, pictures, and maps, tools for work and games for play, clocks and watches which can be felt, a device which threads a needle, talking books, and electrical talking for conversations with blind and deaf people by means of rising keys. Here is a compass to help the owner on his way, and a blind man's lantern enabling him to locate obstacles by echo.

We come to the end of Regent Street, within sound of the traffic roar of Oxford Circus, and all about us are familiar places that have had their part in London life longer than most of us. There is the solid-looking home of the Polytechnic, the famous Queen's Hall, with St George's Hall next door, the little round church of

All Souls which John Nash set up as a fitting end to Regent Street; and now, of course, the wonderful newcomer among all these, the majestic spectacle of Broadcasting House.

All Souls, fashionable for weddings, is the best-known church in Marylebone, with one of the best positions of any church in London. Everyone who knows Oxford Circus knows the candle-snuffer spire rising from the graceful colonnade of the church that sits so modestly at the feet of the BBC. Its bright and cheerful interior is a symphony in green and gold with a gallery running nearly all round. On the balustrade rise columns with gilded capitals holding up the roof.

Queen's Hall has a colonnade on its curved front, and room inside for 2,500 people. It has been London's principal concert hall for a generation, and is known everywhere as the home of the famous Promenade Concerts. Set in niches round the front are groups of sculpture and statues of famous musicians, among them Handel, Mendelssohn, Brahms, Beethoven, and Haydn.

The BBC

Broadcasting House, the home of the most potential institution in the world, the universal expression of the spirit of the twentieth century, is one of the most impressive buildings in the capital, a massive oval block covering 20,000 square feet, and relying for its appearance on skilful groups of masses of stone rather than on ornament. In the hall the only sculpture is Mr Gill's Sower, broadcasting the seed, but in the concert hall is a feast of delight on the east and west walls, where Mr Gilbert Bayes has two friezes, one from old times and one from ours. There are scores of lovely figures in them, and the inspiration of Shakespeare

and Keats. There is a ball game with Odysseus watching it, a foot race with Atalanta stooping to pick up the apple, a little procession to the temple (Keats's Who are these coming to the sacrifice?), music changing the nature of things (all creatures listening to the lyre), and scenes suggestive of poetry, dancing, worship, harvest, and so on. The concert hall itself is the biggest room in the tower and occupies three floors in depth. It seats a full orchestra, whose members have these delightful friezes to look at as they entertain us.

Most large buildings are planned round a quadrangle, so that some rooms take light from the street and others from the quadrangle. This had to be dispensed with. In its place the architect built a tower like a house within a house. This is the highest part of Broadcasting House and contains layers of studios with library rooms and stationery rooms between the floors, further to isolate the studios. As there is no real need for daylight there are no windows in the tower. In order to deaden outer sound, no steel has been used in the tower. It is of brick, with immensely thick walls. In the world of today and tomorrow this is the real Tower of London; from it those voices speak which are heard all over the world.

There are twenty-two studios in the tower, and here also is the music library, perhaps the biggest in the world, with all the classical music and

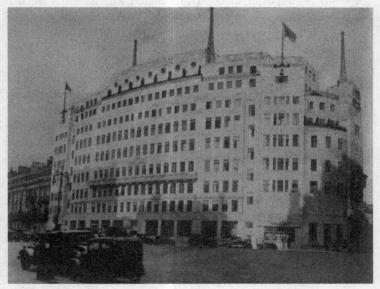

Broadcasting House

the latest stage song. There are more than 50,000 pieces of music for singers, orchestras, and military bands. Round this huge core of the building seven floors of well-lighted offices are grouped, with comfortable rooms for all concerned with the work of the BBC. The Council Chamber is a delightful room, panelled in light Tasmanian oak with beautiful long tables of walnut from Queensland. There is a chimeless clock, which can be made to reproduce Big Ben by electrical arrangement, and on the roof, carrying the eye upward above the hundreds of windows, the aerials rise like petrified lace, soaring above a mass of white cliffs. Between them flies the BBC flag, on which the earth is floating among the planets, the golden ring of broadcasting sweeping round the globe.

This famous building is dedicated to the service of humanity in these fine words, cut in a great stone which greets us as we come: This Temple of the Arts and Muses is dedicated to Almighty God by the first Governors of Broadcasting in the year 1931, Sir John Reith being Director-General.

We are now in Portland Place with its stately houses by the Adam brothers and the gardens at the far end railed round by John Nash. Four monuments run in a line through the length of this fine place. One is the statue of Mr Quintin Hogg, and behind him, halfway up the Place, is the fine bronze of Field-Marshal Sir George White,

defender of Ladysmith, mounted on a charger with his baton in hand. Beyond is a bronze bust of Lord Lister, with a graceful figure about the pedestal; it is by Sir Thomas Brock, and is near Lord Lister's house in Park Crescent, the gardens inside which stands our fourth statue, showing Queen Victoria's father, the Duke of Kent, wearing the Collar of the Garter.

In this place where the influence of the Adam brothers is so plain (there are two dignified rows of Adam houses round the corner of Mansfield Street), we noticed the gabled Adam building of the Institute of Hygiene with a museum devoted to food and clothing. One of the rooms has a ceiling with cherubs running round the frieze and a marble fireplace with a relief of a sacrificial procession showing a bull being led to a little temple. In this room is some seventy-year-old bread from Paris during the siege, and among the collection of clothing on an upper floor is one of the woollen sleeping bags used by Captain Scott and his comrades. There are mummy clothes from Egypt, a mummy bead net 3,000 years old, Roman sandals, medieval pointed shoes, and Tudor caps; and much nearer our own time are modern clothes produced by sweated labour.

The Wonderful House of the Architects

But it is the noble home of the Royal Institute of British Architects that draws our eyes here. It is one of the most remarkable houses in London,

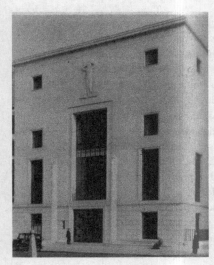

Royal Institute of British
Architects

a straightforward mass of white stone with a flat roof of which the most distinctive feature is the high broad window over the doorway, filling the interior with an abundance of natural light. The walls have a smooth surface which greatly enhances the striking effect of the projecting sculptures, which are by Mr Edward Copnall. On the front the figure of Architecture towers above models of the buildings his spirit has created, and along the side wall is a group of his companion powers, Painter, Sculptor, Artisan, Mechanic, with Sir Christopher Wren in the midst of them. Crowning two high columns flanking the main doorway are figures symbolical of Man and Woman as the creative forces of Architecture, both these by Mr James Woodford, who also fashioned the magnificent bronze doors by which we enter.

The interior of this proud home of the architects relies for its expressiveness on the clever disposition of space and solids, and in a smaller degree on the variety of marbles, rare woods, and other materials used for floors and walls. Much of the decoration is strikingly original, such as the marble panels of the hall floors, patterned with telephones and typewriters, and a new technique has been introduced on the grand staircase, where, framed in the banisters, are panels of etched glass by Mr Jan Juta. The design is simple, made up of lions and heraldic coats. At the top of the stairs are three great screens of etched glass and in the ceiling are plaster reliefs typical of six periods of English architecture.

In the Henry Florence Memorial Hall, where the Institute's exhibitions are held, the floor is constructed for dancing and tubular lamps throw light up

the curtains. Plaster reliefs on the ceiling graphically illustrate the building trades, men working on this house having been used as models. We see Mr Jan Juta cutting glass, and Mr Woodford, the designer of the ceiling, posed as the electrician. Under the east window is a screen of Quebec pine carved from the clay models of Mr Dennis Dunlop, with twenty panels representing peoples, industries, animals, and flowers of the British Empire. The peoples and buildings of the Empire are painted on an ingenious wall in the Henry Jarvis Memorial Hall; the wall weighs five tons, yet it can be moved with a finger and disappears when necessary. On one of the staircase ceilings are reliefs of tools used in the building, and the ceiling of the top landing has a plaster panel showing the building in progress.

Portland Place, which we now leave, is the widest street in London, 120 feet. It brings us through Park Crescent to Regent's Park. Across the Crescent runs Marylebone Road, parallel with the Place on the right runs Great Portland Street, and on the left run the two famous highways of medicine, Harley and Wimpole Streets.

In the Marylebone Road, near the entrance to Park Crescent, stands Trinity Church, built by Sir John Soane. It has a portico inspired by a temple at Athens and a classical tower with a round turret modelled on the Temple of the Winds. The apse and the outdoor pulpit in the wall have been added; the apse is richly decorated with mosaics of Bible scenes. There are two small windows to heroes of the war, one to a Harrow boy who fell in France; he is playing cricket and carrying his bat. On the wall by the door is a white marble relief of a mother and child with a lamb at their feet, the work of Robert William Sievier.

The Home of the Doctors

We turn from Park Crescent into the world of medicine, Harley Street and Wimpole Street, leading us to Cavendish Square. Hereabouts are three notable buildings concerned with our health; the Royal Society of Medicine, the College of Nursing, and the wonderful building of the London Clinic and Nursing Home. It is the first house of its kind in London where patients may be treated by their own doctors with the help of every scientific aid. The building has steep tiled roofs and is guarded at each corner by a tall plane tree. The College of Nursing near Cavendish Square, designed by Sir Edwin Cooper, is the impressive headquarters of English nursing, and has for its next-door neighbour the stately home of the Royal Society of Medicine, a fine modern structure with fluted pillars and serpents coiled round its lamps. Indoors is a library of 150,000 books. Marylebone's oldest church is across the street, built by Lord Harley, who gave his name to the doctor's street.

The flat-fronted houses of Harley Street are familiar to all who have been in search of a specialist; one of them with a long porch is now Queen's College, the first college in London for the higher education of women. It has a lecture hall and three laboratories. Harley Street brings us into Cavendish Square, the nearest square to Oxford Circus, with increasing signs of change yet keeping a fine pair of eighteenth century houses with pillared porticoes and graceful iron balconies, and still presided over by Lord George Bentinck, the Protectionist who defeated Peel. He stands in bronze, wearing a tight frock-coat and with a cloak flung over his shoulder.

At one corner of the square is the great College of Nursing; at another is the Adam house occupied by Brinsmead's. On Brinsmead's is a frieze of a children's orchestra, on a green ground; and three panels of Science, Music, and Art. The front has delightful pillars and pilasters, with hundreds of carved fragments creeping up inside the hollows.

Lord Harley's church (St Peter's) is a plain building by James Gibbs, with a little tower and a cupola. Its vaulted ceiling, resting on pillars rising from the gallery, is decorated with golden flowers. The east window has the red-robed figure of Christ at the Well with the blue-robed woman of Samaria, the figures by Burne-Jones, who also painted the Resurrection above the altar in memory of Frederick Denison Maurice, who preached here for ten years.

In a quiet corner behind Oxford Street is Stratford Place, still with several houses by Robert Adam, one with a pair of torch- extinguishers by the front door. Winding past the end of the Place is Marylebone Lane, its curves now following the course of the vanished stream, St Mary Bourne. It joins the High Street, near which stands the Roman Catholic church of St James, a much- buttressed nineteenth century building with stone-fronted roofs, a triforium, and double aisles which make it like a small cathedral. Most remarkable are the windows of the Warriors Chapel facing the door, for they have in them an aeroplane, a battleship, a gun-carriage, and a saint in a steel helmet.

The Forsaken Church

Two centuries old, near the top of the High Street, is the little old forsaken parish church. About the time of Waterloo the plain little church now deserted gave way to the imposing building close by, facing the York Gate to Regent's Park. It was built by Thomas Hardwick, who worked with Sir William Chambers on Somerset House, and it has an imposing portico with angels guarding a round turret rising from the balustraded roof. The apse came later, the foundation stone being laid by Mrs Gladstone. In it is an altarpiece of the Nativity by Benjamin West. The church has two tiers of

galleries carved with festoons and cherubs, and on the walls are two stones to Devonshire artists of great fame. On one is a medallion of the fashionable painter of the days of George the Third, Richard Cosway. All the beauties of the Court sat for him, and his exquisite delicate miniatures have given him a name that will not die. Three cherubs fly round his portrait here, and with them are some lines by one of his kinsmen, prophesying that while colours last his name shall live.

The Wallace Collection

Dickens's house is at the top end of the High Street; at the lower end is Manchester Square, to which lovers of art have been coming since this century opened. In it is the best small gallery of beautiful things that London has, Hertford House, the balconied eighteenth century building in which is housed the noble Wallace Collection. There are nearly 800 oil paintings and watercolours, representing every school of painting in Europe. The Italian masters from Benvenuto di Giovanni of Siena in the fifteenth century to the Guardis and Canalettos of the eighteenth are reinforced by an exceptional assembly of Dutch and allied painters; a still more imposing array of the Frenchmen from Clouet to Meissonier, and some of the finest efforts of the English portrait painters Reynolds, Romney, and Gainsborough. Velasquez, Murillo, and Holbein are also of the company.

There is a remarkable collection of bronzes and wood carvings, some world-famous. The porcelain, mostly of Sevres, is of a beauty and rarity unexcelled outside France. The collection of arms and armour is of the highest distinction, and of European celebrity. There are specimens of every kind of art which is brought to the notice of a collector with a bottomless purse, and of which he may be willing to acquire some unique example, such as gold and silver work, Limoges enamels, ivories, miniatures, illuminated manuscripts, Italian majolica, rare glass, or objects of historic interest. There is finally the French furniture, the glory of Hertford House. There may be twenty art galleries in Europe among which the collection of pictures here will occupy only a modest place, but the collection of furniture of the periods we know as Louis Quatorze, Louis Quinze, and Louis Seize is equalled by few and excelled by none.

As we enter the doors we face the Grand Staircase, the balustrade of which was in the Bibliotheque Nationale of Paris in the time of Louis the Fourteenth. On the left of the Hall is Gallery One, lit by a noble chandelier which was a famous piece of Caffieri and is signed by him. It is partnered by a cabinet surmounted by a clock from the hand of another great cabinet-maker, Cressent. In the middle of the room is a cabinet of the rare

historic things a rich collector would show to his friends. There is a carved whistle with which Diane de Poitiers called her greyhounds; there is a hand mirror of silver which every day used to reflect the lovely features of Marie Antoinette.

In Gallery 2 hangs perhaps the finest chandelier in the world, and here is the most famous of the many clocks of Hertford House, made in 1725, and showing mean solar time and the time by a sundial, the age of the Moon, the days of the week, the date of the month, the rising and the setting of the Sun and the Moon. It was set going again in 1915 and goes now.

Gallery 3 is filled with bronzes, terracotta statuettes or heads, woodcarvings, Italian majolica dishes, ivories, glass, and Limoges enamels. So rich is this assemblage, nearly each piece of high celebrity, that it is difficult to pick our way among them and single out any example for attention. Among the woodcarvings a little boxwood Hercules swinging a club is known all over Europe as a masterpiece of a sixteenth century artist. It is marvellous in its poise. The first place among the bronzes goes to the enthroned goddess by Giovanni di Cremona. Among the Italian majolica the dish of Bathing Nymphs after Raphael is equalled only by one at South Kensington. There is a dazzling lamp of Arabian or Persian glass and a boxwood tabernacle of the most intricate workmanship.

Apart from these there are two objects which have a special interest for all Englishmen. One is a child's head of Jesus which is the pendant to a John the Baptist said to have been brought from Italy by Sir Richard Grenville. The other is a pouch of red leather with two clay pipes and a tobacco stopper. Cut into the leather is a Latin inscription meaning 'He was my companion during that unhappy time,' and the initials W R. It is said to have belonged to Sir Walter Raleigh, and the unhappy time would mean the years of his waiting for death.

Behind this was Sir Richard Wallace's smoking-room to which none but his most intimate friends were invited. It has now, as Gallery 4, become the repository of Oriental armour, and in the body of the room are two cabinets which none can pass by, filled with lifelike portraits in wax of famous historic figures.

In the three succeeding galleries Sir Richard's collection of European armour stands alone. The arms make a glittering display; some of the pieces are famous all over the world for their rarity and exquisite workmanship. Gallery 8 is something of a Cinderella, but it contains a notable bronze bust by Pilon of that Charles the Ninth of France who sanctioned the Massacre of St Bartholomew and died with its horror still upon him.

The Founder's Room, to which we now come on our return towards the Entrance Hall, is very much as when Sir Richard Wallace sat in it. The bust

of Lady Wallace is there. That of Sir Richard was made after his death. There is a bust also of the Marquis of Hertford, who bequeathed the treasures to Richard Wallace, and another of Sir John Murray Scott, who helped Lady Wallace to her decision to leave it to the nation. Older mementoes are the portrait of George the Fourth by Lawrence, and three slight portraits by Reynolds. One is that of Mrs Siddons as Perdita. By the mantelpiece is a pastel of a man to every Victorian boy's memory dear, Fenimore Cooper.

Gallery 9, behind this room, has its portraits and mementoes of the English Royal Family. It begins at its earliest with one of the historic likenesses of Mary Queen of Scots, and continues with Charles and Henrietta Maria, and a fine miniature of Charles the Second. It is not so impressive as that of Oliver Cromwell, which is placed near it and shows finely the Protector's rugged features. Other portraits which cannot escape attention are Hoppner's George the Fourth, which does that monarch more than justice, and Allan Ramsay's dignified painting of George the Third when still a young man; but the best picture in the room is Romney's Perdita.

Gallery 10 is dignified by one of the portraits Rubens made of his first wife; and Gallery 11 has two cases of miniatures in which are portraits of Admiral Blake and lovely Mrs Fitzherbert as Richard Cosway saw her, a bluff portrait of Hans Holbein, perhaps painted by himself, and a very French Marquise de Pompadour. The chief miniature is one of the unhappy little Dauphin, son of Louis the Sixteenth, by Dumont. The next case takes up the Napoleon era. Here are Napoleon Bonaparte and his mother; Murat, a rustic face though he was one of the best of Napoleon's Marshals; Napoleon's Josephine and Marie Louise, and the baby boy who was made King of Rome but died frustrated and unhappy when he was twenty-one. There is another portrait in this room, by Isabey; it is of the Duke of Wellington three years after Waterloo, and it reveals the soldier in the pride of his martial authority. Meissonier's splendid group of Napoleon with his Marshals keeps these other kings and captains company.

Gallery 12 keeps its Boulle armoire and its Louis Seize armchairs and elaborately carved sofas. These and the famous wall clock, symbolising Love and Time, by Cressent, are its chief ornaments. Pictures of Venice convey the sparkle of the Queen of the Adriatic.

Gallery 13 has fine pieces of furniture, a most graceful writing table, and an inkstand which though designed in France was sent on a two or three years' journey to Japan to be lacquered. The pictures here are the less important ones of the Schools of the Low Countries. There is a good Paul Potter, a better Van de Velde of a Coast Scene, and a Ruysdael landscape which is a little masterpiece in colour and feeling.

Gallery 14 retains only one or two notable pieces of furniture. The pictures are again Dutch or Low Country. There are three delightful little scenes of the wooded landscape, or the path through a wood, that Hobbema so delighted to paint; and two Rembrandts. There is also a Terborch of a Lady at her Toilet which will not let itself be missed.

Gallery 15 might almost be described as the Annexe to the greater one beyond, its furniture not so fine, its painters of less dominance but of first-class importance. The most arresting are the oil paintings of Richard Parkes Bonington. The Wallace Collection contains the finest series of his works to be found anywhere. Whether it is the fanciful little picture of Scheherazade from the Arabian Nights, or the Landscape with Timber Waggon, the Coast Scene near Picardy, or the Seine near Mantes, each reveals the master.

Sir Thomas Lawrence's well-known portrait of Lady Blessington seems to preside over the room as she presided over the famous circle of the wits and men of talent of her day in Kensington. She has here for company, besides Bonington, a number of Meissoniers, a Rosa Bonheur, and a Delacroix of the finest period.

We now reach Gallery 16. This great room, called the Large Gallery, contains alike in its pictures and its furniture the gems of the collection. There are two great commodes, one by Caffieri, the other by Cressent, which are unsurpassable, and two bureaus of the same inspiration, one made by Riesener for the King of Poland, with much beautiful marqueterie, the other a copy. On the walls Rembrandt, Rubens, Ruysdael, Hobbema, Van Dyck, Franz Hals, Murillo, Velasquez, and Titian here keep company with Reynolds and Gainsborough. There is a portrait Sir Joshua painted of little Miss Bowles tightly clasping her dog; and Rembrandt's portrait of his son Titus, whom he so loved and lost. In its spirit and pathos it is more moving than the great canvas of Cornelius the Centurion receiving instructions to go to Joppa, which was painted at the height of Rembrandt's power. Other painters would look on their works in this gallery with the pride coming from the feeling that here their best had been recognised. Sir Joshua Reynolds would welcome his little Strawberry Girl, though he would sigh to see it so faded, and his Nelly O'Brien. Franz Hals would surely be satisfied with his swaggering Laughing Cavalier, Gainsborough would rejoice in his Perdita, one of his most beautiful paintings of Mrs Robinson the actress. Velasquez perhaps painted his daughter in the nobly dignified Lady with the Fan. She is immortal, whoever she was. The Don Baltasar Carlos is a picture of that princely baby which can never grow old.

The Hobbema landscapes in this gallery are among the best that tranquil master ever painted, and the enchanted Landscape with Waterfall is one of the two great examples of Jacob Ruysdael.

Murillo's gentle art reaches its highest expression in The Virgin aud Child. Van Dyck's courtly magnificence was never better expressed than in the two full-length portraits of Philippe Le Roy and his Lady. Pieter de Hooch has two paintings of Dutch interiors.

It is with reluctance that we leave this collection of masterpieces for the galleries beyond, where we can hardly expect to find their equal; but these succeeding rooms have the unique quality of having been arranged as if they were apartments in a French palace. They possess fine pictures. Gallery 17 has several Murillos, a Ruysdael, three Luinis, and a sketch by Rubens.

In Gallery 18 the furniture is noted not only for its richness and profusion of ornament, but because it marks the slow departure from the curves of the earlier periods of French eighteenth century design. The straight line is the marked and dominating feature of this Louis Seize style. The most celebrated piece in this gallery, the upright secretaire, belonged to Marie Antoinette. The gallery glitters with the work of Riesener and Gouthiere the brass chiseller. One piece is said to have been used by Madame le Brun as her painting-table.

The paintings are fully in accord with the furnishing. Madame le Bran's Boy in Red laughs from a wall, which is decorated with the fancies of Fragonard, Boucher, Lancret, and Watteau. The Watteaus are this gallery's chief triumph. There are six, and they reveal him at his best.

Gallery 19 has Boucher as its chief painter and decorator; here is his famous Madame de Pompadour which he painted for her and which she kept till her death. It typifies alike the Belle Marquise and the age in which she moved.

Here again the furniture has the increasing delicacy of the late Louis Seize style, and the panels of painted porcelain which are let into the wood are noticeable. But the crowning decoration of the room is the perfume-burner of jasper on a framework of gilt bronze, as bright as on the day when Gouthiere chiselled it for Marie Antoinette. Festoons of vine hang from satyrs' heads; a serpent is within coiled to spring.

In Gallery 20 is a writing-table in pale green lacquer and bronze which, apart from its beauty of workmanship and the name of its designer (Dubois), has another title to fame. It was made for Catharine of Russia, and on it is said to have been signed the Peace of Tilsit. There is a case containing little objects which carry with them historic memories. The most touching is the ivory necklace given by Marie Antoinette to her friend Princesse de Lamballe, who also perished in the Revolution.

The chief pictures of the Gallery are the pretty heads painted by Greuze, which compete with the pinks and whites of Boucher's nymphs and overflow into the neighbouring galleries.

In Gallery 21 we begin to meet some of the examples of Sevres porcelain for which, next to its pictures and furniture, the Wallace Collection is most famed. But both here, and spreading into the corridor, is a surprising plenitude of clocks and barometers in gorgeous casings. Mirrors and cabinets, magnificent in tortoiseshell, enamel, and inlay, adorn the room.

In Gallery 22 are collected the unsurpassed examples of soft-paste Sevres porcelain which are almost unique. The massed pieces light the gallery with a superb glow of colour. There is also a precious collection of silver.

We have now reached the end of the great treasures of Hertford House, which is veritably so rich that it has banished to the upper rooms some that are worthy of a better fate. Take it for all in all, the Wallace Collection remains for its size the choicest assemblage of the fine arts to be seen anywhere in Europe.

Madame Tussaud's

We are in the streets again, in Baker Street not far from Manchester Square. It is one of the busiest streets in London with its ceaseless throng of people, for it brings us into Oxford Street. It has the famous underground station, with an impressive block of flats above it; the remarkable headquarters of the Abbey Road Building Society with a fine tower floodlit at night; the dignified Bedford House where Cardinal Manning lived and Cardinal Wiseman died; and near by, as all the world knows, is Madame Tussaud's. This famous long building, with a line of flags waving from the roof, has indoors one of the sights of London, its collection of waxworks being unequalled in the world.

Half a Million Photographs

Off Baker Street we come into Portman Square with its dignified houses and its memory of famous people of the end of the eighteenth century. Today Portman Square has two houses famous in the world of art. At Number 32 Sir Robert Witt entertains the seeker after knowledge in his house on the west side of the square, where four librarians control one of the most remarkable collections ever brought together of photographic reproductions of works of art. There is nothing else like it, for it has about half a million photographs, representing the work of 17,000 painters and draughtsmen of the last 800 years or so, organised so that any picture can be found in a minute (100 in a box). This astonishing library is at the service of all who love art.

Twenty Portman Square

But the most wonderful house in the square is Number 20, open to the public on Saturdays. It is now giving temporary accommodation to the Courtauld Institute of Fine Arts. The house is by Robert Adam at his best. The front is decorated with rams' horns and festoons, and there are lamp-stands on either side of the pillared porch.

The house, of remarkable interest for its own sake, has a small collection of pictures left in it by Mr Courtauld, several by Paul Cezanne, and two portraits of Gainsborough and his wife by the artist himself. The decoration of the house is exquisite, and we see from the ingenious planning of the rooms how Adam transformed the domestic architecture of his day. Most of the painting on the walls and ceilings is by Angelica Kauffmann and the Venetian painter she married.

The great circular staircase is the only one of its kind designed by Robert Adam, and is a masterpiece. The panels on the walls have scenes of the burning of Troy, and on one of the ceilings are panels of country life. Reliefs on a marble mantelpiece show little boys carrying baskets of fruit to women in the cornfield. The library walls are adorned with arches, and round its circular ceiling run a dozen medallions with portraits of such people as Francis Drake, Francis Bacon, Isaac Newton, Joseph Addison, and Robert Adam. The mantelpiece has a big painted panel of a Scottish king and Queen Elizabeth, who are being borne by cherubs to a seated figure of History. The ballroom has an astonishingly beautiful ceiling, a dream of harmony with its pale tints and touches of gilding; the middle medallion shows Virgil reading the Aeneid to Caesar Augustus and his beloved Octavia.

In the music-room is an extraordinary decoration of circles which has been described as a tribute to the inventive and harmonising skill of Robert Adam. The squareness of the walls has been broken by a series of apses, and pilastered mirrors reflect the pale light of candles. The boudoir ceiling has four medallions of the Seasons, with cherubs dancing through the delicate design.

The green oasis of Bryanston Square is not far away, overlooked by the splendid round tower of St Mary's, the church built by the architect of the British Museum, Sir Robert Smirke. It is in the massive Grecian style and has a spacious oval roof. A church near by in Marylebone Road is by Sir Arthur Blomfield (its tall tower is now used as the entrance to workrooms), and has iron columns in the nave and three narrow lancets in the east window with glorious figures of St George, St Francis, and Joan of Arc. It is near Marylebone Station, the London terminus of the old Great Central Railway, as it was called when it brought the Manchester, Sheffield, and Lincolnshire

line up to town at the end of last century, the last three miles leading to the station costing a million pounds a mile.

Here we are in sight of Marylebone's magnificent town hall. Its noble colonnaded front of Portland stone, looking on to Marylebone Road, has an entrance guarded by stone lions, which face each other across the great steps. The hall was designed by Sir Edwin Cooper and has a lofty clock tower.

Round about the town hall are a few remarkable churches. One (the Church of the Annunciation) can never be finished, for the land it needed was used for new streets. The lofty nave has blocked arches and blank walls, but there is a fine east window and a rich oak reredos. St Luke's hides itself from Nutford Place, showing little more than a grey tower with a pierced parapet.

The World's Most Famous Cricket Pitch

All the world knows the famous cricket ground of Lord's, now covering 12 acres of that part of Marylebone famous as St John's Wood, which has grown out of St John's Farm, once owned by the crusading knights of the Order of St John.

Lord's is the home of the Marylebone Cricket Club, which governs the game throughout the world. It is the Cricket Parliament for every pitch on which cricket is played.

One of the seats in the pavilion is a plain wooden bench used by spectators when the ground was first opened. There is a bronze bust of the cricketing Lord Harris, a collection of cricket paintings including three Hoppners, a portrait of Thomas Lord by George Morland, and a Gainsborough portrait of George the Fourth playing cricket as a boy. Among the curiosities is a bat damaged by shell-fire in France, and in a glass case is one of the great pretences, an urn for the famous Ashes, which have never been in them because they do not exist.

There is a figure of Father Time carrying off the bail on the roof of the grandstand, and on the walls of the tea-room are cricketing scenes painted by Slade School students. On the outer wall of the grounds is a striking relief of a group of sportsmen, and in the road opposite is the Marylebone Peace Memorial, a bronze of St George and the Dragon, the saint on his plunging horse bending down to pierce the writhing monster in the throat. It is a powerful and energetic group, the work of Mr Charles Hartwell, who received for it the medal of the Royal Society of Sculptors for the best work of the year in the streets of London.

Here we are by St John's Wood Church, opened the year before Waterloo and designed by Thomas Hardwick in the classic style. It has an imposing

portico and a turret decorated with round columns in which a cross shines white by night. At the entrance to the sanctuary is a beautiful Chantrey figure of a girl in draperies, and facing this is a companion sculpture with a group of three young girls who died under fifteen. On the wall by the front is a medallion bust of John Farquhar, a lowly Scot who made a fortune out of gunpowder in India and invested it so wisely at home that he became a millionaire.

In Abbey Road also is St John's Wood Synagogue, one of the most important in London, and hereabouts is the big Victorian church of St Mark's, Hamilton Terrace, with a conspicuous spire and rows of pinnacles. Five panels of the seven works of charity make up the reredos; they are by Edward Armitage.

The Great Spectacle of Oxford Street.

Selfridge's is one of the finest architectural spectacles in London, and those who never spend a penny may find enchantment here. We meet wonder at the very door, for above it is London's most wonderful clock. The doorway itself is so charming that one could wish it were not so crowded. It has a laughing company of children we should like to sit with, twenty-two bronze reliefs by Sir William Reid Dick, rising tier above tier. By the doors are bronze statues of Science and Art, Art looking at a small figure she holds in her hand, Science looking through a real magnifying glass. Let into the threshold is a fine bronze panel showing a flaming torch held by a man on a winged horse, the Pegasus of progress as imagined by our famous sculptor Gilbert Bayes. Set between the columns above this great doorway is the colossal bronze clock, a veritable museum piece among clocks, with sculptural decoration overlaid with gold and inlaid with mosaic and faience. It is an impressive conception, with a ship's prow hewn from a 15-ton block of stone supporting a decorated group of two mermaids holding moons (to represent the tides) and looking up to the Queen of Time, a majestic figure in flowing draperies of blue and gold, with wings outspread, one hand upraised and in the other a tiny figure standing on a globe. She bears on her shoulders an immense clock in the form of a globe with thousands of many-coloured beads set in its two glass dials, and crowning the clock is a little model of a fourteenth century merchant ship, its main mast reaching 24 feet high above the feet of the Queen of Time. Two winged figures beat out with a hammer the passing hours.

The bronze in this great group weighs over seven tons. The hour bell alone weighs three tons, and there is engraved round it: 'Look to this day, for it is life: such is the salutation of the Dawn,' and a Latin inscription which

means that the hours pass and are charged against us. The dials of the clock are opaque by day but partly translucent by night, when the whole group is floodlit with an amber glow.

Orchard House, another notable commercial building, next to Selfridge's, has on its walls a merry collection of keystones designed by the architects of the fine Melbourne House in the Strand. They are a miniature Wonderland in stone, and among the characters vividly represented are the White Knight, the White Rabbit, the Red Queen, the Walrus, and the Carpenter, a second little Zoo for our famous Zoo borough.

The Beauty of Regent's Park

It is a glorious park, 450 acres of beauty maintained by the Government. It has an Outer Circle two miles round, a triangular lake studded with tiny islands, an island rock garden, and an avenue of flowering cherries, a garden of 11,000 rose trees, pastoral scenes that make us feel a hundred miles from London, and a canal meandering through shrubs and trees. On Whit Monday great crowds come to see the cart-horse parade, but it is for its quiet and its beauty, not for parades, that the people love the park. It is hoped that herons may set up housekeeping here some day, for they have been often seen. A hawk has been seen to swoop down and seize a sparrow, and another hawk was mobbed by gulls as it flew across the lawns. The kingfisher has flashed its magic blue on the canal. Robins, thrushes, blue tits, greenfinches, and gulls are regular attendants, and larks and linnets come in parties. Wheatears and redwings, teal and swallows, blackbirds and carrion crow, wagtails and jays, swifts and martins, and even the great spotted woodpecker, come every year. Fifty larks have been seen at one time on the football field, but an even more delightful sight has been seen a thousand times on summer evenings, the Open Air Theatre on the sloping green sward.

There are charming houses facing the Outer Circle, one of them the famous St Dunstan's, designed by Decimus Burton who laid out Hyde Park. It is the house with the little turret in the middle, and it takes its name from the famous clock of St Dunstan's Church in Fleet Street, which after a long stay here has gone back to the City where its two Jacks strike the hour. Everyone knows the almost incredible work done by St Dunstan's in training blind soldiers and sailors to make their way in the world. Over 2,000 of them have been trained here, enabling them to take up civil life, and though the hostel has changed its address and the office has gone to a spot near St John's Lodge in the Inner Circle, the work is carried on. St John's Lodge now houses the Institute of Archaeology, part of London University. Its grounds are open to

the public and there is a delightful rose garden with a bronze statue 'to all protectors of the defenceless.' It is the figure of a goatherd's daughter with a young goat under her arm, and the sculptor was awarded the silver medal for it on its exhibition at the Royal Academy. In the rose garden is a lily pool with a bronze statue of Hylas, a handsome youth beloved by Hercules; we see him about to be drawn into the depths by a mermaid.

The World's Biggest Wild Beast Show

One place of worldwide fame has its home in this great park; it is the Zoo. We can reach it by the Broad Walk, bordered with flowers and a double avenue, one of fine chestnuts and one of elms. Any fine afternoon we can ride on elephants, camels, llamas, and Shetland ponies, and any day we may see the animals fed.

The gardens of the Zoo are beautiful with lawns and flower beds, mostly at the southern end, bounded by the paddocks taken from Regent's Park on condition that the animals there should be seen from outside. If Piccadilly Circus is the Scotsman's Kinema, this is the Scotsman's Zoo, where without paying we may see llamas, yaks, kangaroos, wild boars, and wallabies, with the raccoon washing its food before it eats it.

The north section of the Zoo is joined to the south by tunnels under the Outer Circle Road, and is traversed by a pretty length of Regent's Canal running in a deep grassy cutting after emerging from a tunnel over a thousand feet long. The main entrance is by the green tiled colonnade opposite a delightful rock garden where grass snakes swim in the waters and adders and lizards sun themselves among the flowers. Near by is a giant tortoise that has been in captivity for eighty years and may easily live another twenty. He is not far from the Pets Corner, an enclosure where we may handle tame animals and be photographed with a lion cub, a baby python, a yak, or a chimp. Here every fine afternoon in summer is seen one of the most remarkable sights in London, the Chimpanzee Tea Party, at which the young chimpanzees sit at table on their chairs.

The Marvellous Aquarium

About 150 yards long, with 60,000 gallons of fresh water and 120,000 gallons of sea water always circulating, the Aquarium has hundreds of wonderful creatures which we see under their natural conditions. We see the hideous octopus, the hermit crab sitting in the empty shell of a sea snail, the sea cows which led our sailors to begin to talk of mermaids, the catfish whose transparent body shows us all its bones, the electric eels that give out powerful shocks, the Chinese paradise fish like a rainbow, and the almost incredibly beautiful little angel fish.

The Reptile House is the finest in the world, designed by Sir Guy Dawber. Its cages are decorated with natural scenery, and those animals requiring it have artificial sunlight. We may see crocodiles basking as by their native Nile, and dragons from the Dutch East Indies shooting out their tongues.

On the Pond of Three Islands we see flamingoes feed, and on Ant Island are British wood ants making nests of pine needles, with dozens of glow-worms about them on summer nights. The Children's Zoo grows daily more popular. The first studio of animal art in the world has just been built, and it has a kinema where Zoo films are shown.

St Pancras

From Oxford Street to Ken Wood

All the world knows St Pancras, but who outside these four square miles of North London remembers that St Pancras is also – Highgate!

Every Londoner knows St Pancras Station, with its clock tower 80 yards high, for half a century the terminus of the old Midland Railway. Its huge curved roof is perhaps the biggest in the world without supporting pillars, more than two acres of glass covering eighty yards in a single span. Stretching for 200 yards along the station front is the Midland Hotel, with pinnacled towers, iron balconies, and rows of pointed windows.

Leaving the station we face the most important municipal building in St Pancras, the new town hall built at a cost of a quarter of a million pounds, its front dignified with two porticoes and rows of columns.

Next to the LMS station is the King's Cross terminus of the old Great Northern and now the LNER; it was built in the middle of the nineteenth

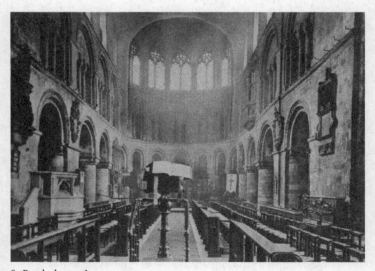

St Bartholomew's

century, and covers 45 acres. The clock in the turret over the front is the one used at the Great Exhibition of 1851.

From King's Cross runs Gray's Inn Road on its way to Holborn, its most important building the Royal Free Hospital, founded nearly a century ago for poor people without letters of recommendation. It was the first hospital in the kingdom to admit women students, and now consists of an old gabled block of buildings with a magnificent new dental clinic given by Mr Eastman of New York.

At the back of a gravel courtyard on the same side of the road is the dull-looking church of St Bartholomew, built a few years before Waterloo by admirers of the coalheaver preacher and impostor, William Huntington.

The broad and straight Euston Road runs from King's Cross to the other side of the borough. Its most striking building is St Pancras Church, the best known work of William Inwood, who lies in the family vault beneath the building. It is very imposing, built in 1820 with porticoes modelled on the Erechtheum, the famous little temple on the Acropolis at Athens. Athenian, too, is the wedding cake tower (165 feet high) supported by pillars, for it is modelled on the Temple of the Winds set up by Pericles, in whose Golden Age the Greeks rebuilt the Acropolis and set up its temples.

The western portico of the church, supported by six fluted pillars, shelters three huge doorways ornamented with rosettes, but far more remarkable are the eastern porticoes, which stand like little copies of the Erechtheum, held up by colossal terracotta figures (caryatids), holding ewers and torches. They guard the entrance to the vaults beneath the church. The massive marble columns round the inside of the apse are copied from the Temple of Minerva. The wood of the handsome pulpit and reading desk came from Essex, made from the famous Fairlop Oak of Hainault Forest, which was blown down in 1820 after long giving shelter to an annual Eastertide fair. The pulpit is raised high on four fluted columns, and is carved with scrolls of foliage.

On the other side of the road is a bronze statue of Edward the Seventh as a Field-Marshal, a scroll in his right hand, and his left on a sword. He is looking benevolently down on the passers-by, and stands in front of a friendly society's building, which he opened with Queen Alexandra. Behind some iron railings near by are the modest premises of the Elizabeth Garrett Anderson Hospital for women and children. It is entirely staffed by lady doctors, and from it has spread the worldwide recognition of medical women.

The Great House of the Friends

The finest building in Euston Road, and one of the best in London, is the impressive headquarters of the Quakers, which has been called one of the most effective architectural creations of our time.

In its dignified simplicity it symbolises the life of the Quakers. It has a stately portico, and a long frontage of stone and purple-grey Luton brick.

In the library is the biggest collection of books in existence about Quakers, and it is especially rich in seventeenth century manuscripts. Here is a bronze bust of George Fox, the founder of the Friends, showing him as a stern-faced man with his hair falling over his shoulders. With his bust is a bronze statuette of John Bright, with hand outstretched as he was so often seen on the platform; it is by Sir Hamo Thornycroft. Another bust, given by the Polish Government to a Quaker in gratitude for relief work, is a delightful bronze of The Sower.

The Marvellous Work of Sir Henry Wellcome

It is fitting that the next-door neighbour to Friends House should be another great building enshrined with the spirit of the Friends; it is the magnificent home of the Wellcome Research Foundation. It is not on the same scale of grandeur as the Rockefeller Foundation, but it has the same noble aim. This magnificent building houses the various research laboratories and museums established by Sir Henry Wellcome. To all the world he was Burroughs and Wellcome, but to very few was the full extent of his generosity known. He founded laboratories at Beckenham and at Esher. He started a historical medical museum, and at length he realised his dream of building this great institute in Euston Road. With the exception of some Italian marble it is British Empire material throughout, but it is built to serve all mankind. On the Euston Road front there are twelve massive columns, the four central ones standing free, crowned by a pediment behind which rises a tower thrown back 30 feet.

It has a collection of relics of Jenner, the founder of vaccination, and of Lister, the father of modern clean surgery. A portion of the original Lister Ward where Lister practised at the Glasgow Infirmary has been reconstructed and fitted up here. In these rooms is told the tale of surgery and medicine from the days of savage medicine men and of amulets and talismans to modern times. The methods of the old alchemists are shown in one room, the microscopes, the ophthalmoscope, the acoustic instruments in another; and the collections are supplemented with many portraits and manuscripts.

The old Euston Square still remains, giving a green approach to the station for the North, and giving sanctuary to Marochetti's frock-coated statue of

Robert Stephenson, Behind the statue is an obelisk unveiled by Lord Haig to the 3,719 men of the London and North Western who fell in the war, of whom three won the VC and 950 gained honours. At the base are four bronze figures with bowed heads and reversed arms, representing the Navy, the Air Force, the Infantry, and the Artillery.

Standing some way back on the other side of Euston Road is a line of delightful squares. The first of them, Cartwright Crescent, takes its name from the bronze statue of John Cartwright, the vigorous reformer who died in one of the houses near by. The sculpture is the best work of George Clarke, the Birmingham Chantrey, and shows Cartwright sitting in a chair speaking from notes.

The neighbouring Tavistock Square has a monument to Louisa Aldrich-Blake, the famous pioneer of woman doctors, and a devoted worker among the local poor.

Opposite is the Jews College, a splendid modern building where ministers are trained for the Orthodox Synagogue. The house is also a communal centre, and the Jewish Peace Memorial Library is here. On an upper floor is the museum, with a collection devoted to Anglo-Jewish objects.

The Cathedral of Gordon Square

A few doors away is the lofty Catholic Apostolic Cathedral built by the followers of another Presbyterian minister. It has the misfortune, which Westminster Cathedral shares with it, of being too mixed up with houses, but, entering by a cloister from Gordon Square, we find ourselves in a cathedral indeed, a soaring wonder in carved stone, with triforium and clerestory rising 90 feet high, only 13 feet short of the highest nave in England.

It is a stately place, with clustered columns rising in splendour to a hammerbeam roof, the capitals delicately chiselled and the pointed arches decorated with thousands of tiny carvings. Most of the decoration is a copy of some existing medieval work in England.

The corbels (many of impressive size) are of very great beauty. Some represent the works of Creation, fashioned into wheat and trees, sun, moon, and stars, fishes and eagles, the lion and the lamb, and Adam and Eve; Eve is a gem. The corbels in the choir are singers and players, among them King David with his harp and Cecilia playing her organ. The base of the altar is of Derbyshire marble in which fossil shell fish are visible; the altar itself is of Derbyshire alabaster capped with white marble, and on it rests a lovely oak tabernacle ten feet high, a beautiful piece of workmanship with small panels carved and divided by buttresses and all the raised work covered in

gold. In four gables set between the pinnacles are four doves, and above these gables rise tiers of sixteen angels and rich tracery. What is called the Angel's Throne is a lovely canopied seat with a high spire, a fitting throne for the bishop. The stone pulpit has a carved bracket of much splendour, with sculptured panels of Bible scenes and a delicately decorated canopy with beautiful cresting. Behind the altar is a stone arch of beautiful tracery work opening into the English chapel, along the walls of which run canopied seats and small sculptured heads. Three of the seats are wonderfully carved with ivy and berries. There are twelve lancet windows in the chapel, with portraits of men famous in Church history, from Thomas Becket to Jeremy Taylor.

The noblest window in the cathedral is the one in the transept, with two tiers of triple lancets and a rose window at the head. The rose has eighty-five compartments, in which are angels trumpeting to all quarters of the universe, the Tree of Life with twelve kinds of fruit growing on it, the colours of the rainbow round the throne on which Christ sits as King, the apostles and cherubim, Solomon with his temple, Elijah with his mantle, and Adam and Eve with pick and spade and distaff. In the lancets below the rose window is a conception of the earth from which humanity has risen to greet the King of Glory, and we see various types of mankind rising to where seven archangels are trumpeting – the scholar in his robes, the navigator with his compass, a king putting off his crown, a group of children from many lands, a missionary bringing coloured men, rich man, poor man, and a mother with her children. From east to west the Cathedral of Bloomsbury, as this place has been called, is 57 yards, and all its work in wood and stone is worthy of a cathedral.

Jeremy Bentham in His Glass Case

Round the corner from the little known Cathedral of Bloomsbury is the beginning of the vast University of London now rising in Bloomsbury a few streets beyond the St Pancras border. This fine classical building, the first structure of the University now being crowned with the vast temple of learning rising close by, is the work of William Wilkins, architect of the National Gallery, and the grand portico raised high on steps overlooks a wide courtyard. In the great hall beneath the dome is the Flaxman Gallery, with many of Flaxman's drawings and a notable collection of casts from his clay models. We can also see the heroic group of Michael Vanquishing Satan, the restoration of the Farnese Hercules, and Flaxman's Shield of Achilles. There are reliefs round the walls, and in another room is a collection of prints, drawings, and etchings. In a cupboard is the skeleton of Jeremy Bentham, one of the founders of the University who died over 100 years ago

and left his body for dissection. Dressed in his clothes, he sits in his glass case in the library, receiving visitors on special occasions, an extraordinary spectacle.

On the outer wall of the engineering laboratory, facing the street, is a bronze relief showing a fine-faced Cornishman of powerful brain, with a primitive steam engine. The inscription tells us that 'Close to this place Richard Trevithick, pioneer of high pressure steam, ran in the year 1808 the first steam locomotive to draw passengers.' The relief was set up in 1933, the centenary of Trevithick's death, in poverty at Dartford.

Across the road is University College Hospital, with balconied wings radiating from a central tower. The hospital was rebuilt on this striking plan at the beginning of the present century, having received a gift of £200,000 from Sir John Blundell Maple, head of the famous furniture shop hereabouts. Imposing new buildings have since been erected with over a million pounds given by the Rockefeller Foundation.

In Tottenham Court Road is Whitefield's Tabernacle, the modern successor of the chapel built here by George Whitefield, the famous evangelist who toured England with John Wesley. It is a great building with an east window of unusual and elaborate tracery, flanked by two turrets with tall balustrades. Within are the original communion table, chair, and writing table, together with Whitefield's own pulpit, from which John Wesley preached his friend's funeral sermon.

Near by is the Scala Theatre, home of amateur dramatic performances, and at the end of the street is Fitzroy Square, still with some of the big houses the brothers Adam designed for it. More old houses in imposing terraces flank the eastern edge of Regent's Park, and behind them runs Albany Street, with its ancient classical church. Albany Street has cavalry barracks, appropriately near to Cumberland Market, the chief London mart for hay and straw, removed from Haymarket in the time of George the Fourth.

In his reign St Katharine's Hospital moved from the Tower, the site being required for St Katharine Dock. It is now situated in a delightful position on the edge of Regent's Park, the new buildings being designed by Ambrose Poynter, the pupil of John Nash, builder of old Regent Street. The hospital buildings are placed round a grassy courtyard, with the chapel at the back, its high west window flanked by two slender eight-sided towers. The wonderful fittings were brought from the old hospital, and form some of the most remarkable old work to be seen in St Pancras. Perhaps most notable among them all is the richly-carved oak pulpit given 300 years ago by Sir Julius Caesar, the judge whose lovely travelling library is in the British Museum.

The altar has three traceried panels 600 years old, while at the other end of the chapel is a group of five medieval wood carvings representing an angel choir.

There are some elaborately carved chairs of the sixteenth and seventeenth centuries, but much more remarkable are the rows of fourteenth century stalls with vaulted canopies, traceried fronts, and carved arm-rests. They show a wealth of odd beasts, mitred heads, angels, foliage, vines, and sunflowers, while carved beneath the tip-up seats is a remarkable series of odd scenes: the elephant and castle, a hawk pouncing on a duck, a lion standing on a dragon, a wyvern hiding among foliage, and a woman riding a man-headed beast.

On an elaborately canopied stone altar tomb lie three alabaster figures looking up at a beautiful traceried ceiling with floral bosses. One is of John Holland, the Duke of Exeter who entered Paris in triumph with Henry the Fifth. He is wearing a coronet and a long cloak, his feet on a lion and his head on a crowned helm. Beside him lie his wives, faintly smiling, with dogs at their feet and angels supporting their heads. The big spandrels of the canopy are carved with angels blowing trumpets, while the little spandrels show censing angels, foliage, and doves. On the eastern side of the arch appear swans, a monkey, and a fox, and on the other side are reliefs of stag-hunting, hare-coursing, and a fox being hanged by a goose. On a stone fastened to the wall is a gilt copper plate engraved with a praying figure of William Cuttinge, who died in the last year of the sixteenth century.

Out of doors again we can see the oak which the famous actor Samuel Phelps planted at the bottom of Primrose Hill on the third centenary of Shakespeare's birth. It came from Windsor Forest, and perhaps feels quite at home, for even the cuckoo is heard in this green space of 60 acres. The top of the hill is nearly 220 feet above the sea, and there is a wonderful view of Harrow church.

Set in a trim garden near the bottom of the hill are the handsome russet-brick headquarters of the English Folk Dance Society, a memorial to the founder, Cecil Sharp. The finely panelled central hall has a carved Musicians Gallery, and an excellent dancing floor. Over the door in this hall are three merry carvings; Jack-in-the-Green, a figure in a dance performed by sweeps; Hobby-Horse, from another familiar folk-dance; and a scene from a mumming play. They are all painted.

We are now not far from Camden Town High Street, a busy tramway centre with a sort of Clapham Junction underground, for here are six tunnels ingeniously interlinked to facilitate through-running between our tube railways. At the end of the street Richard Cobden stands in marble, Napoleon

the Third having given most of the money for his statue because Cobden negotiated a commercial treaty with France. The great Free Trader is shown with his hand outstretched as if addressing the House of Commons.

Hereabouts is a college which several artists helped to found, the Working Men's College for which Ruskin and Rossetti were unpaid teachers. It is housed in a dignified building behind a row of pollarded limes in Crowndale Road, the new headquarters designed thirty years ago by William Douglas Caroe. Round the corner is the Royal Veterinary College, a great building with dormer windows in the roof; the Society was founded at the close of the eighteenth century, but its home is new, including an infirmary for horses, dogs, and cats, lecture theatre, laboratories, a kinema, and even a shoeing forge.

The Little Old Church and its Story

In a town with perhaps too many bricks one brick would hardly seem exciting, but in Pancras Road we came upon a brick which it is thrilling to see, for it is a Roman brick from the ruins of one of our oldest churches, the church dedicated to St Pancras by St Augustine at Canterbury. The brick is in the nave of St Pancras's little old church of St Pancras, a thirteenth century church remodelled last century in the Norman style. In front of the gallery are scrollwork panels 200 years old, and of the same age is a wooden font cover looking like a bell. On the south wall are two seventeenth century monuments, one with busts of William Platt and his wife in oval recesses divided by pilasters, the other set very high up, with a figure of Philadelphia Wollaston reclining in a curtained alcove, flanked by two women.

The old graveyard is now a beautiful public garden, a fine example which might well be copied by other London boroughs. Near the road is a lofty gabled pillar set up by Baroness Burdett-Coutts at a cost of £3,000 in memory of those whose graves have been covered up; and there is a cenotaph of Aberdeen granite set up by Cecil Rhodes to his ancestors, who were here about 200 years ago.

Hidden away in the gabled building of St Saviour's Hospital in Osnaburgh Street is another small church with a group of fine foreign woodwork. It was brought from Holland half a century ago, having been made for a monastery in Bavaria. We enter the chapel by a richly carved door set in a high screen, with lofty stalls towering up on each side. Reclining on the desks by the entrance are two figures of meditating monks in such natural attitudes that they almost startle us. They are the most restful features of a chapel where all else is like an artist's Alleluia. There are oak statues in every conceivable position, and some for which there is no room on the stalls, so that they

stand alone. They are Moses with the Law, Aaron with a censer, Abiathar the High Priest, and Saul, his enemy, playing the harp. Majestic on the chancel screen stand solemn seraphim surveying this riotous array.

Another pleasant surprise is in the graveyard garden in Camden Street, formed fifty years ago from the cemetery of St Martin-in-the-Fields.

Genius and Ne'er-do-Well

One more churchyard in Hampstead Road is now a public garden; it is at the back of St James's Church, and though their graves are unknown, we may walk about this garden feeling that we are in the presence of two artists whose names have great honour in our national collections, George Morland and John Hoppner. The church belonging to the burial-ground in which he lies was built ten years after Waterloo and has its turret hidden from the streets by a bridge linking the old and the new parts of a hospital which has set the world a unique example by banishing alcohol. It is the Temperance Hospital, and its record has been a remarkable witness to the fact that alcohol is not needed for health or for disease.

Farther up the road is one of the most remarkable buildings in London, the gigantic tobacco factory built in the style of a temple of ancient Egypt; it is Carreras. In the evening coloured lights illuminate 600 feet of frontage and by day gleams a winged solar disc, emblem of the sun god that mellows tobacco. There are two bronze cats sitting at the entrance, and above them tower a dozen massive columns ornamented with Egyptian patterns.

In Doughty Street is a plain house Charles Dickens would love to see today. In it he started his married life, and in it he lost his wife's sister Mary, an event affecting him deeply. The house is now run by the Dickens Fellowship and is one of the most interesting corners of Charles Dickens's world, a museum, a library, and a picture-gallery.

Captain Coram's Fields

North of Camden Town is Kentish Town, set between Holloway and Haverstock Hill. Its parish church was built towards the end of the eighteenth century by Wyatt, the destroying architect, but has been greatly changed and now has twin steeples, lancet windows, and a triple chancel arch in Norman style. The bowl of the old octagonal font lies in a corner.

Kentish Town has in Prince of Wales Road the handsome building of the North-Western Polytechnic, completing the chain of technical institutes now serving every part of London. In Southampton Road is the historic church of St Dominic's Priory, a lofty building with a wealth of side chapels. In a corner by the door is a thirteenth century marble column, with a piece of

stone tracery found during excavations in 1900 on the site of the Dominican monastery at Blackfriars; and let into the floor at the base of the column, its slit flush with the ground, is an offertory box, the only one of its kind we have seen, though we come upon them flush with the wall.

Not far away is All Hallows Church containing an ancient pillar. It is a lofty building by Sir Giles Scott, with the base of a column from All Hallows the Great in Thames Street as it existed before the Great Fire. The heavy buttresses without, and curious spreading capitals to the columns within, are doubtless provision for a stone-vaulted roof. Most beautiful are the three lancets of the east window, filled with harmonious glass and figures of saints.

To the north stretch Parliament Hill Fields, the glorious extension of Hampstead Heath with hundreds of acres of grassy parkland. From the top of the hill, 320 feet high, is an extensive all-round view, with the churches of Hampstead and Highgate, and the Surrey hills across the Thames. A short distance from the summit is the little artificial hill called Boadicea's Grave, now hidden in trees and undergrowth. It is 10 feet high and nearly 40 yards across, and is surrounded by a dry ditch, it is thought to be a grave of the early Bronze Age, and thus about 4,000 years old. The mound on the north side has been added in the last two centuries, and was probably formed by beacon fires.

The River Fleet rises between the Hampstead and Highgate hills, and in the eastern valley are the six Highgate Ponds originally designed to supply North London with water. Nowadays one of the ponds is used for bathing and for swimming displays; national competitions have been held here and high-divers trained here for taking part in the famous Olympic Games.

Ken Wood

North of Parliament Hill Fields lies Ken Wood, the magnificent estate of 200 acres where we may roam almost at will, all now open to the public with its fine mansion full of treasures. Nowhere else so near the heart of London can we capture the atmosphere of a private park set down in the heart of the country. Trees planted in the eighteenth century screen Ken Wood on every side, while a badger-haunted stretch of primeval forest has grown so that it completely blocks the view of the Thames. The beeches are some of the finest in England, and there are giant chestnuts and oaks worthy to keep them company. One of the woodland glades is still known as the Duelling Ground, though its traditions of hardy sportsmanship have been transferred to one of the shady ponds near by, where women bathers take to the water all the year round.

Robert Adam's Beautiful House

We enter Ken Wood under a high portico decorated with festoons and find in its most splendid room, the library, some of the finest work that Robert Adam ever did. Each pillared apse at either end forms a fitting finish to this stately salon, its curved ceiling of rich plasterwork with painted panels by Antonio Zucchi, husband of Angelica Kauffmann.

The entrance hall has another lovely ceiling, with a delicate pattern of great grace, while everywhere throughout the house are marble fireplaces and decorative details owing their beauty to Robert Adam's genius. Of furniture and china there is much to admire, and the pictures, mostly eighteenth century English portraits, are by Reynolds and Gainsborough, fifteen canvases of Reynolds exhibiting the master in every mood. The collection is unusually rich in pictures of children; it has Lawrence's little Mary Murray holding out flowers in her white dress, one of the most delightful childhood portraits ever painted. Closely rivalling it are the playful Brummell boys and the portrait of Master Philip Yorke, both by Reynolds.

Another skilful study of boyhood is that of Byron's schoolfellow Sir George Sinclair, painted by Raeburn. By Romney there is little Miss Martindale with a lamb, and his famous Lady Hamilton, spinning. Two of Gainsborough's pictures are masterpieces, his Wife of Admiral Howe, and his Lady Brisco painted nearly twenty years later, dignified and aloof, a harmony of silver and gold. In the breakfast room is Turner's impressive and early Stormy Sea, while Old Crome's Yarmouth Water Frolic is in the drawing-room. In a bedroom hangs a picture of Thetis, the sea goddess, by George Frederick Watts, and Landseer's animals look down from walls in various parts of the house.

There are also some Dutch, Flemish, and French works, Van Dyck being represented by his superb portrait of Henrietta of Lorraine. In the dining-room is the exquisite Lute Player by Jan Vermeer, one of the three pictures of this rarest of Dutch masters belonging to the English people. On an easel in the vestibule is the finest work in the collection, a picture of Rembrandt in his old age. Painted by himself, it shows him with grey hair falling from a white cap, grim, serene, and dauntless.

Wall painting is represented at Ken Wood in the kitchens, now transformed into refreshment rooms, where we can see the outdoor-views of the estate as they appeared in the eighteenth century.

Old Highgate

Highgate village has still several of its old buildings and much of its individuality, and has been famous as a healthy place since Elizabethan

days. The old part of the village gathers round the Grove, with its restful seventeenth century houses surrounding a real grove of limes and elms. By the Grove is Highgate church, designed last century by Lewis Vulliamy. The slender spire, supported by flying buttresses, is a landmark for miles, and on fine days can be seen from Gower Street. The church stands so high that the floor is level with the cross on St Paul's. The fine east window, with its subdued colour, was made in Rome, and shows Christ and the Apostles.

One of the loveliest spots in Highgate is Waterlow Park, nearly 30 acres of beautiful and undulating garden given to the public towards the end of last century by Sir Sydney Waterlow, who stands in bronze watching the people enjoying his gift, he having a top-hat and umbrella in one hand and a key in the other. The park is well wooded with fine oaks, cedars, and other trees, and has a shady pond, with two sheets of water joined by a cascade. The glasshouse has a wonderful autumnal show of chrysanthemums, and in the spring we may see the birds building their nests in an aviary. The refreshment room is in Lauderdale House, built on a terrace 300 years ago, though in the entrance hall is later work, a pilastered recess with a beautifully-carved cornice made about 1700. The overhanging gabled front of the house is supported on pillars which form a verandah, and here is kept a hollow section of what was the oldest elm in Highgate, 17 feet round the trunk, probably planted about 450 years ago.

Stretching from Highgate parish church to the bottom of the hill is perhaps the most famous resting-place in London – Highgate cemetery. It was laid out about a century ago and considered a triumph of landscape gardening. The trees obscure the view today though there are still lovely panoramas from the terraces covering the gloomy rows of catacombs. On the Lebanon Catacomb is an old and beautiful cedar of Lebanon, near by which is the tomb of Carl Nicholas Rosa, the German musician who founded the famous Carl Rosa Opera Company in England.

Chelsea

The Artist's Square Mile

Only a few lifetimes ago Chelsea was one of London's villages.

Now, still the smallest of London's riverside boroughs, it is the Artist's London, with perhaps more mellow Georgian buildings than any other corner of the capital. It covers only one square mile, with 57,000 people in it. All along its southern boundary the silvery Thames salutes its shore, and it is thus that we may come to it, arriving at Chelsea Bridge.

We are now at the military part of the borough, the home of the Pensioners whose scarlet coats are beloved by Londoners wherever they are seen. On a wall by the road is a bold bronze relief of Dragoon Guards who fell in South Africa; it has horses and men on a rocky mountainside, some scouting while one looks after the animals. This admirable bronze is from the Chelsea Studio which has produced some of London's most impressive monuments, the studio of Captain Adrian Jones, best known by his noble Peace Quadriga at Hyde Park Corner.

Up the road is the long lofty line of the Guards Barracks, twin towers guarding the entrance archway. Facing this huge building are the shady walks of Ranelagh Gardens, with a summerhouse on the raised site of the Rotunda, the scene of so many gay entertainments in the eighteenth century. There are few flowers here today, but at the end of every May these town gardens are transformed into a wealth of floral magnificence unsurpassed in any country garden in England, for it is Chelsea Flower Show.

We are near the entrance to Chelsea Hospital, the biggest building in the borough, the homely work of Sir Christopher Wren, changed in due course by Robert Adam. The hospital was founded for veterans battered in the wars, and much of the money was given by Sir Stephen Fox, who had managed the royal household in its exile. The ceremonial approach is by the avenue from King's Road entered by one of several fine gates here, but ordinary folk go in at the side, coming to the courtyard open to the river. Visitors by water once approached from this side, the main building in front of them, dormitory blocks pointing towards them, and at either end a Queen Anne house flanking the whole. Now one Queen Anne house has been made new, a bomb having demolished the original.

A colonnade runs the length of the main building, and above it rises a portico and a windowed lantern with a cupola and a gilded vane. Under

the portico is a medallion of Sir Patrick Grant. From the central saloon we mount by steps to the hall and the chapel.

The simple and beautiful chapel is panelled with Dutch oak. Between the windows rise pilasters with capitals of cherubs and foliage, and from an elaborate frieze springs the arched ceiling. The dome of the apse is covered by an eighteenth century painting of the Resurrection. Below is the imposing reredos, an arch on two pairs of fluted columns. The polished panel in the middle came from Jerusalem, and on it is the Star of Bethlehem, while flanking it are magnificent panels sculptured with festoons and capped with vases of flowers. The altar rails are of seventeenth century woodwork, the handsome organ gallery stands on eight classical columns, and the two Jacobean candlesticks are of great beauty.

The Chapel and the Pensioners

In the chapel hang many tattered flags captured from the enemy, fragments of colours from Blenheim, French eagles from Salamanca, and two pendants from a state elephant's howdah of Tippoo Sahib.

There are about 550 pensioners, and since the year before Waterloo they have used for their recreation the great dining-hall which balances the chapel on the other side of the entrance hall. It continues the impression of spacious, comfortable dignity, and has a gallery at one end, a high platform at the other, and many old tables and benches. Covering nearly the whole wall above the platform is Antonio Verrio's huge picture of Charles the Second on horseback, figures of Treason and Anarchy writhing beneath him, while Peace and Plenty stand around. The picture was finished by Henry Cook, who killed a man and fled from England, and, returning years after, restored Raphael's cartoons at Hampton Court.

Above the panelling on the walls hang other pictures, including one of the Battle of Waterloo by E. M. Ward. There are flags taken at the capture of Malta in 1800, and at the surrender of Aden. By the screen at the door is the table on which Wellington lay in state in this room for a week in 1852, when several people were killed in the crush.

In the colonnade outside, where the old men sit and dream, are many brasses, among them a spirited relief of General Torrens, seated on his charger at Inkerman, encouraging his men. In the middle of the courtyard is a bronze of Charles the Second by Grinling Gibbons, the gift of Tobias Rustat, Page of the Back Stairs, who also gave £1,000 to Chelsea Hospital. The king here wears Roman costume, and carries a laurel wreath.

In the middle of the central walk leading towards the Thames is an obelisk with the names of 250 men killed by Sikhs. The grounds, which include the

Ranelagh Gardens, are shady with avenues of elms and planes, through which once stretched ornamental but unhealthy canals.

On the other side of the Hospital is the dull-looking infirmary designed by Sir John Soane. In the basement is nearly all that remains of the old red brick mansion where Sir Robert Walpole, our first Prime Minister, lived, ruling England from here.

On the embankment at the end of Tite Street are Clock House and Swan House, Clock House with balconies and a clock, Swan House with overhanging storeys and swans on its front door.

Far back from the river stands Christ Church, with a beautifully-coloured west window including figures of Wilberforce and Shaftesbury. Wilberforce holds the chains of two kneeling black slaves, and Shaftesbury rests his hands on two poor children. The panelled porch is to Archbishop Davidson, who spent the last days of his life in this parish and worshipped in this church.

Swan Walk leads to the Thames between lovely old houses and the Chelsea Physic Garden, the oldest botanic garden in England except one. It was formed by the Apothecaries Company after the Restoration, and the formal plots in the grass are now used by the Imperial College of Science for research work and for teaching botany. There are beautiful flowering trees, and in the middle of the garden stands a stone statue by Rysbrack of Sir Hans Sloane, who gave the freehold of the garden, a condition of the gift being that the apothecaries should every year send from the garden 2,000 dried plants to the Royal Society.

Now we come to the famous Cheyne Walk, surely the most dignified and old-fashioned row of houses in England, with the trees and flowers of a narrow public garden between it and the Thames. The houses have their own front gardens, with here an almond and there a magnolia. Some have gates and railings of old iron, and some brackets for lamps and torches.

In the garden opposite is a memorial to Rossetti by the famous artist who taught him, Ford Madox Brown, a granite niche with a bronze figure of Rossetti writing, a faint smile on his bearded face.

Beyond Rossetti's home is the much-changed Don Saltero's Coffee House. Salter was valet to Sir Hans Sloane, and was nicknamed Don Saltero. He filled his house with strange and useless curiosities discarded from Sloane's great collection, and the building became a meeting-place for the wits of the time.

Carlyle's House

Few of the houses round about her home have been altered much since Queen Anne's day. Several are filled with panelling, and have spacious old

staircases with twisted balusters. But the house above all others, with a fame beyond that of architecture, is 24, where lived Thomas Carlyle; his bust on the front is by Mr Charles Voysey. The house belongs to England, for it was bought from public funds and is scheduled as a historic monument, and is visited every year by many Americans.

In the 'sunk storey,' which was the kitchen, is the well and the old pump at which he drew water. All has been restored as nearly as possible to the state in which it was when the Carlyles lived in it, quarrelled in it, were reconciled in it, and found through all the dark vicissitudes of life that love did not desert them. It is filled with the bookcases they used, and the books that were his, and the letters that were sent to him.

Round the corner of Cheyne Row was the site of the Chelsea Porcelain Factory, which in its brief existence produced porcelain such as, in design and grace and the moulding of its figures, was unsurpassed by any factory in Europe. Some of the colours of Sevres are unapproachable, but in every other respect Chelsea china was its equal. To it came Dr Johnson, who conceived the idea that he could make china as well as he could make a dictionary; but each piece of his cracked in the baking. He used to come here twice a week, his old housekeeper carrying his basket, for a day. He was made free of the factory, and when he gave up his unavailing task they presented him with a full Chelsea service, which he bequeathed to Mrs Thrale, and which is still (we think) preserved at Holland House in Kensington.

Chelsea's Old Church

Back on the Embankment is Chelsea's old church, a village church in London, unpretentious, yet with a wealth of splendid memorials and historic associations. Very lovable it is, and visited every year by people from all over the world. Except for the eastern end, all the outer walls were set up soon after the Great Fire, the nave and the tower being of that time.

We enter by the original massive door made for the tower, passing a bell set a few feet from the floor, the gift of William Ashburnham in 1679. When there was no embankment here William wandered into the river one foggy night, and just then the clock struck nine giving him his bearings for the bank, and out of thankfulness he left the money for the bell to be rung at nine every night, as it was for over a hundred years.

We can hang our hats on the eighteenth century stands at the entrance to the nave, and admire the tapering oak cover of the seventeenth century font, capped by a modern dove. It is one of the most graceful bits of woodwork in the church, and has its original gilding. The brass-bound bucket hanging

by the font was given by the choirboys, and is copied from a pail carved on a pillar in the chancel.

As old as the font are gaily-coloured window panels of Flemish glass, showing the Agony in the Garden, Paul before Felix, the mocking of Christ, and Joseph interpreting Pharaoh's dreams.

Under one of these windows are five chained books given to the church by Sir Hans Sloane, one a volume of Homilies with the signature of Sir Jonathan Trelawny, one of the Seven Bishops sent to the Tower, remembered by most of us by Hawker's famous ballad,

High up at the east end of the nave are the tattered remains of four regimental colours given to the Chelsea Volunteers about 1800. They have hung here since the year before Waterloo, and so much have they suffered by time that two of the poles are nearly bare. But an important piece of one of the standards has been preserved in a room in the tower, bearing the monogram of Queen Charlotte, wife of George the Third, who is said to have embroidered the banner herself.

The round chancel arch is only as old as the nave, but the chancel was built about 1300. In it is a pair of brass altar candlesticks and a litany desk decorated with inlaid foliage, both seventeenth century Italian. By the chancel is the lady chapel of about 1325, a plain door leading from it to the vestry being over 300 years old, while in the window over the door are yellow fragments of fourteenth century glass.

The More Chapel, made new in Sir Thomas More's day, 400 years ago, has in one of its windows the oldest glass in the church, a 600-year-old piece showing part of a kneeling saint. There are remarkable capitals on the arch between the chapel and the chancel, probably designed for Sir Thomas More by his friend Hans Holbein, when on a visit here. The western capital is carved with bundles of tapers, crossed candlesticks, a holy water vat and sprinkler, and the Gospel book, symbols of More's religious life. The other capital shows his arms and crest, and a sword crossed with a sceptre. By the south wall of the sanctuary is More's monument, an altar tomb with a vaulted canopy, a little black boy looking out of the top from a cresting of foliage. The whole tomb was renewed a century ago, and little remains of it as built by Sir Thomas for his first wife, Jane. She was buried here with the second wife, and it is thought that Margaret Roper, the faithful daughter, may lie here, though More was taken to the Tower from this very spot while singing in the choir, and his burial place is unknown.

The More Chapel has the most striking monument in the church, an altar tomb supporting three pedestals, each bearing an urn, with statues of Justice and Mercy between them. Flames issue from the flanking urns,

and on the tall one in the middle perches an eagle on a nest. On the central pedestal is a medallion portrait of Sir Robert Stanley, who died 300 years ago, his curly wig falling over his shoulders. With him are medallions of his children, Ferdinand and Henrietta, the smiling girl wearing the eagle crest of the family in a locket round her neck.

On the inner wall of the chapel is a brass of Sir Robert's father-in-law (Sir Arthur Gorges), kneeling in armour at a table with his wife, long drapery reaching from her headdress to the ground. Behind them kneel six sons in cloaks, and five daughters in flowing gowns.

In one corner of the chapel is all that remains of the altar tomb of Jane Guildford, Duchess of Northumberland, who died in the middle of the sixteenth century. The canopy has four bays of fan-traceried vaulting, and under it are kneeling brass figures of the duchess, in a heraldic mantle, with her five daughters, of whom Mary became the mother of Sir Philip Sydney. The names of the girls are engraved above the figures.

A tomb of great interest in Chelsea has over it, high on the wall above the women's stone, a 400-year-old tilting helmet, with a wooden eagle's head perched on the top. Near the end of Elizabeth's reign it was carried in the funeral procession of Lord Dacre of the South, whose tomb by Nicholas Johnson, with rich marble and gilding, is the most gorgeous in the church. Under its canopy lie stately marble figures of Lord and Lady Dacre, tranquil amid all this magnificence. Lord Dacre wears armour, and both have dogs at their feet.

There are fine iron railings round another striking tomb on the other side of the nave, a lofty monument of rich marble to Lady Jane Cheyne, who died three years after the Great Fire. It is one of the most notable tombs ever made abroad for England, and it came in eighteen packing cases from Rome, where it was designed by the son of Paolo Bernini, the world-famous sculptor. Reclining on the tomb in a recess is the figure of Lady Cheyne in a long flowing garment, reading a book. Chelsea knows her because she gave the roof of the nave to Chelsea church, but all England knows her as the heroic defender of Welbeck Abbey against the Roundheads. She lived here in the manor house built by Henry the Eighth, and Cheyne Walk is called after her husband, while her son built Cheyne Row.

In a niche kneels Ursula Hungerford with her husband Thomas, who served Henry the Eighth and all his reigning children. Both wear ruffs, and behind them kneel two sons and one daughter. The monument is by Gerard Janssen, the Flemish sculptor who made Shakespeare's bust for his grave at Stratford.

In the opening leading from the chancel to the Lawrence Chapel is a monument like a Roman triumphal arch, thought to be the only one of

its kind in England. It is ornamented with strapwork and fluting, and is to Richard Gervoise, of Tudor days. The most striking monument in the Lawrence Chapel is an alabaster and marble memorial with a shrouded figure of Sara Colville rising with outstretched hands from her black coffin, clouds and stars carved on the canopy. This is one of the finest figures of its date in England, and is by John and Matthias Christmas. Sara was the eldest daughter of Sir John Lawrence, whose massive monument partly blocks the east window of this chapel.

It is an open pavilion, four round arches disclosing an urn entwined with serpents. It is of great dignity, and is the work of Joseph Wilton.

The Crosby Hall that Shakespeare Knew

The oldest house in Chelsea is its newest important possession, Crosby Hall, now on the Embankment as part of an international hostel and club for women graduates.

Humbly withdrawing itself is the little house from which Turner was carried to his grave in St Paul's; it is marked by a lead tablet designed by Walter Crane, but is easily recognised by the railing Turner erected on the roof so that he might paint the sunset.

From Turner and his sunsets we come to the great symbol of our Electric Age, the power house in Lots Road. The biggest in London when it was built, it is 150 yards long, and its four round chimneys, 275 feet high, are known to all Londoners. The annual output of the station is 425 million watts.

Chelsea Creek forms the borough boundary, but just beyond the railway in Fulham, almost in the shadow of the great gasholders, is a charming old manor with a Queen Anne doorway. It can be seen by permission, and has a square wainscoted hall and an old staircase railed with wide-pitched balusters and ball-head pillars.

Across King's Road from this old manor house is Stanley House, set up about 1700 and now occupied by the principal of St Mark's College for Schoolmasters.

Back towards London, at the corner of Church Street, is the old rectory, its tranquillity assured by a high brick wall. It is as old as Stanley House, but has been partly made new early in our own time. The lawn has great trees, and there is a stately mulberry said to have been planted by Queen Elizabeth. Wellington sat under it when he visited his clergyman brother here.

After the long narrow garden of Carlyle Square we look down another turning to the round pillared porch of the public library, which has a fine collection of pictures of Chelsea, replicas of the figures of Carlyle and Rossetti in Cheyne Walk, and terracotta busts of other famous residents of bygone

days. On the stairs are three bronze-coloured plaster groups by John Birnie Philip, whose studio was on the site of the library. They are original models for the reredos designed by Sir Gilbert Scott for St George's at Windsor, and portray the Ascension, with Our Lord's appearances after death on either side. On the landing is a beautiful portrait of Lady Emilia Dilke, who lived in Chelsea nearly twenty years. In the reference room is a bronze bust of Henry James, modelled from life in 1914 by Francis Derwent Wood, and presented to the library by 150 Chelsea folk. Mr Wood, the Chelsea sculptor, sculptured the Machine Gun Corps Memorial at Hyde Park Corner.

There is a big bronze bust of Carlyle, and in the museum room is his death mask, with a plaque of him as a young man by his great friend Thomas Woolner, the sculptor of the pre-Raphaelite Brotherhood. There is also (a curious exhibit) a cast of the hand of Rossetti. Here is the letter Carlyle wrote to his mother telling her that he was about to begin the French Revolution, and a visiting card of Mrs Carlyle with the address of Charles Dickens scribbled on it. One of the oldest objects in the museum is a bison's horn dug up in Sloane Square. There are relics of Cremorne Gardens, a Chelsea waterman's badge of about 1800, old pottery, and some old editions of the works of Sir Thomas More, with a magnificent volume of his Utopia printed at a private Chelsea press thirty years ago.

On the other side of the road is the twentieth century town hall, a dignified building of great beauty, a portico at both ends, and a clock projecting from a turret in the middle. In the council chamber is a portrait of William Willett, the pioneer of Daylight Saving, who, with his father, made a great reputation by building fine houses.

The magnificent great hall is decorated with splendid wall paintings introducing famous people of the past connected with Chelsea.

Facing the town hall is a street leading to St Luke's Church, the fine though somewhat austere building where Charles Dickens married Catharine Hogarth. It has a pinnacled tower, and at the east end is a pair of slender turrets. Over the aisles are rows of flying buttresses supporting a high vaulted roof. The triforium rests on rows of clustered columns, and there is a gallery with a white marble monument by Chantrey. It came from the old church, and has a relief of two officers in tight breeches and bandoliers mourning over a medallion bust of Colonel Henry Cadogan.

Sloane Square, with its paved open space and fine shops, is Chelsea's busy traffic centre, served by the borough's only station on the Underground. Standing on the platforms we can see an iron pipe spanning the rails. Overlooking a corner of the square are the twin turrets at the west end of Holy Trinity Church, a grand and lofty building with magnificent fittings. Its

finest feature is a huge east window filled with a glorious harmony of blue and red glass against a background of more sober hue. Each panel has the figure of a saint, and the whole was designed by Sir Edward Burne-Jones, who, years before, was living in Sloane Terrace when he fell in love with Georgiana, the sixteen-year-old daughter of George Macdonald.

On the wall of the side chapel is a bronze relief by Frank Pomeroy showing two weeping angels bending over a medallion of John Sedding, architect of this church.

At the back of Holy Trinity rises the Eastern-looking tower of London's first Christian Science church, reminding us that its architect obtained much of his experience in Calcutta.

Sloane Street is a broad and noble thoroughfare lined by fine houses and gardens. It skirts the eastern boundary of Chelsea, and hidden behind it is the delightful garden square of Hans Place, where is a fountain with a broken column. By the basin is a bronze medallion bust of Sir Herbert Stewart, who is buried in the desert, having died of wounds when commanding a column sent to relieve General Gordon. The bronze is the work of Sir Edgar Boehm.

Near by, in Pont Street, is the well-known Scottish church of St Columba, with a tall clock tower, a stone on the chancel wall telling us that the church was designed as a labour of love by John Anderson, president of the Royal Institute of British Architects.

Over the communion table is a mosaic of Our Lord surrounded by trumpeting angels, while the beautifully-coloured window over the entrance shows the angelic host in battle array. The brass bowl of the font was made in Iona, and has a band of interlaced work and handles fashioned as heads of beasts.

A beautiful white marble relief, the work of William Robert Colton, shows the calm face of Sarah MacNaughtan who served the Red Cross in South Africa, Belgium, and Russia.

Finsbury

Crusaders of the Bunhill Fields

It has within its borders a spot for ever sacred in the history of our race, a shabby place that should be made more beautiful. It is the little graveyard of Bunhill Fields. There is not an acre of English earth more precious than this, where we may look across the graves of four of England's matchless men, John Bunyan, Isaac Watts, Daniel Defoe, and William Blake.

John Wesley lies across the City Road in the little graveyard behind his chapel, the mother of 108,000 churches. His bronze statue is under the trees, and shows him as a kindly-looking man in flowing robes, one hand raised in exhortation and in the other his little field Bible. Much of the building is as he knew it, though by the gabled front is a porch set on its columns about the time of Waterloo. In the lobby is a bronze relief of an angel mourning for 26,000 Wesleyans who fell in the war. Along the front wall stand six pine masts from English battleships, presented to Wesley by George the Third for supporting the gallery. Between them is a fine window by Frank Salisbury, a glow of inspiring colour, with a fiery figure of Sir Galahad brandishing a sword over the shadowy forms of Envy, Jealousy, and Greed, while below are the thrilling words of Blake's Jerusalem.

In John Wesley's Chapel

The most striking thing in the chapel is John Wesley's shining mahogany pulpit resting on arches flanked by fluted pillars. The round chancel arch is original, and so are the graceful altar rails with slender balusters. The mahogany panels behind the altar were erected about Waterloo year, forming a background for the dignified chair from Wesley's first chapel, in Bristol. On the altar table is the little mahogany lectern used by Wesley at the Foundery, the disused Finsbury arsenal where he started his London services.

A window in the gallery shows Wesley preaching to the Red Indians in Georgia, and on the sunny side of the nave is another beautiful window by Frank Salisbury, in memory of the sending of the first Methodist missionaries to Australia. The window represents Spiritual Power, and shows an armoured knight with a flaming torch kneeling before a white-clad angel with outstretched arms. Near by is Mr Salisbury's magnificent window to all Methodists who fell in the war, with a figure of Christ calling a soldier and

bearing his pack on His own shoulders. Angels hold scrolls, and a wreath of oak and laurel encircles a figure of St George.

The Methodist Crusaders

On the right of the apse are marble busts of two men who worked for the church in very different spheres, James Calvert, a confident-looking apostle of Fiji, and Sir Francis Lycett with a flower in his buttonhole, a man who did much for this chapel in the Victorian Era. On the south wall is a relief by Samuel Manning showing a woman reclining under a palm tree, a tall-masted ship in the background alluding to the business interests of Lancelot Haslope, who served the Methodists as treasurer a century ago. On the same wall is a stone to three generations of Macdonalds covering 144 years, from 1784 to 1928. On the other side of the chapel is a bust of Dr Jabez Bunting, who was buried here in the middle of last century, having finally severed Methodism from the Church of England.

Dr Morley Punshon's white marble bust is on the north wall, a tribute to the five years he spent at the head of the Methodist churches in Canada. On the same wall is a bust of Dr Robert Newton, one of the most popular Methodist preachers, who travelled 7,000 miles a year, making a profound impression wherever he went. His bust is by Dr Frederick James Jobson, a fervent preacher and architect, whose own bust is in a draped niche.

Facing the sunny side of the chapel is a marble bust of Dr William Fiddian Moulton, rare for showing him with spectacles. At thirty-five he became the youngest of the men who produced the Revised Version of the New Testament. The plain eighteenth century house near the chapel was built by John Wesley and in it he lived for the last dozen years of his life.

The Parade-ground of the HAC

Hereabouts are the headquarters and the parade-ground of the Honourable Artillery Company, perhaps the oldest military organisation in the world. Thousands of troops trained on this ground for the war, and on Finsbury's peace memorial in Rosebery Avenue one of the bronze reliefs shows the HAC forcing the River Piave in boats, the other reliefs showing the naval attack on Zeebrugge, and the Finsbury Rifles attacking Gaza. Standing over all is a figure of Victory, holding the olive branch of peace and the laurel wreath of fame.

The gardens round the memorial are called Spa Green, after the fashionable Islington Spa where Londoners used to flock to drink the waters. Now water is brought to Londoners from New River Head across the road. Here is a successor of the round reservoir first filled on Michaelmas day

in 1613, when Hugh Myddelton brought water by his New River from Ware in Hertfordshire. By the pond has been set up the fourteenth century Devil's Conduit, which supplied Christ's Hospital, and round about lie some of the pipes introduced a hundred years ago, only to be found porous underpressure.

One of the Finest Rooms in London

Here now are the great offices of the Water Board, with balconies and a pierced stone tower. Two high plane trees by the steps may be nearly a century old.

In the fine pillared board room is a chairman's chair made from the wooden lining of Hugh Myddelton's round pond, but for grand woodwork we come to the Oak Room, which formed part of the Water House set up on this site at the close of the seventeenth century. It is one of the finest rooms in London, with black oak panelling and a deep, richly carved frieze running round the walls. The ceiling, richly plastered, was moved in a single piece from the old building, conveyed by a crane. In its great oval panel is a painting of the Virtues holding up a bust of William the Third, a gilded relief of fruit and flowers serving as a frame. Coloured reliefs show scenes on the New River, and some appear to represent fortifications thrown up round London against a possible invasion from France.

The magnificent overmantel of black oak is so grandly carved that it is attributed to the magic touch of Grinling Gibbons. It is flanked by a pair of fluted pillars, and its beautiful reliefs are associated with the New River and its banks. Its crayfish, waterfowl, and angler's net seem almost real, and the corn, fruit, and flowers are like a breath of the country in town.

The Water Board has a museum of exhibits connected with its work, including a tusk and huge teeth of a mammoth from the vast Queen Mary Reservoir by the Thames, in which were also found two Bronze Age urns, at least 2,500 years old. There are Roman urns from Southwark, with burnt bones found inside them, and old elm water pipes, including a fine junction pipe from Coventry Street. There is a collection of the arms used to defend the New River from the Gordon Rioters, and a steel helmet worn by a man on duty at Kew Bridge pumping station in the Great War; with it is the cap of the German bomb which killed him.

Sadlers Wells

The queer little old theatre has given place to a fine building built on clean modern lines, with a stone relief over the entrance portraying Drama. The church is a classical building put up at the end of the

eighteenth century and nearly thrown down in the twentieth by a German bomb.

St Luke's, Old Street, which has a fine organ is one of the dozen London churches which benefited from a million pounds voted by Parliament in memory of the victories of Marlborough. Its striking feature is the obelisk which forms its extraordinary spire.

The dignified interior has two rows of columns supporting a curved roof; the gallery is carved with leaves, and sweeps round to a richly-coloured Victorian window. The white font is 200 years old, and has a little round bowl on a thick stem carved with leaves. The canopied oak pulpit is carved with flowers. John Wesley to the end of his life regarded this as his parish church and preached from the pulpit; on the wall hangs a picture of him.

One of the biggest printing works in England stands close by, built in Caslon's century. It is nearly 500 feet long, with a clock turret above its central gable, and was built as an asylum. Now the printing for the Bank of England is done here; it is the home of our paper money.

Another of Finsbury's huge buildings is the parcels office at Mount Pleasant, where is the room controlling the driverless trains which run along the Post Office Tube from Paddington to Whitechapel. More imposing is the great Northampton Polytechnic Institute, designed towards the end of the Victorian Era by William Mountford. Over the doorway is a tower capped by a balustrade and a cupola, and on the wall is a bronze medallion of the kindly bearded face of William Compton, fifth Marquis of Northampton, put here by his London tenants and friends.

Elementary education is catered for in the high modern buildings of the Dame Alice Owen Schools, where about 800 boys and girls learn their lessons. The church, made new a century after he died, is a plain building with stone balustrades at the corners of the roof, urns on the parapet of the tower, and a short spire.

The plaster ceiling of the nave is like a group of flower beds. The gallery sweeps round three walls like a horseshoe, and there is even an upper gallery, unusual in a church, with a graceful iron balustrade. The Victorian pulpit is fixed high up in the iron chancel screen. Among the church's possessions is a beadle's staff of the seventeenth century, its silver cap engraved with the figures of St James and St John. A brass on the wall has the portrait of John Bell, the famous Bishop of Worcester who tried heretics for Cardinal Wolsey, helped Henry to get his divorce from Catherine, and was one of those who set him free from Anne of Cleves by declaring the marriage illegal.

The dignified Sessions House built on Clerkenwell Green last century is now in private hands; the pediment over the entrance, resting on classical

columns and bearing the Middlesex arms surrounded with foliage is by the fashionable and miserly sculptor Nollekens, who also fashioned the bust of George the Third under the cornice, and the medallions of Justice and Mercy.

The church of the Knights is in St John's Square, and outlined in cobbles on the road in front is the original round nave of the Norman church destroyed by Wat Tyler 600 years ago. It was bigger than the round nave of Temple church, and some of its foundations still exist. The stones of the nave and the tower are said to have been taken by the Protector Somerset to build his mansion in the Strand, where Somerset House now is. The existing nave represents the old chancel, and has Norman bases to its pillars and Norman stonework in its walls.

The dignified west wall overlooking the square was set up over 200 years ago, and is topped by a turret bearing the white cross of the Order, golden lions and unicorns prancing between its eight points. Over the door is a striking relief in wood, carved last century, of the Patriarch of Jerusalem, who consecrated the church in 1185.

The light and beautiful interior of the church is gay with the banners of the Order, hanging from the eighteenth century gallery under a roof of white and gold. The pulpit is oak, with inlaid panels. The oak reredos is eighteenth century. On either side of the altar are some of the most valuable treasures of the church, finely painted panels of wood from Milton Abbey in Dorset, fifteenth century Flemish work. Two scenes show the Madonna and Our Lord being presented as infants in the temple, and on the backs are paintings of the Trinity and John the Baptist. In a chapel is a Spanish picture of John the Baptist painted four centuries ago, and in the window over the altar is a little fifteenth century glass shield. The great east window with Tudor tracery has harmonious modern glass, foremost among its wealth of figures being Raymond de Puy, first Grand Master of the Order. Kept under glass is a magnificent cope made by Clerkenwell nuns; it is of gold damask, richly embroidered with sprays of St John's wort, and a panel with the Madonna and Child. On another wall is a tile on which is the name Jesus in Aramaic (the language Jesus spoke), the tile having been brought by the Knights from Jerusalem not long ago. There is also an altar frontal 400 years old, brought from Florence; it is embroidered with the Annunciation and figures of three saints.

Hallowed with the dust of knights and priors, the crypt is a fine example of Norman work. It is over 20 yards long and has five vaulted bays. Here, on a modern altar tomb, lies a sixteenth century alabaster figure from a cathedral in Spain. It is the figure of an official of the Order, sleeping peacefully in his armour, his sword in his left hand and his feet on a lion. In his right hand is

a rosary, and his mantle is thrown back to show the cross of St John on his breast. At his feet sleeps a curly-haired page in doublet and hose.

In St John Street is the church of St Peter, which stands in memory of sixty-six men and women burned at the stake in Smithfield. Its tower has statues of the martyrs in canopied niches, and there are graphic reliefs of their burning on the walls. Among the statues are Anne Askew, John Bradford, John Frith, John Philpot, John Rogers, and Thomas Tomkins. St Matthew's Church in City Road is the first church entirely designed by Sir Gilbert Scott; it has a pinnacled tower. In Exmouth Street is the Church of the Redeemer, built by John Sedding, a pupil of George Street, though its imposing campanile belongs to our own century. It has a high arched doorway and an impressive pediment leading to a spacious interior with a vaulted roof, the lofty round columns rising from walnut panelled bases. The altar is under a domed canopy with angels on its two pairs of red marble columns; the altar came from the catacombs in Rome. Above it is a lovely copy of Perugino's Madonna and Saints, and on the walls are several other copies of National Gallery pictures. The organ came from the Chapel Royal at Windsor. The church has two fonts, one extraordinarily massive in contrast with a little marble bowl from a lost church of the city.

The Charterhouse

Across Charterhouse Square, a green oasis in the greyness, an avenue leads to the gatehouse which stands on the site of the gate set up soon after 1371. Each century has left its stamp here. The oak panelled gate with its humble little wicket is the oldest part, belonging to the fifteenth century. The lions standing guard over the ancient timbers were set up a hundred years later. In the eighteenth century the gatehouse was finally altered; in the nineteenth the side door was added.

Through it we pass into the Outer Court and see on the left an empty brick arch marking the place of the old inner gateway. Before us is the creeper covered wall of the sixteenth century house of Thomas Howard, Duke of Norfolk, who turned this place into his town house. Here we see the crest of Thomas Sutton, founder of Charterhouse School, a charming device, surmounted by a greyhound – 'Sutton's hound' – which surprises us in many odd corners of Charterhouse. In painted lead, with the year 1611 plainly to be seen, it surmounts the archway which cuts the lower part of Howard House and leads into what is now known as Master's Court, a pleasant quadrangle where grow three of the fifteen mulberry trees Charterhouse is proud of.

On three sides stand the buildings of Howard House, disguised by a

brick facing, and on the fourth is the grand old guest house which Norfolk enriched. We can see on the roof the little erection through which smoke escaped when fires were built in the middle of the floor.

We enter the chapel by a cloister of six seventeenth century arches, now filled in with glass, where cluster precious memorials of scholars of Charterhouse, a curious medley. Among the names are those of Thackeray, Steele, Addison, Lovelace, and Wesley.

At the far end of the cloister is a seventeenth century ornamented doorway with an inscription to Nicholas Man, Master of Charterhouse, set in the decorated cornice. Beneath this heavy ornament a simple sixteenth century door, of oak studded with nails, swings open and admits us to the little ante-chapel built in 1512, where the lay brothers used to sing. It is panelled with sixteenth century oak. In each corner is a corbel of an angel from which the vaulted roof springs.

The most delightful thing in the chapel is the tomb of Thomas Sutton. Enclosed in railings already old when it was built, the tomb is a marvellous mixture of floridness and formality. The lifelike coloured figure of Thomas Sutton, bearded and ruffed, the head on a crimson pillow, lies on its marble couch under a canopy supported by four pillars with gilded capitals. The figures hold a tablet telling the story of his life, and above the canopy is a relief showing eighty brothers listening to a sermon.

By the relief stand curious symbolical figures. There are three meaning Faith, Hope, and Charity, two representing Labour and Rest, and two others which may mean Plenty and Want. The crest of Sutton on a large scale surmounts the monument; and three of Sutton's hounds stand on the grille.

High on the wall is another little monument by Stone, in memory of Sutton's executor John Law. It shows John kneeling in ruff and gown before an open Bible. Strange little panels make a frame for the small figure.

Much of the old carving remains. There is the organ screen, of oak, resting on four posts richly carved, and everywhere rich ornamentation, showing musical instruments and odd trophies of arms.

Over the doorway leading from the ante-chapel is a memorial showing the solemn figure of Francis Beaumont, Master from 1617 to 1634; and near him are two fine memorials: Lord Chief Justice Ellenborough by Chantrey, a fine, dignified figure in judge's robes, and Matthew Raine by Flaxman. He was a Master, and the sculptor has shown two marble classical figures guarding a tablet telling the story of his life. In the vestry is an exquisite fragment of the fourteenth century tomb of Edward Mannay, the monastery's founder, still showing the colouring of vermilion and blue.

Lambeth

River Gate of London Town

Thousands of Londoners have yet to receive the surprise of a first walk over Lambeth Bridge. The bridge itself has the dignity of simplicity, the sense of a fine solid piece of work as we walk across it. Its lamps are beautiful carried on latticework above the parapet, and at each end of the bridge are impressive columns crowned with golden pineapples There are five steel arches over the river (one 53 yards long), set in graceful curves on concrete piers, bearing a road 750 feet long.

The bridge breaks into one of the quietest and best of all the walks by the river, the half-forgotten Albert Embankment which runs for a mile from the Lambeth side of Westminster Bridge. On one side rise the towers of Parliament, and on the other the seven turreted blocks of St Thomas's Hospital, reaching for 570 yards from end to end. The hospital stands on land reclaimed from the marshes, its beginnings lying far back in the ancient story of the monks of Southwark who set up a hospital farther down the Thames 700 years ago. From it has grown St Thomas's in its superb position

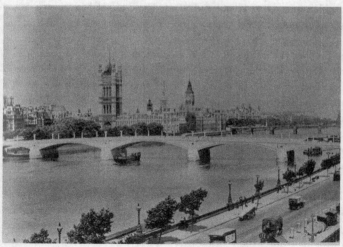

Lambeth Bridge

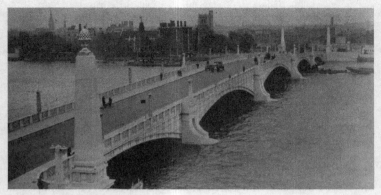

Lambeth Bridge and Lambeth Place

at the foot of Westminster Bridge, seven blocks with 100 beds in each, and a noble record of service to 100,000 people every year. The hospital has a little group of sculpture of much interest. There is a delightful bronze figure of Edward the Sixth in the middle of a grassy courtyard, showing him with his hand held out and the crown on a cushion behind him. Another figure of Edward the Sixth is on the terrace against the centre wall. There is a marble statue by Grinling Gibbons in the courtyard of the Medical School showing Sir Robert Clayton, a lord mayor benefactor of the hospital, who wears a long wig as in the seventeenth century. At the steps of the main entrance are four charming little stone figures of sick people coming for help; they are from the old hospital, carved in the seventeenth century, showing a woman with her arm in a sling, a man with a wooden leg, and so on.

The New Riverside

Lambeth's bridges are Waterloo, Westminster, Lambeth, and Vauxhall, and the Charing Cross Railway Bridge with a footpath along it, and the river front is rapidly transforming itself into a spectacle worthy of its unique position. With the new Waterloo Bridge, designed by Sir Giles Scott, and the new embankment that must one day link it with County Hall and Westminster Bridge, Lambeth's river front will have a line of architectural dignity to match the other side. Beyond the County Hall is the familiar group of the hospital, the walls and towers of Lambeth Palace, and the great new buildings rising on the Albert Embankment as far as Vauxhall Bridge.

Here are the headquarters of London's Fire Brigade, with a dignified front and a remarkable spectacle of balconies at the back where spectators may

watch the drill. The building, ten storeys high, covers square feet and cost £300,000. It has a tower used for drilling, rising 100 feet high, and on the riverside is a pier for fire- floats. The building is decorated with effective reliefs. Over the main entrance, against a background of golden mosaic, is a pair of galleys, with two mermaids squirting water at each other, a chariot drawn by three horses, and a phoenix. Over one door is a relief of men with ladders at a burning house, and at the other side is a relief of a woman sitting between the Houses of Parliament and St Paul's, with a fire-escape in each hand and flames lapping about her feet. The reliefs are very fine.

In the entrance hall stands a memorial sculptured by Gilbert Bayes in memory of the officers and men of the Fire Brigade who have died on duty. It has a central panel with a fire-fighting scene, and above it a group of an old horse fire-engine and escape. To the right and left of this centrepiece are the lists of names on illuminated vellum, and in front of the memorial is a circular mosaic illustrating the Great Fire of London.

The organisation controlled from this great station embraces sixty fire brigades on land and three on the river, with a staff of nearly 2,000 men. There are over 1,700 fire alarms in the streets, and the Fire Brigade has more than 50 miles of hose.

The firemen have a small museum, the purpose of which is to make it possible to trace the history of the Fire Brigade from the days when it was maintained by the insurance companies till now, when it deals with about 6,000 fires every year and receives 3,000 false calls. It is immensely to its credit that less than fifty of these fires are allowed to become serious. In the museum are some very old fire engines, one which used to be pulled by a donkey, old leather hoses, water-mains fashioned from hollow tree trunks, and an array of helmets in memory of men who have lost their lives at fires.

The high and slender chimney farther up the river is at the Doulton Pottery Works, and just beyond it we are at Vauxhall Bridge, the first bridge in London to carry trams. It is built of steel, taking the place of the first iron bridge across the Thames, and it has eight colossal bronze statues by Alfred Drury and F. W. Pomeroy; they are draped women representing the Arts and Sciences. In the mean streets hereabouts is a remarkable bridge which perhaps few people have seen, carrying the main line from Waterloo over Miles Street; it is a skew arch built of nearly a hundred thousand bricks in less than two days and two nights.

County Hall is a severe building of immense strength, with she groups of sculpture by Ernest Cole above windows in the lofty bays of the original building, and more modern groups by Alfred Hardiman on the more recent

addition. Mr Cole's groups show crouching figures supporting a globe, a man and a woman carrying helpless figures, an ancient Briton wielding a bow, and symbolical figures of man's wealth and progress. Mr Hardiman has suggested the care of grown men and women for the child.

London's Parliament House

We may pass from Westminster Bridge into County Hall under arches reminding us of Egyptian pylons, but the main entrance is in Belvedere Road, where we come by bronze doors into a fine entrance hall lined with Roman marble, with fireplaces at each end given to London by the Italian Government. Out of this hall we reach the long central corridor, its panelling beginning with Austrian oak but finishing with English oak, the change brought about by the war. The grand staircase, flanked by shining columns, leads us to the Council Chamber, with a pair of malachite vases at the door which belonged to Tsar Alexander the Second. The chamber is shaped like an octagon and is magnificent.

Above this chair made of timber from beneath our feet rise noble columns fashioned from single pieces of marble from the Alps. In a glass case is the trowel with which George the Fifth laid the first stone of County Hall two years before the war, and with it are the mallet and the spirit-level he used, and the key with which he opened the door of this chamber ten years later.

A little way down the busy road from County Hall, at the point where the streets divide with St George's Cathedral on the left and the Oval on the right, is one of the most interesting Tube stations and one of the most interesting Nonconformist churches. The station was the original south terminus of the Bakerloo Railway; we remember riding long ago on the shield as it bored the tunnel – an astonishing thing it seemed to Londoners then. Today it has a training school for Underground railwaymen, and there is a model track for the signal school with actual brake equipment for teaching drivers. It is a fitting site for it, for there stood here through most of last century, as a bronze inscription tells us, the works of a famous engineering firm from which came many engineers of renown; they built the early engines for the London and Blackwall Railway, and made the machines for the first iron steamer on the Thames.

Christ Church across the road (Christ Church Congregational) is interesting for having stars and stripes in its lofty spire. Half the cost of the tower was borne by Americans, and the memorial stone was laid by the American minister here at the Court of St James's. The interior of the church is octagonal and has tall pointed arches. The alabaster pulpit presented to

Newman Hall is inlaid with ornamental stones gathered by him on his travels, and set in the middle of them all is a crystal from Mars Hill, where Paul preached to the men of Athens. By the pulpit is a bust of Dr Hall, and near it is a beautiful table inlaid with pieces of marble picked up in Rome. There is also a bronze relief of Dr Hall's successor, Dr F. B. Meyer. In what is called the Livingstone Room is a curious possession for a church, a collection of moths and beetles made by Livingstone in the forests of Central Africa, and there is also a cross made from the tree under which Livingstone's heart is buried.

The Old Vic lies in the densely peopled district round Waterloo reached by Lower Marsh, where is one of the most characteristic street markets in London. Above the box office is a bronze relief of Samuel Morley, who in his day was a benefactor of many worthy causes, and is here because the Old Vic was bought by subscription as a memorial to him.

Up the road hereabouts is the Union Jack Club, its front decorated with little domes, and over the door a figure of Britannia offering a laurel wreath. It is a soldier's club started as a memorial to those who fell in the South African War, and over a million men slept in it during the Great War. There is a military association also in St John's Church close by, for it commemorates the Battle of Waterloo. It is a lofty square building with a classical portico capped with carved wreaths. We are struck on entering by the imposing canopy over the altar, with six silver candlesticks soaring upwards. At the back is a fine east window of the Crucifixion on a striking purple background.

By the door is an eighteenth century marble font from Italy, an elaborate and beautiful piece of work with flying cherubs on the sides. The organ, on which Mendelssohn played, is in the gallery above. In a corner of the gallery, in memory of Thomas Lett, a muchloved magistrate, is a statue of Justice. The churchyard is a public garden.

In Stamford Street close by is Cornwall House, the GHQ of the London Telephones. Every year the system controlled from here deals with over a thousand million calls, coming through the 257 London exchanges and handled by about 12,000 operators.

Waterloo

We are now at Waterloo Station, having rambled along the mean streets which cluster by the riverside between Westminster and Waterloo Bridges. This great station, opened when the Victorian Era was ten years old, has been transformed this century at a cost of two million pounds, and is now the biggest railway terminus in the country, with twenty-five platforms

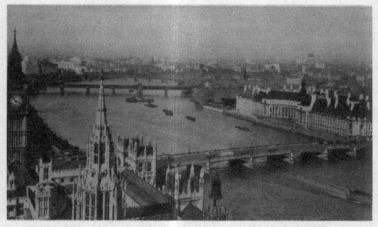

The Thames from the roof of Parliament, looking at County Hall

above the ground and six underground, and a private station which leads to Brookwood Cemetery. The station covers 24 acres, all raised on arches.

The chief entrance to Waterloo is an impressive arch in memory of 600 men who fell in the war. It is approached by a flight of steps, and at the top Britannia sits holding a torch, with groups of War and Peace on each side. In the long subway running under the whole station is an inscription telling us that at this point stood a free buffet from which meals were given to eight million soldiers during the war. Not one soldier paid a penny for his meals.

At one end of the Duchy of Cornwall estate is the simple modern church of St Anselm, and it is of curious interest that its foundation stone was laid about twenty years before its completion, the war intervening. The church is plain and dignified, but the capitals of the pillars indoors are carved with peculiar beasts. Above the door outside is a melancholy little bishop sitting between a lion and a lamb.

Facing us as we reach the end of Kennington Road is the fine park made out of old Kennington Common; the famous Oval Cricket Ground, covering nine acres, was laid out from a spare piece of the common. It is the home of the Surrey Cricket Club.

Looking up Kennington Road is a little house inside the park railings, a solid-looking building with leaded windows and a gabled porch which catches the eye as we turn round for the Oval corner. Looking down on the busy centre at the Oval corner is the round turret capping the massive tower

of St Mark's Church, which was built with money given by the Government as a thankoffering for Waterloo. It stands on the site of the old gallows, and has a portico of fluted columns. The nave is lit by a central dome and the chancel by a skylight over the altar. The plaster ceiling with bold floral designs is the work of Basil Champneys, architect of the beautiful John Rylands Library at Manchester. There is something from three City churches here. The oak panelling of the gallery is from St Magnus the Martyr's at London Bridge, a limewood screen is from St Michael's in Wood Street, and the cherubs by the reredos are from St Katherine's in Fenchurch Street. The limewood screen is supposed to have been carved by Grinling Gibbons, who is also said to have carved the fine pulpit here, with its leaves and cherubs.

We turn here up the busy Brixton Road to the shops and the town hall, passing almost at once Vassal Road, down which is a church, with a lofty spire, by the builder of the Law Courts, Mr G. E. Street. It has a gilded font cover soaring into the gloom of the vaulted baptistry, and a bronze statue of Canon Brooke, a bearded figure in a surplice. On Brixton Road itself, in front of a Congregational Church, is a stone figure of Winged Peace by Richard Belt.

Brixton

Walking on, we come to one of the fine town halls of South London, from which are governed the well-known districts of Vauxhall, Kennington, Stockwell, Brixton, Tulse Hill, West Norwood, and half of Herne Hill, the whole area of 4,000 acres having nearly people. Lambeth has set up her municipal quarters in the heart of the Brixton shops, one of the most crowded shopping areas in London, and her town hall has an impressive clock tower, with statues of Art, Literature, Science, and Justice at the corners. Looking at it from across the way is Lambeth's Central Library, built by the founder of the Tate Gallery, the rich sugar merchant Sir Henry Tate, who invented a machine for cutting sugar into cubes and spent most of his money for the good of the people. In a garden in front of the library is a bronze bust with his smiling bearded face, by Sir Thomas Brock. On one of the walls is a marble relief of Death's Door, fashioned from an engraving by William Blake, who lived for seven years in Lambeth (round about the parish church by the river). The relief shows an old man on crutches going through the doorway of a rocky tomb, above which rises a youth amid the beams of dawn. Facing this sculpture is a portrait of John Doulton, whose pottery works we come upon before we are out of Lambeth, and who gave much of his life to service for the Lambeth poor. Keeping company with the town hall tower at the bottom of Brixton Hill is the open turret of St Matthew's Church, a turret copied from a temple at Athens. Up the hill is

Brixton prison, a crescent-shaped building, and not far from it, standing back in Cornwall Road, is one of Brixton's great surprises, the last windmill in Lambeth and the last workable one in London.

On the neighbouring Denmark Hill, taking its name from Queen Anne's husband, Prince George of Denmark (who had a shooting-box here), is the famous King's College Hospital, a wonderful place with soundproof floors, whose size we may imagine from the fact that it has four miles of corridors, seven miles of hot-water pipes, 100 miles of electric wires, and 1,000 radiators.

Facing the road in front of the hospital is a marble statue of Dr Bentley Todd, an Irish physician of a century ago who helped to found the original hospital in the abandoned workhouse of St Clement Danes. On a shelter here in the park is another memorial, this time to Captain James Wilson, who after an adventurous life at sea, and after fighting in the Battles of Lexington and Bunker's Hill and being confined for two years in a dungeon at Seringapatam, served the London Missionary Society by taking charge of the first British missionary ship of modern times.

Crossing a wide stretch of grass to the far corner of the park we find ourselves by the Public Library at Herne Hill, with a wealth of pictures illustrating Old Lambeth and a magnificent collection of the pottery for which the district has been famous for 300 years.

We come back to the Oval at Kennington to work our way to the river again through Stockwell and Vauxhall. Stockwell Tube Station is famous in underground history as the terminus of the first real Tube Railway in London, long before the people began to talk of tubes. So humdrum was it in those days that the manager had nothing but scorn for a journalist whose imagination leapt at the idea of riding through a tube, and London waited for a more imaginative directorate before the idea of a Twopenny Tube became a magic word. Facing it is Stockwell's Peace Memorial, a stone clock tower in a garden, with a mourning figure of Victory who has put aside her sword. Close by is the famous Stockwell Orphanage founded by Charles Haddon Spurgeon, whose desk is kept here. In the memorial hall is a terracotta statue of Spurgeon by George Tinworth. In these great homes 450 children live under conditions which give them every chance in life, carrying out the spirit of the founder, for 'the grounds are not a prison yard, the houses are not like a workhouse, the rules are not barrack rules.'

The Palace and the Church

We are back at the finest corner of Lambeth, the foot of the bridge with the towers and palaces all about it. Side by side stand the town house of the

Archbishop of Canterbury and the people's parish church, and in front of the church is a little formal garden with a pergola and a sundial and seats for the old folk.

Just inside the doorway is the font, and behind it two flights of marble steps down to a bath which is sometimes used for christening by immersion. The font is enclosed by seventeenth century railings, similar to those in the chancel, which have gateposts beautifully carved with flowers. The terracotta reredos has a Crucifixion scene by George Tinworth, made at the pottery works close by.

The organ case is boldly carved with fruit and foliage; the organ itself was originally built in 1700 by Renatus Harris, the rival of Father Smith, and half a dozen of the original stops remain. At the back of the organ is a brass of Thomas Clere, wearing his armour and with his sword. He was the cousin of Anne Boleyn and fell in France while saving the life of the poet Earl of Surrey. The fine bust of a sheriff of Surrey is also tucked away behind the organ; he was Thomas Lett, and his kindly face was carved by Chantrey. On the chancel wall is a brass of Lady Catherine Howard, wearing a gorgeous heraldic mantle with a long rosary, a squirrel at her feet with a nut in its paws.

A stone on the chancel floor is to Archbishop Bancroft who founded the parish library, and another is to Archbishop Tenison who crowned Queen Anne and founded a school which is still busy educating Lambeth children in a fine modern building near the Oval.

As we enter the outer courtyard we are struck by the oriels, traceried windows, and sculptured frieze of the Great Hall. We look up at the copper weathervane and note that the lantern is of wood, and that above the vane are a ball and a mitre. At the far end of the courtyard rises the two-fold pile of the Lollards Tower, a name keeping alive the myth that Wycliffe's followers were imprisoned in it.

From the tower we descend to the crypt beneath the chapel, 90 feet long and early thirteenth century. Its vaulted roof is supported by three slender pillars. There are stone seats to the small windows, which have remarkable arched heads and in some cases retain their old iron grilles.

From the crypt we reach the Post Room, with carvings of Henry the Sixth and Margaret of Anjou. On the east side is the doorway of the ante-chapel, the oak woodwork of which is understood to be as old as the crypt. The Post Room is the ground floor of the Water Tower, built in the fifteenth century and once with a landing-stage on a creek of the river. Between the two first-floor windows on the riverside frontage is a vaulted niche in which stood a figure of Thomas Becket, and to which the watermen used to doff

their caps in passing. From the third floor a winding stone stairway leads to a small turreted chamber with massive double doors, the outer one three inches thick, with an observation wicket. The windows are heavily barred and in the walls are wire hooks and rings. This was the Lollards Prison, and the walls still have names scratched on them by the captives.

Passing through the doors of the lovely oak screen set up by Archbishop Laud, we find ourselves in one of the most beautiful thirteenth century chapels in London, 72 feet long and 25 wide, its buttressed walls linked by curtain arches. The glass window is nineteenth century and is a Poor Man's Bible, following the original scheme of the windows destroyed in the Commonwealth. The beautiful carved woodwork of the stalls remains from Laud's time. The Archbishop's canopied stall is of great beauty, and the altar gates set up by Bishop Juxon (to whom Charles Stuart spoke his last word) are of rich Jacobean carving.

The tower has five storeys, and on the ground floor in the vestry is a beautifully carved ivory chalice which belonged to Archbishop Laud. There are some old paintings in the modernised galleries of the palace, one representing with crude realism the murder of Becket, and in a case is an odd thing to find, the shell of a tortoise belonging to Archbishop Laud. There are more pictures in the dining hall, which has preserved its fourteenth century oak roof, among them being a series of historic portraits of Primates, and canvases by Holbein, Van Dyck, Hogarth, Reynolds, Romney, Lawrence, and others. On the staircase by which we descend to the Great Hall is a memorial to John Richard Green, who was Librarian there. The hall has seven bays, with two projecting oriel windows, one window filled with ancient glass which must have looked down on the scene in the old hall when Sir Thomas More and Bishop Fisher refused to take the oath demanded by Henry the Eighth, and so passed from here to the Tower and then to the block. In that old hall took place also the stormy scenes between Cranmer and Bonner, and between Bishop Gardiner and Cardinal Pole.

The Great Hall is now used as the library, which has a vast accumulation of manuscripts and 40,000 books. Passing from the library to the inner courtyard, which gives us a good view of the residential buildings, the eye is drawn to the green plot on which stands the tall memorial to Archbishop Davidson, the work of Sir W. Reynolds-Stephens. We notice also a mounting-block, a memory of the days when bishops rode on horseback.

Camberwell

Crowded Streets and Green Spaces

It has a famous name and a famous reputation. How many other London boroughs have two art galleries? How many have done so well as Camberwell in blotting out slums and setting up such splendid blocks of houses?

Its green is now a little park of about two acres, and round about it is the memory of Robert Browning, Christopher Wren, Oliver Goldsmith, Tom Hood, John Ruskin, Joseph Chamberlain, and Mendelssohn. Wren is said to have lived in a road just off the green. Browning was born here. Goldsmith was an usher at a school at Camberwell when he planned the Vicar of Wakefield, and there is still a school named after him.

Camberwell church is near the green, and is said to stand on the site of a Saxon building, though the work we see is Gilbert Scott's barely a century old. The church has an elaborate gabled spire, and bears on one of its corners caricatures of statesmen of last century We notice at once, on entering, the east window designed by John Ruskin, a field of rich purple glass with red medallions of Bible scenes. In the west window, a harmony of quiet colour, is the oldest possession of the church, some thirteenth century glass with coloured borders, foliage, and medallions. Only a century younger is the church's most beautiful possession, the lovely stone sedilia.

Camden church, a few yards away, was built at the end of the eighteenth century, and the transepts were added a hundred years ago for the increasing congregation attracted here by Henry Melvill, the most popular preacher in London. Among his hearers every Sunday were John Ruskin from Denmark Hill and Robert Browning from New Cross, but it was not until after Melvill's ministry here that they became known to each other. A minute's walk away from the church, the impressive front of the town hall looks down on Peckham Road, a striking sight with its deeply arched doorway, with a great recessed window above it.

The South London Art Gallery

Near by is the South London Art Gallery, sharing a building with Camberwell's School of Arts and Crafts. On the front of the three gables are reliefs symbolical of the work done here.

On the wall is an oil sketch by Lord Leighton when he was eighteen, a foretaste of the splendid colour by which he was to be known all over the world. Here, too, are delightful pastoral scenes by John Collier, though perhaps the most famous picture is Hogarth's lighthearted painting of a suburban dance.

A collection of small objects found in London, of stone, metal, bone, and earthenware, dates from prehistoric times; and there are Roman household gods from the City, bone skates made from the thighs of a horse, and eighteenth century wig-curlers from Bishopsgate. There is also an iron cannonball, probably fired from the Tower when Sir Thomas Wyatt was attacking London in Mary Tudor's reign. Two lovely busts of young women are by Henry Pegram, one being his wife, while in the lecture gallery is his delightful white marble bust of Mrs Browning.

Very striking is Ford Madox Brown's cartoon of the close of the Battle of Hastings, showing the body of Harold being borne off the field. It was done for a competition for decorating the Houses of Parliament. One famous member of the House figures in a showcase here, for he was born in Camberwell and here received his first schooling. He was Joseph Chamberlain, and here is the account book of Miss Pace's school in Camberwell Grove showing the receipt of little Joseph's school fees in 1845. His birthplace is still standing at the top of Camberwell Grove, and is recognised by an inscription and a balcony with graceful iron railings.

Not far from the art gallery is the central library, opened by Edward the Seventh as Prince of Wales. There is an eight-sided clock tower over the porch, and inside is an arcaded corridor with shining columns of grey granite. In the new room hang pictures of the Italian home of Sir Richard Burton, the famous Victorian explorer and scholar, with a painting of him translating the Arabian Nights.

The canal began with last century, and when the century was a quarter old they built St George's Church in the green fields on its banks, tiers of its high tower being reflected in the water. The big portico is carved with wreaths. The flat ceiling of the nave is divided into floral squares, and on the high classical reredos above the altar is a mosaic of the Crucifixion, the figures red and blue, with the golden walls of Jerusalem in the background. This beautiful composition is the work of Basil Champneys, architect of the great John Rylands library building at Manchester, who also designed the arcaded screen of the side chapel here, picked out in gold. Over its altar is a beautiful little round window with blue and yellow glass showing Christ in majesty. In front of the church is the peace memorial, a statue of Christ holding a crown of thorns.

Rising from a lawn in front of another building is a statue of Prince Albert, a colossal figure showing the Prince replying to an address, dressed as when he laid the foundation stone of this building – the Licensed Victuallers Benevolent Institution. The institution is a huge building set up well over a century ago in the fields near Old Kent Road, and is the biggest place of its kind in existence, containing 176 separate houses. The front surrounds three sides of a garden, and in the middle of the block is an imposing turreted portico, the entrance to the chapel, in which are stained glass windows telling the Bible story. High on the wall is a medallion bust of Alfred Lewis Annett who for over half a century rendered devoted service to this institution.

One of the newest Camberwell churches is St Mark's in Coburg Road, a lofty building adding dignity to a drab street. It was designed by Norman Shaw, and we must all admire the white wooden vaults of his roof rising from octagonal pillars of brick with green panels on the base. The walls are green, and are decorated with gay shields-of-arms belonging to the church at home and overseas.

St Luke's is a plain Peckham church, but it has done its best to bring the world to its doors. Round the peace memorial crucifix in the churchyard is a rockery formed of stones from cathedrals in various parts of England, and the plants growing on them come from the corners of the Empire.

The threshold stone of the Children's Chapel came from Sinai, and was laid by Meletios the Second, Pope and Patriarch of Alexandria. The altar candlesticks of Dutch pottery were given by the Archbishop of Utrecht, and the little crucifix in the Chapel of Unity is a Swedish carving of the sixteenth century presented by the Archbishop of Upsala. In this chapel is a wonderful little collection of the religious pictures called ikons.

St Chrysostom's is a Peckham church opened the year before Waterloo, though its timbered turret was set up later. In the gallery is a peace memorial chapel panelled in oak, the labour of love of one Peckham working man. Here is a bell from a French church, which was captured and used as an alarm bell in the German trenches, and was brought home by a soldier.

A historic Peckham street is Meeting House Lane, with a row of little houses built about 1700. On one is a bronze inscription marking this as the site of the original meeting-house used by William Penn before he was shut up in the Tower in 1668.

The Glass House of Peckham

One of the most interesting of all Peckham's buildings is its remarkable Health Centre, a high structure with glass walls, looking like a fine modern factory set in an orchard. In setting up this great Health Centre Peckham

has set a fine example to the densely peopled areas of our great cities. The West End of London has nothing to equal it.

The best-known open-air health centre of Peckham is the Rye. Peckham Rye is Peckham's Pride, and rightly so, for it has over a hundred acres of great beauty in the midst of so much that is dull. First there is the common, a great grassy playground fringed with trees, where even the dogs have their own pond. For quieter folk there is the park, delightful with its old wooden farmhouse, and lovely with an old English garden shaded by pergolas of roses. In March the crocuses in the avenue are one of the sights of London.

The Rye is a stream, which has now unhappily been covered over, and Peckham probably means the peak estate, the peak being Telegraph Hill, the high open space just inside Lewisham.

Another lofty open space is One Tree Hill, taking its name from an oak under which Queen Elizabeth is said to have dined on the last May Day of her life. At the bottom of the hill is the huge Beachcroft Reservoir, marked by a dome and covered with concrete arches hidden by grass.

Collecting for the British Museum

On the slope of the hill is Camberwell's new cemetery, replacing the old one, in which lies Albert Edward McKenzie, the first London sailor to win the VC in the war; he won it for fearless bravery on the Mole at Zeebrugge. The oldest and most beautiful of Camberwell's cemeteries is Nunhead's, a glory of almond blossom in early spring. Near the gate is a striking and lofty obelisk known as the memorial of the Scottish political martyrs in memory of Thomas Muir, Thomas Palmer, William Skirving, Maurice Magarot, and Joseph Gerrald, exiled for 'advocating with fearless energy the principles of parliamentary reform.'

In the shadow of a group of tall elms lies Sir Wallis Budge, a famous collector for the British Museum and one of our chief authorities of the ancient empires

In Nunhead Lane, not far away, is St Antholin's church, a modern building with a fine oak reredos by Christopher Wren, brought from a lost City church. The wood is enriched with classical columns, and there are cherubs and festoons of fruit.

Scotland, Yard's Steel Masts

Pointing the way to Denmark Hill are three steel lattice masts at Grove Park, one of the highest parts of London. They are 100 feet high, and they enable Scotland Yard to maintain wireless communication with police cars within 50 miles of headquarters. Another lofty landmark is by Denmark

Hill Station, the William Booth Memorial Training College, a huge building by Sir Giles Scott.

Standing high, as all these buildings do, is St Paul's Church on Herne Hill. It has a tall tower with flying buttresses supporting a spire, and was designed by the famous nineteenth century architect, George Edmund Street. On a wall within is a medallion bust of a learned-looking man with unruly hair, and we read that he is John Ruskin 'brought to 28 Herne Hill by his parents in 1823, he dwelt on Herne and Denmark Hill for fifty years.' On the opposite wall is a medallion spiritedly carved with a four-masted ship in full sail, in memory of Captain James Horsburgh, a famous hydrographer of a century ago.

The Unique Village of Dulwich

To most people it will seem that the most appealing corner of Camberwell is Dulwich, London's little village set in the valley and looking up to the hills, for it has Denmark Hill and Champion Hill in the north, Sydenham Hill and Knight's Hill in the south and west, and Forest Hill in the east.

Modern Dulwich is in four places, but the village is the jewel of the crown which Edward Alleyn so long ago burnished and perfected. On the way to the delightful village street is the great modern church of St Barnabas, with magnificent carving of oak screens and panels, the bulk of it done in six years of joyful labour by nine woodcarvers who belonged to the congregation. Farther on is the Alleyn burial-ground, gracious with its trees and greensward. Here, in a huge tomb, lies the body of Richard Shawe, who defended Warren Hastings and spent his £40,000 fee in building a palace on Denmark Hill which became the residence of Prince Joseph Bonaparte, uncle of the little Napoleon.

On the gates of the burial-ground are two exquisite sprays of laurel beneath the central pyramid of twisted scrolls, and farther on, when we reach the gate of the old College, we see another pair of gates.

They are massive yet graceful, forming a beautiful design of heavy bars and twirling scrolls and leaves.

Shakespeare's Friend

Here we approach the man whose memory lives in this estate, Edward Alleyn, friend of Shakespeare, actor, theatre proprietor, and Keeper of the King's Bears. It was his acting and producing that made the dramatic fame of Christopher Marlowe. While Shakespeare was building up his estate at Stratford, Alleyn applied himself to similar ends at Dulwich, spending what would now be £200,000. He bought the entire manor, and built a college for twelve poor scholars and almshouses for sixteen old people.

What we see now of the college buildings is mostly modern; it is a splendid block. The almshouse wing and that of the school are joined by a cloister with a foreign-looking tower. At the back of the cloister is the chapel, the organ by George England, who built the eighteenth century instrument at the famous City church of St Stephen, Walbrook. The chancel screen and the traceried stalls are believed to have been in the Great Exhibition, and are carved with fruit and foliage. Its beautifully-coloured mosaic shows the Adoration of the Kings, one with the features of Edward Alleyn, and included in the scene are two boys in the school costume of bygone days. The treasure of the chapel is the marble font designed by James Gibbs, of a creamy white veined with grey, the oval bowl resting on a round baluster stem. Edward Alleyn lies under a black marble stone in the floor of the choir; around him are many Alleyns and Allens, for he insisted that all masters of the college should bear his name.

A fine art treasure of the chapel is a copy of Raphael's Transfiguration, ascribed to one of his pupils. A window gives us a glimpse of the chaplain's garden with a famous catalpa tree which Shakespeare may have seen, and a wonderful old Judas tree whose timber is hidden in blossom every May.

The Romantic Story of Dulwich Gallery

The original school is now the estate office, with many original windows intact and hosts of initials and caricatures of generations of scholars. On the other side of the garden courtyard are the almshouses, with their sixteen pensioners; but we must walk a hundred yards along Gallery Road, an unspoiled country lane, to enter Dulwich Art Gallery, which has a beautiful little mausoleum in which sleep the three benefactors who gave it, above them a graceful little tower capped with urns.

There have since been many additions to the many pictures Desenfans bought in Paris at the time of the French Revolution, and the collection is an unexpected delight to come upon in this country lane.

Among portraits widely known here is the striking Philip of Spain by Velasquez, and James the First by his court painter Marcus Gheeraerts. Another portrait we must not miss is that of Philip James de Loutherbourg by Gainsborough, for it was in de Loutherbourg's studio that Sir Francis Bourgeois acquired his taste for art.

It is surprising to learn that this little gallery was the first public art gallery in London. It has been a fount of inspiration and teaching to both artists and poets. John Ruskin, who lived in the neighbourhood, spent hundreds of days in it, and it is named after him. Robert Browning often came to see it.

In front of the gallery stands a stone sundial, and farther up the lane is the

new college school, set in splendid playing fields of 45 acres. In the middle
of this imposing block of buildings is the great hall with a graceful pierced
parapet bn its central gable. The wings at the side are joined by cloisters,
and over the windows are heads in relief of famous poets, historians, and
philosophers of three countries – England, Italy, and Greece.

Queen Elizabeth's Barge and Shackleton's Boat

The young College has intimate and precious links with the old. Its collection
of manuscripts is widely celebrated, for it contains, among other treasures,
the Henslowe Diary, to which all students of Shakespeare turn, and Alleyn's
diary, one entry in it recording the founder's purchase of a book: Shaksper
Sonnetts, 5d. In the library are the remarkable painted panels Edward
Alleyn bought from Queen Elizabeth's barge. They represent Liberality and
Piety. Alleyn's diary shows that he spent £2 9s 5d in fitting them into the
mantelpiece of the Great Chamber of the Old College. They are among
the most thrilling possessions Dulwich has; we must imagine that the eyes
of Drake and Raleigh and all the great Elizabethans of the Court fell on
these painted timbers as they went riding down the Thames. They rank in
historic interest with the timbers of the Golden Hind which we have found
in the Temple, in the Bodleian Library at Oxford, and in Drake's old house
down in Devon.

Worthy to keep these timbers company is another boat of great adventure
here, kept in a building in the cricket ground. It is the boat in which an
old College boy, Sir Ernest Shackleton, made one of the most tremendous
voyages in the history of navigation, the voyage which crowned his heroic
adventures after his ship had been shattered and sunk in Antarctica. In it
he sailed 800 miles to seek help for his men, and here is his boat (often to
be seen from the road) as he last stepped out of it, with the sails and gear
used for the voyage, and the fragile wooden patches still covering the holes
which rocks and ice made in the timber.

There is a bronze tablet which tells the famous story in these words: In
this boat Shackleton, with five comrades, made, in 1916, his famous voyage
over 800 miles of Antarctic sea to South Georgia. This voyage resulted in
his saving the lives of twenty-two members of the Endurance expedition
who were marooned on Elephant Island. To recall his heroism to the boys
of Dulwich the boat was presented to the College by Dr T. Q. Rowett, Old
Alleynian.

Dulwich Park is one of the loveliest of all London's green spaces. It has
outside it, in College Road, London's only tollgate, and not far away is
one of London's last farms. It is 72 acres of these meadows, given by the

College, that have been made into Dulwich Park, with wonderful flower beds, an aviary, a lake for boating, a waterfall and a stream, and a mass of rhododendrons which is one of the sights of London, especially in the little dell so beloved by Queen Mary, whose visit to it every year has been one of the chief delights of this country scene in town.

Sir Edward Poynter's Fresco

College Road mounts by fields and woods up to St Stephen's Church, designed by Mr Charles Barry with one of his father's pupils, Robert Banks. The church has an apse and a slender spire, and its most famous feature is in a recess of the chancel wall, a fresco by Sir Edward Poynter. It shows the martyrdom of Stephen, who stands in a marble hall before his judges, his hands upraised protesting his innocence. Below him Roman soldiers are restraining a lightly-clad group of muscular men from stoning Stephen too soon, among them one named Saul.

There is a brass inscription on the wall to the last survivor of Havelock's officers at the Relief of Lucknow,

At the top of a hill is an obelisk marking the water-level for the Water Board, and at the top of another hill there stood until not long ago the huge glittering mass of the Crystal Palace, the most old-fashioned thing in England, now like an old friend gone.

Southwark

The Crowded Town with Two Cathedrals

It takes its very name from London Bridge, for Southwark means the south
work of the bridge – the gateway, we should say. The bridge as we see it is
little more than a centenarian, for it was designed by the son of John Rennie
whose lovely Waterloo Bridge is down at last. It was only at the beginning of
our own century that London Bridge was widened by carrying the footpaths
to overhang the Thames; the lamps that light the walker's way were made
from the bronze of guns captured from the French by Wellington.

At the foot of the bridge stands Southwark's old cathedral; after
Westminster Abbey the best example of Gothic architecture in London. The
noble tower is five centuries old, and from it the engraver Wenceslaus Hollar
drew his famous pictures of London at the time of the Great Fire.

From the cathedral (to which we shall return) Bankside runs by the river.
It stretches between London Bridge and Blackfriars, a strange region of
cobbled streets, curious old wharves, and dark alleys, with an occasional
glimpse of shipping on the river. The approach from the cathedral is by
Clink Street, one of the oddest ways in London, hazy with floating flour and
flanked by tall cliffs of warehouses joined by narrow wooden bridges.

There is a movement for brightening up Bankside by rebuilding the
Globe Theatre and the Mermaid Tavern, a wonderful idea which the next
generation may see realised. The place where the theatre stood is now a
brewery covering eight acres, producing twenty million gallons of beer every
year.

It is churches and cathedrals for which we come to Bankside, for from
here is the finest view of St Paul's, the whole of its great length before us,
with the towers of the City churches clustering like children round their
mother. At the end of Bankside are the works of the London Hydraulic
Power Company, on the site of a house where Sir Christopher Wren used
to come to watch the building of St Paul's.

Blackfriars Bridge is higher up the river, and is the broadest of all the
Thames bridges, over 100 feet. Fine views of the Embankment can be had
from the alcoves, supported by red granite piers with water birds on the
capitals. From here, too, is a view of River Plate Wharf, its tower a much-
needed ornament to the Surrey side. Round the corner in Stamford Street is

the fine classic portico of a chapel designed by John Rennie, architect of the first Southwark Bridge, and across from the chapel is an inscription marking the site of the house where he died. Here too was born the famous Punch artist John Leech, who was but three years old when John Flaxman found him sketching on his mother's knee. 'He will astonish the world,' he said.

Across the street in a leafy churchyard is Christ Church, Blackfriars Road, flanked by the cliff-like walls of a factory. The walls of the church are not 200 years old, but in the panelled gallery is woodwork from the church of Restoration days. The choir stalls have some twisted balusters two centuries old, but the oldest thing in the church is an Elizabethan iron chest, probably of German make, with a wonderful locking mechanism in the lid.

South of the church are some quaint weather-boarded houses of the seventeenth century, with dormer windows in their tiled roofs. Near by is Nelson Square, with houses of 1799 shaded by tall planes, while across the road is a dingy octagonal building with a little dome in the middle called the Ring. Nowadays it is famous for boxing, wrestling, and Sunday Shakespeare, but in 1782 it was built as a chapel for Rowland Hill, who preached here for nearly fifty years. The Brewery has swallowed up the Independent chapel; the Ring has swallowed Rowland Hill's. Here the first Sunday School in London was opened in 1785.

One of the greatest surprises in Southwark is the group of almshouses in Holland Street, founded in the middle of the eighteenth century for twenty-eight people. They form a delightful and peaceful oasis at the back of shady lawns, while round the corner is all the roar of Southwark Street, a broad thoroughfare parallel with the Thames. It is lined with lofty warehouses of a certain dignity and austere beauty, dingy though they be.

Halfway along is Southwark Bridge road, where the London Fire Brigade once had its headquarters in a long range of tall buildings which are still here. A picture of the brigade turning out was probably the first British news film ever taken. The Hop Exchange, the centre of London's hop trade, is at the end of Southwark Street, and near it is the Borough Market for fruit and vegetables, entered by a square arch from High Street.

Lower down High Street is Southwark's principal peace memorial, the work of Philip Lindsey Clark, D S O, whose sculptures are in Westminster Cathedral. Here is a bronze statue of a soldier striding forward in full equipment, vigour and grim determination in every line, and on the sides of the tall base are reliefs of fighting by air and sea.

There is more fine carving in Newcomen Street near by, where an inn has as its sign the beautifully-carved royal arms set up 200 years ago on Southwark itself, the south work of London Bridge. The gate was removed

with the houses on the bridge, and alcoves were built at intervals along the parapet. One of these alcoves now stands in a courtyard of Guy's Hospital round the corner, with 600 beds and 600 students. In niches on the gabled front of the main building are figures symbolical of Medicine and Health, while three odd carvings illustrate the practice of blood-letting, an operation which Keats may have seen when he studied medicine here the year after Waterloo. In the courtyard below is a fine bronze statue of Thomas Guy the London bookseller who founded the hospital in 1721, dying when the roof was being put on.

London's Finest Galleried Inn

In the old days Borough High Street was famous for its inns, from one of which the Canterbury Pilgrims set out with Geoffrey Chaucer at their head. One inn still remains, the seventeenth century George, the last galleried inn in London, with bedrooms still opening on to balustraded balconies overlooking the yard. It was in such a yard in this very street that Mr Pickwick met Sam Weller. Here now is the headquarters of the Puppet Guild, whose enthusiastic members are trying to keep alive their captivating form of drama. The inn belongs to the National Trust.

Dickens brought the George into Little Dorrit, and down the street is another George called Little Dorrit's Church, where Dickens set her baptism and her wedding. It is St George the Martyr, Southwark's best-known parish church, made new 200 years ago. Within is a fine plaster ceiling forming an enormous oval decorated with reliefs of cherubs and festoons of drapery. In the gallery is the eighteenth century organ flanked by seventeenth century paintings of Moses and Aaron, both from the demolished church of St Michael in the City. The choir has to sit in this gallery, for there is only room in the chancel for its two seventeenth century chairs.

Below the gallery is the font, its round cover capped by a gilded dove. In a lobby is a big lead cistern finely ornamented about 200 years ago with heads of monsters in relief. The vestry is a place where people may rest and take their meals, and Dickens describes how Little Dorrit slept there. The churchyard is sometimes called Little Dorrit's Playground, and is bounded by the tall walls and barred windows of some printing works. Notices tell us that these works are on the site of the Marshalsea Debtors Prison, where Dickens lays the scene of Little Dorrit's childhood.

London's Oldest Outdoor Statue?

Not far away is another big church, Holy Trinity, with a tall tower rising above the fluted columns of a portico. During the war the crypt was used

as an air-raid shelter, but fortunately no bomb fell near enough to damage the beautiful east window, with its grey and yellow glass symbolising the Trinity.

The church was built in 1824, when Trinity Square was being laid out in front of it, and when statues were being moved from niches in the outer wall of Westminster Hall. One of the statues came here, a colossal stone figure of a king gathering his robes round him. It is probably the oldest outdoor statue in London, far older than the Queen Elizabeth in Fleet Street, for it was set up by Richard the Second in 1395, when he was giving Westminster Hall its magnificent roof, and it is said to represent King Alfred.

Near by is Great Dover Street, cut early in the last century to make a nobler entrance into London. At its end is the town's Carnegie Library, its tower with a windvane like a Viking ship. A later phase of Southwark's story is shown by the bright mosaics on the library wall, Chaucer's Canterbury Pilgrims feasting at the Tabard Inn, and assembling in its courtyard. Cheerful glass in the windows shows the journey.

From the library runs the Old Kent Road of Albert Chevalier's famous song, and standing a little way back from it is the Coster's Church, where at the hawker's harvest festival the wealth of pearlies dazzles the eye. By New Kent Road is David Copperfield's Garden, with a stone statue of a stout little baby blowing a shell trumpet. It connects this spot with the flight of David Copperfield to his aunt at Dover: 'I came to a stop in the Kent Road, at a terrace with a piece of water before it, and a great foolish image in the middle blowing a dry shell.'

Close by is the busy traffic centre of St George's Circus, the meeting-place of three Roman roads, where six streets cross, four of them radiating to bridges over the Thames. A library here has a number of original etchings by Hogarth, and at the entrance is a pair of plaques by Sir George Frampton showing two of Southwark's MP's, Sir William Molesworth and Sir Henry Layard. The library is on the site of St George's Fields, famed for its violets, where strolling Londoners would take a Sunday walk in Stuart times. It was here that the No Popery rioters met in 1780, near where St George's Cathedral now stands. It was the first important Roman Catholic church built in London in modern times, a notable example of the Gothic revival of the Forties. At the end is a graceful pair of turrets, and along each side runs a pierced parapet broken by pinnacles.

We enter through the massive stump of an unfinished tower, finding with surprise that the altar is at the west end instead of the east, a curiosity we have only come upon once or twice in our tour of England. A lofty arch forms a fitting frame for the chancel, its reredos rich with gilding and carved

work. All the colours of the rainbow stream through the stained glass. On this bishop's throne Cardinal Wiseman, first Archbishop of Westminster, was enthroned in 1850. One of his great friends, Dr Thomas Doyle, has an altar tomb in a canopied recess in the nave. Founder of this church, he lived till he was eighty-six, and he is a tranquil figure on his tomb.

In the nave is a smiling bust of the first Catholic Bishop of Southwark, Thomas Grant, a man much loved for his simplicity and self-denial. Near by is the canopied monument of the second Archbishop of Westminster, lying in his mitre and robes, holding his pastoral staff. He is Cardinal Manning, whose body lies in the crypt of Westminster Cathedral.

The Museum of the Great War

St George's Cathedral is one of the best buildings of Augustus Welby Pugin, who, when overwork affected his brain, was confined in Bethlehem Hospital opposite, the solid-looking building once known as Bedlam, built as a lunatic asylum in the year of Waterloo and now the home of the War Museum, housing relics of one of the greatest tragedies in the history of mankind. The imposing black and white dome was added thirty years later by Sydney Smirke, who helped his brother with the building of the British Museum.

What fighting on meant is pictured here in a hundred ways, a hundredfold more graphic than the shining guns and shells. There are models of dug-outs, miserably lit by a single candle, and even here seeming to reek of mud. There are models of sunken galleries and trenches worse than any prison, and a landscape above them of splintered trees, houses with a few bricks remaining, and desolation marked by bursting shells in the painted sky.

One relic of the naval war, placed above the torpedoes and the mines,

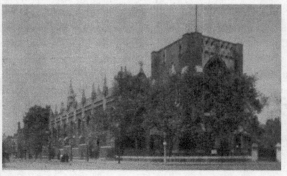

St George's,
Southwark

affords a solitary gleam of humour amid the melancholy. It is the head of the Dresden's pig. After the Battle of the Falkland Islands the Dresden was chased by the Glasgow and made a prize. With the prize went the pig, joyfully accepted by the Glasgow as a mascot.

One of the pleasantest things to look on in this Chamber of Horrors was presented by Sir Herbert Samuel. When he was High Commissioner of Palestine he found in a village by the Jordan, near the place where Christ was baptised, a sickle or pruning hook, and on examining it was surprised to find that it had been a German bayonet, beaten into a pruning hook by some peasant. Sir Herbert bought the sickle from its peasant owner, and here it hangs with an account of its discovery, and, in the three languages of Palestine (Hebrew, Arabic, English), the prophecy that: They shall beat their swords into ploughshares and their spears into pruning hooks; nation shall not lift up sword against nation, neither shall they learn war any more.

From the Elephant and Castle runs Walworth Road, passing a group of buildings which come into Southwark's story. The first is St Peter's Church, set in a garden fringed by high trees. Built by Sir John Soane, the famous architect of the old Bank of England, it has a tall tower rising with a slender turret from a graceful balustrade. Indoors it has bright and harmonious patterns painted on galleries, walls, and ceiling. Its proudest possession is the glass in three round-arched windows above the altar, a rare example of English glass-painting of its time. The middle window has a coloured medallion of the Road to Calvary, and the brown scenes at the sides are apparently copies of engravings. This great tabernacle has been rebuilt on the ashes of the old one burnt down at the end of the last century. It was the gathering-place of the greatest religious congregations ever known in England, 7,000 every Sunday.

Last but not least in our survey of Southwark's buildings is the town hall, famous for the Faraday Library and the Cuming Museum. The library, which has the latest scientific books, was opened by Sir Oliver Lodge in memory of a Southwark blacksmith's son who changed the face of the world, for he was Michael Faraday, founder of our Electric Age. Round the walls of the library here are some facsimile pages of his laboratory notes, and in the room above is a bronze bust of him, showing his fine head with an unruly crop of hair. In another room is a set of alloy buttons he made, with a wonderful permanent polish. These Faraday relics form part of the Cuming Museum, a collection of 15,000 exhibits which has been called a British Museum in miniature.

Southwark Cathedral

Although its magnificent old tower is as well known as the dome of St Paul's, thousands of people pass it daily all unheeding. Matching the grandeur of the exterior, the interior of the cathedral, 300 feet by 130, has a new nave, a triumph for Sir Arthur Blomfield, who, following drawings of the original, has produced a perfect harmony with the thirteenth century east half of the church. He has preserved some thirteenth century arcading, and, in the north wall, the Norman doorway of the priests, a Norman recess, and the Norman doorway of the thirty-one priors who ruled here. By the priors' doorway we find two consecration marks, and beyond are several Norman columns with carved capitals, and a huge holy water stoup, which seems sinking into the ground until, glancing down the opening in the corner, we discover that the Norman floor is three feet lower than that of the present nave.

Near the west door we can place our fingers in holes made in the oak floor by a German aeroplane bomb which, piercing the roof in 1917, left these scars as well as the pits and scratches high up on the west wall.

The general impression of the cathedral is one of spacious and lofty grandeur, of stately pillars carrying beautiful pointed arches, with a triforium which still has a practicable pathway right round the east end of the church, and a lovely clerestory. To a thirteenth century setting have been added the riches of a high altar shimmering as with gold; above it the famous canopied screen of Caen stone set up by Bishop Foxe in the year of the Field of the Cloth of Gold. Crowned now by a triple lancet window, its twenty niches, left bare by him, have been filled with modern figures, each costing some £70.

By the altar is another figure of Henry the First, and, above him two medieval carvings, one of a man clutching the tail of a fox the other a man holding the hind leg of a stag. On the opposite side Bishop Foxe holds a model of his screen; near him is a laughing monk and a man with palmer's hat turned back to reveal his sensitive, humorous features. The high altar reminds us by central figures of Christ and the Madonna that at the Restoration the name of the church was compulsorily changed from St Mary Overy to St Saviour's. The chair of the bishop, carved oak with a gilt scroll on the canopy, is, like those of his two suffragans, unusually placed on the north side of the sanctuary, perhaps so that backs may not be turned on that fine scholar Bishop Andrewes, who, removed for the third time, now lies in one of the open bays.

Wearing his robes, with the Order of the Garter, he lies, holding his famous book of Devotion, splendid on an altar tomb whose canopy, rich with heraldry, is borne by columns adorned with gold and black. Master of

fifteen languages, and famous for his share in the translation of the Bible, he preached the funeral sermon of Queen Elizabeth and helped to crown her successor. From the prayer desk near the tomb we picked up a venerable little copy of his Devotions, the original of which, worn by his fingers and wet with his tears, was clasped in his hands when they found him dead in his bed.

In the next bay sleeps Southwark's first bishop, Edward Talbot. He is a figure in what seems shining gold on an altar tomb of gold, with the emblems of the Apostles at the four corners also in gold. Startling if first seen, as we first saw it, in the gloom of the choir aisle, this brilliant tomb was designed as part of the decorative scheme of the lighted sanctuary, and viewed in that position it completes a dazzling picture.

The Lady Chapel

Beyond the sanctuary is that pearl of the thirteenth century, the Lady Chapel, looking grace and tranquillity in perfection. Six slender columns, each with four detached Purbeck marble columns, support the delightful roof, divided into nine ribbed and vaulted divisions; the whole scene lily-like in delicacy and lightness, yet a monument to the stability of thirteenth century material and method. The chapel is virtually four chapels, with four altars privately maintained.

But another famous chapel calls us, that which was for 500 years the resting-place of Gower, its builder, but since 1905 the Harvard memorial. Entered by two Norman arches, the chapel has a Norman column to the left of the altar, and here, by removing a stone left loose for the purpose, we see more carved stone at the back, the remains of the apse of the Norman priory. The chapel, which was restored by graduates of Harvard in memory of their founder, has a fine window by La Farge of New York, which, including the only ancient glass we were able to find – a golden square of Tudor work – has the arms of Harvard College, and those of John Harvard's old college at Cambridge, and, below, the baptism of Christ with an attending angel on either side.

Stained windows are, of course, a great feature, and unhappily they darken this fine place. It is in the nave that the windows most appeal to us; here is a series devoted to literature and the drama. We see Bunyan, with a subject from his masterpiece, a gift from children. Here is Alexander Cruden of the Bible Concordance; Dr Johnson, often here during his visits to the Thrales; Oliver Goldsmith, who began and ended his medical career in Southwark; and, celebrating the 500th anniversary of his birth, a picture of Chaucer and his merry company setting forth from Southwark.

Meanwhile there is much to occupy us. Across the nave under his pinnacled canopy lies John Gower, who lived in the priory, married there, and there died. Beneath his head are his three most famous books, the nearest to his head, as if the dearest, being his Confessio Anrantis, which he wrote in answer to the request of Richard the Second for 'something new.'

From Gower's tomb we are attracted to the transept built by Beaufort, son of his old enemy. For half a century a leading figure in our history, in one year he signed the death warrant of Joan of Arc, saw her perish at the stake, and, a few months later, crowned the King of England as King of France, the only English monarch enthroned in that country.

One of the biggest monuments here is that of John Trehearne, Master Porter to James the First, holding a blank tablet between himself and his wife; and one of the most exciting discoveries is that the sculptor of the Shakespeare bust and of this great coloured monument are the same man, Gerard Janssen, a Southwark-born Fleming, who must have known Shakespeare and have been seen by him here on earlier work.

There are two very grotesque monuments, one on which reclines Lionel Lockyer, a pill-vending quack of the time of Charles the Second; the other the overpowering Jacobean wall monument of William Austin, bristling with Latin and spectacular absurdity.

Among many fine examples of old woodcarving here is what we may call Southwark's Unknown Crusader, a magnificent thirteenth century wood figure, of which there are only about a hundred in England. In helmet and chain armour, his feet on a lion, the knight seems about to speak as for the last time he sheathes his great sword.

Still more remarkable in another way is a collection of some three dozen carved wooden bosses stored in a rack in the south choir aisle. For four centuries 150 of them studded the roof, and these are the remnant of those brought down with it a century ago. Actually they are baulks of oak, about two feet long and a foot broad and astonishingly heavy.

Probably the oldest things here are the two great stone coffins, one lidless, the other, which when found contained remains supposed to be those of a Norman prior, retaining half its lid. This is beautifully carved with a strange cross, which, with the sun, the moon, and two stars about it, has a singular handle-like loop with square base at the end of each limb.

One more detail, this in a vestry – the remarkable Abyssinian brass cross which, when we bring it under a good light, astonishes us by revealing a number of figures engraved in the style of our old missals, men, women, animals, a boating scene, in all thirty-six beautifully designed figures, fourteen on one side, and twenty-two on the other.

And now we turn again to the window gallery in the nave, where the biggest of these windows shows the Spirit of Poetry enthroned, with Shakespeare on her right hand and Spenser on the other. Below is the Shakespeare Memorial, the cenotaph subscribed for in 1909 by English and American lovers of the poet.

Paddington

Famous Memories of a Crowded Town

It is one of the most crowded of London's towns, with over a hundred people to every acre. It has wide roads, quiet squares, and fine avenues of trees, and has grown up rapidly round its best-known building, Paddington Station, built in open fields north of Hyde Park; many of us know the famous picture of it by W. P. Frith, one of the best pictorial records of Victorian London.

The station remains much as when it was finished by Isambard Brunei in 1855. The peace memorial of the Great Western is in the main station, a massive bronze figure by Charles Jagger, the vigorous young sculptor whose death deprived our Art of so much high promise.

The fine new blocks of offices have soaring vertical lines, a contrast to the hotel, one of the first great railway hotels in the world. There are rows of balconies with scrolled ironwork, and many symbolical figures, festoons, and urns.

The hotel has a famous neighbour in St Mary's Hospital, one of the biggest in London. It is the youngest of the great teaching hospitals, and was opened in 1851. The old building, with its many balconies, is joined to a fine new medical school built in a modern yet human style which symbolises recent advance in healing.

Yet the Green outside has lawns and flower-beds shaded by fine planes. Many remember the ballad called Little Polly Perkins of Paddington Green, but she has now given place to Mrs Siddons, who sits with her head on her hand watching the passing crowds. She is a splendid figure. The robed statue, unveiled by Sir Henry Irving, shows the famous actress with a dagger in hand portraying her greatest tragic part, Lady Macbeth. She is buried under a tall tree in the great grassy churchyard joining the Green, and her tomb is like a cage, with iron railing and glass roof.

There is a tablet to Mrs Siddons on the sanctuary wall of the church of St Mary not far from her grave. It is the oldest church in Paddington, built in 1790 to replace the building where Hogarth celebrated his runaway marriage to Sir James Thornhill's daughter 200 years ago. It is square, and

is neighboured by tall trees. Its lofty portico faces Harrow Road, and we enter by a smaller, round portico at the side. A gallery rests against three of the panelled walls. The pulpit has polished walnut sides inlaid with oak panels carved with the Madonna and Child, a bearded prophet, a crowned woman, and an angel with a chalice.

The parish church of Paddington is now St James's, in Sussex Gardens, standing behind lofty planes at the end of a long, broad avenue. The walls are faced outside with flint, and lined inside with rich marble. The clustered columns have richly carved capitals, and over the altar is a white marble relief of the Last Supper. The panels on either side show Balm of Gilead, mustard, and other seeds mentioned in the Bible.

Behind a little lawn off the Bayswater Road is one of the surprises of Paddington, a sacred treasure-house. It is the Chapel of the Ascension, founded in 1893 by Mrs Russell Gurney and designed by Herbert Horne, its walls decorated with paintings by Frederick Shields.

The chapel has a tiny rose window in the gable, and over the twin doors are paintings of the Prodigal Son returning to his father. The walls of the outer chapel show Man rejecting and then heeding the call of Conscience, with symbolical portrayals of Meditation and Prayer.

To enter the inner shrine is to behold a rare revelation of rich and mysterious delight. All the walls are covered with masterly painting, from Creation (at the entrance) to the Ascension (above the altar). The entire work was designed by Shields, much of it carried out on canvas in his studio. As the conception of a single artist it is one of the most remarkable examples in England, and many of the paintings are sheer works of genius.

Over the organ gallery are scenes of Adam and Eve, painted by the light of a feeble oil lamp in the cold foggy winter of 1894. Surrounding the arch is a frieze of cherubs. The north wall shows the Gospel story, with figures of the Apostles, whose Acts are shown on the opposite side. Above the altar the whole theme rises to a grand crescendo, the Passion, the Resurrection, and the Ascension being framed by attendant designs of Hope and Love. Each picture has a wealth of symbolical meaning, and the harmonious colours and inspiring technique are a delight to the eye.

The Passover of the Holy Family is from an unfinished design by Shields's friend Rossetti, carried out after Rossetti's death. The originality of the work of Shields is shown particularly in a figure of Love teaching a white child to love its black playmate. On the south wall are many martyrs, from St Ignatius, thrown to the lions under Trajan, the Roman Emperor, to heroes of our own day, and on the same wall is a family at prayer in an English cottage.

By the altar of the mortuary chapel are two marble medallions by Alexander Munro, one showing the mother of Mrs Gurney in a lace cap. The other is a pathetic chubby figure of Mrs Gurney's small sister lying among bluebells and ferns. On the wall is a figure mourning over a profile bust of John Webber, the draughtsman who accompanied Captain Cook on his second voyage round the world. A fine picture of Lazarus coming out of the tomb is one of the great series of paintings by Frederick Shields.

A Little-Known Open Space

Unsuspected by most who pass by is the old burial-ground of St George's, Hanover Square, a surprisingly big open space behind the chapel. Most of the tombstones are set against the wall, and the wall itself is interesting because it was built to prevent body-snatching, and the graves have given place to tennis, archery, and vegetables.

St Augustine's Church at Kilburn, built by John Loughborough Pearson, has a lofty spire and turrets. With its high-vaulted roof, its big rose window, and its processional ways, it is like a cathedral, and the elaborate decoration makes it a rich gallery of Victorian art. The chancel has a beautiful marble floor, and everywhere are saints, prophets, and Bible pictures – in the rich windows, carved on the font, the pulpit, and the roodloft, and painted on the walls.

Three highly valuable pictures hang in the chapels, happily lit by electric light so that we may see the beauty of these precious canvases. They are medieval masterpieces from Italy, painted about 1500, and were presented by Lord Rothermere in memory of his mother, who frequently worshipped here. In a chapel by itself hangs Filippino Lippi's Blue Madonna, in a wonderful state of preservation; it has cherubs singing praises in the sky. Palmezzano's Holy Family hangs in the south chapel; it shows the Madonna sitting on the ground with the Child on her knee, while Joseph stands behind, and John and St Katherine kneel at prayer. Near by is part of an altarpiece by Carlo Crivelli, the Venetian, many of whose pictures are treasured in England; in this one a red-robed figure of Christ stands on a green carpet held by delightful angels.

Paddington's Cathedral

But, rich as is St Augustine's, Paddington's cathedral is not here but in the Moscow Road. It was built towards the end of last century for the Greek Church by John Oldrid Scott, son of Sir Gilbert, a Byzantine building with one of the most beautiful interiors in London.

The roof is crowned with a copper-covered dome rising above brick walls which do little to prepare us for the magnificence within. Here coloured

marbles line the walls, while the great dome and the arches supporting it are covered with rich mosaic designs by Arthur Walker. In the middle of the dome, brooding in blessing over the church, is a gigantic mosaic figure of Our Lord sitting on a rainbow, with arms upraised against a background of glowing gold. Twelve cherubims surround Him, and between the windows stand the Twelve Apostles.

The arch of the apse shows Moses and Aaron reclining among trees, framing a mosaic of Christ in Glory, angels by the throne fanning with palms, while winged trumpeters sound their praise above. The walnut screen across the apse is painted with Bible scenes and inlaid with mother-of-pearl, and above the vestry door is a beautiful picture of Christ blessing the children. The pulpit and stalls are of richly carved walnut, and there are walnut galleries for the choir and for visitors who care to hear the beautiful unaccompanied singing.

The Ethical church has a crescent-shaped hall near by. Before the tribune stands the marble Altar of the Ideal, and above is painted what is described as the race of hero spirits passing the torch from hand to hand. Round the walls are statues of teachers and idealists of all ages, from Dante to Abraham Lincoln, and by the tribune are figures of Christ and Buddha. A window shows the martyrdom of Joan of Arc.

Westbourne Park Baptist chapel has a bronze bust of one of the most outstanding Paddington men of his time, Dr John Clifford.

The Dummy Houses

It was Dr Clifford who founded Westbourne Park Building Society, whose fine headquarters, with a pillared portico, are in Westbourne Grove. There is nothing small about these massive offices, and surely no building society ever had on its books a tinier house than 10 Hyde Park Place, wedged between lordly neighbours on either side. The windows are dummies, and the frontages are held by girders over the Metropolitan Railway. The houses were gutted when the line was made, the fronts being retained to avoid spoiling the street.

There is no sham about Whiteley's, perhaps the most famous shop in Paddington, known all over England. It has big windows with long rows of lofty columns, and has grown out of the humble establishment William Whiteley opened near by in 1863.

The Russian Eagle on a column in Orme Square near by was set up as a tribute to the Russian triumph over Napoleon, and also in honour of the Czar's visit to this country in 1814. A house in Gloucester Square bears a tablet saying that Robert Stephenson died here in 1859. His famous tubular

bridge stands by Telford's suspension bridge across the Menai Strait, and he was taken from this house to lie by Telford in Westminster Abbey.

Paddington has an early engineering work of its own, the Grand Junction Canal, which was opened to Uxbridge amid great rejoicing in the first year of last century. Passengers were conveyed five days a week, and as late as 1853 country excursions were still being advertised. It is joined to the Regent's Canal at a quiet basin with wooded island and stone balustrade.

A great patriot and philanthropist is remembered by a fine monument in an open space facing Hyde Park. On the front is a bust of the Earl of Meath, to whom this memorial was unveiled by the Duke of Connaught on Empire Day in 1934.

But perhaps the most tragic place in all Paddington is where the ceaseless tide of traffic swirls round Marble Arch, for here stood Tyburn Tree, London's execution place for 600 years. The site took its name from the little river Tyburn, one of whose arms crossed Oxford Street here. Tyburn then lay among the fields, with only a few houses, from one of which the sheriffs watched the executions. Round the gallows were stands with seats, let to spectators at half a crown.

Shoreditch

The Cradle of Our Immortal Heritage

The Shoreditch of these days has nearly 100,000 people on its one square mile, and more than 10,000 to every acre of its open spaces. It adjoins the prosperous City on the south, and much of its northern boundary runs with the Regent's Canal.

Its roots are deep in the past, for far below the line of Old Street have been found remains of a Roman Road. Now the buses run over it, past the imposing twentieth century town hall, which has in a niche of its tall tower a figure of Progress with a lighted torch. The chief local industry is cabinet-making, and parts of the tables, chairs, and beds are displayed in the shop windows, as well, of course, as in the delightful little group of buildings now known as the Geffrye Museum.

Shoreditch is happy in its possession of this place, one of the finest small collections in the world, a museum of practical usefulness as well as of great beauty. The LCC has done its work well and preserved this plot as an oasis of quiet and beauty in a neighbourhood much in need of it. It is a unique museum of furniture in the midst of the great furniture-making industry of East London.

Over the doorway is a lead statue of Sir Robert Geffrye, a copy of the original which was taken away to adorn the new almshouses at Mottingham. Sir Robert has gone too, though the little shaded plot where he was laid remains, with the chapel behind the bell turret of the quadrangle, in which most of the fittings have been left.

Some of the exhibits are splendid, notably the staircases which mysteriously climb up to the low roofs to vanish there and lead nowhere; but the museum rejoices in one or two rooms set up in all completeness and modesty, vaunting their worth or antiquity. Chief of them is the Master's Parlour of the Pewterers Hall, the first building to be reconstructed after the Great Fire, tradition associating it with the name of Wren. Beyond dispute the beautiful oak staircase from a church on Watling Street is Wren's.

Other panelled rooms stand as witness to the honest workmanship and sometimes to the talented design of a forgotten artist, among them one with a chimneypiece from Lincoln's Inn Fields. There is a cottage interior of Queen Anne's day and another with a collection of cooking appliances unsurpassed in London. There are chimney cranes, spits, jacks, lazybacks,

tongs, fire shovels, toasting forks, a mechanical bellows, boilers, kettles, saucepans, and holders for rushlights. The rooms and their contents are all treated with affectionate discretion, cleaned and refurnished but never painfully restored. In one room the window spaces are filled with strips of Chinese wallpaper in the fashion of the time, and the dust of centuries cannot dim their brightness.

Here we may see mirrors, tables, and chairs made by Chippendale Hepplewhite, Sheraton, and Adam. Some are simple, many are beautiful, and for its size there is no museum anywhere which reveals better the framework of the story of English furniture from the seventeenth to the nineteenth centuries.

In the garden of the museum is a bronze bust by Paul Montford of a Wiltshire boy who started life in a shipyard, became a carpenter, found his way to Parliament, and won the Nobel Prize by his work for Peace; he was Sir William Cremer. The bust has a spray of laurel for this man who should be remembered.

In a Hoxton Street window we found an exhibition that would have delighted Robert Louis Stevenson, for here was a model theatre in the very shop visited by Stevenson before immortalising it in one of his essays, Penny Plain and Twopence Coloured.

Farther up this lively street is the famous Britannia Theatre, now a kinema but steeped in stage tradition. The theatrical tradition has invaded the Hoxton public library, for its entrance hall has a sculptured frieze of Shakespeare's plays. One of its windows shows Caxton presenting some of his work to Edward the Fourth, and on the stairs are two bronze reliefs by Sir George Frampton, who fashioned Peter Pan in Kensington Gardens. One shows the fine face of Keats, who was born over a stable near the borough boundary, and the other the lovable face of Charles Lamb, once an inmate (like his tragic sister) of the private asylum he called the Old House at Hoxton. Both these bronzes were given by John Passmore Edwards, the philanthropist whose white bust stands at the top of the stairs. In the newspaper room is a bust of the sturdy and stern-faced Charles Bradlaugh, the Radical who lived in Shoreditch and made so great a commotion in England.

Haggerston's library has a reading shelter in its garden, and in the reference room is a marble bust by Henry Pegram of genial Edmund Halley, in his lace cravat and with a curly wig falling over his shoulders. This famous Astronomer Royal, who discovered the famous comet called after him, was born at Haggerston during the Commonwealth, and his grave is at Lee, in Lewisham.

One Hoxton church has a link with the City, for in the modern St Mary's is a beautiful seventeenth century panelled pulpit from the lost church of

St Mary Somerset, whose tower still stands in Upper Thames Street. The beautifully-coloured little window in the middle of the apse shows the descent of the Holy Spirit.

Hoxton's oldest and finest church is the nineteenth century St John's, a good example of Greek architecture. Two fluted pillars flank the door, and above rises the square base of the round tower, pierced with arches. The ceiling is painted with angels, and the impressive east window shows Christ enthroned. The pulpit is kept under the gallery, and is pulled forward on its rails for the sermon. On a wall stands out in relief calm-faced Anthony Plimbley Kelly, first minister of this church, who served it for thirty-eight years. It is good to see that the graveyard has been made into a gay garden.

The nineteenth century St Mary's at Haggerston is a Gothic building much altered since it was designed by John Nash, the famous architect of old Regent Street. The lofty tower is capped with embattled pinnacles and flanked by embattled turrets. It is a landmark, and can be seen at a distance soaring above the roofs of the houses. In the nave are clusters of slender pillars soaring roofward to support two graceful arcades of pointed arches.

But it is the historic St Leonard's, the venerable mother church at Shoreditch, which stirs us all. It stands on the site of a Norman church which had a Roman road running through its graveyard. The thirteenth century church has vanished but the Shakespeare memories it enshrined must for ever linger in this place. On the old site stands the eighteenth century church designed by George Dance, architect of the Mansion House. The tower rises from a high portico, and has a lofty steeple, its little dome capped by a slender spire.

The interior is light and spacious, with some of the loftiest arcades we have seen. The glory of the church is the Flemish glass in the east window, some of the finest old glass in London. In the middle is Jacob's dream, his prayer for deliverance, and his reconciliation with Esau; and below is the Last Supper, with three little scenes above it of Christ washing the disciples' feet, the Agony in the Garden, and Judas receiving the thirty pieces of silver.

The massive oak pulpit is 200 years old, and richly carved with eaves; its panels are inlaid with stars, and the canopy rests on a pair of fluted pillars. The organ in the gallery is in an old Spanish mahogany case, and the pipes rise from brackets carved with cherubs. The gallery front has gilded carving of fruit and flowers over the clock is an eagle. Under the gallery is a font cut out of a solid block of marble, perhaps 200 years ago.

Hanging on the wall is the standard of the Middlesex Regiment, and below it is a huge glass case containing four drums. They were in the battle of Loos, Cambrai, and Armentieres, when most of the men who went into action with them made the great sacrifice.

Bermondsey

The City's Riverside Neighbour

Fertile market gardens preserved the site of its beautiful park, its fine air made it long ago a tripper's resort, a great fire has put it into history books, and the waters of the Thames bring it commerce from beyond the seas.

Its most striking wharf, seen from London Bridge, is a fine modern building with long central windows surrounded by nearly forty splendid plaques of gilt faience designed by Frank Dobson. They illustrate commercial energy in dockland, and their variety of cranes, barrels, and ships tells us what to expect if we venture down the narrow riverside street.

We will go instead to London Bridge Station, Bermondsey's best known building, extending over many acres. It was a century ago the terminus of the London-to-Greenwich line, the first railway in London, which still stands on 900 arches that have been here while railways have spread themselves over the earth. At Corbetts Lane Junction was the world's first signal box; now there are over ten thousand on our British railways and the London Bridge signals control 1,000 trains a day.

Under London Bridge Station, with its twenty-one platforms, run many gloomy tunnels, queer underground streets, and almost next door is something more beautiful, the chapter house of Southwark Cathedral It was once St Thomas's Church, and joined to it is a row of beautiful eighteenth century houses which were part of St Thomas's Hospital before it was moved to Lambeth, and set up in such noble dignity to look across at Parliament. The dignified church with its slender brick tower was built about 1700, and the centuries old cherubs still look from its tall windows. The walls and doors are panelled, and above the painted reredos is a Bible picture attributed to Murillo, which for almost thirty years lay forgotten in the crypt.

A turning near the church leads to the lofty building of the London Leather Market, for Bermondsey is the great centre of the tanning industry, a business believed to have started with the Huguenots who fled from France. The Leather Sellers Technical College in Tanner Street, and an inn named Simon the Tanner, all remind us of it.

A happy contrast to the tanyards is the scent of the flowers in the garden of Bermondsey's mother church, St Mary Magdalene. It is one of the town's

pleasant islands of rest free from its seething traffic. The church is noted for its Restoration fittings, and has big round-headed windows of that period. The core of the tower is fifteenth century, while the stone panelling, the leafy pinnacles, and the curious gabled spire were added just over a hundred years ago.

Round columns separate the nave from the aisles, and everywhere indoors are the popular cherub ornaments of the seventeenth century. The church is cheerful and flooded with light, and for the dark hours art splendid brass chandeliers, two of them with curling arms nearly 300 years old. From the same age comes the oak pulpit carved with its flowers and shells and more entrancing cherubs.

The dignified reredos is of dark oak, largely Restoration work, enriched by bold carving of cherubs, flowers, and fruit, with paintings of Moses and Aaron at the sides. At the other end of the church is the organ, its seventeenth century panelled case carved with scrolls, books, and acanthus leaves. It is in the gallery, also seventeenth century. On the chancel wall is a relief of a fully-rigged sailing ship set among skulls, fruit, and flowers in the fashion of the eighteenth century; it is in memory of William Steavens.

The church has the most complete set of registers in South London, beginning in 1549, but its most precious possession is older still, a richly-ornamented silver plate believed to have been made in Spain about 1400. On it is engraved the scene of a lady setting a helmet on the head of a knight kneeling by his horse.

On the floor of an aisle lie two Norman capitals carved with writhing dragons, nearly all that is left of the famous Bermondsey Abbey, which stood on the south of the church. Only fragments remain of this abbey of great memories.

Bermondsey's town hall, in Spa Road, is an imposing stone building with a colonnaded portico, and on the walls of the council chamber are two drawings showing a Bermondsey hero (Corporal Holmes) winning the VC by carrying a comrade to safety through a storm of shells and returning single-handed to bring in a gun.

St James's Church at the end of Spa Road has a tall colonnaded entrance built in the Grecian style so popular in the early years of last century. Above the high square steeple and open spire is a dragon windvane, and in the tower is a fine peal of ten bells made from guns which thundered for Napoleon at Waterloo. In place of an east window is a picture of the Ascension 25 feet high and 11 feet wide, which won a prize of £500 competed for by eighty artists.

The church of St John, which has stood near Tower Bridge Road for over two centuries, has one of the most unusual spires we have seen – a

wonderfully graceful column, fluted and tapering, which has become a landmark reminding railway travellers that they are approaching London Bridge. The tower is adorned with many niches, and the spire has a golden star on the top.

The home of the Three Tailors of Tooley Street is near by, Tooley Street being the centre of the London egg trade. Down the street is a bronze statue by Sydney March of Colonel Bevington, a bearded figure standing in his robes as first mayor of Bermondsey. Opposite the mayor stands St Olave's Grammar School, a fine modern creeper-covered building with a pair of gables, and a row of dormer windows in its steep roof. This famous school joins the approach to Bermondsey's greatest spectacle. It is the Tower Bridge, the eastern gate of the City, built by the architect of the Griffin at the City's western gate, Temple Bar. Set up at the close of last century by Sir Horace Jones, the Tower Bridge is with its approaches over half a mile long, it cost one and a half millions, and is the most majestic of the Thames bridges. The great Gothic tower on the southern side forms the most impressive entrance into Bermondsey.

We see the bridge as a whole from Cherry Garden Pier, and it is Bermondsey's finest view. Tall warehouses frame the imposing pageant of Thames shipping. Fresh breezes blow up the river, the water sparkles in the sun, and even the cherry trees are not far away, for we find them in

The Tower Bridge

Southwark Park, an open space of 63 acres opened in Victorian days at a cost of over £100,000. Where once were market gardens are now great playgrounds, a lake for boating and swimming, and a fine chrysanthemum show in a winter garden.

Southwark Park has nothing to do with Southwark, Bermondsey sharing it with Rotherhithe, a district of docks and wharves with two famous tunnels, the first and the biggest under the Thames. The Thames Tunnel, oldest of all the under-river ways, was begun in 1805, but not opened till 1843. A little downstream is Rotherhithe Tunnel, the biggest Thames tunnel, nine yards wide. Over its entrance is a steel arch which formed the cutting edge of the tunnelling shield, and next to this is Bermondsey's most beautiful building, the 20th century church for Norwegian sailors, opened by the Crown Prince of Norway. The front looks like a house, and from the roof rises a graceful needle spire capped by a Viking ship.

Rotherhithe's Mother Church

Rotherhithe's mother church, near by, was made new 200 years ago, but it has in its churchyard the grave of a man who played his part in history before the church was built. He was Christopher Jones, captain and part-owner of the Mayflower, who sailed to America with a Rotherhithe crew. The graceful nineteenth century spire on the church rises from pillars set on a balustraded tower, and is a landmark for Thames pilots. The east window has an eighteenth century figure which is thought to be German, showing the sorrowful Madonna in red and blue, with a halo enclosing seven stars. The 200-year-old reredos covers the whole of the wall, its flat fluted columns enclosing Bible pictures. It is enriched with carvings of fruit, flowers, and wheat which are interesting because they are said to be by Grinling Gibbons. The organ case is as old as the church, and on top of the towers of gilded pipes recline two angels blowing trumpets. The lectern is a massive affair of black oak, made up of seventeenth century woodwork carved with scrolls and acanthus leaves.

The most beautiful thing in the church is the sixteenth century alms-dish, probably Spanish, with rich bands of ornament on which leopards, deer, and rabbits frolic among foliage. The oddest thing here is the mysterious symbolical oil painting hanging in an aisle. The design is said to have been suggested by Charles Stuart, and the picture is thought to have been given to the church by Charles the Second; it shows his father kneeling at a table, from which he is taking a crown of thorns, while his own crown lies on the ground.